Cultural Calendar
of the **20th Century**

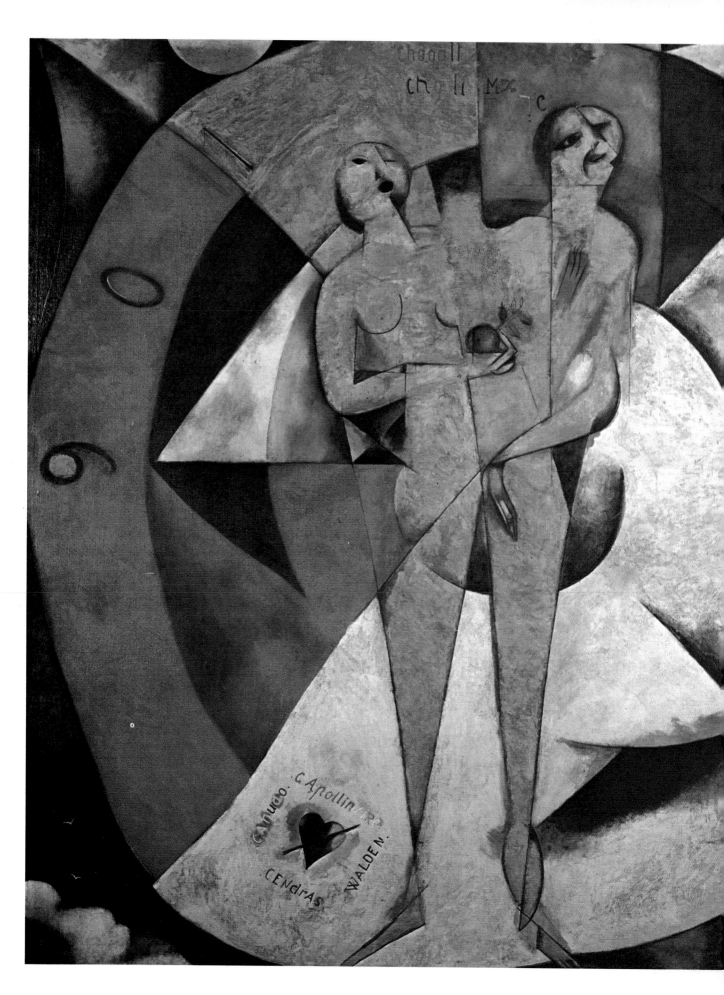

Cultural Calendar of the **20th Century**

Edward Lucie-Smith

PHAIDON

Title page: Chagall — *Hommage à Apollinaire* (1911)
Right: George Grosz — *Grauer Tag* (1921)

Phaidon Press Limited
Littlegate House, St Ebbe's Street, Oxford

Published in the United States of America by
E.P. Dutton, New York

This edition first published 1979
© 1979 by Phaidon Press Limited

British Library Cataloguing in Publication Data

 Lucie-Smith, Edward
 Cultural calendar of the twentieth century
 1. Arts, Modern — 20th century — Chronology
 I. Title
 700'.9'04 NX456

 ISBN 0 7148 1930 1

Library of Congress Catalog Card Number: 79–87454

Printed in Italy by Amilcare Pizzi, Sp.A.

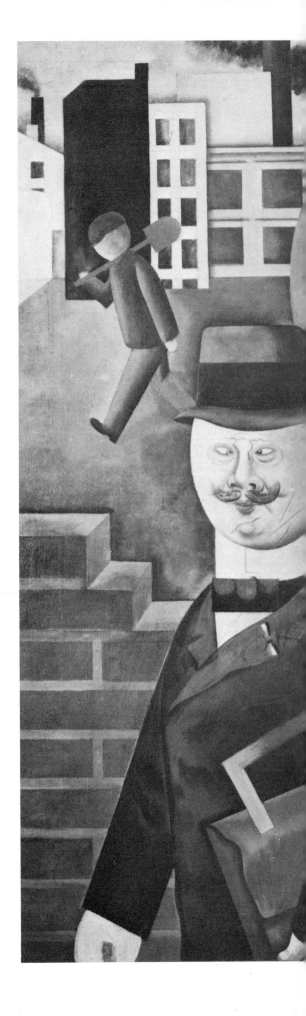

Contents

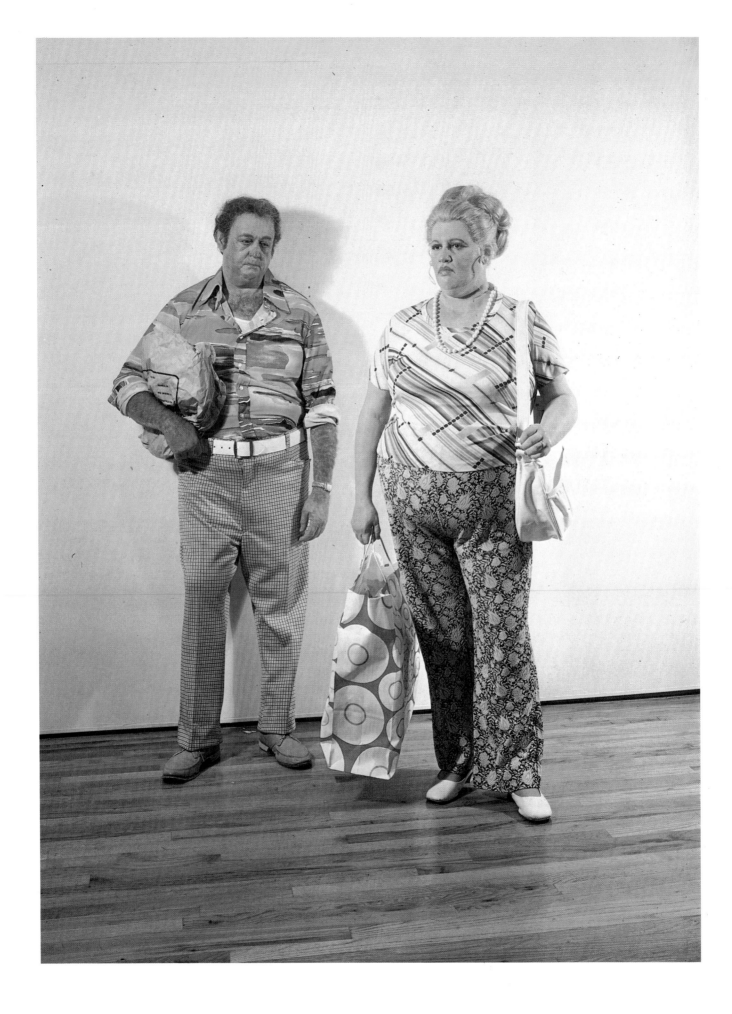

Preface

This book is an attempt to show, in words and pictures, the immense variety of twentieth-century cultural activity against a background of world events. There are four basic ingredients – a continuous narrative history; a visual narrative with pictures of all kinds, ranging from contemporary news photographs to reproductions of acknowledged masterpieces of painting and sculpture; a list of world events for each year; and another list of cultural landmarks.

Clearly it would need twenty books the size of this one if such a history were to make any pretence at completeness. Equally clearly, the author concerned would have to be not only incredibly omniscient but inhumanly detached and judicial. My own enterprise is therefore frankly impressionistic. It aims to give the feel of a particular time, a particular year, not to tell the reader every possible thing about it. And the point of view is unashamedly that of the late 1970s. The things which are emphasized are the things that seem important now. They might not have been stressed to the same extent in 1950, and the emphasis will very probably be different again once we have reached the year 2000. Even so, the reader will note that one area of activity has been omitted, that of the executant as opposed to the creative arts: there are playwrights but no actors; composers but no opera-singers or violinists. A decision was made to concentrate on what the twentieth century has created for itself, rather than on the way it has – often brilliantly – given life to the creations of the past. Where the focus does occasionally shift to the performer it is because he or she seems to summarize the attitudes and aspirations of a particular moment, as Presley did in the late fifties. Even in the case of rock music I have been interested chiefly in singers or groups who composed.

Left: Duane Hanson *Couple with Shopping Bags* (1976). Super Realist sculpture can be cruelly accurate. This couple have become consumers before they are anything else, not only of consumer goods, but of popular culture.

From the standpoint of 1979, the main cultural fact of importance seems to be the impending death of the Modern Movement. It is certainly modernism which dominates the whole of the period between 1905 (the year when the Fauve painters first exhibited as a group in the Paris Salon d'Automne) and 1975, which is the date of the most recent lists in this book. Yet most thinking people have been aware of an increasingly rapid change in the cultural climate since the end of the sixties.

Perhaps one can put the beginning of this change about 1968, which was the year of the Paris 'events' (so important in memory, and yet so strangely without practical consequences), and also that of the Soviet intervention in Czechoslovakia. Successive shifts of mood since then have been marked by the Watergate scandal in America, by the Yom Kippur War and the energy crisis which followed it, and by the final collapse of the American effort in South Vietnam.

Yet it is still impossible to point to one significant cultural, rather than political, event, and to say unequivocally 'modernism ended here'. This is not wholly unexpected – in the analysis of cultural events, beginnings are more crucial than endings.

If one may venture a comparison, however, it would be one between modernism and the Mannerism of the sixteenth century. In many respects the similarities are striking. Mannerism began to show itself about 1505, and was to last until the first stirrings of the Baroque around the year 1590. It was thus, as art-styles go, exceedingly long-lived; more so, even, than the Romanticism of the late eighteenth and early nineteenth centuries. Mannerism, like modernism, was international – its influence spread throughout Europe. And, once again like modernism, it was a learned, esoteric style – widespread geographically, but never able to

Preface

leaven the mass. In fact, it represents the point at which the gap between 'high' and 'low' culture first began to open – a split widened later by the effects of the Industrial Revolution.

One feature of Mannerism was the large body of artistic theory which it built up; so much so, in fact, that it was often the pre-existing theory which produced the work of art, rather than the other way round. This, too, is something we can recognize in the culture of our own day.

As a final comparative point, Mannerism developed from being something wholly unofficial and rebellious into being an accepted and rather rigid official style. Many people would deny that this is what has happened to modern art and literature, and would point out that the artist is still radically alienated from the society in which he lives. This is true only up to a point. In fact, modernism receives a greater and greater degree of official support. It remains as misunderstood as it has ever been by the majority, but is nevertheless accepted by a ruling bureaucracy as the authentic cultural expression of our time.

One reason why this comparison cannot be pressed too far, however, is that during the two eras there were great differences in the methods by which information about the arts was communicated.

In 1900, information travelled in much the same way that it had always travelled. People experienced works of art directly, not as yet through photographic reproductions. Music remained in the concert hall; though Edison had invented the phonograph in 1877, it was so imperfect throughout its early years that it took a long time to affect musical culture. The chief means of disseminating cultural information was still the printed word, though since the 1840s newspapers had increasingly challenged the pre-eminence of books in this field. But print has undergone a series of revolutions, and we have arrived in the age of colour reproduction. Good quality, cheap colour printing has led to the creation of what André Malraux dubbed 'The Imaginary Museum'. We now live, not in a single, unitary culture, but in one which is plural. We are at liberty to pick and choose between different aesthetic and historical traditions.

Meanwhile, other means of communicating ideas have arisen to challenge the dominance of print. First there was the radio; then came television. All kinds of artistic events and experiences have become available to the majority, in a way that would not have been possible as little as seventy years ago.

We live in a society where access to culture is considered to be everybody's right. Yet this right is one which many people do not wish to exercise. The modern arts, in particular, continue to arouse a mixture of hostility and derision; and it sometimes seems as if this reaction is something necessary to their identity – that the artist cherishes his situation as an alienated being.

What modernism has achieved needs to be retested in the light of absolutely contemporary experience. This whole book is intended, not so much as a contribution to cultural history, but as a kind of sounding board. I believe that, as one looks through the text and pictures, taken in conjunction, all kinds of unexpected points appear – concealed correspondences, hidden links. In addition to those which are already visible to me, as author of the book, many others will make themselves visible to readers with a range of experience different from my own. In a way it is a pity that the information given here cannot be published, not as a book, but as a pack of index cards, so that things could be added or subtracted by each individual user at will.

In case anyone wishes to attempt such an enterprise, let me explain some of the pitfalls I have already encountered. Selection of facts, events and pictures for a book of this kind has to proceed on two different and sometimes conflicting sets of principles. There are the things which seem important in the light of hindsight, and the things which seemed important to the people of the time. The major international exhibitions which have been a feature of cultural life in this century have attracted a great deal of attention, and have occupied many column inches of newspaper and magazine space at the time when they were open and available to the public. But, considering the

Three images from 1968, the turning point of the post-war era. The scene from Richard Lester's film *The Bed Sitting Room* (below) suggests youthful alienation and the 'generation gap', a popular cliché of the time. The poster for the Beatles' film *Yellow Submarine* (right) denotes the triumph of Pop culture, here in its 'psychedelic' phase. The Czech poster protesting the Russian invasion (below right) exemplifies the current political anxieties, which included invasions, assassinations and student protest.

amount of money spent, and the journalistic interest aroused, they have not, in most cases at least, made any lasting impact. The *Exposition des Arts Décoratifs* held in Paris in 1925 was one of the few exceptions to this rule, since it managed to give its name to a new decorative style.

On the whole, where considerations of space have forced me to choose one thing rather than several, I have chosen what seemed important in the long run even though it may not have been considered crucial at the time. In the cultural lists this has led to a bias towards the *avant-garde*. There are perhaps subtler distortions as well. In the case of writers, for instance, the choice has tended to veer towards an earlier rather than a later book, as a way of marking, not merely an achievement which was noteworthy, but the appearance of a new voice.

A very particular difficulty is the fact that creative activity is often opposed to the kind of cut-and-dried chronological treatment which is necessary if the lists are to be of anything approaching manageable length. A notable building may take many years to construct, but the plans may be published quite early in the construction period, and may already begin to influence other architects. It has sometimes been difficult to know what was the right spot to introduce an especially notable work. Brecht's best plays, for example, were written in the very late thirties and early forties, in the enforced leisure of exile, but were not produced in most cases until a decade had passed. Schoenberg's *Moses and Aaron* was begun in 1930, was put aside unfinished in 1932, and the massive torso was at last staged in 1957, after the composer's death. Samuel Beckett's *Waiting for Godot* was written between October 1948 and the end of January 1949. It was published in French in 1952, and first performed on 5 January 1953, after being in rehearsal more than a year. An abridged radio performance, however, had already taken place in February 1952. Hindemith's *Harmonie der Welt* is, in its symphonic form, dated 1951 in Grove's *Dictionary of Music and Musicians*. The *Oxford History of Music* dates the expanded, operatic version as 1956, apparently implying that this was the date at which the composition was finalized. The first performance of the opera did not in fact take place until 11 August 1957.

Because of such difficulties, I have not been able to be completely consistent in my system of dating, and the problem has been aggravated by the discovery of frequent disagreements, and indeed of obvious inaccuracies, among standard works of reference. What I have tried to do is to give the date when the work first began to influence people. Brecht's circle of intimates already knew about his plays, and his theories had started to be discussed, and this is the reason for placing them under dates of composition rather than dates of first performance. But on the whole I have preferred the date when a work of whatever kind became generally available in whatever form.

A further difficulty has arisen over the translation of the titles of foreign works. Constant translation can result in absurdities, and I have decided to put each title into the form in which I feel that it would be most familiar to English-speaking readers.

Finally, I would like to mention that this book has benefited from the help of four people, who did far more for me than I deserved. They are my editor, Roger Sears; Célestine Dars, who did the picture research; Dr I. Grafe, who made many valuable suggestions and saved me from many errors; and Sarah Tyzack, who was responsible for the design. I would like to acknowledge and thank them all, with many apologies for the amount of work I have caused them.

EDWARD LUCIE-SMITH

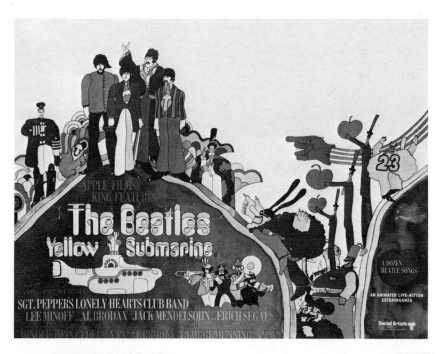

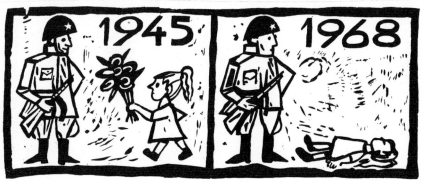

Below: Detail from an opulently Art Nouveau fabric
designed by the famous poster-artist Alphonse
Mucha, typical of the taste of the early 1900s.

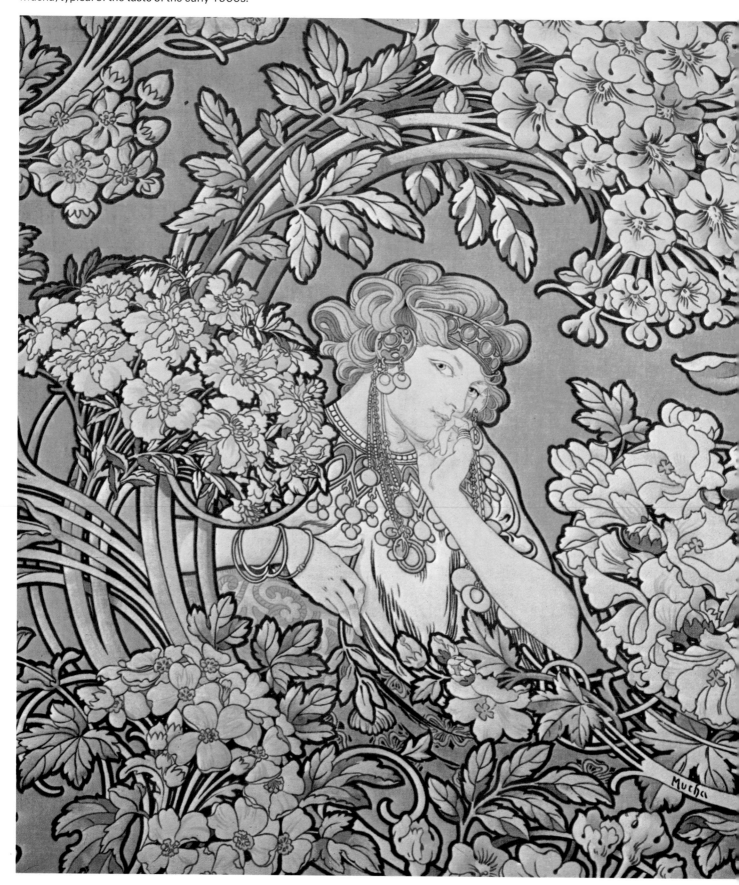

The Birth of Modernism

1900 – 1913

The period from 1900 until the outbreak of the First World War can be seen as culturally the most important in the whole of the twentieth century. We can look back, from the standpoint of the late seventies, and see the beginnings of many processes which are still working themselves out. Within this period, however, it is useful to make a distinction between the years 1900–05 and those which lead up to the catastrophe. During the first five years of the century one is conscious of an attachment to the past which is only gradually being loosened, of a world order which retains a precarious stability, of the existence of a consensus about the nature of society and the arts. The world of 1903 or 1904 was not so very much altered from that of the 1880s.

There is also a distinction to be made, at perhaps a more superficial level, between the world as it then appeared to the majority of educated Europeans and North Americans and a number of developments which were taking place under the surface. In Paris, for example, the arrival of a new century was celebrated with all due pomp in the Universal Exhibition of 1900, latest in a whole series of such events which had taken place since the Great Exhibition of 1851. Neither the grandiose buildings, in best nineteenth-century Beaux-Arts style, nor the majority of the displays, gave the slightest hint of what was to come. The exhibition, which most people accepted as a landmark, had more to do with the past than it did with the future.

The clothes people wore, and the interiors the prosperous inhabited, also speak of a world very different from our own, and based upon very different intellectual and social assumptions. In the 'progressive' sector of the decorative arts the vogue for Art Nouveau was still at its height, and the puritan concept of 'fitness for use' was a correspondingly long way in the future.

Nevertheless Art Nouveau was a form of design which worked well within its own terms, and these were still largely those of the aristocratic tastes of the eighteenth century.

Politically speaking, the people who lived in this luxurious and protected world had much to occupy their minds. In Europe it was an age of anarchist assassinations and labour unrest. Spain and Russia were particularly plagued by anarchist activity, and Russian politics were moving towards their first major crisis. The military disaster of the Russo-Japanese War was to be followed by the abortive Revolution of 1905. Many could see the need for reform in Russia, but few realized how far the disease had gone; indeed, this held true until the October Revolution of 1917. Nor did many people grasp the significance of the fact that a supposedly European nation had been soundly thrashed by a non-European power.

Meanwhile, the restless ambition of Kaiser Wilhelm II was gradually forcing Britain apart from Germany. The German decision to embark on a naval arms race with the British was followed by the signature of the *Entente Cordiale* between Britain and France, an event which took place in 1904.

When the European powers thought in terms of warfare, however, it was colonial events which pre-occupied them. In 1900 Britain was still trying to subdue the Boers, who enjoyed the covert or even overt sympathy of most of the rest of Europe. Nevertheless, when President Kruger appealed to Germany for help, the Kaiser did not dare to receive him. The Boxer Rising in China produced no change in predatory European attitudes. The European powers thought, not of strengthening and reforming the decadent Chinese Empire, but of carving out new spheres of interest for themselves. The sacking of the Summer Palace brought a great

11

The Birth of Modernism

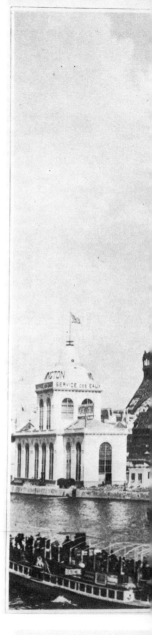

flood of Chinese material onto the European art market, much of a kind and a quality previously unknown there, but this had curiously little cultural impact. Europeans only began to have a profounder view of Chinese culture in the early twenties, and it was only then that the purity and simplicity of 'Chinese taste' porcelains, bronzes and jades began to be appreciated.

The visual arts had already begun to take over from literature as perhaps the most consistently progressive area of cultural activity, but progress itself still moved for the moment in separate streams, not in one broad and irresistible river. Then, too, it was more to be associated with individuals, rather than with organized movements and groups. Basically, three different tendencies can be detected – Symbolist, Expressionist, and what it is convenient (though perhaps anachronistic) to call Formalist. These tendencies are not necessarily associated with young artists – they can also be linked with older ones, such as Cézanne and Gauguin, who were near the end of their careers but whose full influence was yet to be felt.

Symbolism had been the leading progressive tendency in European art since the 1880s, and in some areas it was to continue unchecked until the outbreak of war. The most active Symbolists of the post-1900 period, and the most genuinely creative ones, were the members of the Vienna Secession and particularly Gustav Klimt, whose elaborately patterned compositions sum up the refined luxuriousness of Viennese society at that time. Simultaneously, they hint at the spiritual malaise which in turn prompted the researches of Freud.

Gauguin, who died in the Marquesas in May 1903, after a final absence from France which had lasted for nearly eight years, was another Symbolist whose work provided an important pointer towards the future. His nostalgia for the distant and the barbarous was an inheritance from nineteenth-century Romanticism, but in his hands it became something prophetic. His Tahitian and Marquesan pictures show little real knowledge of native art or native customs, but they are nevertheless the direct precursors of Picasso's Negro Period (and thus to some extent of Cubism), of the fierce primitivism of Russians such as Larionov and Gontcharova, and even of Stravinsky's epoch-making *Rite of Spring* (which has as little to do with ethnography as Gauguin himself).

The most obvious bridge between the two art movements of Symbolism and Expressionism is the work of the great Norwegian painter Edvard Munch, who occupies a crucial position in the history of proto-modernism. Essentially Munch was a Symbolist, ambitious as all Symbolists were

1900

General Events

A Zeppelin airship made its first trial flight.
The British Labour Party with Ramsay MacDonald as its first secretary was founded.
The Boxer Rising took place in China.
The constitution of the Commonwealth of Australia was proclaimed.
The United States adopted the gold standard.
A secret Franco-Italian agreement gave France a free hand in Morocco, while the Italians had a correspondingly free hand in Tripoli.
England and Germany signed an agreement over spheres of influence in the Yangtze Basin.
The German government decided to build a fleet of thirty-eight battleships within the following twenty years.
Umberto I of Italy was assassinated by an anarchist.
Britain annexed the Transvaal and the Orange Free State.
The Boer President Kruger fled to Europe but was denied audience by Kaiser Wilhelm II, who had previously supported him.
Planck published his work on quantum theory.

The Arts

Literature
Joseph Conrad – *Lord Jim*
Theodore Dreiser – *Sister Carrie*
Colette published the first novel in the 'Claudine' series.

Drama
Chekov – *Uncle Vanya*
Shaw published 'Three Plays for Puritans'
Strindberg – *The Dance of Death*, Parts I & II

Music
Puccini – *Tosca*
Mahler – Fourth Symphony
Elgar – *The Dream of Gerontius*
Charpentier – *Louise*

Art
Cézanne – *Still Life with Onions*
Toulouse-Lautrec – *La Modiste*
Renoir – *Nude in the Sun*
The Rodin Exhibition at the Place de l'Alma finally established the sculptor's reputation.
The Wallace Collection opened in London.

Architecture
Lutyens – Deanery Gardens, Sonning, Berks.
Hector Guimard designed the entrances to the Paris *Métro*.

Cinema
G.A. Smith – *Grandma's Reading Glasses* (pioneered the use of sequences)

FIGAI

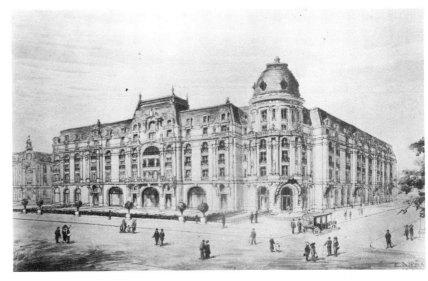

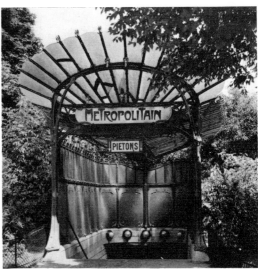

Above: Hotel Negresco, Nice, by E. Niermans — Beaux Arts luxury.

Left: This *Figaro* cover shows the Eiffel Tower in its setting as a focal point of the Paris Exhibition of 1900.

Right: The classic Art Nouveau of one of Guimard's *Métro* entrances.

Below: *L'île heureuse* — mural by Albert Besnard for the 1900 Exhibition.

Left: The Legation Quarter, Peking, destroyed in the Boxer Rising.

The Birth of Modernism

to express the fullness of life through his art, and making use of a whole repertoire of symbolic devices. However, he was unlike other Symbolists because art was for him essentially autobiographical, a means of asserting the importance of the self. In this he steps back beyond Symbolism to Courbet, who did much the same thing. But the formal values of his art, as well as its content, are affected by personal emotion, and this is one of the things which gives it its originality. His finest period, which lasted from about 1896 until 1908, when he suffered a mental collapse, laid the foundations of a new, unashamedly subjective way of painting.

The father of modernist Formalism is without question Cézanne. This does not, however, mean that he is the direct ancestor of the whole of modern art. His earliest work shows that he came close to an Expressionist idiom several decades before Munch. In his maturity, he reversed his attitudes and became less interested in expressing subjective feeling than in the problems of depiction. The Impressionists had dissolved the world and all the objects within it into a film or veil of opalescent colour which stretched uniformly across the whole surface of the canvas. In his late work, and particularly in the *Waterlilies*, Monet carried this procedure to an extreme which had no immediate result where painting in general was concerned, but which had an appeal for artists working post-1945. Cézanne wanted, on the other hand, to preserve the rationality and the tactility of French classical art, but to present these qualities in such a way that the picture-surface as well as what was shown had its own continuous logic of arrangement and organization. Finding the right language to translate three dimensions into two became not only the subject of his researches but of the pictures themselves. The Symbolist principle of 'art for art's sake' was thus carried to a new and revolutionary extreme, which was to have considerable consequences.

Interestingly enough, sculpture, the three-dimensional art *par excellence*, was at this time taking an almost entirely opposite course. Rodin, the first really major sculptor to appear in Europe since the neo-classicist Canova, and a dominant artistic figure of the first decade of the century, is generally classified as an Impressionist because of his liking for the play of light on elaborately wrought surfaces. But in fact his true position is much closer to the Symbolist Movement. The wish to convey symbolic content inspires many of his most typical devices – the use, for example, of a part or fragment to stand for the whole, and a deliberate lack of finish in certain areas which leaves room for the multiple play of meaning so dear to all Symbolists.

1901

General Events

Queen Victoria died, and was succeeded by her son, Edward VII.
The Peace of Peking was signed between China and the Great Powers.
The President of the United States, William McKinley, was assassinated and succeeded by Theodore Roosevelt.
The first Nobel prizes were awarded.
The Social Revolutionary Party was founded in Russia.
Slavery was abolished in Nigeria.
Britain broke off negotiations for an Anglo-German alliance.
There were labour riots in Spain.
The first petrol-engined motorcycles appeared in Britain.
Japan dropped negotiations with Russia, deciding instead to conclude an alliance with the British.
The Russian Minister of Propaganda was murdered.
Freud published *The Psychopathology of Everyday Life*.

The Arts

Literature
Kipling – *Kim*
H.G. Wells – *The First Men on the Moon*
Thomas Mann – *Buddenbrooks*
Selma Lagerlöf – *Jerusalem*
Maeterlinck – *The Life of the Bee*

Drama
Chekov – *The Three Sisters*
Shaw – *Caesar and Cleopatra*
Strindberg – *A Dream Play*

Music
Elgar – *Cockaigne Overture*
Rachmaninov – Piano Concerto No. 2

Art
Edvard Munch – *Girls on a Bridge*
Renoir – *Young Renoir Drawing*
Walter Richard Sickert – *The Interior of St Mark's, Venice*
Picasso – *Evocation*

Architecture
Louis H. Sullivan – Carson, Pirie & Scott Department Store, Chicago (1899–1901)
Victor Horta – A l'Innovation Department Store, Brussels

Cinema
George Méliès – *The Indiarubber Head*

Right: Symbolism had spread to America, and appeared in modified form in Maurice Prendergast's *Central Park*. Its true flavour is distilled more powerfully below, however, in this detail from a now-destroyed mural by the Viennese artist Gustav Klimt.

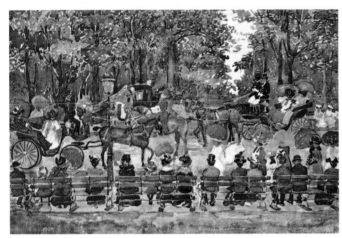

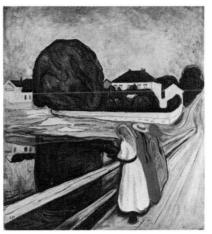

Left: Edvard Munch — *Girls on a Bridge.* In Munch's hands, Symbolism was turning into Expressionism.

Below: Meanwhile modern building technology asserted itself in the form of skyscrapers in New York.

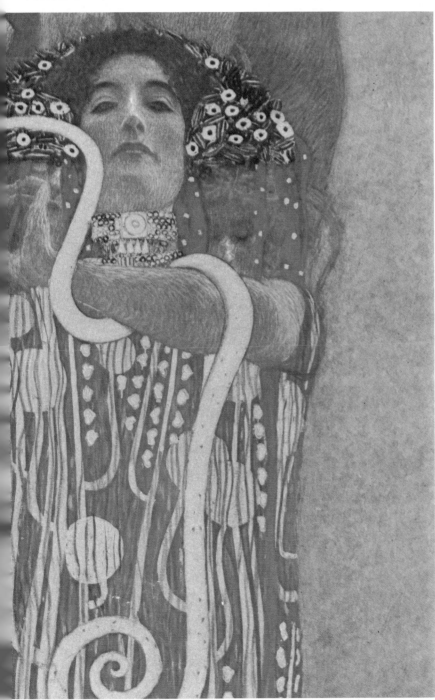

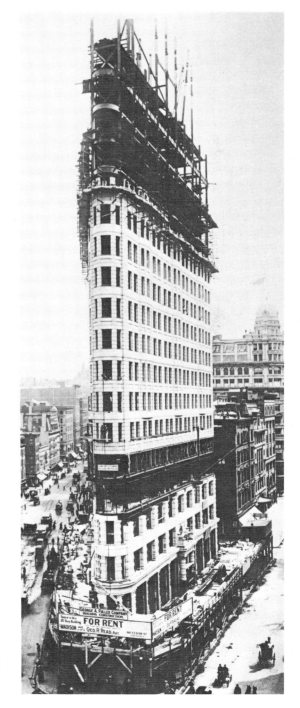

The Birth of Modernism

A study of the early architecture of the twentieth century shows that modernism here is a question of artistic as well as of purely technical innovation. Architects had to come to terms with new materials – for example, ferro-concrete, which was to the first years of the new century what iron-frame construction had been to the mid-nineteenth. They also had to provide solutions for new problems of use, which occurred most characteristically in America, with skyscrapers, office-blocks and department-stores. But they also wanted to express a new sensibility.

In a way, the architects of this period were more individual than their successors, the inventors of International Modernism. Their buildings were widely different from one another in appearance, and expressed a common conviction that it was the architect's right and duty to forge for himself a language at once coherent and unique. This is the thing which Lutyens and Frank Lloyd Wright (themselves very different from one another) have in common with Art Nouveau architects such as Gaudí and Mackintosh.

The most important name of all is that of Wright, since it was his designs, published in Europe in a luxurious edition in 1910, which supplied the spark of inspiration for the architects of *De Stijl*, and through them those of the Bauhaus.

Literature, the chief stimulus of the Symbolism of the 1880s, takes a back seat in the years immediately following 1900. The naturalistic novel continued to flourish both in Britain and in the United States, with work by Dreiser, Jack London and others. Symbolism, in relatively subdued form, showed itself in novels by the Anglicized Pole, Joseph Conrad, while Henry James, by this time in his 'Old Pretender' phase, published three magnificent novels – *The Wings of the Dove*, *The Ambassadors*, and *The Golden Bowl* – between 1902 and 1904. Chekov was also at the height of his productivity: *Uncle Vanya* dates from 1900, *The Three Sisters* from the following year, and *The Cherry Orchard* from 1904. It was in 1904, too, that the Abbey Theatre in Dublin was founded, and both Yeats's *On Baile's Strand* and J.M. Synge's *Riders to the Sea* were produced. It is therefore a key date in the history of the Celtic Renaissance. But it is James's novels and Chekov's plays in particular which sum up a certain phase of European civilization – rich, complicated, already conscious of its own doom.

Music had not as yet begun to feel the impact of modernism. Opera was still a full-blooded popular art, and Puccini produced two of the most important examples of the Italian verismo style: *Tosca* in 1900, and *Madama Butterfly* in 1904. *Tosca*, indeed, has some claim to be the most

1902

General Events

The Peace of Vereeniging ended the Boer War.
Cecil Rhodes died.
The Russian Minister of the Interior was assassinated.
Portugal went bankrupt.
The signature of the Anglo-Japanese alliance marked the end of Britain's 'splendid isolation'.
The Aswan dam was opened.
The Times Literary Supplement was first issued.
There was a coal strike in the United States.
The Triple Alliance between Germany, Austria and Italy was renewed.
J.M. Bacon crossed the Irish Channel in a balloon.
Balfour became Prime Minister of Britain.
Croce published *Estetica come scienza dell'espressione*.
William James published *Varieties of Religious Experience*.

The Arts

Literature
Gide – *The Immoralist*
Kipling – *Just So Stories*
Conan Doyle – *The Hound of the Baskervilles*
Henry James – *The Wings of the Dove*
Beatrix Potter – *Peter Rabbit*

Drama
J.M. Barrie – *The Admirable Crichton*
D'Annunzio – *Francesca da Rimini*
Wedekind – *Pandora's Box*

Music
Edward German – *Merrie England*
Elgar – *The Coronation Ode*
Debussy – *Pelléas et Mélisande*

Art
Rodin – *Romeo and Juliet*
Gauguin – *Horsemen on the Beach*

Architecture
Perret – Block of flats at 119 Avenue Wagram, Paris
Frank Lloyd Wright – W.W. Willits House, Highland Park, Illinois

Cinema
Méliès – *Voyage to the Moon*

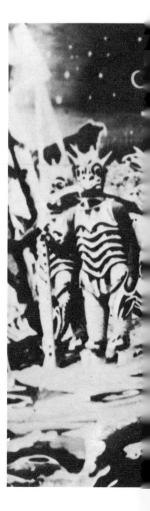

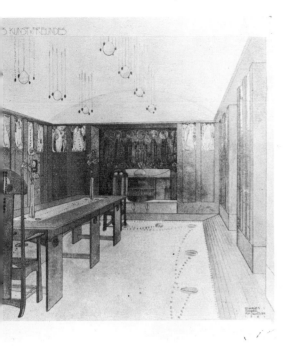

Right: An early 'prairie house' by Frank Lloyd Wright at Oak Park, Illinois, already shows the horizontal lines typical of modern architecture.

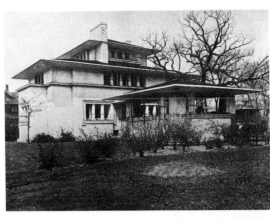

Below: Colonialism in its heyday. The Emperor of Annam (now Vietnam) at a review with the French Governor-General of Indochina.

Above: Interior designed by the Glasgow architect, Charles Rennie Mackintosh.

Below: Film as a vehicle for irrational fantasy — a still from Georges Méliès' *Voyage to the Moon*, which was a compendium of trick effects.

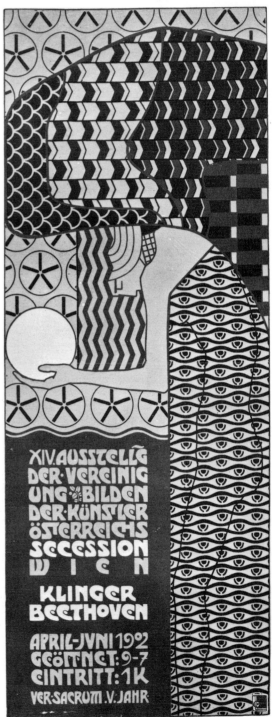

Right: A powerful expression of the most progressive design ideals of the time. Alfred Roller's poster for the Fourteenth Exhibition of the Vienna Secession.

17

The Birth of Modernism

efficient theatrical mechanism ever created in operatic form. Even in opera there were some intimations of change, however, and Debussy's *Pelléas et Mélisande* of 1902 fits neatly in time between the two Puccini operas, although it belongs to a completely different world. This is not merely because it is an example of Symbolism in music, but because of the difference in the composer's attitude towards the relationship of words and accompaniment. Puccini, with his shifting bar lines, is in fact more modern than most people give him credit for. Debussy goes beyond him, in preserving not only the flexibility of speech, but actual speech rhythms, and in this way seems to look forward to the *Sprechgesang* of Schoenberg's *Moses and Aaron*.

Surprisingly enough, other musical forms in some ways remained less experimental than opera. Mahler's Fourth Symphony (1900) is one of the culminating points of the German symphonic tradition, and Elgar's *Dream of Gerontius* does much the same thing for English oratorio. Rachmaninov's Piano Concerto No. 2 (1901) is a vehicle for the kind of romantic virtuosity which had been common currency in European music since the days of Liszt, but which was soon to become a trifle suspect.

All these pieces of music remain in the concert repertoire today. Indeed, they enjoy immense popularity with contemporary audiences. Yet, when we listen to them, they seem to transport us into a world which, in terms both of its assumptions and its sensibility, seems almost impossibly remote from our own. They make us aware that the Modern Movement in the arts was not merely a matter of gradual change but of sudden and cataclysmic revolution.

If one has to choose a key date, that date must necessarily be the year 1905. The pattern of political and intellectual events is fascinating in itself. It is not only the year in which the first, abortive Russian Revolution took place, but that in which Einstein evolved his Theory of Relativity.

In France the Fauves, exhibiting as a group in the Salon d'Automne, acquired their nickname from the critic Louis Vauxcelles, while in Germany the foundation of *Die Brücke* in Dresden marks the first tentative beginning of Expressionism as a fully organized art movement.

Politics, especially after the Agadir Incident of 1911, and the three Balkan Wars of 1912–13, began an acceleration towards disaster. Each shift of alliances brought the catastrophe closer, and though many people were aware of this, they were powerless to alter the course of events. In the world of the arts there developed an impatience with prevailing assumptions which became at times a posi-

1903

General Events

The first radio message was transmitted from the United States to England.
The first powered aircraft was flown by the Wright Brothers at Kitty Hawk, North Carolina.
The first Ford motor factories were established.
The British Parliament passed the Irish Land Act.
King Alexander I and Queen Draga of Serbia were assassinated.
Pope Leo XIII died, and was succeeded by Pius X.
The first motor-taxis appeared in London.
The Krupp arms factory was founded in Essen.
The religious orders were dissolved in France.
The Women's Social and Political Union was founded in Britain by Emmeline Pankhurst.
Edward VII visited Vienna.
Panama made herself independent of Colombia.
The Russian Labour party split into the Menshevik (Majority) and Bolshevik (Minority) factions. The latter was led by Lenin and Trotsky.
G.E. Moore published *Principia Ethica.*

The Arts

Literature
Samuel Butler – *The Way of All Flesh*
Henry James – *The Ambassadors*
Erskine Childers – *The Riddle of the Sands*
Jack London – *The Call of the Wild*
Hofmannsthal – *Gedichte*
Thomas Mann – *Tonio Kröger*

Drama
Shaw – *Man and Superman*
Hofmannsthal – *Electra*

Music
Delius – *Sea Drift*
Richard Strauss – *Symphonia Domestica*
The first complete recording of an opera was made (Verdi's *Ernani*).

Art
Degas – *Dancers in Yellow Skirts*

Architecture
Mackintosh – Hill House at Helensburgh
J.F. Bentley – Westminster Cathedral, London

Cinema
Edwin S. Porter – *The Great Train Robbery*

Periodical
Stieglitz founded *Camera Work* (published until 1917).

Right: The automobile was beginning to make progress as something more than a toy, but experiments continued. This poster for the French Gardner-Serpollet steam car conveys contemporary feelings.

Below: Photography had for some time been in a self-consciously 'artistic' phase. This is a portrait by the American Gertrude Kasebier.

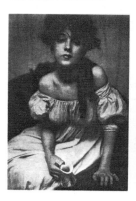

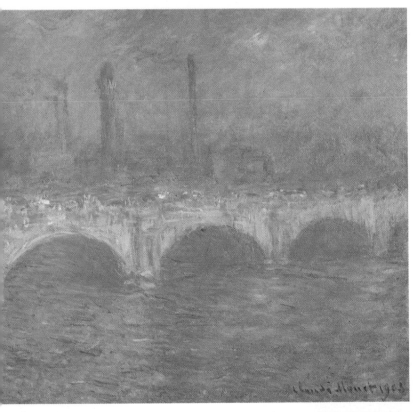

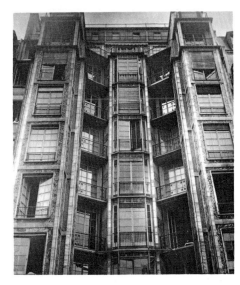

Above: Auguste Perret's Rue Franklin Apartments pioneered the use of concrete.

Left: Impressionism was entering an experimental late phase. Monet's *Waterloo Bridge, London.*

Below: Fashions were still quite conservative. La Gandara's portrait of the Comtesse de Noailles.

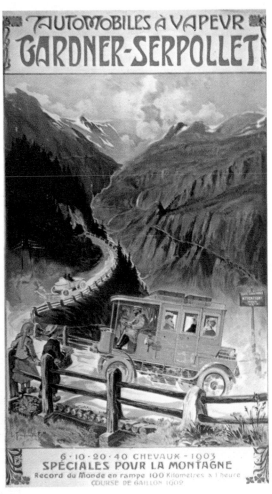

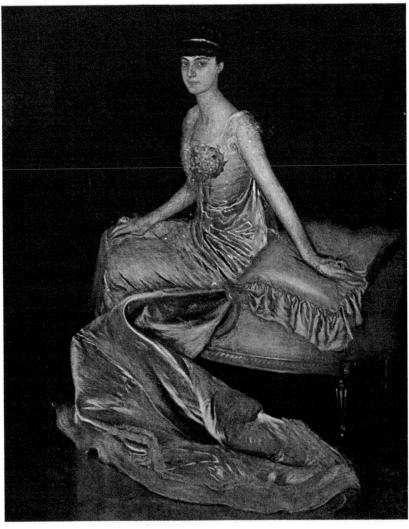

The Birth of Modernism

tive longing for the arrival of Armageddon – a mood best summed up in some of the Futurist manifestos. The cult of unrestrained feeling, exemplified in music by Strauss's *Salome* and *Electra*, as well as by Schoenberg's *Gurrelieder* (begun *c.* 1899, but first performed in 1913), was linked to a desire to shake a corrupt society to its foundations.

Technological progress continued apace. The internal combustion engine established its growing dominance in surface transport, and the conquest of the air, begun by the Wright brothers at Kitty Hawk in 1903, was consolidated. Only occasional disasters, like the Messina Earthquake in 1908, and the sinking of the *Titanic* in 1912, reminded men that their control of their environment was still far from complete.

The Fauves, the first examples of fully developed modernism in the visual arts, were not, paradoxically enough, an organized movement, but a grouping invented for their own purposes by the critics. They, and particularly the man who came to be recognized as their leader, Matisse, had three basic sources of influence in the immediate past. These were orthodox Symbolist painting, Gauguin, and Van Gogh. It was orthodox Symbolism, for example, which taught them that a picture must be an icon, in which all the complexities of a particular emotional state were mirrored, though not necessarily resolved. It was the classicizing decorator, Puvis de Chavannes, rather than Matisse's own teacher Gustave Moreau, who prompted the idea that such an icon could best be achieved by simplification and stylization of outline – in any case, the latter technique also owed something to the bold graphic art used in Art Nouveau poster design.

Van Gogh suggested that colour must correspond to the emotional state of the artist, rather than to the things that could objectively be seen in nature. This idea had been foreshadowed in a famous sonnet by Arthur Rimbaud, and could be seen somewhat before 1905 in the work of Edvard Munch. Gauguin, too, reinforced these ideas about colour but was perhaps even more important as the chief inspirer of Fauve primitivism.

The curious thing was that Matisse, by temperament, was by no means a fierce revolutionary. His later work, and indeed all his pronouncements on the subject of art, both show that he thought a picture should convey a feeling of well-being to the spectator. The paintings he produced in the twenties and thirties showed a close kinship with those of Bonnard and Vuillard, 'drawing-room artists' in the strictest sense of the phrase, even though, through association with the late Symbolist Nabis group, they can also be seen as following from Gauguin.

1904

General Events

The *Entente Cordiale* was signed between Britain and France.
There was a general strike in Italy.
The Russo-Japanese War began.
The construction of the Panama Canal began.
The Rolls-Royce Co. was founded.
The Dogger Bank incident (between the Russian fleet and British fishing boats) brought Britain and Russia to the brink of war.
There was a Hottentot rising in German S.W. Africa.
The Broadway subway opened in New York, with electric trains from City Hall.
An abortive civil war began in Uruguay.

The Arts

Literature
Joseph Conrad – *Nostromo*
Henry James – *The Golden Bowl*
Jack London – *The Sea-Wolf*
O. Henry – *Cabbages and Kings*
Romain Rolland – *Jean-Christophe*
D'Annunzio – *The Daughter of Jorio*

Drama
Chekov – *The Cherry Orchard*
J.M. Barrie – *Peter Pan*
W.B. Yeats – *On Baile's Strand*
J.M. Synge – *Riders to the Sea*
The Abbey Theatre was founded in Dublin.

Music
Puccini – *Madama Butterfly*
Delius – *Appalachia*
Janáček – *Jenufa*

Art
Rodin – *The Thinker*
Picasso – *The Two Sisters*
Bonnard – *The Boulevard*

Architecture
Otto Wagner – Postal Savings Bank, Vienna (1904–6)

Right: *The Frugal Repast*, a masterpiece of Picasso's Blue Period — poverty was pitiable but picturesque.

Below: The actress Suzanne Després in an amazingly elaborate creation by Jacques Doucet, later to be one of the most *avant-garde* patrons of his time.

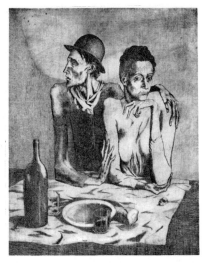

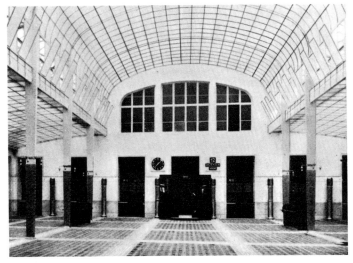

Left: Half way to real modernism — Otto Wagner's Postal Savings Bank, Vienna (1904—6).

Above: André Derain — *Barges.* The beginning of Fauvism.

Right: A late design from the Arts and Crafts Movement — silver and glass decanter by C.R. Ashbee.

The Birth of Modernism

Essentially, there was no real break between Fauve painting and the Symbolist art which had preceded it. The uproar caused by its appearance in the Salon d'Automne of 1905 was exactly the kind of uproar previously caused by the advent of Courbet, and then by that of Manet and his followers, the Impressionists. It was a well-established ritual response, which took on significance from all the other events surrounding it.

The Fauve attitude towards patronage, however, was something of an innovation. Throughout the nineteenth century the so-called 'dealer-critic' system had been growing up, first as a supplement to, and then as a substitute for, success in the official Salons. Symbolist art, which avoided making public pronouncements, often preferred to find its patronage privately. Though the Fauves made their initial impact through a public exhibition, it is clear that they chiefly hoped to dispose of their work through dealers, and were not in the market for large-scale public commissions. Though they certainly welcomed the opportunity to work decoratively on a large scale – for example Matisse and *La Danse* (1909–10) – they did not regard state patronage as being their due in the way that many of their predecessors had done – and this was a confirmation of their essential élitism, which was to have profound consequences for the development of the Modern Movement as a whole. In France, Puvis was probably the last innovative artist for some years to regard state patronage of this sort as a component in his career, though the tradition continued longer elsewhere – for example, in the commissions given to Munch in Norway and to Gustav Klimt in Vienna, until at last it overlapped with the renewal of public art during the 1930s.

The next stage in the public career of modernism, after the scandal generated by the Fauves in 1905, was the launching of the Futurist Movement in 1909, with a manifesto printed in the French newspaper *Le Figaro* – a fact which was a curiosity in itself, since the founders of Futurism were Italian. Futurism, unlike Fauvism, was an organized attempt to change the face of the arts, undertaken under the leadership of the writer F.T. Marinetti. According to the Futurists' own declarations, their chief quarrel was with Symbolism. Their opposition to the immediate Symbolist past was summed up in a favourite slogan: 'Murder the moonlight!' Because it was founded by a literary man, Futurism, like Symbolism before it and Surrealism after it, began as a literary movement which afterwards attracted or adopted visual artists.

Marinetti and his followers certainly claimed to be radical innovators, but how far was this claim justified?

1905

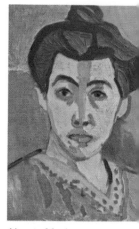

Above: Matisse — *Portrait of Madame Matisse with a Green Stripe.*

General Events

The Industrial Workers of the World Organization was founded in the United States.
Grand Duke Serge, Governor of Moscow, was assassinated in the Kremlin.
The Franco-British military convention was signed.
Norway became independent of Sweden.
The Sinn Fein party was founded in Ireland.
Albert Einstein published his Special Theory of Relativity.
The first motor-buses appeared in London.
Sir Henry Campbell-Bannerman became Prime Minister of Britain.
State and church were separated in France.
The International Agricultural Institute was founded in Rome.
The Tsar was forced to create a Duma.
The Japanese totally destroyed the Russian fleet at the Battle of Tsushima (27 May).
There was a general strike in Russia.
St Petersburg workers formed the first Soviet.
Freud published *Three Treatises on the Theory of Sex*.
Treaty of Portsmouth signed in New Hampshire to end Russo-Japanese War.
Santayana published *The Life of Reason*.
Bergson published *Creative Evolution*.
William James published *Pragmatism*.

The Arts

Literature
H.G. Wells – *Kipps*
Baroness Orczy – *The Scarlet Pimpernel*
Edith Wharton – *The House of Mirth*
Heinrich Mann – *Professor Unrath*

Drama
Max Reinhardt's production of *A Midsummer Night's Dream*
Hofmannsthal – *Oedipus and the Sphinx*

Music
Richard Strauss – *Salome*
Debussy – *La Mer*
Lehár – *The Merry Widow*

Art
J.S. Sargent – *The Marlborough Family*
Cézanne – *Les Grandes Baigneuses*
Die Brücke (The Bridge), the group which formed the focal point for the German Expressionist movement, was founded in Dresden.
The critic Louis Vauxcelles coined the name *'Les Fauves'* (The Wild Beasts) for a group of young artists led by Matisse.

Architecture
Franz Jourdain and Henri Sauvage – La Samaritaine Department Store, Paris
Ernest Flagg – The Singer Building, New York

Cinema
A five-cent cinema in Pittsburgh showed *The Great Train Robbery*, with enormous success.

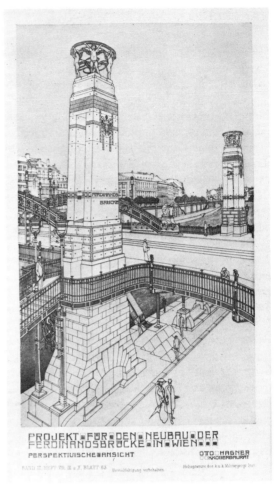

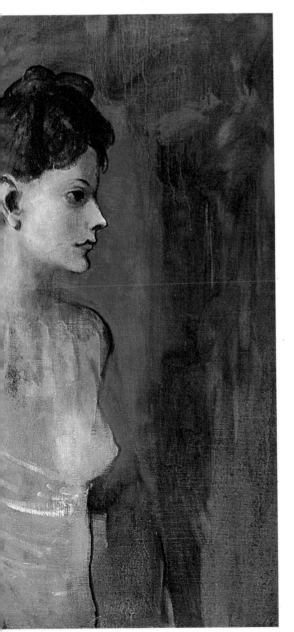

Above: Franz Jourdain and Henri Sauvage — La Samaritaine Department Store, Paris. Modern building techniques, nostalgic decoration.

Left: Picasso — *Woman in a Chemise.* The style can be seen as Lautrec meeting Burne-Jones.

Above: Otto Wagner — design for the Ferdinandsbrücke, Vienna. Some details may have been suggested by Near Eastern archaeology.

Below: Cézanne — *Les Grandes Baigneuses.* The artist struggled for more than seven years with this uncompromising image, 1898–1905.

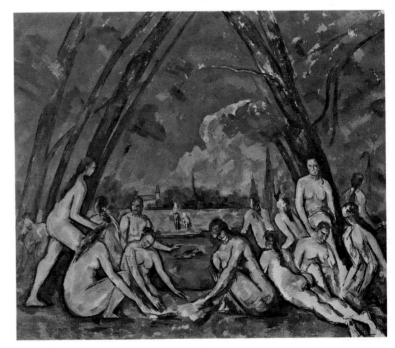

The Birth of Modernism

Futurism did exhibit features which were genuinely new, and it is worth noting the most conspicuous of them. First, the noisy worship of the machine. In a famous phrase, the First Futurist Manifesto proclaimed that: 'A racing automobile is more beautiful than the Victory of Samothrace!' Secondly, there was the Futurist obsession with violence, and especially with war, shown for example in Marinetti's 'liberated words' describing the bombardment of Adrianople (1911). Futurist painting was technically innovatory in its use of 'simultaneous' images based on experiments with simultaneous photography made as long ago as the 1880s by men like Étienne-Jules Marey. Finally, and most important of all, there was Futurism's emphasis on art as 'effect' and 'event' rather than as 'object'. This point is made particularly clear in the Futurist manifesto on the variety theatre (1913).

But in each case it must also be noted that the Futurist originality was more limited than it appears to be at first glance. The worship of the machine was more a response evoked by Symbolism and limited by it than something fundamentally innovative. Futurism demonstrated its essential dependence on the Symbolist aesthetic by a superficial reversal of its values. Paradoxes of this sort were in any case inherent in Symbolism and could be accommodated by it. Futurism showed little sympathy for, or understanding of, true industrialism.

The Futurist obsession with violence can also be seen as a version of the existing Symbolist worship of the primitive, as a product of the need (not unknown to Symbolists such as J.K. Huysmans, author of *A Rebours*) to tickle the jaded palates of their public.

The Futurist use of simultaneous imagery in painting can be related not only to Marey's photography, but also to the use made by the Impressionists of scientific research into the mechanics of vision. However, there was one thing which was important – it was the first occasion that painting had tried to represent more than a single instant by depicting a sequence of instants which nevertheless could be instantaneously apprehended.

The emphasis placed by the Futurists on art as effect was a reversion to some aspects of the Baroque aesthetic of the seventeenth century, and this was, in context, more thoroughly innovative than anything else they proposed. It seems to have been an unconscious response on their part to the fact that the machine provides, not unique objects, each with its own character, but identical objects, indistinguishable from one another, characterless, and not intended to last. The Futurists were obsessed by the idea of obsolescence, and went so far as to envisage their own art as a commodity with

1906

General Events

The Aga Khan founded the All-India Moslem League.
Night work by women was internationally forbidden.
There was an Austro-Serbian customs war.
Helmuth von Moltke became chief of the German General Staff.
A British general election brought about a Liberal landslide. Campbell-Bannerman's cabinet embarked on sweeping social reforms.
There was a liberal revolt in Cuba.
'Everyman's Library' was founded.
The Trades Disputes Act legitimized peaceful picketing in Britain (where the population was now 38.9 million).
The drainage of the Zuyder Zee was begun.
Dreyfus was freed.

The Arts

Literature
Galsworthy – *The Man of Property*
Upton Sinclair – *The Jungle*
Jack London – *White Fang*
Hardy – *The Dynasts* (1906–8)
Rilke – *Cornet Christoph Rilke*

Drama
Claudel – *Partage de Midi* (written, but not performed)
Pinero – *His House in Order*
Galsworthy – *The Silver Box*

Music
Elgar – *The Kingdom*
Massenet – *Ariane*
The first Mozart Festival was held in Salzburg.

Art
Derain – *The Pool of London*
Rouault – *At the Mirror*

Architecture
Frank Lloyd Wright – Unity Church, Oak Park, Illinois
Lutyens – Hampstead Garden Suburb
Mewes and Davis – The Ritz Hotel, London

Above: In this *Self-Portrait* Picasso is beginning to move towards Cubism.

Below: Michel Fokine, who created *Chopiniana* (later *Les Sylphides*).

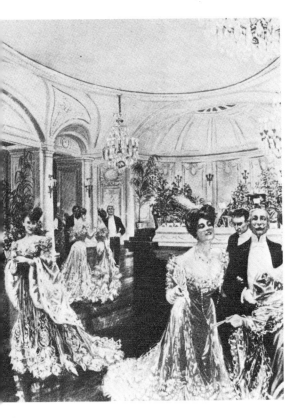

Above: *The Pool of London*, another river scene by André Derain, shows that in two years his technique had become much bolder.

Above: The new Ritz Hotel in London offered every comfort to those able to afford it. But society — as symbolized by the picture of a slaughterhouse in Chicago (below) — was still founded on huge inequalities.

Right: An advertisement for couturier Paul Poiret, pioneer of a looser, easier line.

PAUL POIRET 37 RUE PASQUIER A PARIS

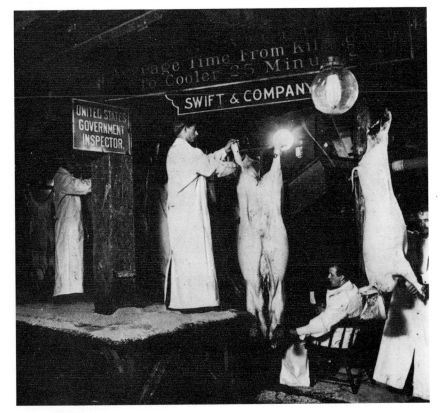

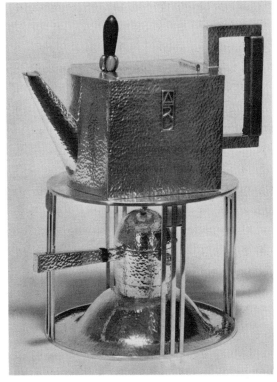

Right: Tea-pot designed by Josef Hoffmann for the Wiener Werkstätte, 1905–6. Art Deco fifteen years before its time.

The Birth of Modernism

a strictly limited life-span. The movement thus prepares not only for the machine-aesthetic of the twenties and thirties, but for the mass-consumerism of the epoch following the Second World War.

In art-historical terms, Futurism has strong and surely not accidental resemblances to Neo-Classicism – it was a puritan revolt against a hedonistic culture; it was aggressive and proselytizing. These characteristics were to be passed on to the other modernist movements which followed in its tracks. Above all, Futurism resembles Neo-Classicism in that the theory came first, while the works (paintings, sculptures, projects for buildings) were afterwards created to fit. The resemblance is emphasized, not coincidentally, by the similarities between the projects of A.C. Boullée, the greatest of the neo-classical visionaries, and those of the short-lived Futurist architect Sant'Elia. Sant'Elia's work anticipates many of the distinguishing features of the late twentieth century metropolis, not least its crushing and dehumanizing giganticism.

Dehumanization is one of the marks of Futurist art in general – the movement was hostile to humane emotions, which its leaders repeatedly branded as sentimental. His obsession with ideas of force, power and leadership was eventually to lead Marinetti into the Fascist camp.

Marinetti deliberately set out to export the gospel of Futurism to countries other than Italy and France. His spectacular lectures and demonstrations attracted publicity even when they did not make converts. His most noteworthy success was in Russia, and Marinetti also sowed the seeds of the short-lived Vorticist Movement in England. It can thus be said that Futurism did more than any other contemporary force to make the Modern Movement international.

Curiously enough, however, it never really scored a major success in Paris, where it had been launched, and this is one reason why its contribution to the making of modernism has been consistently undervalued. Paris remained, as it had been throughout the nineteenth century, the focal point of aesthetic innovation. But here Futurism was only one of a number of art movements which had started to dispute the Symbolist heritage. The Orphism created by Robert Delaunay had many features in common with what the Italians were doing, not least a lyric celebration of modern metropolitan life. The French art movement which commanded most attention among the well-informed, however, and subsequently came to be considered the most important, was not Futurism but the Cubism of Braque and Picasso.

Precociously brilliant, Picasso made his mark in Barcelona, which, though not his native town, was

General Events

Female suffrage was introduced in Norway.
Universal suffrage was introduced in Austria.
The Triple Alliance was again renewed.
The French blockaded Casablanca, and Casablanca and Rabat were occupied.
Gandhi organized the first passive resistance movement among Indians in the Transvaal.
The first successful borings for oil were made in Persia.
The Boy Scout movement was founded by Baden-Powell.
Colour photography was invented by A. Lumière.
Oklahoma became a State.
The Shell Oil Trust was founded.
Lenin left Russia.
Pavlov conducted research into conditioned reflexes.

The Arts

Literature
Joseph Conrad – *The Secret Agent*
Gorky – *The Mother*
Rilke – *Neue Gedichte*

Drama
Shaw – *Major Barbara*
J.M. Synge – *The Playboy of the Western World*

Music
Vaughan Williams – *Towards the Unknown Region*
Holst – *A Somerset Rhapsody*
Edward German – *Tom Jones*
Elgar – *The Wand of Youth*
Mahler – Eighth Symphony (*Symphony of a Thousand*)

Art
Rousseau – *The Snake Charmer*
Picasso – *Les Demoiselles d'Avignon*
George Bellows – *Stag at Sharkey's*
John Sloan – *The Wake of the Ferry*
An exhibition of Cubist paintings was held in Paris.

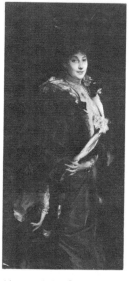

Above: John Singer Sargent's *Portrait of Lady Sassoon* shows one aspect of what was possible in art. Picasso's revolutionary *Les Demoiselles d'Avignon* (below) shows quite another.

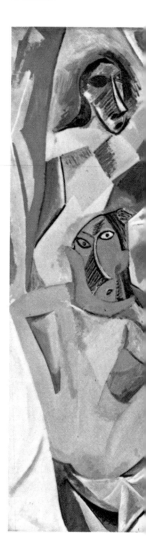

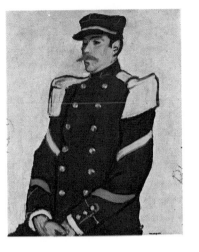

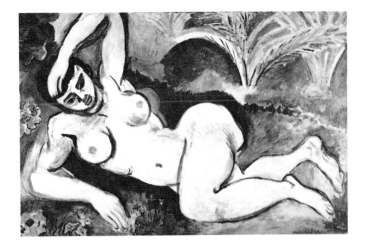

Left: Matisse had caught the mood of savagery with *Blue Nude.*

Above: Albert Marquet's Fauve portrait of a Sergeant of the Colonial Army makes an equally telling contrast with Baron de Meyer's Symbolist photographic still life (right).

Below: The stresses of urban life were steadily increasing.

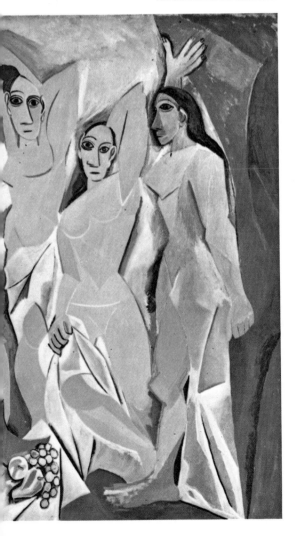

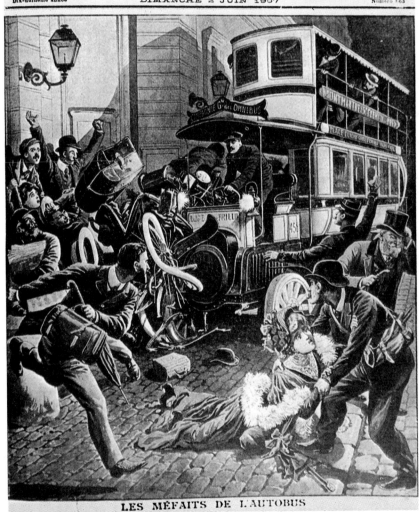

The Birth of Modernism

where he had been brought up. The milieu he frequented there was a Symbolist one, and he remained a Symbolist artist even after he had transferred himself to Paris, a process which took place in stages during the early years of the century. Beardsley and Burne-Jones left their mark on the Blue and Rose periods, and so did Puvis and Toulouse-Lautrec.

Picasso's Cubism evolved in three stages, only two of which concern us here. First came the so-called Negro Period, beginning in 1906, and culminating in a key work, *Les Demoiselles d'Avignon* (the title is an untranslatable pun) in 1907. This was followed by the breakthrough into Cubism in 1908–9. The *Demoiselles* is a painting which has often been misinterpreted, in the sense that historians have scrutinized it for pointers to the future rather than for connections with the past. In effect, Picasso's use of Negro art is at first emotional, rather than an objective search for new forms. He likes the primitive for the reasons that moved Gauguin, and he likes it too because it enables him to make a violent gesture of revulsion against conventional, and especially Symbolist, ideals of beauty. It was only later that the cubical forms of Negro sculpture suggested an affinity with the methods of unifying the surface already used by Cézanne.

Picasso's move towards Cézanne was in fact also a return to one of the basic Symbolist tenets – the idea that art governed life, and not *vice versa*. Cubism in its first phase – Analytic Cubism as it has come to be called – proclaims that the methods whereby a painting is made are inevitably its true subject. The analysis of form pioneered by Cézanne was combined with the Futurist notion of simultaneity, so that the spectator seems to move round the object, exploring each aspect successively. Because the method of representation was so complex, the subjects chosen were necessarily simple – still lifes, often featuring musical instruments, and portraits of people whom the artists knew sufficiently well to be able to count upon them to endure the tedious number of sittings required.

In one sense Cubism can be seen, not as the beginning of something, but as the end of something: a desperate last attempt to prove that painting could give a more convincing and coherent account of the world than the one proposed by the camera. Yet, by a strange irony, Cézanne's reform, which had its roots in the camera-influenced visual patchiness of conventional, realistic Salon painting, led eventually in Cubist hands to the exaltation of the patchy – the invention of collage (1912). The Cubists – from the Analytic period onwards

General Events

King Carlos of Portugal and the Crown Prince were assassinated.
The Young Turks rose against the Sultan in Turkey.
Wilbur Wright flew in France.
Campbell-Bannerman resigned as British Prime Minister, to be succeeded by Asquith.
The London *Daily Telegraph* published an interview with Kaiser Wilhelm II, in which he stated that the German people were hostile to Britain, though he himself was friendly.
William Howard Taft won the U.S. presidential election.
The National Association for the Advancement of Colored Peoples (N.A.A.C.P.) was founded in the United States by W.E.B. du Bois.
The Federal Council of Churches was founded in the United States.
The Olympic Games were held in London.
There was a disastrous earthquake in South Calabria and Sicily (the 'Messina Earthquake').
Old Age Pensions were introduced in Britain.

The Arts

Literature
Kenneth Grahame – *The Wind in the Willows*
E.M. Forster – *A Room with a View*
Arnold Bennett – *The Old Wives' Tale*
G.K. Chesterton – *The Man Who Was Thursday*
Colette – *La Retraite Sentimentale*
Anatole France – *Penguin Island*
Valéry Larbaud – *Poèmes d'un riche amateur*
Stefan George – *Der Siebente Ring*

Music
Bartok – First String Quartet
Elgar – Symphony No. 1 in A flat (Op. 55)
Ravel – *Mother Goose* suite
Charles Ives – *The Unanswered Question*

Art
Monet – *The Ducal Palace, Venice*
Chagall – *Red Nude*
Vlaminck – *The Red Trees*
Brancusi – *The Kiss*
Epstein – Carvings for the British Medical Association Building, The Strand, London

Architecture
Greene & Greene – The Gamble House, Pasadena, California
Peter Behrens – Cuno and Schröder Houses, Hagen-Eppenhausen

Cinema
Luigi Maggi – *The Last Days of Pompeii*

Below: Henri Rousseau — *The Football Players*. Rousseau's imagination, like that of many other artists at this time, was excited by the dynamism of sport.

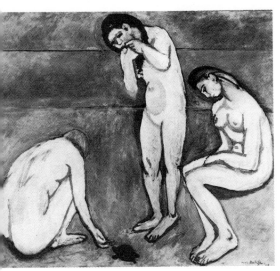

Left: Matisse — *Bathers with Turtle*. This painting represented the dream of *'luxe, calme et volupté'* inherited from Symbolism.

Above: Advertisement for corsets. European women, unlike European men, still lived constricted lives.

Below: The Empress Dowager of China in the grounds of her palace. Her death in this year hurried the end of the Manchu Dynasty.

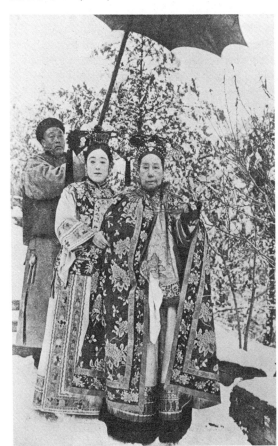

The Birth of Modernism

Picasso had been joined in his researches by Braque – discovered that, while Cubism was in one way a satisfactory answer to the problem of representing three-dimensional forms on a flat surface, it had nothing to say about hue, texture or physical substance. The *ad hoc* solution was to offer a representation which included actual samples of what was represented – newsprint, wood-grained paper, canework – stuck to the painted surface. In solving one problem, however, the Cubists immediately created another – what they were now doing seemed to suggest that reality was multiple rather than single. This in turn undermined the argument that the true aim of the artist was to produce a completely objective representation of truths which could themselves be objectively ascertained. So-called Synthetic Cubism, which developed after the invention of collage, therefore implies a retreat from the basic aims the artists had proclaimed earlier. Now the patchwork of painted areas which fills the picture surface is given an independent life of its own, ceasing to be a method of showing what is real and becoming instead a system for creating decorative effects.

Expressionism, which was to achieve an importance in Germany equivalent to that Cubism enjoyed in France, took an entirely different tack in its approach to the phenomenal world. The term seems to have made its appearance in Germany in 1910. In the following year, it was used in the catalogue of an exhibition organized by the Berlin Secession to describe a room of French Fauve and early Cubist paintings. Between 1910 and 1912 an angular, distorted, violently emotional native style established itself and took possession of the label. Expressionist criteria were immediacy and passion. It was what the artist felt about his subject which dictated the way in which he showed it, and therefore there was no such thing as a fixed system of pictorial representation of the kind elaborated by the Cubists. Expressionism was not simply a German, but a North German phenomenon. The *Blaue Reiter* group, founded in Munich in 1911, was more mystical and calmer in its approach. One of the artists connected with the group was the Russian Kandinsky whose text, *On the Spiritual in Art*, published in 1912, clearly shows the mystical and spiritual nature of his beliefs. At this time Kandinsky had already reached the point of pure abstraction – his first wholly abstract water colour is dated 1910.

The path followed by Kandinsky in the early part of his career, via sophisticated primitivism to pure abstraction, was typical also of *avant-garde* artists who remained in Russia. For historical reasons the worth of the Modern Movement in Russia has only

1909

General Events

Louis Blériot crossed the Channel in an aeroplane.
The Girl Guides were founded.
The British Parliament passed the Navy Bill (because of growing alarm in Britain over the growth of the German navy).
The murder of Hirobuni Ito of Japan by a Korean fanatic led to Japanese rule in Korea.
There was a Franco-German agreement on Morocco.
The Young Turks deposed Sultan Abdul Hamid, and replaced him by Muhammad V.
The Anglo-Persian Oil Co. was founded.
There was a revolutionary rising in Catalonia.
Lloyd George's Finance Bill ('The People's Budget') was rejected by the British House of Lords, and Parliament was dissolved.
Shah Muhammad Ali was deposed in Persia, and was succeeded by Ahmed Shah (aged 12).
Leopold II of the Belgians died, and was succeeded by Albert I.
Bethmann-Hollweg became German Chancellor.
Diaghilev launched the *Ballets Russes* in Paris.

The Arts

Literature
André Gide – *La Porte Étroite*
H.G. Wells – *Ann Veronica*
Apollinaire – *L'Enchanteur pourrissant*
Heinrich Mann – *Die Kleine Stadt*

Drama
J.M. Synge – *Deirdre of the Sorrows*
Maeterlinck – *The Blue Bird*
Galsworthy – *Strife*

Music
Vaughan Williams – *Fantasia on a Theme by Tallis*
Mahler – Ninth Symphony
Rimsky-Korsakov – *The Golden Cockerel*
Lehár – *The Count of Luxembourg*

Art
Matisse – *La Danse*
Bonnard – *Standing Nude*
Bourdelle – *Hercules the Archer*
Kokoschka – *Portrait of Dr Tietze and his wife*
Klimt – *Salome*

Architecture
Peter Behrens – AEG Turbine Factory, Berlin
Frank Lloyd Wright – Robie House, Chicago
Ragnar Östberg – Stockholm Town Hall (1909–23)

Cinema
D.W. Griffith transformed the child actress Gladys Smith into Mary Pickford.

Periodical
La Nouvelle Revue Française founded.

Below: Poster for the major cultural sensation of the year, the first *Ballets Russes* Season.

Above: Photograph by Alice Boughton from *Camerawork*. Like her contemporary Kasebier, Boughton found that photography offered women a creative outlet.

Right: Georges Braque — *Piano and Mandola.* Fully developed Analytic Cubism.

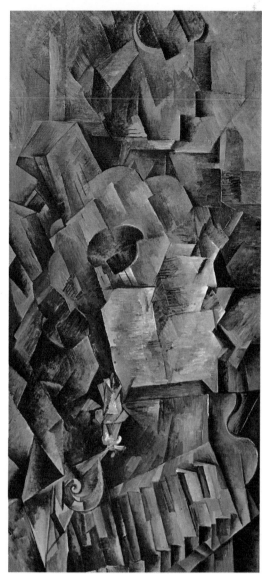

Below: Frank Lloyd Wright — Robie House, Chicago. Simple horizontality.

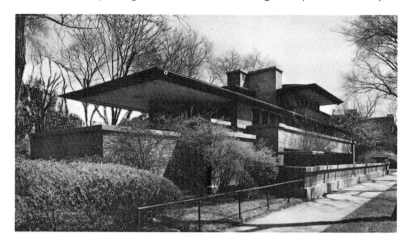

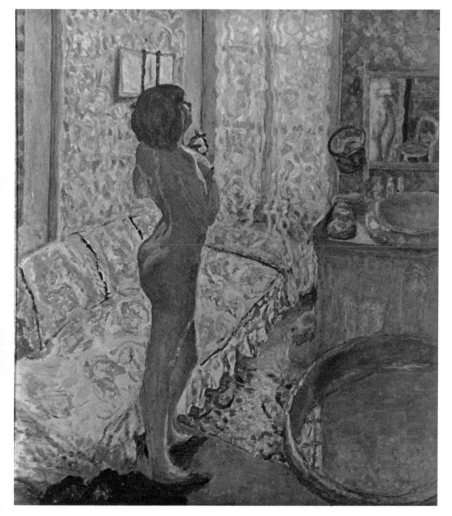

Above: Pierre Bonnard — *Standing Nude.* The perfection of Symbolist Intimism.

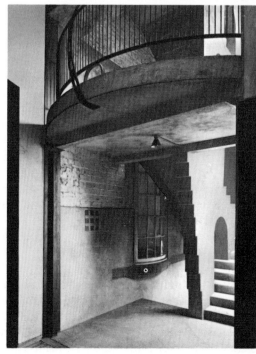

Right: Charles Rennie Mackintosh — Glasgow School of Art, 1898–1909.

The Birth of Modernism

1910

Right: Severini — *The Boulevard* reflects the Futurist interest in urban life.

recently been subjected to proper investigation and evaluation. Yet some of the most interesting art produced in the first phase of modernism had its origins in this vast and still semi-barbarous nation.

Throughout the nineteenth century, the suppression of political activity in Russia gave a special resonance to the activity of artists, using that noun in the broad sense. The concern felt by the Tsars about the opinions and activities of men like Pushkin, Turgenev, Dostoevsky and Tolstoy may seem to us exaggerated, but this demonstrates our ignorance of the Russian context. The arts retain this inherent political dimension in the Soviet Union to this day.

In the latter part of the nineteenth century, in the hands of Repin and other members of the school known as the Peripatetics because of their habit of travelling round the country, 'advanced' art had been promoted chiefly through its attachment to liberal politics. Technically these artists, and Repin in particular, were some of the most gifted heirs of the great French academician J.L. David. Inevitably there was a reaction away from direct confrontation with reality towards the end of the century. Symbolism, as an essentially élitist style, found its true setting in the hot-house world of St. Petersburg. Its focus was the *World of Art* magazine founded by Diaghilev and a group of associates, and its finest product was to be the *Ballets Russes*, with which Diaghilev eventually took Paris by storm.

When Marinetti came to Russia to preach the gospel of Futurism he achieved a more genuine success than any he had enjoyed elsewhere, for several reasons. First, his obvious impatience with the rarefied world of Symbolism appealed to Moscow artists who resented the dominance of Petersburg. Being removed from the centre of political and artistic power, they were impatient for change and willing to try a frontal assault. But at first they preferred the doctrine of primitive force to the accompanying precept of the supremacy of the machine. The earliest Russian Futurism, that of the young Larionov and the young Natalia Gontcharova (1909–10) looked to Russian folk art as a justification for the deliberate crudity of its new style — a sophisticated crudity which paralleled what had already been done by the Fauves in Paris. Marinetti's means of propaganda — his lectures and performances — were also taken up with some enthusiasm in Moscow. Indeed, they were elaborated into full-scale cabaret turns, and it was the pre-First World War Moscow Futurists who staged the first 'happenings'.

One very Russian aspect of Russian Futurism was that, contrary to *avant-garde* art elsewhere, it

General Events

Edward VII died, and was succeeded by George V.
Revolution in Portugal; King Manuel II fled to England.
Old Age Pensions were introduced in France.
The Union of South Africa became a Dominion.
The Swedish constitution was revised.
A commercial treaty was signed between Austria and Serbia.
A Russo-Japanese agreement was concluded concerning Manchuria and Korea.
Plastics were invented.
A Labour Party was formed in New Zealand.
The first Labour Exchanges were opened in Britain.
Manhattan Bridge was inaugurated in New York.
Sir Arthur Evans began to excavate Knossos, thus revealing Minoan civilization.
The first volume of *Principia Mathematica* was published by Russell and Whitehead.

The Arts

Literature
Arnold Bennett – *Clayhanger*
E.M. Forster – *Howard's End*
D'Annunzio – *Forse che sí, forse che no*
Claudel – *Cinq grandes odes*
W.B. Yeats – *The Green Helmet and other poems*
H.G. Wells – *The History of Mr Polly*

Music
Stravinsky – *The Firebird*
Elgar – Violin Concerto
Puccini – *La Fanciulla del West*
Sir Thomas Beecham staged his first opera season at Covent Garden.
This was the year in which a Negro dance-band in Memphis is supposed to have introduced the blues.

Art
Modigliani – *The Cellist*
Léger – *Nudes in the Forest*
Picasso – *Portrait of Ambroise Vollard*
The First Post-Impressionist Exhibition was held in London.
An exhibition of Islamic Art was held in Munich.
The National Federation for the Arts was founded in the United States.
Kandinsky painted his first abstract composition.

Architecture
Max Weber – Jahrhunderthalle, Breslau
Gaudí – Casa Milá, Barcelona (1905–10)
Adolf Loos – Steiner House, Vienna

Right: Mikhail Larionov — *Rayonism* shows the early development of abstract art in Russia under Futurist influence.

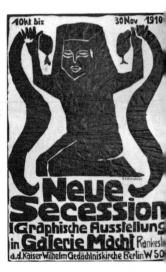

Above: Ernst-Ludwig Kirchner's design for a poster advertising the New Secession Exhibition in Berlin shows the deliberate primitivism of much Expressionist art.

Right: Gaudí's Casa Milá, Barcelona, 1905–10. Total individualism was still possible in architecture.

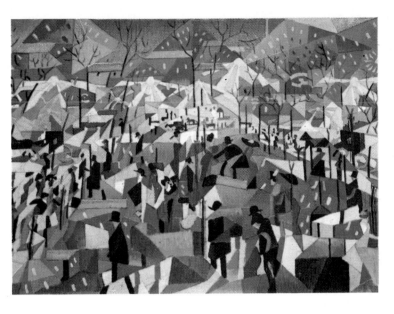

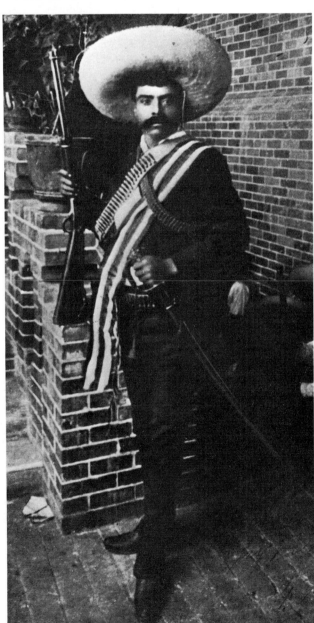

Left and below: The 'primitive' image of a European aesthete contrasts with the sophisticated pose struck by a Mexican revolutionary. Herwarth Walden portrayed by Kokoschka. Zapata by an unknown photographer.

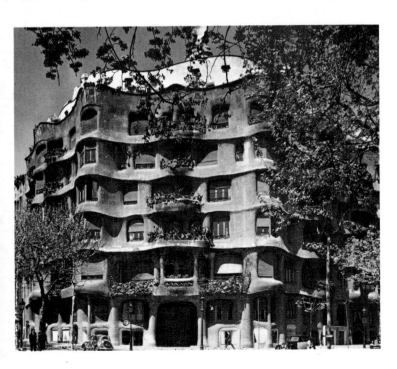

The Birth of Modernism

1911

was not élitist. An attempt was made to carry the new gospel to the people by travelling throughout the nation, just as the Peripatetics had done previously. The journeys made at this time by the Burliuk brothers had for precedent those of Repin and his friends, and they were to be followed in the Revolutionary period by those of the Agitprop trains sent out under the aegis of the Constructivists. It is in Russia that we see for the first time the now apparently mandatory alliance between *avant-garde* art and left-wing politics — Marinetti too was a radical of sorts politically, but also very much a man of the right.

Futurism in Russia soon developed into what has been called Cubo-Futurism. Futurism, as Marinetti imported it, could not for long remain uncontaminated by other 'isms', especially as Russians had, from the days of Catherine the Great, long been enthusiasts for everything Parisian. Matisse found Russian patrons (indeed, all his earliest important buyers were Russians) and now it was the turn of the Cubists to attract attention. Russian artists had no doctrinal inhibitions about trying to combine the two styles, but they interpreted them according to their own traditions. Malevich painted Russian peasant subjects in a Cubist idiom; then, impelled by the age-old Russian impulse towards abstract pattern, evolved further, until by 1913 he was painting completely abstract canvases in a style he labelled 'Suprematist'. Often these were composed of the simplest elements — a large black square symmetrically placed on a white ground.

But there are three further modernist developments during this period which deserve to be mentioned. One is *'Pittura Metafisica'*, the Italian alternative to Futurism. Giorgio de Chirico, who was born in Greece and trained as an artist in Munich (where he became an admirer of the Swiss Symbolist, Arnold Böcklin) was painting in this manner as early as 1911, when he went to Paris and came into contact with the poet and critic Guillaume Apollinaire. Metaphysical painting is a late variation of Symbolist art, and nothing in it is more fantastic or irrational than the images to be found in the prints of Odilon Redon. It is also a bridge to the Surrealism of the immediately post-war period.

The second development arose because of the way in which modern art evolved in the United States. American artists had been aware of *avant-garde* developments in Europe from a very early date, and those of them who crossed the Atlantic soon became involved in what was going on there. To choose just one instance of this involvement, totally abstract compositions were produced by

General Events

There were suffragette riots in Whitehall.
Stolypin, the Russian Prime Minister, was assassinated.
The Spanish Prime Minister was assassinated.
The London dockers struck and refused to return to work until other transport workers' claims were satisfied.
Lloyd George introduced the first National Health Insurance Bill in Britain.
George V was crowned.
A military convention was signed between France and Russia.
Italy and Turkey were at war over Tripoli.
Portugal adopted a liberal constitution.
There was a revolution in Mexico.
The arrival of the German gun-boat *Panther* at Agadir created international tension.
Amundsen reached the South Pole (December 15).

The Arts

Literature
Hugh Walpole — *Mr Perrin and Mr Traill*
D.H. Lawrence — *The White Peacock*
G.K. Chesterton — *The Innocence of Father Brown*
Masefield — *The Everlasting Mercy*
Thomas Mann — *Death in Venice*

Drama
Basil Dean opened the Liverpool Repertory Theatre.
Max Reinhardt produced Vollmöller's *The Miracle*.

Music
Richard Strauss — *Der Rosenkavalier*
Mahler — *The Song of the Earth*
Ravel — *Daphnis and Chloe*
Irving Berlin — *Alexander's Ragtime Band*
Schoenberg completed *Gurrelieder*.

Art
Braque — *The Man with a Guitar*
Matisse — *The Red Studio No. 1*
Renoir — *Gabrielle with a Rose*
Schiele — *The Self-Seer*
Malevich — *Taking in the Harvest*
Epstein — The tomb of Oscar Wilde in Père-Lachaise cemetery, Paris
The *Blaue Reiter* (Blue Rider) group of artists was founded in Munich.
The *Mona Lisa* was stolen from the Louvre (and recovered in 1913).

Architecture
Walter Gropius and Adolf Meyer — Fagus Factory, Alfeld-an-der-Leine
Josef Hoffmann — The Palais Stoclet, Brussels (1905–11)

Above: Nijinsky as the Spirit of the Rose, by Jean Cocteau — an evocation of the romantic side of the *Ballets Russes*.

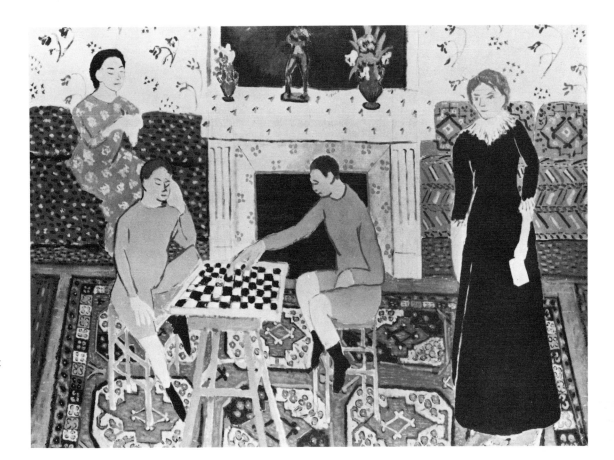

Right and below: Both Matisse's group portrait of his family and Josef Hoffmann's Palais Stoclet in Brussels (1905–11) display a rich but restrained feeling for exotic luxury.

Right: East European emigrants, here arriving in New York, mostly sought security rather than luxury in the United States.

The Birth of Modernism

American painters working in Munich very soon after Kandinsky's breakthrough. There was, however, no attempt to proselytize the American public until the Armory Show of 1913 in New York. This had the same function as the Post-Impressionist exhibitions which had previously been organized by the painter-critic Roger Fry in London. But the Armory Show was on a far more massive scale and addressed itself to a broader public – indeed to a broader public than any which had had access to modern art elsewhere. It was immediately successful, and drew great crowds. It was the Americans as well as the Russians who were responsible for the first efforts to make modern art democratic, but with an interesting difference of approach. The Russians came to believe that art itself must be reconstructed to make it accessible to a mass audience; Americans were content to take every opportunity to make modern art work with the public on its own terms.

Finally it is necessary to say something about the development of sculpture. The first signs of something new were to be found in the occasional sculptures produced by men whose real vocation was painting, Matisse and Picasso in particular. Cubism brought with it the attempt to make Cubist sculpture, which might seem to be a contradiction in terms, since Cubism was essentially a technique for translating three-dimensional forms into two dimensions. When the émigré Russian, Archipenko, tried to translate the conventions of Cubist painting into a completely different medium, the results were necessarily a compromise. It took another Russian, Tatlin, to discover that sculpture could be completely abstract, an arrangement of planes. The collage-reliefs he executed in 1913–14 are now lost, though reconstructions have subsequently been made. Even in blurred newspaper photographs, however, one can see the boldness of his experiment. But there were talented figurative sculptors at work as well – the two names which most immediately come to mind are those of Epstein and Brancusi. Both at this period were searching for authoritative forms which would be complete metaphors for experience. The radical simplification achieved by Brancusi in *The Kiss*, for instance, has nothing to do with abstraction, however many times it has ignorantly been called abstract. Each work is an essence, a distillation. The thing which helped both men to move towards this distillation was the use of direct carving in stone. This may have had distant roots in the Arts and Crafts tradition in England, but essentially it was a rebuke to the near-industrial methods of production which had been employed by so many of the leading sculptors of the nineteenth century.

1912

General Events

The Manchu dynasty abdicated in China, and a provisional republic was established in its place.
Scott reached the South Pole (January 18) to find that Amundsen had beaten him to it.
The *Titanic* struck an iceberg on her maiden voyage (April 15), and sank with the loss of 1513 lives.
Grand Central Station was opened in New York.
The Olympic Games were held in Stockholm. For the first time the events were electrically timed.
A naval convention was signed between France and Russia.
Delhi was made the official capital of India.
In the United States, the first parachute drop was made from an aircraft.
Cellophane was first manufactured.
A Socialist Labour Party was organized in Chile.
The First Balkan War took place (October–December).

The Arts

Literature
Compton Mackenzie – *Carnival*
Gerhart Hauptmann – *Atlantis*
Pound – *Personae*

Drama
Claudel – *L'Annonce faite à Marie*

Music
Schoenberg – *Pierrot Lunaire*
Stravinsky – *Petrushka*
Delius – *On Hearing the First Cuckoo in Spring*
Richard Strauss – *Ariadne auf Naxos*

Art
Picasso – *L'Aficionado*
Kandinsky – *Improvisation*
Léger – *Woman in Blue*
George Frampton – Statue of 'Peter Pan' in Kensington Gardens, London
Modigliani – Stone Head
Duchamp – *Nude Descending a Staircase*
Schiele – *Cardinal and Nude*
Delaunay founded Orphism
The Cubists invented Collage

Architecture
Ralph Knott – County Hall, London
Adolf Loos – Gustav Scheu House, Vienna

Cinema
Queen Elizabeth (with Sarah Bernhardt).
Charles Pathé produced the first newsreel.
Five million Americans were now visiting the cinema daily.

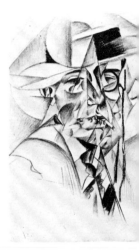

Above and right: All but one of the images on these pages are works of art. They illustrate the rich variety of early modernism. Severini's faceted self-portrait drawing (above) is a simpler version of Braque's Cubism, as exemplified by this work, *Guéridon* (right).

Right: The ominous contrast — the Kaiser and his generals watching manoeuvres.

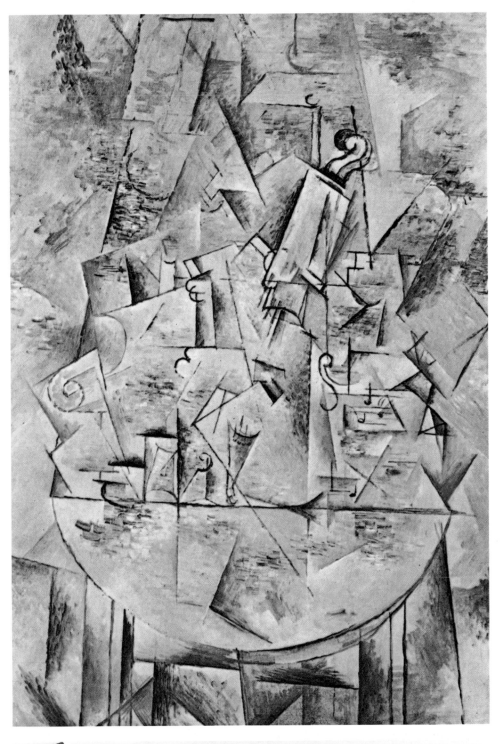

Above: Francis Picabia —
Procession at Seville.

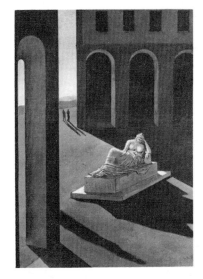

Above: Giorgio de Chirico —
Melancholy.

Below: Marcel Duchamp — *Nude
Descending a Staircase.*

The Birth of Modernism

1913

In literature, the developments most closely linked to the rise of modernism in the visual arts were of course in poetry. The great German Symbolist Rainer Maria Rilke was an admirer of both Rodin and Picasso (he lived for a while in Rodin's house and acted as his secretary). His collection *Neue Gedichte* appeared in 1907, and the first of the *Duino Elegies* was written in January 1912. Stefan George represented another aspect of German Symbolism. In Paris, both Max Jacob and Guillaume Apollinaire were closely associated with the world of modern artists, and Apollinaire was an influential interpreter of the *avant-garde*. His collection *Alcools*, which contains some of his best-known lyrics, appeared in 1913. Valéry Larbaud's *Poèmes d'un riche amateur*, published in a limited edition in 1908 and reissued with revisions, under the title *Poésies de A.O. Barnabooth* in 1913 has something to say about a new attitude towards the modern world. Writing in English, Gertrude Stein was making some of her very earliest experiments with language in the year 1913, but these were to remain unpublished. Perhaps the most extraordinary linguistic transformations, however, were those undertaken by some of the writers associated with Russian Futurism. Velimir Khlebnikov's *Incantation by Laughter*, a tribute to the plasticity of the Russian language, dates from 1910; while Kruchonykh's brief *Heights*, part of an attempt to evolve a universal language of pure sound, was written in 1911.

Drama shows an extraordinary range of possibilities – there are Claudel's magnificently rhetorical poetic dramas, which by his own decision remained unacted, and there is the rational comedy of George Bernard Shaw.

The development of music has already been touched on – it culminates in Stravinsky's epochmaking *Rite of Spring*, which also showed how far Diaghilev's *Ballets Russes*, a most effective instrument of aesthetic propaganda, had moved from its Petersburg Symbolist origins. The fact that Strauss's *Salome* and Lehár's *Merry Widow* came before the public in the same year (1905) should, perhaps, act as a warning against easy aesthetic categorizations.

In fact, the aggressive activities of the *avant-garde* were cocooned within a world which still, despite assassinations and other intimations of trouble ahead, lived comfortably in the warm but fading light of the *Belle Epoque*. The opulent interiors inspired by the Fokine-Bakst ballet *Schéhérazade* tell as much about the real climate of the epoch as the spiky inventions of the Cubists and the Futurists. But even *Schéhérazade* tells a story that finishes with a bloodbath.

General Events

The Second Balkan War took place (February–April), followed by the Third (May–August).
Germany began to enlarge her army.
Britain forbade the sending of arms to Ireland.
Conveyor belt assembly technique was introduced by Henry Ford.
Niels Bohr discovered the structure of the atom.
King George I of Greece was murdered at Salonika.
Conscription was introduced in Belgium.
The French Army Act made three years' military service compulsory.
Artificial fertilizers were invented (1913–14).
The *New Statesman and Nation* was founded.
Greece formally annexed Crete.
A German-Turkish military convention was signed, and aroused opposition from Britain and France.
The President of Mexico was assassinated.
There was an unsuccessful monarchist uprising in Portugal.
Freud published *Totem and Taboo*.
Husserl published *Phenomenology*.

The Arts

Literature
D.H. Lawrence – *Sons and Lovers*
Proust – *Swann's Way*
Alain Fournier – *Le Grand Meaulnes*
Robert Frost – *A Boy's Will*
Apollinaire – *Alcools*
Blaise Cendrars – *Prose du Transsibérien*

Drama
Shaw – *Androcles and the Lion*
Shaw – *Pygmalion*
Pirandello – *Se non Cosa*

Music
Stravinsky – *The Rite of Spring*
Scriabin – *Prometheus*
Vaughan Williams – *Hugh the Drover*
Schoenberg – *Die Glückliche Hand*

Art
Epstein – *Rock Drill*
Walter Richard Sickert – *Ennui*
Franz Marc – *The Bewitched Mill*
Marsden Hartley – *Forms Abstracted*
Maurice Prendergast – *The Promenade*
Harold Gilman, Sickert and Wyndham Lewis form the London Group.
The Armory Show, in New York, introduces Post-Impressionism to the American public.
Marcel Duchamp made the first readymade.

Cinema
Enrico Guazzoni – *Quo Vadis?*
Cecil B. de Mille – *The Squaw Man*
Chaplin made his first film.

Above: Alexander Archipenko — *Carrousel Pierrot*. Cubist sculpture evolving towards Constructivism.

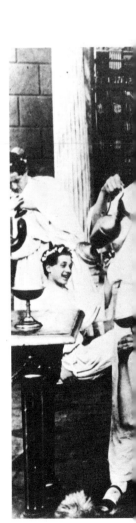

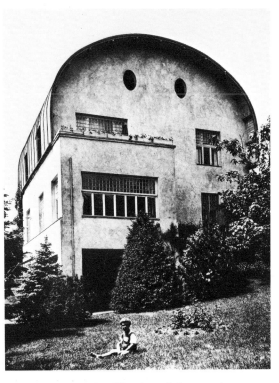

Above: A radical simplification of elements is displayed by this house in Vienna designed by Adolf Loos.

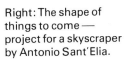

Right: The shape of things to come — project for a skyscraper by Antonio Sant'Elia.

Below: Diaghilev and Nijinsky at a performance of *The Rite of Spring* — a caricature by Cocteau.

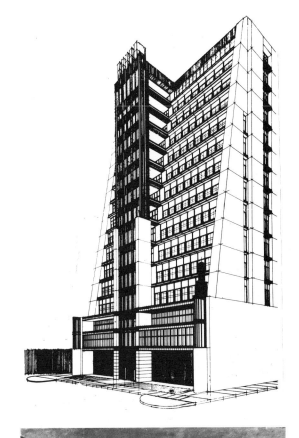

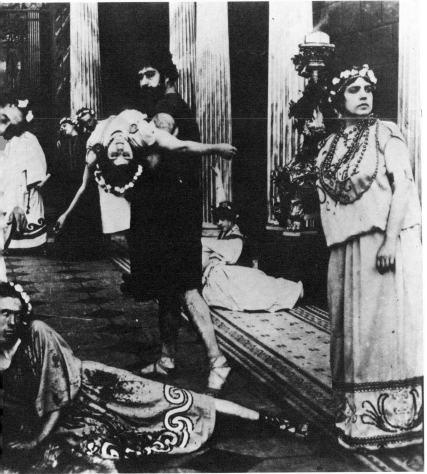

Above: A world about to be destroyed, perhaps through boredom; Sickert's *Ennui.*

Left: The birth of epic cinema. A scene from *Quo Vadis?*

Below: It was often lesser-known artists who gave the most accurate picture of World War I. This painting by George Levoux is a vivid rendering of the hell of the trenches.

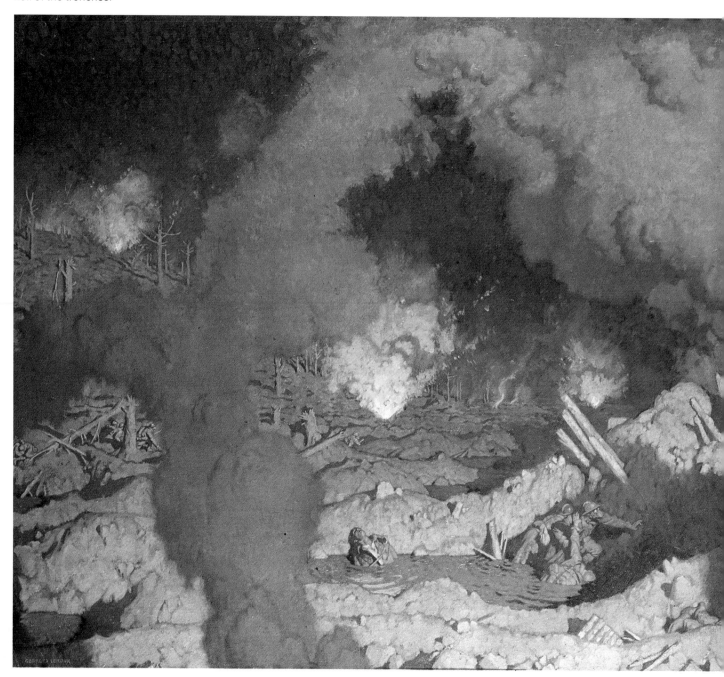

Armageddon
1914 – 1918

It might have been supposed that the terrible war years would administer a decisive check to the development of the Modern Movement. The map of Europe was entirely changed, and the modern arts changed with it. But they retained their vitality, and the changes were not always the ones that might have been predicted.

Certainly, war curtailed creative activity in some directions. There was hardly any significant progress in architecture, except in the United States, which remained isolated and prosperous until at last it too was forced to join the general conflict. As in the pre-war period, American architecture was less conservative in the mid-west and far west than it was on the Atlantic seaboard. In Europe, the war very occasionally acted as a kind of forcing-house for new technological developments in building. An example of this process is Freyssinet's impressive reinforced concrete hangars at Orly, near Paris, created by one war, and subsequently destroyed in another.

Painting and sculpture developed in a fashion which may seem contradictory. Some artists identified themselves with the war, and tried to show what it was like. This was the case with the Italian Futurists. Futurist pictures painted in the early years of the war are full of generalized images of combat and excited patriotic rhetoric. British artists, some of whom had been associated with the short-lived Vorticist movement (an offshoot of Futurism), also tackled the war directly, but in a more pragmatic spirit. Two leading ex-Vorticists who painted fine war pictures were Wyndham Lewis and C.R.W. Nevinson. Nevinson, indeed, found his true subject-matter in France, and never did better work. He was eventually made an official war-artist, as were Paul Nash (later to be associated with English Surrealism), his brother John, and

numerous others. A considerable body of painting was thus built up, much of which has remained in the possession of the Imperial War Museum in London.

The Germans and the French had no war-artists scheme, and the war took heavy toll of talented painters, especially on the German side. August Macke, one of the leaders of the *Blaue Reiter*, was killed in September 1914. Franz Marc died at Verdun in 1916. Expressionism, the leading *avant-garde* style in Germany when war broke out, was apparently well suited to expressing the horrors and splendours of the conflict. But in fact German painters had all too little opportunity to set down their impressions, and when they did so – one can cite the early work of George Grosz and Otto Dix – it was the horror that they emphasized.

The French *avant-garde* tended to stand aside from the war. The majority of the really effective images inspired by it were contributed by French caricaturists (Rouault's *Guerre et Misère* series is perhaps the sole exception), and most of these belonged to quite a senior generation. A memorable design, *Le Borne* (*The Limit*) expressing the French will to resist at Verdun, was created by the veteran Forain, whose career stretched back, past the Dreyfus case, to the early years of the Third Republic. It was scattered in thousands of copies behind the German lines.

In wartime Paris, Cubism continued to develop, apparently in total isolation from world events. Its technical armoury was now more or less complete, and in the period just before the war it had attracted a mass of new recruits, many far less talented than the original founders and had also, *post-facto*, brought in writers who provided it with a rationale. Apollinaire was the leader, writing texts in 1912 and 1913, but he was followed by another poet, Pierre

41

Armageddon

Reverdy, whose important essay 'On Cubism' was published in the review *Nord-Sud* in March 1917. The fact that Cubism was able to maintain an unruffled continuity was due to one practical circumstance. Two of the most important Cubists – Picasso and Gris – were Spaniards, and exempt from service in the French army.

In the United States, artists were still absorbing the impact of the Armory Show. There were two important foci for *avant-garde* activity. One was '291', the gallery founded by Alfred Stieglitz, the photographer and editor of *Camera Work*. The other was the circle which formed around the collector Walter Arensberg and his wife Louise. Among the artists shown by Stieglitz before the gallery closed in 1917 was the young Georgia O'Keeffe. And among those patronized by Arensberg was the *émigré* Frenchman Marcel Duchamp, whose *Nude Descending a Staircase* had been the sensation of the Armory Show.

Duchamp's sojourn in New York seems, however, to have been the thing which brought about his definitive separation from conventional forms of art. In 1913 he had already mounted a bicycle wheel to a kitchen stool in order to make a kind of readymade sculpture. Now he went further. A snow shovel bought at a hardware store was labelled 'in advance of the broken arm' and presented as a readymade art object. In 1915, Duchamp, as a member of the jury of the first New York *Salon des Indépendants*, submitted an object entitled *Fountain*, and fictitiously signed 'R. Mutt'. It was an ordinary porcelain urinal, and R. Mutt was the name of a firm of sanitary engineers. As Duchamp had hoped and expected, the supposedly *avant-garde* committee of jurors rejected it. It was an act of provocation which was to be the model for many others in the history of modern art.

Duchamp was moving in a direction which in some ways matched what was going on in Zurich, where the most controversial art-movement of the time was born in 1915. Its members were German-speaking and largely German in origin, though two of them – Tristan Tzara and Marcel Janco – were Rumanian, and one – Hans Arp – came from Alsace. What mattered was the fact that these poets and painters had opted out. They came to neutral Switzerland in order to get away from the war. Their movement (it was called Dada, apparently after the French word for a hobby-horse) was a protest against the hideous madness of the world. The Dadaists made this protest by embracing a deliberate nihilism and by ironically proposing a reversal of all artistic conventions. Later, Duchamp was to make Dada into a philosophic system; and, on his return to Berlin, Richard Hülsenbeck, with

1914

General Events

The 'Curragh Mutiny' took place, a rebellion of officers of the British Army against their Government's Irish policy.
Velazquez's *Rokeby Venus* in the National Gallery, London, was damaged by a suffragette.
Archduke Francis Ferdinand of Austria and his wife were assassinated at Sarajevo.
Austria declared war on Serbia.
Germany declared war on Russia (August 1), and on France (August 3).
Britain declared war on Germany.
The German army occupied Brussels.
The name of St Petersburg was changed to Petrograd.
Russia declared war on Turkey.
The Panama Canal was officially opened to traffic.
The Canadian Grand Trunk Pacific Railway was completed.
Britain declared the North Sea a war-zone, and the blockade of Germany began.
A German naval squadron was destroyed by Admiral Sir Frederick Sturdee off the Falkland Islands.
The Germans defeated the Russians at the Battle of Tannenberg (26 – 28 August).
First Battle of the Marne halted the German advance on Paris (5–12 September).

The Arts

Literature
Conrad – *Chance*
Joyce – *Dubliners*
Edgar Rice Burroughs – *Tarzan of the Apes*
Gide – *Les Caves du Vatican*
George Moore – *Hail and Farewell*
W.B. Yeats – *Responsibilities*
Thomas Hardy – *Satires of Circumstance*

Drama
Elmer Rice – *On Trial*

Art
Picasso – *The Small Table*
Matisse – *The Red Studio No. 2*
Braque – *The Guitarist*
Oskar Kokoschka – *The Vortex*
Joseph Stella – *Battle of Light, Coney Island*

Architecture
H.P. Berlage – Holland House, London
Henry Bacon – The Lincoln Memorial, Washington (completed 1917)
Walter Gropius – Office wing of a model factory; Exhibition of the Deutscher Werkbund, Cologne

Cinema
Chaplin – *The Little Angel*
Louis Feuillade – *Fantomas* (serial)
The Perils of Pauline (serial featuring Pearl White)

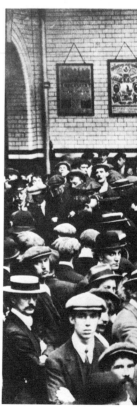

Below: *Here She is at Last!* Fashion design by Bonnard. In some respects 1914 was almost continuous with 1919 — the intervening years were simply lost.

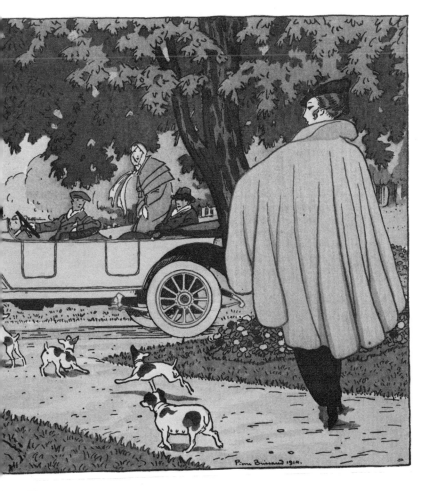

Top and above: Gropius-designed office-wing for a factory; Kokoschka's *Bride of the Wind.* Contrasting images of reason and passion.

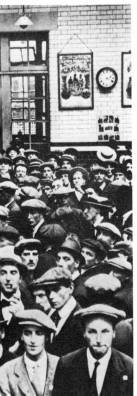

Far left and left: A news photograph shows Englishmen hearing of the declaration of war. A drawing from *Simplicissimus* celebrates the first German attack.

Armageddon

the aid of the Herzefelde brothers, was to make it political, a weapon in the hands of the extreme left. In the beginning, however, it was simply an anarchic force, creative through its very denial of accepted ideas about creativity.

The alliance between the *avant-garde* in the arts and revolutionary politics had come into being even earlier in Russia. The early years of the war saw a rivalry between the Suprematism of Malevich and the Constructivism of Tatlin and his colleagues. Malevich claimed that he had begun working out his Suprematist system as early as 1913. However, its first results were not exhibited until December 1915. Suprematism began with simple combinations of geometrical elements. Gradually, however, Malevich became more mystical, more interested in producing a sensation of infinite space. The painting of 'pure sensation', as Malevich labelled it, culminated in the 'White on White' series of 1917–18, where the simple geometrical elements are almost dematerialized because they contrast so little with their background.

In developing in this way, towards mysticism, Malevich was moving in an almost diametrically opposite direction to Tatlin and his allies, though both based their work on geometrical forms. Both, too, were sympathizers with the political changes which overtook their country.

In 1913–14 Tatlin who, like Malevich, had originally been influenced by Cubism, made his first 'painting-relief'. In these works, made of scrap materials, he tried to carve out forms from space itself. The resemblance to actual paintings grew ever less marked as Tatlin did away with any kind of frame or background, ending up, instead, with what was really a new and original kind of sculpture, with consequences for the future of all modern art.

Tatlin gradually came to believe that there was no frontier between fine art and design: 'Work on the formation of material,' he declared, 'is art.' From this attitude, in turn, sprang the idea, accepted by all the Constructivists, that abstract art could be thought of as something with its own special kind of 'concreteness' – as something possessing a reality which surpassed mere imitation. The Constructivist Movement was the first to pinpoint the difference between art which attempted to add new and original forms to those produced by nature, and art which simply copied pre-existent forms. The Constructivists thought that visual art could be a precise language, with its own visual vocabulary and its own grammar of relationships. Such an attitude left no room for sympathy with transcendental aspirations, but it did mean that there was a bridge between the ideas of the Constructivists and the dialectical materialism of Marxist-Leninism.

1915

General Events

Four Russian divisions were encircled and captured near the Masurian Lakes (7 February).
Poison gas was first used by the Germans.
Britain, France and Italy signed a secret convention.
Anglo/French forces landed at Gallipoli (25 April).
Italy joined the war on the side of the Allies (23 May).
The Allies landed troops at Salonika (5 October).
A German submarine sank the liner *Lusitania*.
Hugo Junkers made the first all-metal aircraft.
Outbreaks of tetanus in the trenches were controlled through the use of serum injections.
A coalition government was formed in Britain led by Asquith.
The Allied forces began their withdrawal from Gallipoli (19 December).

The Arts

Literature
D.H. Lawrence – *The Rainbow*
Somerset Maugham – *Of Human Bondage*
Buchan – *The Thirty-Nine Steps*
Conrad – *Victory*
Ford Madox Ford – *The Good Soldier*
Kafka – *Metamorphosis* (written 1912)
Hermann Hesse – *Knulp*
Pound – *Cathay*
Mayakovsky – *The Cloud in Trousers*
Virginia Woolf – *The Voyage Out*

Drama
The Washington Square Playhouse (reorganized as the Theatre Guild in 1919), the Neighbourhood Playhouse and the Provincetown Players were all founded.

Music
Holst – *The Planets*
Frank Bridge – *Lament*
Debussy – *Études for piano*
Richard Strauss – *The Alpine Symphony*
Manuel de Falla – *Love the Magician*
Sibelius – Symphony No. 5 (1914–15)

Art
Chagall – *Poète Allongé*
Tatlin – *Corner Relief*
Boccioni – *Charge of Lancers*
Balla – *Flags on the Altar of the Fatherland*
Picasso – *Harlequin*

Architecture
Irving Gill – Walter Dodge House, Los Angeles (1915–16, now demolished)

Cinema
D.W. Griffith – *Birth of a Nation*
Cecil B. de Mille – *Carmen*
Feuillade – *The Vampires* (ten-part serial)
Mack Sennett – *Tillie's Punctured Romance*

Above: *European Suicide* — a print by Alberto Martini.

Above: Marianne cocks a snook — French war poster. The war produced a rich crop of allegorical images in every mood and by artists of all nationalities.

Below and right: Official grief and official gaiety. The stars-and-stripes to cover a victim of the sinking of the *Lusitania*; entertainers at Queen Alexandra's garden party for children.

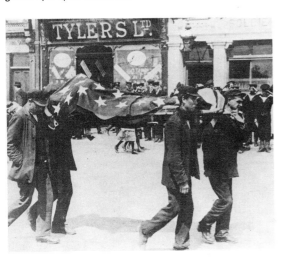

Below: A brief return for social realism. C.R.W. Nevinson's painting of a food-queue.

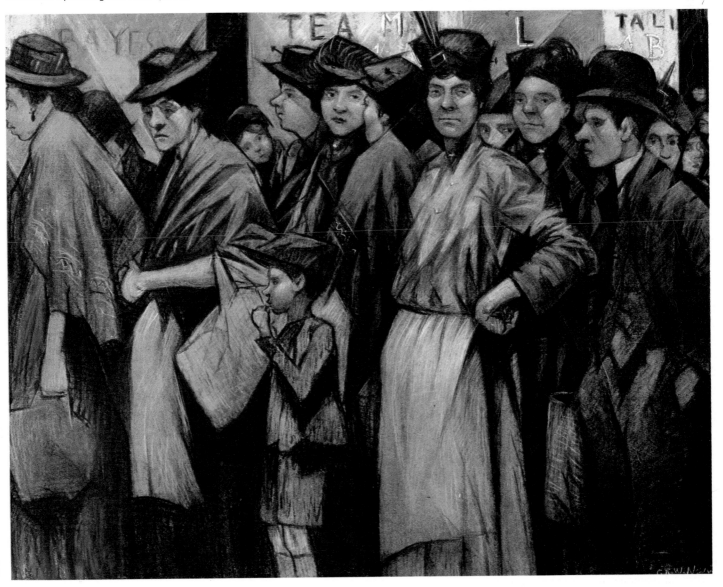

Armageddon

It was therefore the Constructivist group which, after the revolution of October 1917, came to play a particularly prominent part in reorganizing the cultural life of Russia. It was the Constructivists who were to take charge of the organization of revolutionary festivals. On the first anniversary of the revolution, for example, Nathan Altman took charge of a gigantic demonstration-cum-performance in the great square in front of the Winter Palace in Petrograd. The buildings round the square were disguised with modernistic designs, while other designs of the same sort were projected skywards with the aid of search lights.

Constructivists decorated the propaganda trains which took the revolutionary message to people in the remotest parts of Russia, and, more important still, it was Constructivists who were put in charge of a new and very different programme of art-education. For the moment it looked as if the Bolshevik regime would bring with it a drastic change in all the means of visual expression.

A more sober attempt to change the basis of art, and to change it in much the same way, was being made simultaneously in neutral Holland, by a group of artists, designers and architects associated with the magazine *De Stijl*, first published in 1917. The central doctrine of the group is well summarized by something written by a prominent member, Theo van Doesburg: 'The machine is, *par excellence*, a phenomenon of spiritual discipline. Materialism as a way of life and art took handicraft as its direct psychological expression. The new spiritual artistic sensibility of the twentieth century has not only felt the beauty of the machine, but has also taken cognizance of its unlimited expressive possibilities for the arts.'

The doctrines professed by *De Stijl* were in large part to be taken up after the war by the artists and architects connected with the Bauhaus.

It was literature, rather than art, and most especially poetry, which was to prove the most suitable vehicle for giving a direct response to the war. Yet 'war poetry', as a genre, was to be confined fairly strictly to verse written in English, and even to verse written by Englishmen. It went through two phases. The first, sentimental, patriotic and basically optimistic, is represented at its best by Rupert Brooke. The second, expressing a sense of tragedy and of bitter opposition to the slaughter, was written somewhat later and often had to await publication until the twenties. It is associated with the names of Siegfried Sassoon, Robert Graves, Wilfred Owen and Isaac Rosenberg. Of these, both Rosenberg and Owen are to some extent technically experimental, and it is Rosenberg's work which has the closest resemblance to what was being written

1916

General Events

Conscription was introduced in Britain.
First Zeppelin raid on Paris took place.
The Battle of Verdun (21 February – 16 December).
Germany declared war on Portugal.
The Easter Rising took place in Dublin.
The Battle of Jutland (31 May – 1 June).
H.M.S. *Hampshire* with Lord Kitchener aboard was sunk by a mine with the loss of all hands.
There was severe food-rationing in Germany.
'Summer time' was introduced in Britain.
The Battle of the Somme (1 July – 8 November).
The first tanks were used (September) by the British on the Western Front.
Woodrow Wilson re-elected as President of the United States.
Treatment of casualties led to the development of plastic surgery.
Rasputin was murdered (29 December).
Pareto published his *Treatise of General Sociology.*

The Arts

Literature
Joyce – *Portrait of the Artist as a Young Man*
Theodore Dreiser – *The Genius*
Buchan – *Greenmantle*
Edith Sitwell – *Twentieth Century Harlequinade*
Barbusse – *Le Feu*

Drama
Harold Brighouse – *Hobson's Choice*
Eugene O'Neill – *Bound East*

Music
Elgar – *The Spirit of England*
Erich Korngold – *Violanta*
Delius – *Requiem*
Manuel de Falla – *Nights in the Gardens of Spain*
Bartok – *The Wooden Prince* (ballet)

Art
Matisse – *The Three Sisters*
Man Ray – *The Rope Dancer Accompanies Herself with Her Shadows*
Monet – *Waterlilies*
Klimt – *Portrait of Frederika Maria Beer*
Modigliani – *Portrait of Lapoutre*
Rouault began the *Guerre et Misère* series of etchings.
Dada flourished in Zurich.
Georgia O'Keeffe had her first exhibition at '291'.

Architecture
Eugène Freyssinet – Hangars at Orly (first really large-scale structures to use reinforced concrete)

Cinema
Chaplin – *The Pawn Shop*
D.W. Griffith – *Intolerance*

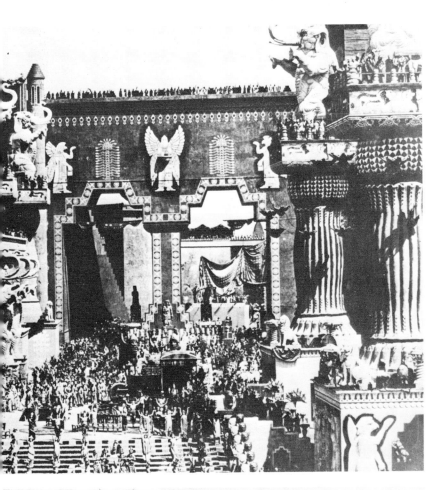

Above: Dublin suffered heavy damage during the Easter Rising; the turmoil in Ireland was accompanied by a cultural renaissance of considerable importance.

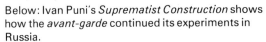

Below: Ivan Puni's *Suprematist Construction* shows how the *avant-garde* continued its experiments in Russia.

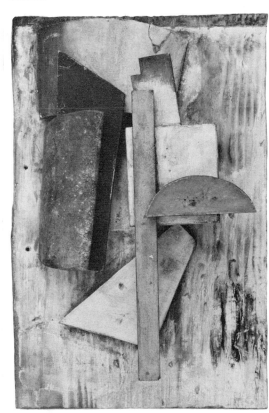

Left: The real but sordid epic of the Western Front. German troops in the mud at Verdun.

Armageddon

by German-speaking Expressionist poets at the same time. The greatest of these is Georg Trakl, one of the finest of the many writers destroyed by the war. German Expressionism dealt more successfully with the war in poetry than it did in painting. The German poets generally wrote of it less specifically than their English counterparts, but what they wrote came to express an even deeper disillusionment, as can be seen from the harshly cynical work of Gottfried Benn. Differently expressed, this disillusionment also appears in the nonsense poems written by Dadaists such as Hugo Ball.

Scattered poems dealing with the war were written by the Italian Ungaretti, and the Frenchmen Apollinaire and Jean Cocteau (some of the latter's best early work), but the Latin languages produced no coherent body of poetic literature dealing with this tremendous subject.

More important for the future of English literature than the great outburst of war poetry was the steady appearance of some of the fundamental texts of literary modernism. Yeats's *Responsibilities* and Joyce's *Dubliners*, both published in 1914, still cling to the old world. Pound's *Cathay* (1915) is already moving away from it, and by the time of T.S. Eliot's *Prufrock* (1917) the break is complete, despite Eliot's debt to the Frenchman Laforgue.

Prufrock can also be seen in a European context, since the war years also saw the appearance of milestones in both French and Russian literature. Mayakovsky wrote *The Cloud in Trousers* just before the Revolution, and Blok wrote *The Twelve* just after it. Their brilliant contemporaries included Esenin, Mandelstam, Marina Tsvetayeva and Anna Akhmatova, as fine a group of poets as any literature has produced at one time. In France, Valéry broke a long poetic silence with *La Jeune Parque*.

The long hiatus imposed by the conflict had one curious effect upon French literature. It more or less imposed on *A la Recherche du Temps Perdu*, perhaps the greatest novel and certainly the greatest novel-sequence of the century, the form that it finally took. Proust had published the first volume of the series in 1913. The war allowed the rest of his narrative time to grow, and by the time he was again able to publish it had acquired an impetus which was to drive Proust on until his death in 1922. The last volume of the series was not in fact to appear until 1927, so great was the mass of material Proust had left behind. *A la Recherche* is an immense and marvellous meditation on the whole elaborate society the war had destroyed.

In English prose, certain texts published during the war foreshadowed the typical tone of the

1917

General Events

Bread rationing was introduced in Britain.
Tsar Nicholas II abdicated (16 March) and was succeeded by a government headed first by Prince Lvov, then by Alexander Kerensky.
The United States declared war on Germany (8 April).
Lenin arrived at the Finland Station in Petrograd (16 April).
A selective military conscription bill was brought in in the United States (18 May).
Second Battle of Verdun (20 August – 15 December).
Third Battle of Ypres (31 July – 10 November).
The Austrians routed the Italians at Caporetto (24 October).
Lenin led the Bolsheviks against the Kerensky government in the October Revolution.
Carl Jung published *The Psychology of the Unconscious.*
A literacy test was imposed on immigrants into the United States.
American troops came into action for the first time on the Western Front (November).
The Balfour Declaration on Zionism promised a Jewish national home in Palestine.
The Turks surrendered Jerusalem to Allenby.
German and Russian delegates signed an armistice at Brest-Litovsk (5 December).

The Arts

Literature
T.S. Eliot – *Prufrock*
Valéry – *La Jeune Parque*
Siegfried Sassoon – *The Old Huntsman*
Norman Douglas – *South Wind*
Lion Feuchtwanger – *Jew Süss*
Mary Webb – *Gone to Earth*
Knut Hamsun – *Growth of the Soul*

Drama
Apollinaire – *Les Mamelles de Tirésias*

Music
Stravinsky – *Renard*
Prokofiev – *Classical Symphony*
Ravel – *Le Tombeau de Couperin*
Satie – *Parade* (ballet)
The first jazz record was issued by the Original Dixieland Jazz Band.

Art
Modigliani – *Crouching Female Nude*
Renoir – *The Washerwoman*
Piet Mondrian – *Composition in Black and White*
Naum Gabo – *Head of a Woman* (1916–17)
De Chirico – *The Sinister Muses*
Malevich – *Suprematism: Yellow and Black* (1916–17)

Cinema
Maurice Tourneur – *Poor Little Rich Girl*
Feuillade – *Judex*
Chaplin – *Easy Street*

Right: Picabia — *Prenez garde à la peinture.* An ironic assault on traditional values in art.

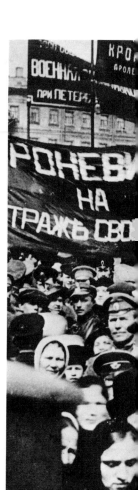

Above and below: 'Welcome to Siberia!' *Simplicissimus* greets the Tsar's deposition. In Russia itself, it was a time for banners and rhetoric.

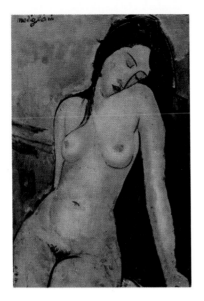

Above: Modigliani's lovely painting of a nude re-affirms classic values.

Left: Picasso and Cocteau caricature one another. Both were in Rome with Diaghilev.

DEBOUT DANS LA TRANCHÉE QUE L'AURORE ÉCLAIRE, LE SOLDAT RÊVE À LA VICTOIRE ET À SON FOYER. POUR QU'IL PUISSE ASSURER L'UNE ET RETROUVER L'AUTRE, SOUSCRIVEZ AU 3e EMPRUNT DE DÉFENSE NATIONALE

Above and below: A French savings poster emphasizes endurance; an American poster adopts a more aggressive approach. The American intervention in the war was a decisive factor in its outcome.

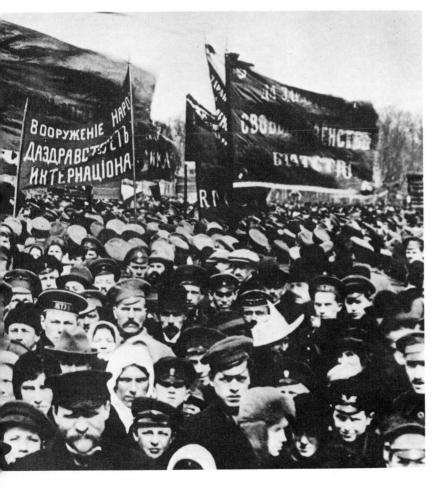

Armageddon

literature of the twenties. Striking examples are Norman Douglas's novel *South Wind* (1917), and Lytton Strachey's collection of brief biographies, *Eminent Victorians* (1918).

Strachey's choice of subjects, and his treatment of them, combine to bid a derisive farewell to many things the previous era had still valued. The timeliness of his book was shown by the fact that it attracted a considerable number of readers, and made a celebrity of its author almost overnight. *South Wind*, with its cheerful amorality, its polite cynicism, is even more decisively in advance of its time. Norman Douglas makes a bridge between the wits of the nineties and the bright young cynics of the Jazz Age. Almost equally significant is the fact that his book is given the kind of Mediterranean setting which was to have an irresistible attraction for authors otherwise as different from one another as Scott Fitzgerald and Cyril Connolly.

Musical styles changed to suit the changing conditions with astonishing rapidity. What had been ambitious, overblown and romantic rapidly became dry and epigrammatic. There is a world of difference between *Josephslegende*, the score Strauss wrote for Diaghilev, and which the latter mounted as a ballet in 1914, and Satie's *Parade* of 1917. But Satie had already spent a lifetime puncturing post-Wagnerian pretensions. It was just that the moment was now ready for him. More genuinely typical of the changed atmosphere are works by two leading Russian composers, both dating from the crisis year 1917. One is Prokofiev's *Classical Symphony*, the precursor of so much twenties classicism in music; and the other is Stravinsky's *The Soldier's Tale*, which prefigures the 'alienation effect' of Bertolt Brecht, and which is as conspicuously modest in its demands as *The Rite of Spring* had been conspicuously ambitious.

The cinema, thanks partly to the tremendous popularity of Chaplin, had now established itself fully with audiences, and at the same time was becoming something more than simple popular entertainment. If Chaplin and Mack Sennett exploited the possibilities of visual comedy to the hilt, D.W. Griffith, taking hints from pre-war films such as *Quo Vadis?* and *The Last Days of Pompeii*, showed that the medium could also be epic, though *The Birth of a Nation* is a masterpiece deeply flawed by the director's racism. Cinema, which addressed itself to a mass public, kept some of the expansive emotion of the nineteenth century, and preserved a romanticism which was fading from the other arts. The late entry of America into the war, and the advantages of the Californian climate, gave the United States a pre-eminence in film which they were never afterwards to lose.

1918

General Events

Woodrow Wilson issued his Fourteen Points for world peace in a message to congress.
Russia proclaimed the Union of Soviet Socialist Republics (U.S.S.R.).
The Bolsheviks occupied Helsinki.
The Germans shelled Paris from 75 miles away.
Second Battle of the Marne (15 July – 14 August).
Ex-Tsar Nicholas II and his family were executed.
Turkey capitulated (31 October).
The allies signed an armistice with Austria (4 November).
Kaiser Wilhelm II abdicated (9 November).
The Allies signed an armistice with Germany at Compiègne (11 November).
Civil War in Russia.
In Britain, women over thirty were given the vote.
Russell published *Mysticism and Logic*.
Spengler published *The Decline of the West*.

The Arts

Literature
Gerald Manley Hopkins – *Poems* (posthumous)
Lytton Strachey – *Eminent Victorians*
Rupert Brooke – *Collected Poems*
Apollinaire – *Calligrammes*
Cesar Vallejo – *Los Heraldos Negros*
Wyndham Lewis – *Tarr*
Arthur Waley – *A Hundred and Seventy Chinese Poems*
Blok – *The Twelve*

Drama
Joyce – *The Exiles*

Music
Elgar – Cello Concerto
Puccini – *Il Trittico* (three one-act operas)
Bartok – *Duke Bluebeard's Castle*
Stravinsky – *Ragtime for Eleven Instruments*
The Original Dixieland Jazz Band made a European tour, and introduced jazz to Europe.

Art
Malevich – *Suprematist Composition: White on White*
Paul Klee – *Gartenplan*
Van Doesburg – *Composition II*
Morandi – *Large Metaphysical Still Life*
Modigliani – *Portrait of Zborowsky* (1917 – 18)
Picasso – *Mme Olga Picasso*
Juan Gris – *Scottish Girl*
Ozenfant and Le Corbusier published their manifesto on 'Purism', entitled *'Après le Cubisme'*.

Cinema
Chaplin – *Shoulder Arms!*
Chaplin – *A Dog's Life*
Ernst Lubitsch – *Carmen* (with Pola Negril)
Winsor McCay – *The Sinking of the Lusitania*

Above and right: After the war men hastened to resume their civilian clothes in the current fashion and their occupations, but women — this flour worker is an example — had become used to doing men's jobs.

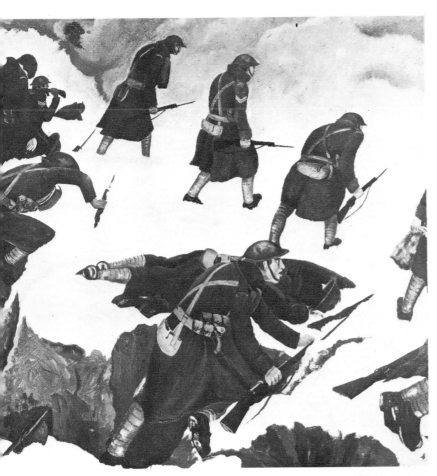

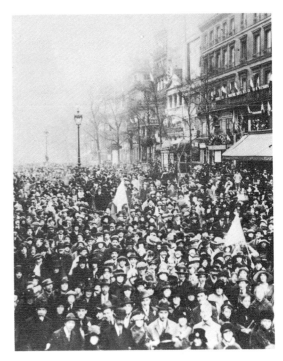

Above and below: Cheering crowds greeted the armistice in Paris, but Schiele's *The Family* convincingly renders the exhaustion of a Europe soon to be swept by the Spanish flu that killed the artist.

Above: John Nash — *Over the Top.* One of the best-known renderings of the stubborn heroism of trench warfare.

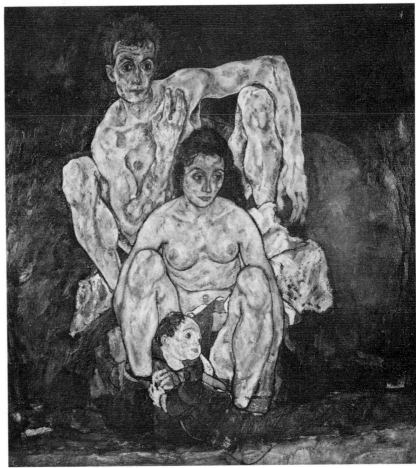

Below: Croydon airport in the twenties, painted by
Kenneth McDonough. Visible are an Air Union
'Golden Ray' airliner and a Breguet 280. Air travel
was becoming commonplace, and its aura of speed
became a symbol of twenties hedonism.

The Jazz Age
1919 – 1931

Though many artists, writers and musicians had prophesied the First World War, and had even in a sense encouraged it to happen, the extent of the damage when it came was to take them, like the rest of the world, by surprise.

It is sometimes customary to think of the 1920s as being all of a piece, the *années folles*, the Jazz Age, in which people tried to forget the full horror of what had happened in a whirl of excitement and enjoyment. This was true only in a very superficial sense. Politically and socially the twenties were disturbed. The war left distinct eddies in its wake – the Greco-Turkish War, which led to the rise of a new, wholly transformed Turkey under Ataturk; Italian irredentist ambitions on the other side of the Adriatic; difficulties over the allied armies of occupation, and in particular over the occupation of the Saar. There was civil war in Russia, in the wake of the Revolution; and there were the attempts made by other powers, particularly Britain, to contain the consequences of this vast upheaval. The shakiness of the Italian social and political structure led to the Fascist takeover under Mussolini. In Britain, the social conflicts of the time erupted in the General Strike of 1926; in Germany inflation further undermined an already eroded confidence in social institutions, and opened the way to all extremists.

In France, the traditional centre of European culture, the trend was towards a kind of conservatism, a drawing back from the more *outré* experiments of the pre-war period. Picasso painted a final Synthetic Cubist masterpiece, *The Three Musicians*, in 1921, but this overlapped with his neo-classical phase, which seemed like a re-affirmation of traditional values after the Cubist experiment. Stravinsky, Russian by birth but owing much to the French musical milieu, also entered a neo-classical period. The new French composers,

the group called '*Les Six*', which included Poulenc, Milhaud and Auric, also seemed to assert the values of an established musical language. Among the leading writers was Valéry. His wonderful collection *Charmes*, published in 1922, fused classicism and symbolism to create something which was recognizably in the great tradition of French poetry, as it descended from masters such as Malherbe and Racine. Proust continued his *roman fleuve*, with its impassioned exploration of a hierarchical society, until his death in 1922.

In the decorative arts, there was also an attempt to reassert traditional French values, while at the same time catering to the fashionable taste for novelty and luxury. This was the period of Art Deco, so named from the great Exposition des Arts Décoratifs held in Paris in 1925. Art Deco now seems a curious mixture of influences. Classical Chinese art of the Sung period, virtually unknown in Europe before the Boxer rebellion of 1900, was now at last beginning to make an impact. It led to a liking for smooth surfaces, often lacquered, and simple, massive forms. There was an interest in African art inherited from Cubism, and later both Ancient Mexico and Ancient Egypt were to make a contribution, the latter thanks to the enormous interest aroused by Howard Carter's discovery of the tomb of the boy pharaoh, Tutankhamen. The basic influence, however, remained the decorative arts of the Louis XVI and Napoleonic periods, which were adapted to new conditions with great skill.

The leading cabinet-makers and decorators were aware of their own élitism, and not at all ashamed of it. They liked to think that they served a clientele very like the one which had existed before the French Revolution. Emile-Jacques Ruhlmann, perhaps the greatest of all the French Deco cabinet-makers, had this to say about the subject: 'We are

The Jazz Age

forced to work for the rich because the rich never imitate the middle-classes. In all periods craftsmen have followed the leaders whose work is addressed to the rich. And the rich, without grudging it, are prodigal with the money – and time – necessary to the solution of problems. It is the élite which launches fashion and determines its direction. Let us produce, therefore, for them.'

The development of Art Deco can be split into three phases. The first lasted from immediately after the war until 1925. During this period the cabinet-makers and other craftsmen worked largely for a wealthy private clientele, often drawn from the world of fashion and the theatre. The exhibition of 1925 publicized what they were doing, and the style also began to be popularized by the more enterprising of the large Paris department stores. This led, on the one hand, to official commissions for banks and offices; and on the other took the style somewhat down-market, introducing it to a broader public. At the same time modernist influences from Germany, and the Bauhaus in particular, were rather reluctantly absorbed. Finally, with the slump, Deco became a heavy, official style, used largely for public work.

France was not, however, without an *avant-garde*, though this took different directions in painting and sculpture on the one hand, and in architecture and the decorative arts upon the other.

One group of *avant-garde* artists in France were clustered round the dictatorial figure of André Breton. The period 1919–24 covers the gestation of the Surrealist Movement. It stretches from the foundation of the ironically entitled magazine *Littérature* to the appearance of the First Surrealist Manifesto. Inspired in almost equal measure by Zurich Dada and by the doctrines of Freud, Surrealism urged creative man to put his trust in the promptings of his own unconscious mind, and to insist on the uttermost liberty of expression and behaviour, no matter what rules society might seek to impose. Like Futurism, Surrealism started life as a literary movement, but soon attracted the interest and loyalty of practitioners of the visual arts.

From 1925 onwards, the Surrealists became increasingly preoccupied with revolutionary politics, and in particular with Communism. Breton and some of his closest associates finally joined the Communist Party in 1927. But they were always to be restive under discipline, and the relationship remained an uneasy one. The disagreements beneath the surface flared up in acute form when the poet Aragon, from the beginning one of Breton's most valued associates, published the violently pro-Communist poem *'Front Rouge'* late in 1931. Breton's uneasy defence of his friend when the latter

1919

General Events

The Treaty of Versailles was signed.
Hitler founded the National Socialist German Workers Party.
The Spartacist Rising took place in Berlin, and there was civil war in Bavaria.
The new German Republic adopted the Weimar Constitution.
Mussolini founded the *Fascia di Combattimento* in Italy.
The Comintern was founded.
Allied intervention against the Bolsheviks failed.
Alcock and Brown made the first non-stop flight across the Atlantic.
J.M. Keynes published *The Economic Consequences of the Peace*.
Bertrand Russell published *Introduction to Mathematical Philosophy*.
Huizinga published *The Waning of the Middle Ages*.
The socialist republic of Bela Kun was overthrown in Hungary.
The Spanish flu epidemic killed almost as many people as the Great War.

The Arts

Literature
James Branch Cabell – *Jurgen*
Joseph Conrad – *The Arrow of Gold*
Somerset Maugham – *The Moon and Sixpence*
André Gide – *La Symphonie Pastorale*
Blasco Ibanez – *The Four Horsemen of the Apocalypse*
Jean Cocteau – *Le Potomak*
Sherwood Anderson – *Winesburg, Ohio*
W.B. Yeats – *The Wild Swans at Coole*

Drama
Shaw – *Heartbreak House*

Music
Stravinsky – *Piano-Rag Music*
Falla – *The Three-Cornered Hat*
Bartok – *The Miraculous Mandarin*
Richard Strauss – *Die Frau ohne Schatten*

Art
Beckmann – *Die Nacht*
Tatlin – *Monument to the Third International* (project, 1919–20)
Brancusi – *Bird in Space*
The Bauhaus was founded at Weimar.

Cinema
Robert Wiene – *The Cabinet of Doctor Caligari*
D.W. Griffith – *Broken Blossoms*
Abel Gance – *J'Accuse*
United Artists was founded.

Above: This anonymous design symbolizes Italian irredentist ambitions and foreshadows Mussolini.

Left: Texas oilfields symbolize the American industrial upsurge, and the beginnings of the great corporations.

Above: George Grosz caricatures the corruption of post-war Germany, attacking profiteers.

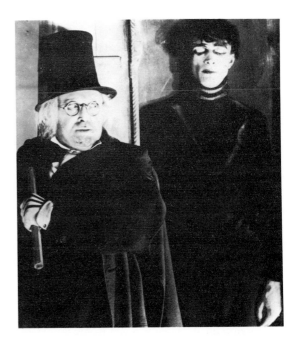

Above: The famous Expressionist film *The Cabinet of Doctor Caligari* presents another aspect of the post-war German mood.

Left: Picasso's curtain for the ballet *The Three-Cornered Hat*, with choreography by Massine.

55

The Jazz Age

was prosecuted by the French authorities led to a final breach between them.

From the creative point of view, the years 1924–31 were among Surrealism's most important. Painters such as Miró, Ernst and Tanguy did some of their finest work, and Ernst in particular was especially prolific in inventing new techniques, such as *frottage* and *grattage*. Salvador Dali's adhesion to the movement in 1929 was a counterweight to the numerous defections which took place in that year, and marked the fact that Surrealism was now becoming an international art movement, rather than a purely French one.

The other aspect of the *avant-garde* in France was represented by the Swiss-born architect, Le Corbusier, who began his public career as an artist advocating a refined and purified version of Cubism. His magazine *L'Esprit Nouveau*, published from 1920–3, nevertheless covered a very wide range of subjects, and in 1923 he published *Vers une architecture*, a collection of statements on the subject which had already appeared in the magazine. Le Corbusier was not entirely without practical experience as an architect – he had already been responsible for a few small and not especially distinguished buildings – but the book marked his definitive choice of profession. It also marked the start of a new thrust towards a truly rational view of architecture itself, more rigorous though perhaps also less practical than the ideas being put forward at the same time in Holland and Germany. The *Pavillon de l'Esprit Nouveau*, Le Corbusier's dissenting exhibit at the Arts Décoratifs show of 1925, marked the next stage in his efforts to change the world around him. He did not get the opportunity to build very much at this time, but what he did build, such as the Villa Stein at Garches (for Gertrude Stein's brother Leo), or the famous Villa Savoye at Poissy, is outstanding not only for its radicalism but also for its elegance.

Like the Bauhaus architects, Le Corbusier was also responsible for a certain amount of furniture, designed in collaboration with Charlotte Perriand. This, too, was a statement of the machine aesthetic, quite different from the traditional craftsmanship of a man like Ruhlmann.

Le Corbusier was asked to participate in the Weissenhof exhibition at Stuttgart in 1927. This was organized by Mies van der Rohe, one of the leading spirits in the Bauhaus, and later to become its director. Weissenhof, a collection of experimental buildings in a modern suburb, was the work of architects from all over Europe – the first practical collective statement of the principles of the new architecture. It must have seemed natural that such a statement should be made in Germany, and

1920

General Events

The first meeting of the League of Nations took place.
American women received the vote.
Sacco and Vanzetti were tried.
Prohibition was introduced in the United States.
Clemenceau was defeated in the French presidential election.
The Allies occupied Constantinople.
Admiral Horthy was elected Regent of Hungary.
Joan of Arc was canonized.
Jung published *Psychological Types*.
Michelson measured the diameter of Betelgeuse – the first accurate measurement of a star.
The first public broadcasting stations were set up both in Britain and the United States.
Gramophone records were first recorded electrically.
All factories in Russia employing more than ten workers were nationalized.

The Arts

Literature
Agatha Christie – *The Mysterious Affair at Styles* (her first mystery novel)
D.H. Lawrence – *Women in Love*
Katherine Mansfield – *Bliss and other stories*
F. Scott Fitzgerald – *This Side of Paradise*
Pound – *Mauberley*
Wilfred Owen – *Poems* (posthumous)
Sinclair Lewis – *Main Street*
John Galsworthy – *In Chancery*
Colette – *Chéri*

Drama
O'Neill – *The Emperor Jones*
Georg Kaiser – *Gas*
Galsworthy – *The Skin Game*

Music
Ravel – *La Valse*
Stravinsky – *Symphonies of Wind Instruments*
Satie – *Socrate*
The French group of composers, 'Les Six', was first named as such by the critic Henri Collet.

Art
Modigliani – *Reclining Nude*
Juan Gris – *Guitar, Book and Newspaper*
Matisse – *The Odalisque*
Charles Demuth – *Machinery*

Architecture
Mendelsohn – Einstein Tower, Potsdam

Cinema
Paul Wegener – *The Golem*
Fred Niblo – *The Mark of Zorro* (with Douglas Fairbanks)

Above: This project for a skyscraper by Mies van der Rohe envisages the use of a steel skeleton and glass curtain walls. It is a masterpiece of precognition.

Below: Henry Ford was bringing motoring within reach of the majority.

LA CÉLÈB

F

4 CYLINDRES
COMPLÈTE EN ORDRE DE MA

HENRI DEP

Right: Three designs from the *Story of Two Squares* by El Lissitzky show Russian Constructivism at its most dynamic.

Left: Mondrian's mature style sums up twenties rationality and the taste of the time for a kind of abstract classicism.

Above: This British Labour Party poster for the 1920 election emphasizes economic distress, and particularly the fate of the men who had returned from the trenches.

The Jazz Age

under Bauhaus auspices. During the twenties it was Germany, far more than France, which set the tone for a new way of living and a new attitude towards the environment. It was the Bauhaus which provided a focus for innovation of this type.

One must be careful, however, not to think of the Bauhaus as something totally novel and original. Some of its ideas and principles were inherited from those which had been professed by the Deutscher Werkbund before the war; while some came from Holland, from the architects associated with *De Stijl*; and others still were influenced by the Russian Constructivists.

Material conditions in Germany were so bad in the years immediately following the war that few opportunities for building, and especially experimental building, arose. The same was the case in Russia, where resources to fulfil the ambitious plans made by the Constructivists were equally lacking. It is one of the ironies of history that the most prominent surviving example of Constructivist architecture is Lenin's tomb in Moscow. It is thus to Holland that one must turn in the early twenties, in order to see any practical examples of the new architecture. The clean-edged cubical style, soon to be labelled International Modern, makes its first tentative appearance in the work of Dutch architects such as J.J. Oud and Gerrit Rietveld.

What the Bauhaus can be said to have done was to provide both a focus for new architectural ideas, and an effective means of disseminating them. It began its existence in Weimar in 1919, and the Bauhaus of the early years, until the move to Dessau in 1925, was somewhat different from the institution as it developed afterwards – more craft-oriented, less conscious of its role as a force for social change. Though Walter Gropius was its presiding genius and founder, the stormy directorship of Gropius's successor, the left-wing Swiss architect Hannes Meyer, had much to do with the Bauhaus's subsequent reputation.

The essential element, however, was there from the start – a complete design course, starting from first principles and only later branching out into various forms of specialization; and the idea of design as a totality, combining form, function and material into an ideal unity. Some of this came from Russia which, while out of contact with the victorious Allies, was still able to maintain close links with defeated Germany. Constructivist philosophy and Dutch practical experience were brought together in a new and potent amalgam.

The Bauhaus's chief architectural monument was its own new building at Dessau, built by Gropius and his partner. It can be said that this was a less effective instrument of modernist architectural

General Events

The first Fascists were elected to the Italian Parliament.
The Greco-Turkish war ended in a Greek defeat, and a Turkish nationalist government was set up in Ankara.
The Hashemite kingdom was established in Iraq.
The N.K.V.D. was founded in the Soviet Union.
The first Indian parliament met.
Germany defaulted on reparations.
There was a widespread famine in Russia.
The Thompson sub-machine gun was invented.
The prints of the Abominable Snowman were first reported from the Himalayas.

The Arts

Literature
Aldous Huxley – *Crome Yellow*
George Moore – *Héloïse and Abélard*
Italo Svevo – *The Confessions of Zeno*
D.H. Lawrence – *Sea and Sardinia*

Drama
Pirandello – *Six Characters in Search of an Author* (revised 1925)
Shaw – *Back to Methuselah*
Karel Čapek – *The Insect Play*
Eugene O'Neill – *Anna Christie*
Somerset Maugham – *The Circle*

Music
Honegger – *King David*
Prokofiev – *The Love of Three Oranges*
Janáček – *Katya Kabanova*
The first Donaueschingen Festival of *avant-garde* music.

Art
Miró – *The Farm*
Picasso – *The Three Musicians*
Braque – *Still Life with Guitar*
Fernand Léger – *Le Grand Déjeuner*
Max Ernst – *The Elephant Celebes*
Stuart Davis – *Lucky Strike*

Architecture
Michael de Klerk – Eigenhaard flats, Amsterdam
W.M. Dudok – Villa Sevensteign, The Hague

Cinema
D.W. Griffith – *Dream Street*
Ernst Lubitsch – *Anna Bolena*
Erich von Stroheim – *Foolish Wives*
Feyder – *L'Atlantide*
Rex Ingram – *The Four Horsemen of the Apocalypse* (with Valentino)

Above and below: Léger — *Le Grand Déjeuner* (above). Picasso — *Three Women at the Fountain* (below). In their treatment of the same subject matter — a group of three women — both artists reach answers that owe a lot to nineteenth-century neo-classicism.

Above: This early, intensely Spanish, painting by Miró, *The Farm*, once belonged to the writer Ernest Hemingway.

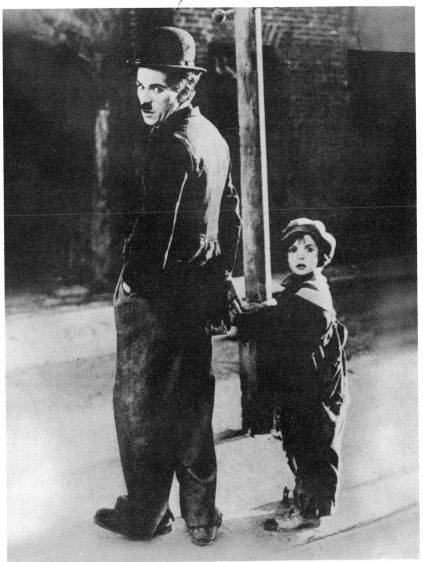

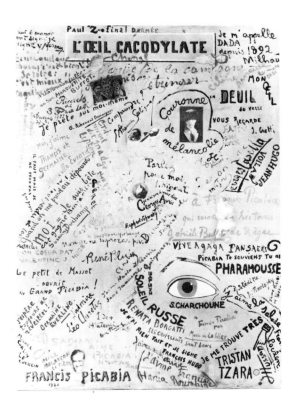

Above: Picabia gleefully pokes fun at the public with this collection of graffiti.

Left: Charlie Chaplin and Jackie Coogan in *The Kid*, one of Chaplin's greatest comedies.

59

The Jazz Age

propaganda than the department-stores built only a little later by Erich Mendelsohn, whose clean-lined, dramatic façades were a direct way of projecting the new design image to a mass public. On the other hand, the Bauhaus designs did have a marked and immediate impact on the appurtenances of daily life. Bauhaus furniture, china, glass, lighting fittings and wallpaper penetrated the popular consciousness, and, made by various commercial firms on licence, achieved quite a wide distribution, particularly within Germany itself.

Yet this entailed a certain irony. The Bauhaus designers were inclined to put forward their products as purely practical solutions to problems, thus essentially styleless. Sometimes, in fact, they went so far as to claim that their designs provided the only sensible answer to some contemporary need. The public, nevertheless, stubbornly persisted in seeing their productions in terms of style, as symbols of an allegiance to a new, more modern way of living. In addition, Bauhaus practicality sometimes turned out to be a sham. The steel cantilever chairs designed by Mart Stam, Mies van der Rohe and Marcel Breuer acquired an immediate symbolic value they still retain today. But it is easy to demonstrate that equivalents in cheaper materials, especially wood, were a better choice in terms both of ease of manufacture and actual comfort. The Bauhaus was not innocent of the 'mechanolatry' which marked the whole period.

The Bauhaus forms only one part of an extremely complex cultural scene. The collapse of Germany in 1918 threw that country into a state of confusion at least as complete as that which prevailed in Russia at the same time.

From the political point of view, the situation was perhaps even more obscure, since no commanding political personality stepped forward to govern the nation, as Lenin had in Russia. The Communists formed a strong faction, but were opposed by equally powerful groups of right-wingers. Some of the German-speaking Dadaists who had been members of the Zurich group returned to Berlin in order to throw themselves into the fray, and evolved an art which was politically involved on the side of the left-wing – the presumption being, as with the otherwise very different Russian Constructivists, that radical art was necessarily in alliance with left-wing politics. Berlin Dada, not being attached to a party in power, pursued a different course from Constructivism, criticizing the evils it saw in the present rather than proposing models for the future. It made new use of methods first evolved by the apolitical Cubists. John Heartfield (born Herzefelde) became a master of the politically oriented photo-collage. The tradition to which he

1922

General Events

The Coalition Government in Britain was defeated, and Lloyd George resigned. Bonar Law became Prime Minister.
There was civil war in Ireland. Michael Collins was assassinated.
Mussolini led his March on Rome, and became Italian Prime Minister.
The B.B.C. began regular broadcasts.
Insulin was isolated from the pancreas, thus providing a treatment for diabetes.
Wittgenstein wrote the *Tractatus Logico-Philosophicus*.
The cocktail made its debut.
Howard Carter discovered the Tomb of Tutankhamen.

The Arts

Literature
Joyce – *Ulysses*
Sinclair Lewis – *Babbitt*
Mauriac – *Le Baiser au Lépreux*
D.H. Lawrence – *Aaron's Rod*
F. Scott Fitzgerald – *The Beautiful and the Damned*
Rilke – *Sonnets to Orpheus*
Valéry – *Charmes*
T.S. Eliot – *The Waste Land*
W.B. Yeats – *Later Poems*
Edith Sitwell – *Façade*

Drama
O'Neill – *The Hairy Ape*
Brecht – *Baal*
Brecht – *Drums in the Night*
Pirandello – *Enrico IV*

Music
Ravel – Cello Sonata
Vaughan Williams – *Pastoral Symphony*
Carl Nielsen – Symphony No. 5

Art
Brancusi – *Torso of a Young Man*
Léger – *Woman with Flowers in Her Hand*
Charles Sheeler – *Offices*
Alexei Gan published his Constructivist Manifesto.

Architecture
Freyssinet – Bridge at Saint-Pierre-du-Vouvray
Gropius and Meyer – Dr Olte House, Berlin Zehlendorf (1922–3)
Fritz Höger – Chilehaus, Hamburg (1922–3)

Cinema
Fritz Lang – *Dr Mabuse*
Murnau – *Nosferatu*
Robert J. Flaherty – *Nanook of the North*

Below: Twenties elegance — an evening dress by Callot Soeurs, photographed by Beaton.

Above: Birth of the International Style — a project by Le Corbusier for Maison Citrohan No 2.

Left: American Precisionism — Charles Sheeler's painting, *Offices*, celebrates the skyscraper.

Right: The liberated man of letters — D.H. Lawrence at Santa Fé.

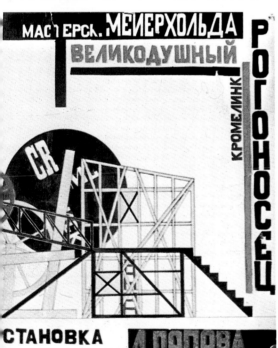

Above: Constructivist stage-design — Popova's set for Meyerhold's production of *The Magnanimous Cuckold* by Goldoni.

Right: A type of the twenties — Van Dongen's portrait, *La fumeuse*, typifies the *garçonne*, or boy-girl.

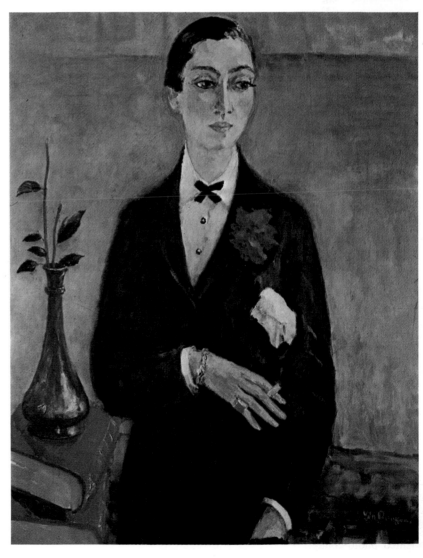

The Jazz Age

and his fellow-satirist, George Grosz, belonged was that of the great German-language satirical magazine *Simplicissimus*. But it is equally important to note that Herzefelde's true successors and heirs were not men of his own political persuasion, but advertising designers, who in due course developed and perfected his techniques.

Yet it was not Herzefelde and his colleagues who provided a direction for German art after the war. This came from a movement dubbed *Die Neue Sachlichkeit* – the New Objectivity. This was realist art which acknowledged a debt to Expressionism, but which aimed to look at the world in a more detached and critical way. The images of misery painted by Otto Dix and his fellows were often fierce, because they reflected the squalor and disruption which for many ordinary people characterized life in the Weimar Republic, and prepared the way for the Nazi take-over in 1933.

One little emphasized influence on the German art of the Weimar period was the German Middle Ages. What especially attracted the attention of artists like the sculptor Barlach and the painter and printmaker Käthe Kollwitz was the way that late medieval art in northern Europe appealed to a community united by faith. In their case, however, the faith was humanitarian and political rather than religious.

The rich culture of Weimar affected not only the visual arts but literature, drama and music as well. For most people this is the era epitomized by the poetry of Bertolt Brecht and the music of Kurt Weill, and particularly by *The Threepenny Opera*, a topical reworking of an eighteenth-century work, *The Beggar's Opera* by John Gay. Yet if we look only at the Brecht-Weill collaboration we tend to miss the full complexity of the German literary and musical scene. Brecht himself works only slowly towards a fully committed political stance. His early dramas, such as *Drums in the Night*, still have links with the Expressionist theatre. Opposed to his poetry, even within the boundaries of the German language, stands the refined symbolism of Rilke's *Duino Elegies*, and the poetry of Stefan George and Yvan Goll. Thomas Mann's *The Magic Mountain* also offers another, and very different kind of literary dimension.

Where music is concerned, the mixture is even richer. Next to Weill's plaintive jazz-influenced songs (by no means his only manner) we can put the more didactic but still popular style adopted by Hans Eisler and the classicism of Hindemith. The Austrian twelve-tone school of Schoenberg, Berg and Webern arrived at a full development of their demanding method at this very period, writing music in such a way as to suggest an inevitable

1923

General Events

Calvin Coolidge was elected President of the United States.
In Britain, Bonar Law resigned due to ill health and Baldwin became Prime Minister.
Canberra was founded.
The French occupied the Ruhr.
German inflation reached its height.
Hitler's *Putsch* failed in Munich, and Hitler himself was imprisoned.
Primo de Rivera became Spanish dictator.
The Chinese Nationalist Government was established by Sun Yat Sen.
Mustapha Kemal (Kemal Ataturk) became first president of Turkey.
The first helicopter flew.
Maritain published *Éléments de Philosophie*.
The Le Mans 24-hour race was established.

The Arts

Literature
Joseph Conrad – *The Rover*
Aldous Huxley – *Antic Hay*
Raymond Radiguet – *Le Diable au Corps*
Rilke – *Duino Elegies*
Ronald Firbank – *The Flower Beneath the Foot*
Wallace Stevens – *Harmonium*
D.H. Lawrence – *Birds, Beasts and Flowers*

Drama
Čapek – *R.U.R.*
Elmer Rice – *The Adding Machine*

Music
Schoenberg – Five Piano Pieces, Op 25 (they ushered in the 12-tone system)
Milhaud – *La Création du Monde*
Hindemith – *Marienleben*
Sibelius – Symphony No. 6 in D minor
The first two-sided discs were issued by Victor.

Art
Max Beckmann – *The Trapeze*
Augustus John – *Thomas Hardy*
Picasso – *Seated Woman*
Utrillo – *Ivry Town Hall*
Dufy – *On the Banks of the River Marne*
Kandinsky – *Circles in the Circle*
Max Beckmann – *Dance-Bar in Baden-Baden*
Max Ernst – *Men Shall Know Nothing of This*
Paul Nash – *The Coast*
Frank Dobson – *Sir Osbert Sitwell*

Architecture
Erich Mendelsohn – Dr Sternefeld House, Berlin
Raymond Hood – Chicago Tribune Building
Georg Muche and Adolf Meyer – Experimental house 'am Horn', Weimar
Le Corbusier published *Vers une architecture*

Above: Design by Gontcharova for *Les Noces*, music by Stravinsky, choreography by Bronislava Nijinska.

Right: Caricaturist Karl Arnold comments on the German inflation.

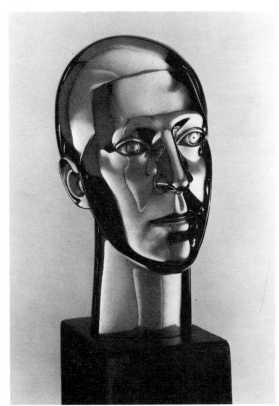

Left: Léger's design for *La Création du Monde*, a ballet, with music by Milhaud, mounted by the *Ballets Suédois* of Rolf de Maré.

Below: Frank Dobson's famous portrait of Osbert Sitwell.

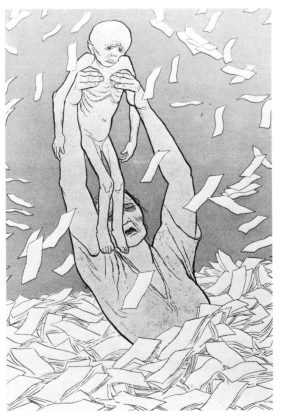

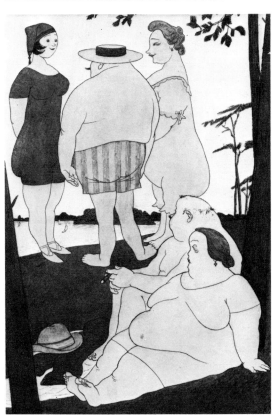

Above: Hitler's unsuccessful *Putsch*. He proclaims a German government, 8th November 1923.

Right: Karl Arnold, at his most cruelly perceptive, showing Berliners at play. It was the middle classes who were to turn Hitler's fantasies into reality.

The Jazz Age

separation between what was 'serious' and what was 'popular'. With its twin criteria of strict internal logic and fidelity to the chosen musical method, the twelve-tone school might seem to be a rejection of all values with the exception of purely musical ones, and it interpreted even those in a peculiarly puritanical way. Yet Berg's *Wozzeck*, based on Büchner's passionate play of 1836, is both an affecting human tragedy and a fiercely emotional denunciation of social injustice. These qualities are to be found in the music just as they are in the text.

But twelve-tone music in general, despite Berg's masterpiece, did seem to many people in the German-speaking world, and also elsewhere, to involve a deliberate alienation of the great mass of the musical public. Alarmed by the gap which seemed to be opening between the serious composer and his audience, some musicians began to experiment with what was called *Gebrauchsmusik* (Workaday Music). They addressed themselves to amateurs, to students and to the young, trying to create works which were both simple to play and easy to listen to. Among the composers who became involved with this kind of experiment were Hindemith, Weill and Eisler. Hindemith wrote, in 1927: 'The days of composing for the sake of composing are perhaps gone forever. A composer should write today only if he knows for what purpose he is writing.' He backed up his belief by writing works such as *Wir bauen eine Stadt* (*We are Building a City*), which he subtitled 'a musical game for children'.

It was an important period for the German theatre and for the German cinema. Piscator, perhaps the most important of the German theatre directors, opened his Proletarian Theatre in Berlin in October 1920 and, though the enterprise closed the next year, the pattern for the immediate future had been set – the theatre was to be, *par excellence*, the place where experimentation and political agitation were combined.

The early twenties were the period of Expressionism in the German cinema, and Robert Wiene's *The Cabinet of Dr Caligari* (1919) is an important landmark in its development. At the beginning of the next decade, Fritz Lang's *M.*, ostensibly about a mass-murderer, shows an acute consciousness of the looming Nazi menace.

Because of a lack of resources, the artists and architects in Russia fared even worse than their German counterparts. Most Constructivist architecture never got beyond the planning stage. Some of it, like Tatlin's *Monument to the Third International*, was probably in any case technically unfeasible. Yet it is impossible, even today, to look at the projects of an architect such as the scarcely

1924

General Events

Lenin died. Petrograd was renamed Leningrad.
The first British Labour Government was formed under Ramsay MacDonald. The 'Zinoviev Letter' affair brought about its fall, and Baldwin formed his second ministry.
The United States limited immigration.
Italy gained control of Fiume.
Mussolini's opponent Mateotti was murdered.
The loudspeaker was invented.
The first insecticide was developed.
Photographs were transmitted across the Atlantic by wireless telegraphy.

The Arts

Literature
E.M. Forster – *A Passage to India*
Mauriac – *Genitrix*
Hemingway – *In Our Time*
David Garnett – *A Man in the Zoo*
Radiguet – *Le Bal du Comte d'Orgel*
Ronald Firbank – *Prancing Nigger*
Saint-John Perse – *Anabase*
A.A. Milne – *When We Were Very Young*
Bulgakov – *The White Guard*
Thomas Mann – *The Magic Mountain*

Drama
Shaw – *Saint Joan*
Noel Coward – *The Vortex*
Eugene O'Neill – *All God's Chillun Got Wings*
Sean O'Casey – *Juno and the Paycock*

Music
Gershwin – *Rhapsody in Blue*
Puccini – *Turandot* (left incomplete at the composer's death; premièred in 1926).
Richard Strauss – *Intermezzo*
Schoenberg – *Erwartung*
Respighi – *The Pines of Rome*
Berg – Chamber Concerto
Stravinsky – Piano Concerto
Janáček – *The Makropoulos Affair*

Art
Brancusi – *The White Negress*
Miró – *Catalan Landscape*
Gerald Murphy – *Razor* (c.1922 – 4)
André Breton issued the First Surrealist Manifesto.

Architecture
Oud – Workers' Housing, Hook of Holland (1924 – 7)
Gerrit Rietveld – Schröder House, Utrecht
Erich Mendelsohn – Herpich fur store, Berlin

Cinema
Raoul Walsh – *The Thief of Baghdad* (with Fairbanks)
Mauritz Stiller – *The Saga of Gösta Berling*
F.W. Murnau – *The Last Laugh*
John Ford – *The Iron Horse*
Erich von Stroheim – *Greed*
Cecil B. de Mille – *The Ten Commandments*
Léger – *Le Ballet mécanique*

Right: Kandinsky — *Shrill-Peaceful Rose Colour.* The modernist pioneers were now beginning to explore further the new visual languages they had invented.

Below: Prohibition in the United States — enforcement officers destroying barrels of liquor.

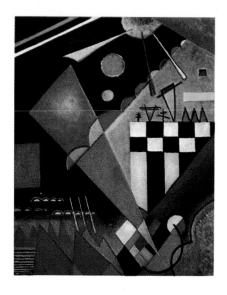

Below: Sybil Thorndike gave her greatest performance when she created the title-role in Shaw's *Saint Joan.*

Above: F. Scott Fitzgerald in Paris with his wife Zelda and daughter Scottie. *The Great Gatsby* was published in the following year.

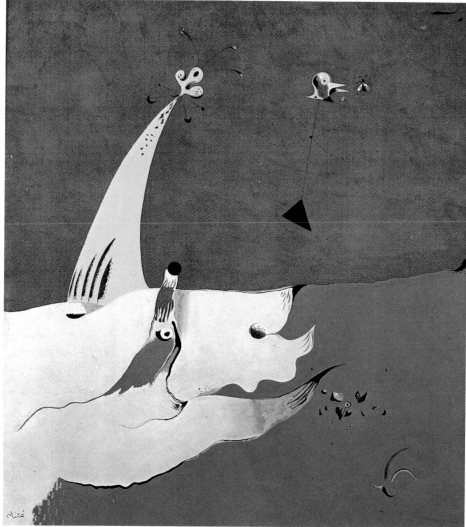

Above: Miró — *Paysage.* Miró was using abstraction, not for its own sake, as Kandinsky was, but with Surrealist wit.

The Jazz Age

known Leonidov, particularly his project for the Lenin Institute of 1927, without feeling a stirring of excitement at the thought of what might have been.

One sphere of activity where Russian artists could see immediate results was in the making of political posters. A large quantity was produced, in a wide variety of different styles. The best are extraordinarily bold in their combination of images and graphic emblems, and their influence on typography, and on graphic design in general, is felt to this day.

The Constructivists also became heavily involved with the theatre. The name of Meyerhold is the one which occurs most prominently, since it was he who was specifically entrusted, by Lunarcharsky, the Commissar for Education, with the task of 'relating the theatre to Soviet reality'. His famous 1921 production of *The Magnanimous Cuckold*, with scenery by Liubov Popova, gave Constructivism a new role in the theatre, just as its future was beginning to look doubtful elsewhere. Inevitably, however, it declined from the mid-twenties onwards, as the Soviet authorities began to harden their attitude towards the *avant-garde*, and as the *avant-garde* began to lose confidence in its own philosophies.

In the young Soviet Union, the medium of expression which was to burst into a new and astonishing flowering was cinema. Here it is Eisenstein's name which dominates the rest, and *Battleship Potemkin*, in particular, which still has some claim to be called the most famous movie ever made. Certainly many of its images have passed into the popular consciousness, and would be recognized by people who have never actually seen the film itself. But Eisenstein was surrounded by a constellation of other gifted directors, among them Vertov, Dovzhenko and Pudovkin.

The twenties in Russia also saw the start of a notable musical career, that of Dmitri Shostakovich. The period of Shostakovich's full success was yet to come, but he was offered exceptional opportunities because of the defection to the West of most of the best-known figures in Russian music, among them Stravinsky, Rachmaninov and later Glazunov. Essentially an orchestral composer (despite the very considerable achievement of his operas), Shostakovich escaped the full force of the bureaucratic pressures which gradually crippled the work of most Russian artists.

He was also fortunate, like other composers of Slav origin, in having a national and even racial tradition to draw on. Indeed, nationalism in music was almost everywhere a countervailing force to modernism, since there was implicit within it a demand that the composer should be accessible at least to his compatriots, with whom he shared, not

1925

General Events

The Fascists became the only permitted political party in Italy.
Britain returned to the gold standard.
Trotsky was dismissed from the chairmanship of the Russian Revolutionary Military Council.
Lloyd George succeeded Asquith as Liberal leader, thus officially reconciling the two halves of the Liberal Party.
Mein Kampf, Vol. I was published.
Marshal Hindenburg became President of the German Republic.
The *New Yorker* published its first issue.
The first traffic light was installed in London.
Milliken discovered cosmic rays.

The Arts

Literature
F. Scott Fitzgerald – *The Great Gatsby*
Franz Kafka – *The Trial* (published anonymously)
Theodore Dreiser – *An American Tragedy*
John Dos Passos – *Manhattan Transfer*
Anita Loos – *Gentlemen Prefer Blondes*
Aldous Huxley – *Those Barren Leaves*
Virginia Woolf – *Mrs Dalloway*
Eugenio Montale – *Cuttlefish Bones*
Gertrude Stein – *The Making of Americans*

Drama
Noel Coward – *Hay Fever*
Cocteau – *Orphée*

Music
Busoni – *Dr Faustus*
Berg – *Wozzeck*
Stravinsky – Serenade in A major (designed for recording)
Kurt Weill – Violin Concerto
Gershwin – Concerto in F
Ravel – *L'Enfant et les sortilèges*
Sibelius – *Tapiola*

Art
George Grosz – *Max Hermann-Niesse*
Klee – *Fish Magic*
Picasso – *Three Dancers*
Epstein – *Rima*
The Bauhaus re-opened at Dessau.
Exposition des Arts Décoratifs held in Paris.
The *Neue Sachlichkeit* exhibition opened at Dresden.

Architecture
Walter Gropius – The Bauhaus, Dessau

Cinema
Eisenstein – *Battleship Potemkin*
Eisenstein – *Strike*
Fred Niblo – *Ben Hur*
King Vidor – *The Big Parade*
Rupert Julian – *The Phantom of the Opera*
George Fitzmaurice – *Son of the Sheik* (with Valentino)
Chaplin – *The Gold Rush*

Right: The *Porte d'honneur* at the *Exposition des Arts Décoratifs* which gave its name to Art Deco.

Below: Picasso — *Three Dancers*. A response to Surrealism.

66

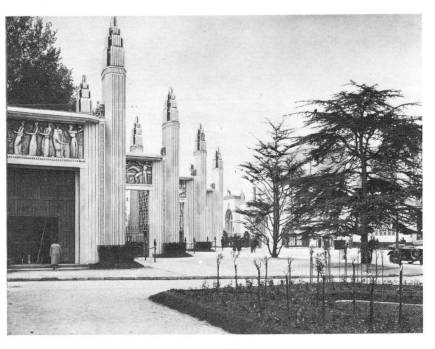

Above: Bauhaus style.
Walter Gropius's office
at Dessau.

Above: Valentino in his
most famous role as *The
Son of the Sheik.*

Left: A striking image
from one of the most
powerful of all films,
Eisenstein's *Battleship
Potemkin.*

The Jazz Age

merely common origins and language, but an inherited musical idiom. Janáček is a nationalist composer in this sense in his opera *Katya Kabanova* (1921); and so too, for that matter, is Vaughan Williams, in the *Pastoral Symphony* (1922).

Music presents several interesting comparisons between contemporary Russian culture and the situation in England. If creative life in Russia was being forced towards a new conservatism because the revolutionary authorities increasingly favoured such a course, conservatism prevailed in England through heritage and temperament.

On the eve of the First World War, *avant-garde* activity in England had made only a tentative beginning. Much of it was the work of American expatriates such as Pound and Epstein. The war administered an almost fatal check: the drawing back from experiment is even more conspicuous in London than in Paris. While the literature of the English twenties is often very different in tone from what had been written in the Edwardian period, it is not usually very different in method. For example, innovators in fictional technique, such as Ronald Firbank, were rare and marginal; and it took even Virginia Woolf a long time to create a truly innovative style. Indeed, one might claim that she did not fully achieve it until *The Waves* (1931).

Long before that Virginia Woolf had become one of the focal points of the so-called Bloomsbury Group, a loose alliance through blood relationship and friendship of artists and writers who played a leading role in England during the twenties. They included the biographer and essayist Lytton Strachey, the art critics Roger Fry and Clive Bell, and the painters Duncan Grant and Vanessa Bell (the latter was both Clive Bell's wife and Virginia Woolf's sister). The economist J.M. Keynes and the novelist E.M. Forster were also associated with the circle.

Though Bloomsbury has come to dominate accounts of the period, it did not encompass everything of cultural value happening in England at the time. Opposed to it in varying degrees were the three Sitwells, Osbert, Edith and Sacheverell, who were noisy propagandists for their own kind of *avant-garde* work, and isolated mavericks such as Wyndham Lewis and D.H. Lawrence. With poetry, for instance, Bloomsbury had few dealings, although the Woolfs did offer support to T.S. Eliot through the Hogarth Press. And though it is the Bloomsbury writers who now attract the attention of biographers, its influence was perhaps more genuinely decisive in the visual arts. Vanessa Bell and Duncan Grant were both attempting to adapt and temper the discoveries of the Fauves and the Cubists in order to make them compatible with the

1926

General Events

Eamon de Valera resigned as head of Sinn Fein in Eire; subsequently, he founded the Fianna Fail party.
Ibn Saud was proclaimed King of the Hejaz, and the name of the kingdom was changed to Saudi Arabia.
There was a miners' strike in Britain (1 May – 19 November).
There was a general strike in Britain (3 May – 12 May).
Gomes da Costa seized power in Portugal.
Germany was admitted to the League of Nations.
There was an Imperial Conference in London: Britain and the Dominions were declared autonomous communities with equal status.
Television was invented by J.L. Baird.
Rocket-powered guided missiles were first built.
Pilsudski staged a coup in Poland.

The Arts

Literature
André Gide – *Si le grain ne meurt*
Franz Kafka – *The Castle* (posthumous)
D.H. Lawrence – *The Plumed Serpent*
T.E. Lawrence – *Seven Pillars of Wisdom*
A.A. Milne – *Winnie the Pooh*
Ernest Hemingway – *The Sun Also Rises*
Ronald Firbank – *Concerning the Eccentricities of Cardinal Pirelli*
Lorca – *Romancero Gitano*

Drama
Sean O'Casey – *The Plough and the Stars*
Eugene O'Neill – *The Great God Brown*

Music
Kurt Weill – *The Protagonist*
Constant Lambert – *Romeo and Juliet*
Hindemith – *Cardillac*
Kodály – *Háry János*

Art
Epstein – *The Visitation*
Henry Moore – *Draped Reclining Figure*
Otto Dix – *The Matchseller*
George Grosz – *Pillars of Society*
Kandinsky – *Accent in Pink*
Arshile Gorky – *The Artist and His Mother* (1926 – 9)
Stanley Spencer – Murals for Burghclere Chapel (1926 – 32)

Architecture
Mies van der Rohe – Monument to Karl Liebknecht and Rosa Luxemburg, Berlin
Adolf Loos – Maison Tristan Tzara, Paris

Cinema
Fritz Lang – *Metropolis*
Jean Renoir – *Nana*
Pudovkin – *The Mother*
Albert Parker – *The Black Pirate* (with Fairbanks)
Buster Keaton and Clyde Bruckman – *The General*

Above: Max Ernst — *Edge of a Forest*. The imagery was developed by means of frottage — a rubbing taken from a found object.

Right: Georgia O'Keeffe — *Black Iris*. This painting, like Ernst's, depicts nature as mysterious.

Below: The Charleston was the new craze.

Below: Buster Keaton's *The General* made him Chaplin's nearest rival.

The Jazz Age

English approach to art. Bloomsbury art-theory and art-criticism were in any case francophile to an exaggerated extent. It was Fry and Clive Bell who did much to implant the idea that what English artists produced must always and inevitably be inferior to the products of their French counterparts.

As a result, the few first-rate artists working in England during the twenties got less support than they deserved for their efforts. The harsh personality of Wyndham Lewis, and the slowness of his working process, might in any case have seen to it that he remained under-appreciated, but there was less excuse for the failure to understand the work of Stanley Spencer and Jacob Epstein, though both, for somewhat different reasons, attracted a good deal of attention in the popular press. Spencer, despite the power, ambition and sheer ingenuity of his compositions, was dismissed as a kind of gifted primitive; while Epstein, every time he unveiled a new work, unleashed a new scandal. His work was gradually declining from the peak it had reached in the immediately pre-war period, and was showing signs of the coarseness which was to mar it as he grew older, but he was still at this period one of the most powerful and original sculptors in the world.

Towards the end of the period being reviewed here one becomes conscious of a decisive shift in the English literary climate. It is signalled by the appearance of three important first novels – Evelyn Waugh's *Decline and Fall* (1928), Graham Greene's *The Man Within* (1929), and Anthony Powell's *Afternoon Men* (1931). There was also an important book of poems: W.H. Auden's first commercially published collection, *Poems 1930*. Waugh's book, besides being the earliest, is perhaps the most thoroughly attached to its own decade, taking hints from Firbank and perhaps from Aldous Huxley, but the ruthlessness of its comedy is a herald of social change. Greene's less authoritative book is a tentative step into a new moral universe, as well as showing traces of a new kind of sensibility. Powell combines elements which appear in both Greene and Waugh. Auden's poems, as was widely recognized at the time, were a decisive break with anything that had gone before them. References to psychology, to the physical sciences and to the industrial landscape all struck a new note.

Compared to that in England, the situation in the United States seems in this period simultaneously richer and more uncertain. One factor was the voluntary expatriation, for longer or shorter periods, of many leading American writers. Yet the most prestigious of all the English-speaking exiles was, of course, not American at all. Ejected from Trieste by the war, James Joyce had settled in

General Events

Lindbergh flew solo from New York to Paris.
Mein Kampf, Volume II was published.
Sir Leonard Woolley excavated Ur.
The British Trades Union Act declared certain strikes and lock-outs illegal.
The World Economic Conference took place at Geneva.
The Chinese Nationalist Government was established at Hankow.
Britain, the United States and Japan conferred in Washington on naval disarmament, but failed to reach agreement.
Chiang-kai-shek broke with the Communists, and overthrew the Hankow government.
Italy and Hungary signed a treaty of friendship.
There was a general strike in Vienna (15 – 18 July).
Sacco and Vanzetti were executed.
Trotsky was expelled from the Communist Party as a deviationist.

The Arts

Literature
Hemingway – *Men without Women*
Bertolt Brecht – *Hauspostille*
Virginia Woolf – *To the Lighthouse*
Henry Williamson – *Tarka the Otter*
Elizabeth Bowen – *The Hotel*
Sinclair Lewis – *Elmer Gantry*
Willa Cather – *Death Comes for the Archbishop*
Hermann Hesse – *Steppenwolf*

Music
Křenek – *Jonny Spielt Auf*
George Antheil – *Ballet Mécanique*
Shostakovich – Symphony No 2
Stravinsky – *Oedipus Rex*
Ravel – Violin sonata
Weill – *Kleine Mahagonny* (with Brecht)

Art
Stuart Davis – *Egg-Beater No 2*
Max Ernst – *The Great Forest*
Lyonel Feininger – *The Steamship Odin II*
Oskar Kokoschka – *Mont Blanc near Chamonix*

Architecture
Le Corbusier – Les Terrasses, Garches
Mies van der Rohe – Flats, Weissenhof Estate, Stuttgart
Buckminster Fuller – Dymaxion House (model)
Alvar Aalto – Municipal Library, Viipuri (1927 – 35)
Le Corbusier – Villa Savoye, Poissy (1927 – 31)
Erich Mendelsohn – Schocken Store, Stuttgart

Cinema
Al Jolson in *The Jazz Singer* (the first full-length talking film)
Abel Gance – *Napoléon*
Cecil B. de Mille – *King of Kings*
The Academy Awards were instituted.

Right: The beginnings of an entirely new China. Mao-tse-tung, having led the abortive Autumn Harvest uprising, fled to the hills and there began to build the Red Army.

Right: Charles Demuth — *My Egypt*. Industrial themes continued to fascinate American artists.

Left: Napoleon escapes from Elba — an image from Abel Gance's film, *Napoléon.*

Right: Brilliant propaganda for the Modern Movement in architecture — Mendelsohn's façade for the Schocken Store, Stuttgart.

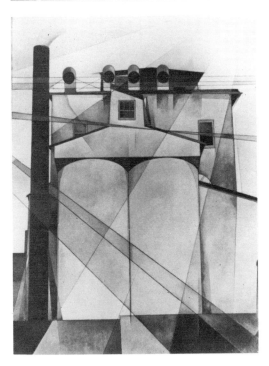

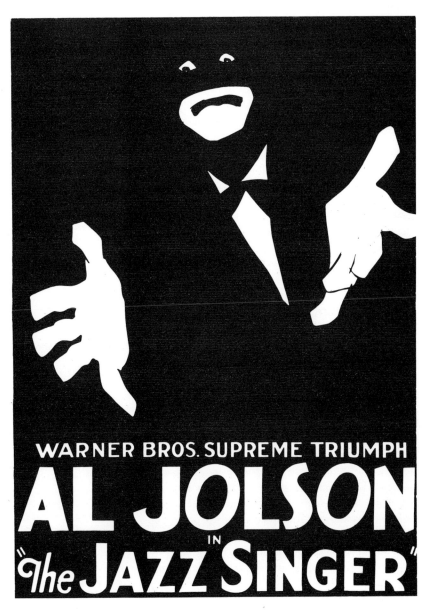

WARNER BROS. SUPREME TRIUMPH
AL JOLSON
IN
"*The* JAZZ SINGER"

Above: The coming of the talkies — a poster for *The Jazz Singer.* The effect in Hollywood was stunning; all the studios rushed to use the new technique.

The Jazz Age

Zurich, and his long awaited *Ulysses*, after abortive serial publication in America, was finally published in Paris in 1922 in a complete and unexpurgated edition. But Joyce might now be counted as a kind of honorary American, thanks to the generous American patronage which had sustained him through the long years needed for the composition of his masterpiece. The impact of *Ulysses* is still problematical. It can be seen both as a new beginning and as a magnificent dead end; but so far as one can judge, its consequences have been greater in America than they have been in England.

A more central figure, both geographically and in terms of the influence she exerted, was Gertrude Stein, long an *habituée* of the Paris *avant-garde*, whose most ambitious work, *The Making of Americans*, written in 1906–8, was published in 1925.

Though he was later to deny the fact, Stein's experiments with simple, repetitive phrasing seem to have had an effect on the young Ernest Hemingway, whose formative period in Paris, in the years 1921–6, was later to be evoked, with affection and malice, in his posthumously published autobiographical fragment *A Moveable Feast* (1964). Hemingway became the leading spokesman for the 'lost generation', those who had been damaged physically and psychologically by the war. His subject-matter often contradicts the sophisticated milieu in which the early novels and stories were conceived, since Hemingway makes a speciality of dealing with primitives – frontiersmen, sportsmen and professional athletes.

Other American writers did not have to displace themselves so completely in order to deal with the various problems of being American. William Faulkner spent a brief period in Paris in 1925, and returned home to publish *Soldiers' Pay* (1926), but did not find his true vein until 1929, with the publication of *Sartoris*, the first volume in his huge Yoknapatawpha saga. He became the outstanding chronicler of the splendours and miseries of his own southern states. Scott Fitzgerald, Hemingway's friend and rival, summed up a certain aspect of the American twenties once and for all in *The Great Gatsby* (1925), a novel set among the new and old rich of the eastern seaboard. Dreiser, Upton Sinclair and John Dos Passos attempted a realistic portrayal of contemporary American society, and with their work the ambitious documentary novel seemed to take up residence once and for all in the United States.

American poetry began to give evidence that Pound and Eliot were symptoms of a true resurgence. Wallace Stevens's first book *Harmonium* (1923) was one of the most important

1928

General Events

The voting-age for women in Britain was reduced from 30 to 21.
The Russian government announced the first Five Year Plan.
Alexander Fleming discovered penicillin.
Chiang-kai-shek became President of China; the Chinese Red Army was founded in Hunan province.
The Brazilian economy collapsed owing to over-production of coffee.
Trotsky was deported to Central Asia.
Land was collectivized in Russia (progressively until 1931).
The Kellogg-Briand pact, outlawing war and providing for the peaceful settlement of disputes, was signed in Paris.
The Union of the Left won the French elections.
Mussolini disfranchised two-thirds of the Italian electorate.

The Arts

Literature
Aldous Huxley – *Point Counter Point*
D.H. Lawrence – *Lady Chatterley's Lover*
Radclyffe Hall – *The Well of Loneliness*
André Breton – *Nadja*
W.B. Yeats – *The Tower*
Evelyn Waugh – *Decline and Fall*
Wyndham Lewis – *The Childermass*

Drama
Eugene O'Neill – *Strange Interlude*

Music
Brecht/Weill – *The Threepenny Opera*
Schoenberg – Variations for Orchestra, Op. 31 (1927–8)
Webern – Symphony, Op. 21
Gershwin – *An American in Paris*
Ravel – *Boléro*

Art
Matisse – *Seated Odalisque*
Braque – *Still Life: The Table*
Georgia O'Keeffe – *Nightmare*

Architecture
Aalto – Building for the newspaper Turun Sanomat, Turku (1928–29)

Cinema
Walt Disney – *Plane Crazy* (the first Mickey Mouse cartoon)
Eisenstein – *October*
Carl Dreyer – *The Passion of Joan of Arc*
Erich von Stroheim – *Queen Kelly*
René Clair – *An Italian Straw Hat*
G.W. Pabst – *Pandora's Box* (with Louise Brooks)
Pudovkin – *Storm over Asia*
Buñuel and Dali – *Un Chien Andalou*

Above: Soutine — *Choirboy*. There were still many successful artists who worked independently of any movement. Soutine's work often fitted no established pattern.

Right: John Sloan's *Sixth Avenue Elevated at Third Street* — the essence of New York.

Below: Buñuel's Surrealist beginnings — *Un Chien Andalou*. The sequence of the razor blade slitting the eyeball is justly famous.

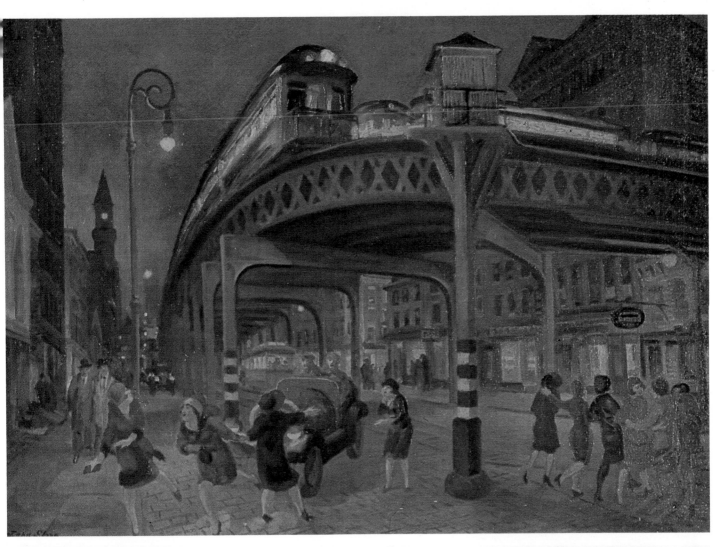

Above: The early Garbo — a face to launch a thousand newspaper columns.

The Jazz Age

1929

collections of verse published in any language during the twenties; and there was fine poetry from e.e. cummings, William Carlos Williams, Marianne Moore and others. At the beginning of the new decade Hart Crane's *The Bridge* (1930) appeared – for all its many flaws one of the major masterpieces of twentieth-century poetry in English.

American art was not as yet making as much progress as American literature. The idea of modernism was increasingly accepted, and typical works began to find their way into museums as well as into private collections. But these were generally the work of foreign artists. American painters and sculptors inevitably found themselves regarded as second best, and many had to struggle hard to escape from their own subservience to imported ideas. There was a drawing back from extremes, and particularly from abstraction. The most interesting new development was the work of the Precisionists who, though influenced by Cubism, nevertheless made a programmatic return to American scenes and sources, accepting the banality of American urban and industrial landscape and transforming it by intensity of vision.

The form of musical expression which most Europeans came to think of as quintessentially American during this period was jazz. Jazz was Negro music. It had its origins in New Orleans, in the red-light district of Storyville, and many elements went into its creation: African rhythms, French and Spanish songs, plantation worksongs, spirituals and military music. It was a means of rejoicing, but also the protest of an oppressed race.

New Orleans jazz was formulated during the first decade of the century. By 1911 it was being heard throughout America, when Joe 'King' Oliver made a long tour with what was called the Original Creole Orchestra. It reached Europe after the First World War, and at the same time it moved out of New Orleans and established itself in Chicago, as part of the Negro migration northward. Here, in keeping with its new environment, it acquired a harder-driving, more urban character. At the same time it became more varied rhythmically, and instrumental and vocal solos acquired an increased importance and improvisatory freedom. The middle and late twenties were the era of instrumentalists such as 'Bix' Biederbecke and Louis Armstrong, of Jelly Roll Morton and of the great blues singer Bessie Smith, whose tragic story (she died in 1937 when, following a car accident, she was refused admission to a white hospital) later came to sum up the humiliations and triumphs of her race.

In the white world, jazz made itself felt in two ways – by its impact on popular entertainment, and through its status as a cult.

General Events

A royal dictatorship was established in Yugoslavia.
Trotsky was banished from Russia.
Germany accepted the Kellogg-Briand Pact.
In Britain, the Labour Party won the General Election;
 Ramsay MacDonald became Prime Minister.
Kodak developed 16 mm colour film.
The airship *Graf Zeppelin* flew round the world.
Hoover was inaugurated President of the United
 States.
The Lateran Treaty regulated relations between the
 Italian government and the Papacy. Vatican City
 became an independent state.
Turkey adopted women's suffrage.
The iron lung was invented.
The 'Black Friday' Wall Street crash took place (24
 October), initiating a world economic crisis.

The Arts

Literature
Robert Graves – *Goodbye to All That*
Graham Greene – *The Man Within*
Ernest Hemingway – *A Farewell to Arms*
Ivy Compton Burnett – *Brothers and Sisters*
J.B. Priestley – *The Good Companions*
Erich Maria Remarque – *All Quiet on the Western
 Front*
Jean Cocteau – *Les Enfants Terribles*
Virginia Woolf – *A Room of One's Own*
William Faulkner – *Sartoris*

Drama
Claudel – *Le Soulier de Satin*
Mayakovsky – *The Bed Bug*

Music
William Walton – Viola Concerto
Lambert – *Rio Grande*
Hindemith – *Lehrstück* (text by Brecht)
Stravinsky – *Capriccio*

Art
Mondrian – *Composition with Yellow and Blue*
Picasso – *Woman in an Armchair*
Epstein – sculptures of Night and Day on the London
 Transport building
Diego Rivera – Murals at the Cortez Palace,
 Cuernavaca, Mexico

Architecture
Mies van der Rohe – German Pavilion, Barcelona
 Exhibition

Cinema
Hitchcock – *Blackmail*
Lubitsch – *The Love Parade*
King Vidor – *Hallelujah* (the first feature film with an
 all-black cast)
John Grierson – *Drifters*

Above: Disney's Mickey Mouse was an international success — a scene from an early *Silly Symphony*.

Right: A fresh start in English sculpture — Barbara Hepworth's *Figure of a Woman* (1929–30).

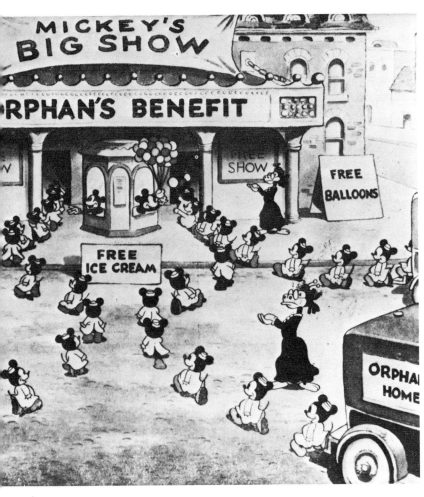

Below: A statement of ideals which were soon to be defeated — the German Pavilion designed by Mies van der Rohe for the International Exhibition in Barcelona.

Below: W.H. Auden at twenty-two. He was just becoming known as a poet. Photograph by Beaton.

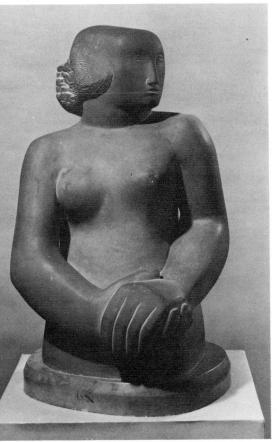

Below: Headlines proclaiming the Wall Street crash.

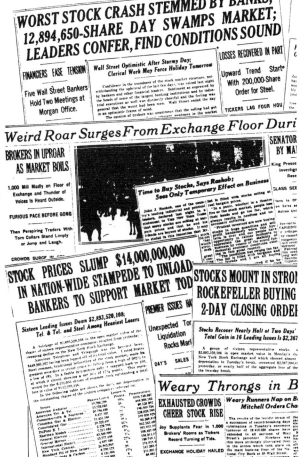

The Jazz Age

Its most profound impact was on American show music. The twenties were the first great epoch of the American musical, and produced a galaxy of talented composers and lyricists, of whom George Gershwin was perhaps the most important. Gershwin's shows of the middle twenties – *Lady Be Good* (1924), *Tip Toes* (1925), *Funny Face* (1927) – each contain at least one song which has become a popular classic. But Gershwin went further still towards jazz with his *Rhapsody in Blue*, first presented at New York Town Hall on 12 February 1924. The soloist was the jazz-musician Paul Whiteman, and the piece was a resounding success not only in America but throughout Europe. It was followed, the next year, by Gershwin's *Concerto in F*, which uses the same idiom.

Gershwin's attempts to reconcile jazz and classical technique had already been anticipated by leading European composers – by Stravinsky in *Ragtime for Eleven Instruments* (1918) and *Piano-Rag Music* (1919), and by Darius Milhaud in *La Création du Monde* (1923), produced as a ballet by the Swedish choreographer Jean Bourlin, with scenery by Léger. Gershwin knew these works, and they influenced him. The important thing, however, was that he came from the other side of the fence. It was not merely that he was an American, but that he had served his apprenticeship in the world of popular music.

The American film industry, with ever-increasing output, now provided heroes and heroines for the whole world. The most spectacular of these, but one of the least durable, was the great romantic star Rudolph Valentino, whose premature death at the height of his fame plunged millions into mourning. Chaplin's vast popularity as a comedian continued, and he was joined by another great comic, Buster Keaton. There was an immensely significant technical development with the arrival of the talking pictures in 1927 – the pioneer talkie was Al Jolson's *The Jazz Singer*. Many careers were ruined by the new invention, while others survived triumphantly. Garbo's distinctive accent, for example, made her more fascinating than ever. Disney came up with a purely artificial star, a thing of celluloid only – Mickey Mouse. As a new attraction, the innocent animated cartoon found a rival in something more sinister, the gangster picture. In 1930, *Little Caesar*, with Edward G. Robinson, even turned the gangster into a kind of hero. The depression, instead of ruining the movie-makers, made their fortunes more secure than ever. People went to the pictures in order to escape the miseries they suffered outside.

The nations whose artistic activities in this period have so far been mentioned are those which in one sense or another can lay claim to a certain

1930

General Events

A naval treaty was signed in London between Britain, France, Italy, Japan and the United States.
The planet Pluto was discovered.
Amy Johnson flew solo from Britain to Australia.
The British airship R 101 crashed.
Gandhi opened a civil disobedience campaign.
Perspex was invented.
Ras Tafari became the Emperor Haile Selassie of Abyssinia.
The Nazis won 107 seats in the *Reichstag.*
Uruguay won the final of the first World Cup in football (soccer).
The last Allied troops left the Saar.

The Arts

Literature
Hart Crane – *The Bridge*
Edith Sitwell – *Collected Poems*
T.S. Eliot – *Ash Wednesday*
W.H. Auden – *Poems 1930*
Robert Frost – *Collected Poems*
Evelyn Waugh – *Vile Bodies*
John Dos Passos – *The 42nd Parallel*
Somerset Maugham – *Cakes and Ale*
Dashiell Hammett – *The Maltese Falcon*
Wyndham Lewis – *The Apes of God*

Drama
Noel Coward – *Private Lives*
Shaw – *The Apple Cart*
Mayakovsky – *The Bathhouse*

Music
Stravinsky – *Symphony of Psalms*
Janáček – *From the House of the Dead*
Weill – *Der Jasager*
Shostakovich – *The Nose*
Weill/Brecht – *Aufstieg und Fall der Stadt Mahagonny*
Eisler/Brecht – *Die Massnahme*
Schoenberg – *Accompaniment to a Film Scene*

Art
Hopper – *Early Sunday Morning*
Thomas Hart Benton – *City Scenes*
Grant Wood – *American Gothic*
Max Beckmann – *Self-portrait with Saxophone*

Architecture
Shreve, Lamb and Harmon – Empire State Building, New York
Hans Scharoun – Siemensstadt housing estate, Berlin
Mies van der Rohe – Tugendhat House, Brno
Pier Luigi Nervi – Communal Stadium, Florence (1930 – 2)

Cinema
Josef von Sternberg – *The Blue Angel* (with Dietrich)
René Clair – *Sous les Toits de Paris*
Hitchcock – *Murder*
Howard Hughes – *Hell's Angels* (with Jean Harlow)
Mervyn Le Roy – *Little Caesar* (with Edward G. Robinson)

Below: The effects of the slump — the unemployed in New York. But not everyone found motoring an impossible luxury during the slump — (bottom) a 1930 Austin 7.

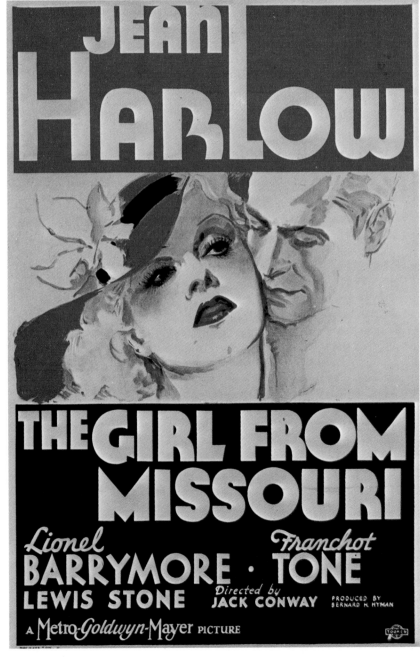

Right: The movies offered the consolation of dreams — Jean Harlow was the new screen goddess.

The Jazz Age

centrality. It remains to complete this account of the jazz age by adding a few notes on countries which for one reason or another remained on the margin.

The most important of these is Italy, where Mussolini's seizure of power brought with it a slackening of the artistic pulse. Fascism did not suppress *avant-garde* art; neither did it support it. Official patronage became a question of personal influence within the regime; and the regime itself, insofar as it had an artistic policy at all, indulged in daydreams of Roman grandeur. This in turn affected chiefly architecture. The great Fascist building projects belong to the thirties, and will be mentioned in their proper place, but the Foro d'Italia in Rome, so typical of Fascist taste, had already been begun by 1927 (it was not to be completed until long after Mussolini had fallen). In certain circumstances, great originality remained possible. Pier Luigi Nervi's stadium in Florence, with its brilliantly daring use of reinforced concrete, was begun in 1930.

Painting settled into a kind of quietism, typified at its best by the still lifes of Morandi; and literature, too, turned inward upon itself. What is perhaps the most distinguished book of Italian verse published this century, Eugenio Montale's *Ossi di Seppia* (*Cuttlefish Bones*), appeared in 1925, not long after the Fascist takeover.

In Spain there were signs of the brilliant renaissance of Spanish poetry which was to be cut short in Europe by the Civil War, but which was to migrate to Latin America and create a new literature there. Federico García Lorca, one of the war's victims, brought out *Romancero Gitano* in 1926.

In Finland, the young Alvar Aalto was starting work on his first significant buildings, proving that the new style of modern architecture could be at once more flexible and more human than it seemed in the hands of his French and German colleagues.

In Mexico, in 1929, Diego Rivera, once an associate of the French Cubists in Paris, painted some of his earliest and best murals in the gallery of the sixteenth-century Cortez Palace at Cuernavaca, proving that what was recognizably modern art could still, in certain circumstances, retain the popular touch. The Mexican experiment, which began with Rivera's return to Mexico in 1921 and his first mural commission in 1922, was later to have significance for the development of art in the United States in the thirties and forties.

Rivera's art has another kind of significance: it raises the question of how modern art, having already borrowed so lavishly from exotic cultures of all kinds, was eventually to reconcile itself with them. It is a question which is still unsettled today.

1931

General Events

Laval became Prime Minister of France.
Oswald Mosley broke with the British Labour Party and founded the New Party.
Russia and Turkey signed an agreement on naval relations in the Black Sea.
Britain abandoned the gold standard, followed later in the year by Japan.
There was a revolution in Spain. King Alfonso XIII was deposed.
I.C.I. produced petrol from coal.
After the British general election Ramsay MacDonald formed a National Government.
There was a British naval mutiny at Invergordon due to pay cuts.
Japan invaded Manchuria.

The Arts

Literature
Pearl Buck – *The Good Earth*
Antoine de Saint-Éxupery – *Vol de Nuit*
Faulkner – *Sanctuary*
Virginia Woolf – *The Waves*
Edmund Wilson – *Axel's Castle*
Anthony Powell – *Afternoon Men*

Drama
O'Neill – *Mourning Becomes Electra*
Brecht – *Mann ist Mann*
Zuckmayer – *The Captain from Koepenick*

Music
William Walton – *Belshazzar's Feast*
Ravel – Piano Concerto for the left hand
Hans Pfitzner – *The Heart*
Stravinsky – Violin Concerto
Shostakovich – Symphony No. 3
Malipiero – *The Triumph of Love*

Art
Ben Shahn – *The Passion of Sacco and Vanzetti* (1931–2)
Charles Sheeler – *Classic Landscape (River Rouge Plant)*
Salvador Dali – *Persistence of Memory*
Epstein – *Genesis*

Architecture
Le Corbusier – Hôtel Suisse, Cité Universitaire, Paris (1931–2)
André Lurçat – School, Villejuif (1931–3)
Rockefeller Center, New York (1931–47)

Cinema
Chaplin – *City Lights*
René Clair – *Le Million*
Lamprecht – *Emil and the Detectives*
Pabst – *The Threepenny Opera*
René Clair – *A Nous la Liberté*
James Whale – *Frankenstein* (with Boris Karloff)
Carl Dreyer – *Vampyr*
Fritz Lang – *M.* (with Peter Lorre)
Disney – *Flowers and Trees* (his first colour film)

Above: This poster for the Calais-Dover Channel ferry emphasizes the glamour of travel in the thirties.

Below: Hollywood glamour photographer George Hurrell portrayed Joan Crawford as the classic hardened goddess, cynical and world-weary.

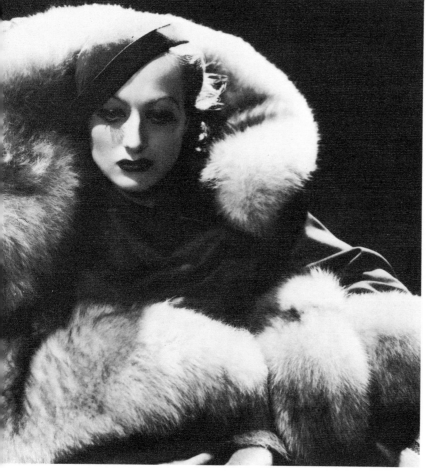

Left: 'Unbelievable! This creature steals the limelight from all the V.I.P.s!' Mickey Mouse triumphantly made his way into *Simplicissimus* through the work of Karl Arnold.

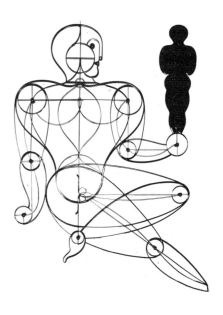

Above: The Weimar Republic was creative to the end. This wire sculpture is by Oskar Schlemmer.

Below: Heartfield's savage attacks on the Nazis (Goering is shown as a tiger in this classic photomontage) could not stop their rise to power.

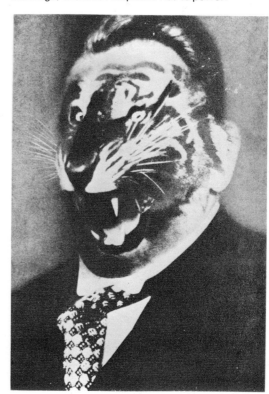

79

Salvador Dali's *Autumn Cannibalism* (1936) shows
Surrealist painting in the 'veristic' phase typical of the
thirties. The images are dreamlike, but are painted
with the meticulous realism of nineteenth-century
Salon art. The painting reflects Dali's reaction to the
outbreak of the Spanish Civil War: the first outbreak
of open hostilities between the ideological forces at
work in the thirties.

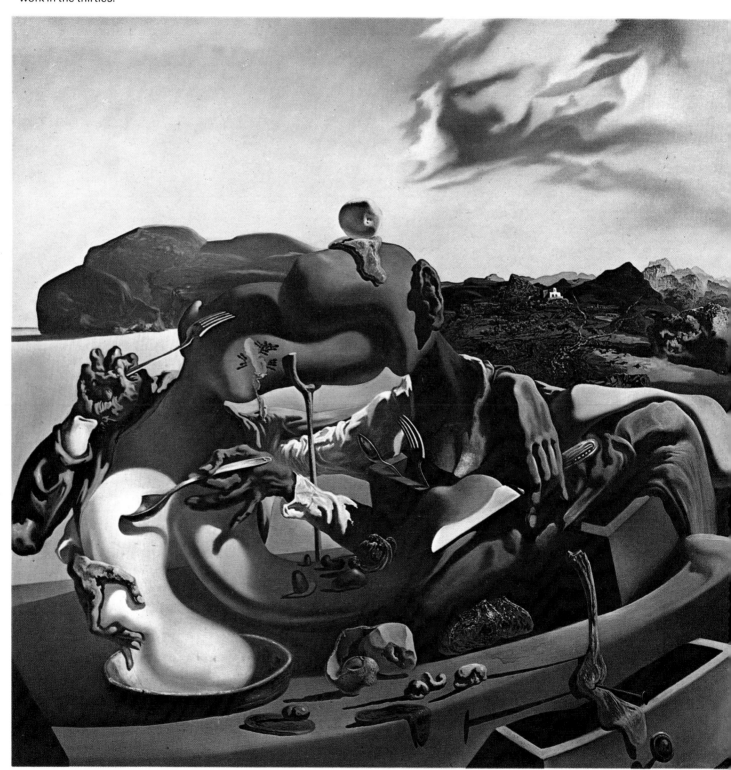

Ideologies in Conflict

1932 – 1938

The period 1932 to 1938 was a time of ideologies in conflict, a conflict set against a background of economic recession and actual or impending war. Hitler took power in Germany; Stalin tightened his grip in Russia; Mussolini gave rein to his expansionist ambitions in Abyssinia; civil war in Spain provided both the Germans and the Italians with a testing ground for new weapons and new ways of using them.

There was continuing conflict in China, where Chiang-kai-shek, leader of the Kuomintang, or Nationalist Party, was opposed by the communists under Mao-tse-tung, and was compelled at the same time to deal with Japanese aggression. He was finally forced to declare war on Japan in 1936. Most of China's principal cities fell to the invader, and the Kuomintang government had eventually to move its capital to remote Chungking. Meanwhile relations between the United States and Japan, now rivals in the Pacific, became increasingly strained, with a dangerous flare-up when the American gunboat *Panay* was sunk by Japanese planes in Chinese waters.

Political events acted more directly on the arts than ever before, but the reactions among the arts were not always entirely logical. In England, for example, almost the entire intelligentsia became obsessed by the struggle in Spain. Some, such as the poets Auden and Spender, visited the zone of conflict in order to report on what was happening there; others, among them George Orwell, fought in the ranks of the International Brigade, which attracted recruits not only from all classes in Britain (from Welsh miners to Cambridge intellectuals), but from all over Europe and from the United States as well. Very few writers and thinkers – the South African poet Roy Campbell was a conspicuous exception – sympathized with the cause of General Franco. In the circumstances it was perhaps natural that the more-than-occasional misdeeds of the left in Spain should be tacitly ignored.

More extraordinary was a resolute refusal on the part of the majority of left-wing intellectuals to see anything wrong in what was happening in Russia. The veteran British socialists, Sidney and Beatrice Webb, visited the Soviet Union in 1933, and published their book of impressions, *Soviet Communism*, in 1935. The verdict they gave was almost wholly favourable to Stalin's government, despite famine, forced collectivization, and the fact that the first Moscow show trials had been triggered off by the assassination of Serge Kirov in 1934.

In fact, the idealization of Russia, regardless of the facts, was inspired by a corresponding hatred of fascism. Intellectuals on both sides of the Atlantic shut their eyes to communist sins because communism seemed to them the only effective opponent of the right-wing dictatorships. One could forgive any communist simply because he was heroic and took risks. It was the English poet C. Day Lewis who penned the notorious couplet:

> Why do we all,
> Seeing a Red, feel small?

Political activity often tended to displace creative work. In America, the veteran painter Stuart Davis, Executive Secretary of the Artists' Congress, an association of painters, designers and photographers formed to combat fascism, complained that the 'prevalence of meetings, petitions, picket-lines and arrests' left him little time in the studio.

The blindness of the left with respect to what was going on in Russia was matched by that of the great majority – politicians and ordinary newspaper readers alike – about the true intentions of Hitler and the Nazis in Germany. It was not merely that Hitler's insatiably expansionist ambitions were

Ideologies in Conflict

1932

glossed over by statesmen who hoped to contain him through traditional diplomatic means (this attitude lay at the roots of the Franco-British policy of appeasement and led to the Munich agreement of 1938), but that the hideous facts about the concentration camps and the persecution of the Jews, though available to many, remained unpublicized. Those who did try to bring the effects of the Nazi terror to the attention of a wide public were mostly communists, and this devalued their efforts in the eyes of those who belonged to different political persuasions.

As the most public of the arts, architecture was the one perhaps most directly affected by the new political climate. One thing which was to have far-ranging effects was the dissolution of the Bauhaus. Most of the prominent architects associated with it were forced to emigrate, and this in the long run meant a widespread dissemination of Bauhaus principles, ultimately leading to the creation of a true International Modernism in architecture.

Yet one must be careful, when discussing the effects of the new political climate, not to fall into the trap of saying that architecture divided along strictly political lines. The characteristic architectural style of all the dictatorships, whether fascist or communist, was a stripped-down classicism, often monotonous in effect and usually grandiose in scale. It appears – differently accented – in Italy, in Germany and in Russia. The Italian version, in any case closely related to native traditions in building, was perhaps the most free and successful, and it has recently begun to be realized that the Italian fascist period was by no means completely barren architecturally. There is something to be said for the new towns, such as Sabaudia, on the outskirts of Rome, and something, too, for the new University City of Rome. Pier Luigi Nervi, an architect-engineer of genius, was given the opportunity to continue his experiments with reinforced concrete in utilitarian structures such as the aeroplane hangar he built at Orvieto. In Germany, where Hitler was passionately interested in architecture, grandiose structures were erected in Nuremberg to the designs of Albert Speer and others were planned for Berlin. The most successful buildings created by the new regime were, however, the Olympic Stadium and other structures connected with the Olympic Games of 1936.

Russian classicism was the most traditional of all, and also the fussiest. Buildings often took on strange disguises. A cinema would be dressed up as a country mansion of the 1820s. The strangest results of Stalin's retrograde architectural policy were probably the extravagant stations provided for the new Moscow underground, built between 1934

General Events

The Manchoukuo Republic was proclaimed in Manchuria.
The Disarmament Conference opened at Geneva.
The Indian Congress was declared illegal, and Gandhi was arrested.
The second Five Year Plan began in the U.S.S.R.
Vitamin D was discovered.
The British Union of Fascists was formed by Sir Oswald Mosley.
Von Papen became German Chancellor.
There were hunger marches by the British unemployed.
Karl Jaspers published *Philosophie*.
President Paul Doumer of France was murdered by a Russian emigré.
Karl Barth published *Christian Dogmatics*.
Lindbergh's infant son was kidnapped.
Roosevelt won the U.S. presidential election.
Karl Jansky pioneered radio-astronomy.
Hindenburg defeated Hitler in the German presidential election.

The Arts

Literature
Ernest Hemingway – *Death in the Afternoon*
Aldous Huxley – *Brave New World*
Boris Pasternak – *Second Birth* (poems)
W.H. Auden – *The Orators*
Céline – *Voyage au Bout de la Nuit*
Erskine Caldwell – *Tobacco Road*
Damon Runyon – *Guys and Dolls*
Evelyn Waugh – *Black Mischief*

Drama
J.B. Priestley – *Dangerous Corner*
Bertolt Brecht – *The Mother*

Music
Benjamin Britten – *A Boy was Born*
Stravinsky – *Duo Concertante*
Schoenberg finished the first two acts of *Moses and Aaron*.

Art
Grant Wood – *Daughters of the Revolution*
Léger – *Balancing Act*
Giacometti – *Woman with Her Throat Cut*
Dali – *The Birth of Liquid Desires*

Architecture
Meyer and Hand – Broadcasting House, London

Cinema
Renoir – *Boudu sauvé des eaux*
Tod Browning – *Freaks*
Cocteau – *Le Sang d'un poète*
Julien Duvivier – *Poil de Carotte*
Josef von Sternberg – *Shanghai Express*

Right: A music room with fabrics and carpet designs by Bloomsbury artists Duncan Grant and Vanessa Bell at London dealers Alex, Reid & Lefevre.

Right: The Depression made visible, in Washington D.C.

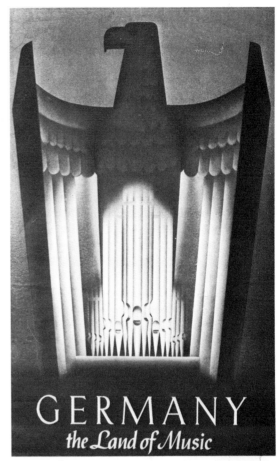

Left: Edward Burra's *John Deth* adapts Surrealism to English taste.

Below: Heinemann's poster shows the Nazi style before the Nazis were fully in power.

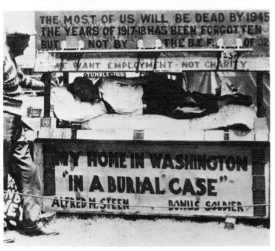

Above: Karl Arnold, of the satirical magazine *Simplicissimus*, equated Hitler and Frederick the Great. The title is '*Hail Prussia!*'

Right: The Marx Brothers generated their own brand of Surrealism in *Horse Feathers*.

Ideologies in Conflict

and 1938. Each of these was in a different style, but each strove to give an impression of pre-revolutionary splendour. The thinking behind these buildings was in its own way quite logical – the Russian idea of luxury had been formed by what the Tsars had built from the eighteenth century onwards. To create buildings for democratic use in the styles the Tsars themselves had favoured was an effective way of symbolizing the triumph of the mass. Here and there, however, a building was put up which contained some elements of the now discredited Futurist aesthetic. A case in point was the office-block designed by N. Golossov for the newspaper, *Pravda*.

A kind of classicism was also favoured for official building in countries which were not subjected to dictatorial regimes. The structures associated with the Paris Exhibition of 1937, among them the Palais de Chaillot, are not so far in style from some of those created at the same period by Mussolini's architects.

Official interiors, following a tendency which had already established itself in the late twenties, were often carried out in a sumptuous but increasingly heavy version of Art Deco. The best surviving examples are those in Rockefeller Center, New York, closely rivalled by those in the Palacio de Bellas Artes in Mexico City – the latter have some especially curious 'Aztec' details. There were other, even grander ones in the French liner *Normandie*, fitted out in 1935. The designers of the ship made use of all the leading French craftsmen of the time. A more popular version of Deco was standard for the great cinemas of the period, where luxury was deliberately democratized, just as it was on the Moscow underground.

Modernist thinking in architecture was not completely suppressed. The thirties, for example, were the years when a number of extremely advanced buildings were put up in England. Some were the work of German refugees, who often, for legal reasons, worked in partnership with Englishmen. Others were the work of English architects such as Amyas Connell, Colin Lucas and Maxwell Fry.

In America, Frank Lloyd Wright reasserted his leadership. This was the period of some of his most stunningly imaginative buildings, among them what most people would think of as the definitive Wright house – the Edgar J. Kaufman house at Bear Run, Pennsylvania, cantilevered so as to project over a natural waterfall.

If architecture often spoke naturally with a public voice, poetry had to seek for one. The search was conducted with particular assiduity in England, where a group of poets led by W.H. Auden aimed to make verse accessible again, after the esoteric

1933

General Events

Hitler became German Chancellor.
The *Reichstag* was burned.
The persecution of the German Jews began.
German parties other than the Nazis were forbidden.
Roosevelt began the New Deal.
The *Falange Española* (Spanish Fascist party) was founded.
Dollfuss suspended parliamentary government in Austria.
Japan left the League of Nations.
A.N. Whitehead published *Adventures of Ideas*.
There was a bank crisis in the United States.
Polythene was discovered.
Prohibition was repealed in America.
The Japanese occupied China north of the Great Wall.
Anderson and Millikan discovered positive electrons.

The Arts

Literature
Malraux – *La Condition Humaine*
Orwell – *Down and Out in Paris and London*
Gertrude Stein – *The Autobiography of Alice B. Toklas*
Pablo Neruda – *Residencia en la Tierra*
Nathanael West – *Miss Lonelyhearts*
Thomas Mann – *Joseph and his Brethren* (1933–43)

Drama
Eugene O'Neill – *Ah, Wilderness*
Elmer Rice – *We, the People*
Lorca – *Blood Wedding*
Sean O'Casey – *Within the Gates*

Music
Strauss – *Arabella*
Roy Harris – First Symphony
Aaron Copland – *The Short Symphony*

Art
Matisse – *La Danse*
Giacometti – *The Palace at 4 a.m.*
Dali – *Gala et l'Angélus de Millet*

Architecture
Aalto – Viipuri City Library (1933–35)
University City, Rome (1933–35)

Cinema
Leo McCarey – *Duck Soup* (with the Marx Brothers)
Korda – *The Private Life of Henry VIII*
Reuben Mamoulian – *Queen Christina* (with Greta Garbo)
Jean Vigo – *Zéro de Conduite*
Cooper and Shoedsak – *King Kong*

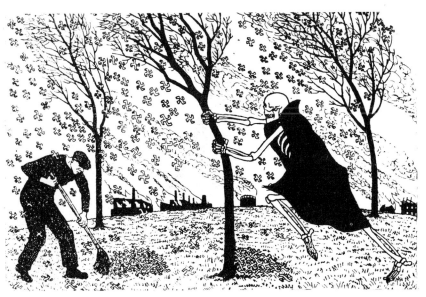

Below: The Rockefeller Center, New York — Art Deco architecture, with murals by Diego Rivera. The enormous complex was not complete until 1947.

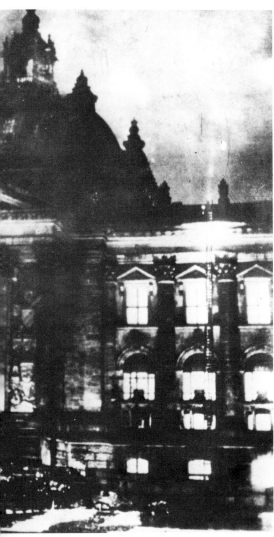

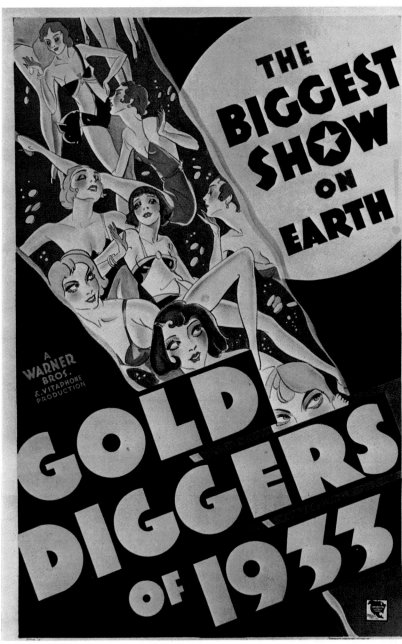

Above: The Reichstag Fire on 27 February was a symbol of doomed democracy and played an important part in the Nazi takeover in Germany.

Right: *Gold Diggers of 1933* — a poster that conveys the euphoric quality of the best thirties entertainment.

Ideologies in Conflict

1934

experiments of the first phase of modernism. It is Auden himself who now seems to give utterance to the ideas, feelings and even follies of the period in a way that no-one else could. Many of the lines and phrases he coined then are in the process of becoming part of the language, even though the poet himself later repudiated them. The mixture of elements and influences in his work has also come to seem especially characteristic of the time. One finds there Brecht and Freud, Surrealism and communism, geology and Anglo-Saxon studies.

In general, however, it was perhaps a better time for fiction than it was for poetry. Amidst such a wealth of talent certain authors are outstanding, not so much because they are better than the rest, but because they seem to catch the tone of the time. Though André Malraux's reputation as a novelist has somewhat sunk, *La Condition Humaine* still seems, for all its flaws, to be the epic novel which best sums up the political preoccupations of the thirties. In the English language, the outstanding fiction is the work of Hemingway, who catches the stoicism of a troubled epoch with his clipped style. The early novels of Graham Greene, and the crime novels of Dashiell Hammett, are also outstanding, mainly for the way in which they take an existing popular genre, revivify it, and give it a resonance which it did not previously possess. *Brighton Rock*, the finest of Greene's early novels, is particularly significant because Greene's Catholicism leads him towards the idea of absolute evil as well as that of absolute good, and in a sense its moral intransigence is a precise counterpart to what in Hemingway can sometimes seem like nihilism. Evelyn Waugh, another Catholic, takes a somewhat different line. As Anthony Burgess perceptively remarks in *The Novel Now*, Waugh 'is recording an age so lacking in roots or ethical convictions that enormities like even cannibalism (in *Black Mischief*) can find no category of judgement, hence no condemnation.'

Jean-Paul Sartre, in his first novel, *La Nausée*, gives the moral screw a different twist. The hero, Roquentin, discovers existence through his disgust at the moral squalor which surrounds him. In fact, nearly all the significant novels of the thirties make the writer into a moralist in an immoral age, though the absolutes to which his morality relates may differ according to experience and temperament.

In the cinema it was, *par excellence*, the era of the great Hollywood stars – of Garbo, Dietrich, Bette Davis, Joan Crawford, appearing in vehicles carefully tailored to show off their various talents. It was also the age of the anarchic comedy of the Marx Brothers and of the elegant cinematic musical. Fred Astaire, the greatest dancer for the camera of all time, brought a special suavity and

General Events

Civil War in Austria; the Socialists were suppressed.
A trade pact was signed between Britain and the U.S.S.R.
Hitler was appointed *Führer.*
Roehm and other Nazi opponents of Hitler were murdered.
Purges began in Russia after the assassination of Kirov.
The Royal Indian Navy was established.
Mao-tse-tung led the Chinese Communists on The Long March.
Niebuhr published *Moral Man and Immoral Society.*
King Alexander of Yugoslavia and Barthou, the French Foreign Minister, were assassinated at Marseilles.
The cat's eye road reflector was invented.
Lewis Mumford published *Technics and Civilization.*
Hitler and Mussolini met in Venice.

The Arts

Literature
Robert Graves – *I, Claudius*
F. Scott Fitzgerald – *Tender is the Night*
Evelyn Waugh – *A Handful of Dust*
Mikhail Sholokhov – *And Quiet Flows the Don*
Dylan Thomas – *Eighteen Poems*
John O'Hara – *Appointment in Samarra*
Louis Aragon – *Houra l'Oural*

Drama
Cocteau – *La Machine Infernale*
J.B. Priestley – *Eden End*

Music
Rachmaninov – *Rhapsody on a Theme of Paganini*
Shostakovich – *Lady Macbeth of Mtensk*
Virgil Thomson – *Four Saints in Three Acts* (libretto by Gertrude Stein)
Schoenberg – Suite for String Orchestra in G major
Webern – Concerto for Nine Instruments, Op 24
Stravinsky – *Perséphone*
Hindemith – *Mathis der Maler* (completed; première banned by the Nazis – first performed in 1938 in Zurich)

Art
Marcel Duchamp – *The Green Box*
Max Ernst – *Garden Aeroplane Trap*
Giacometti – *Invisible Object*
Magritte – *The Rape*
André Masson – *Divertissement d'été*
Charles Sheeler – *American Interior*

Architecture
Erich Mendelsohn – De La Warr Pavilion, Bexhill (–35)
Stations on the Moscow Underground (–38)

Cinema
Jean Vigo – *L'Atlante*
Leni Riefenstahl – *Triumph of the Will*

Above: This demonstration at Bückeburg shows the carefully orchestrated quality of Nazi ceremonies.

Right: A still from Robert Flaherty's poetic documentary film, *Man of Aran.*

Right: Clark Gable and Claudette Colbert in *It Happened One Night.* They both won Oscars.

Above: Paul Nash — *The Phases of the Moon*. Poetic Surrealism, with a resemblance to Giacometti's sculptures of the same period.

Below: Thirties luxury — a 1934 Rolls Royce Phantom II.

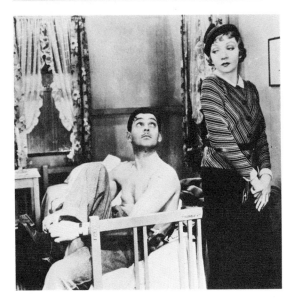

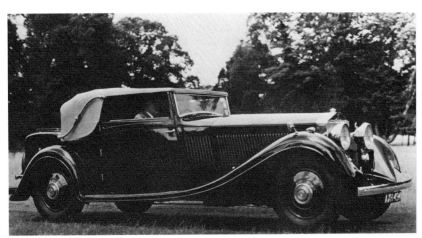

Ideologies in Conflict

1935

elegance to a number of these light-hearted films, qualities which have, in turn, endowed them with surprising durability. They bear revival far better than many which were more seriously intended.

In Europe, France replaced Germany as the place where the most imaginative films were made. There was a galaxy of great French directors. They included Jean Renoir, son of the artist, Jean Vigo, Julien Duvivier, René Clair and Marcel Carné. The great script-writer of the period was the poet Jacques Prévert, who had intimate connections with the Surrealist Movement. Commentators have seen in many of the most typical French films of the period a fundamental conflict between the desire to use popular forms — that of the *film noir* or story about criminals and the underworld, for example — and the desire to maintain the aristocratic poise of the true artist. Yet the amalgam is a peculiarly seductive one, and the note of stoicism and of disdain in the face of defeat, struck by so many of the characters played by the actor Jean Gabin, is also the note we find struck in many of the best novels of the period.

In fact these French films, like many other works of art of the period, are about a sense of romantic exclusion. Intellectuals were deeply concerned with the fate of the world, but the world did not repay their interest. Even the cold official style of the buildings of the period seemed designed to create an environment in which the sense of alienation was paramount.

One of the ways in which artists fought against this sense of exclusion — and this observation applies to the world of the visual arts in particular — was by creating their own grouping within society. The most all-embracing of these was the International Surrealist Movement. Having failed to form a lasting alliance with Soviet Communism, Surrealism became almost a political party in itself.

Surrealism made its presence felt in two different ways: through a succession of magazines, and through collective exhibitions. One of the most important of the magazines was *Minotaure*: the first issue appeared in February 1933, and the last in May 1939. *Minotaure* differed in one very obvious and important way from the various Surrealist reviews which had preceded it — it was much more lavishly produced. The fact that Surrealism could sustain such a publication marked a new phase in its history. Thanks to its political impotence, it was now possible for the movement to attract the interest and patronage of the fashionable world which had once supported Diaghilev and the *Ballets Russes*. Surrealism was now to become a source of inspiration for window-dressers, couturiers and designers of advertisements. The dress-designer

General Events

The Saar was restored to Germany after a plebiscite.
Cardinal Fisher and Sir Thomas More were canonized.
An oil pipeline from Iraq to the Mediterranean was inaugurated.
The show trials began in Russia.
Pan-American Airways began a trans-Pacific service from California.
Robert Watson-Watt built the first practical radar equipment for detecting aircraft.
Karl Jaspers published *Suffering and Existence.*
Roosevelt signed the Social Security Act.
King George V celebrated his Silver Jubilee.
Italy invaded Abyssinia.
Stanley Baldwin formed a National Government in Britain.
Germany reintroduced conscription.
France and Italy signed an agreement on Africa in Marseilles.

The Arts

Literature
Malraux — *Le Temps du Mépris*
Isherwood — *Mr Norris Changes Trains*
Ivy Compton-Burnett — *A House and its Head*
Marianne Moore — *Selected Poems*
John Steinbeck — *Tortilla Flat*
Cyril Connolly — *The Rock Pool*
Graham Greene — *England Made Me*
James T. Farrell — *Studs Lonigan*

Drama
Robert Sherwood — *The Petrified Forest*
Auden and Isherwood — *The Dog Beneath the Skin*
T.S. Eliot — *Murder in the Cathedral*

Music
Gershwin — *Porgy and Bess*
Berg — Violin Concerto
Richard Strauss — *Die Schweigsame Frau*
The term 'swing' was coined.

Art
Dali — *Giraffe on Fire*
Epstein — *Ecce Homo*
Max Ernst — *Lunar Asparagus*
Magritte — *Ceci est un morceau de fromage*

Architecture
Michel Roux-Spitz — Post office, Lyons (1935–38)
N. Golossov — Office block for *Pravda*, Moscow

Cinema
Sam Wood — *A Night at the Opera* (with the Marx Brothers)
Mark Sandrich — *Top Hat* (with Fred Astaire and Ginger Rogers)
Jacques Feyder — *La Kermesse héroïque*
Reuben Mamoulian's *Becky Sharp* was the first feature in 3-colour technicolour.

Above: A destitute Ozark family in Arkansas — a brilliant photograph taken by artist Ben Shahn for the U.S. Farm Security Administration.

Right: Caricature of George Gershwin from *Vanity Fair*.

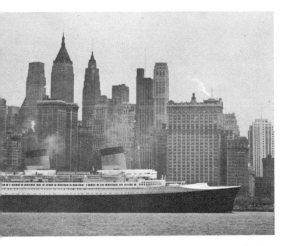

Right: Fred Astaire and Ginger Rogers in *Top Hat*, perhaps the best of the Art Deco musicals.

Left: The new French liner *Normandie* outward-bound from New York. The poster by Cassandre (below) conveys the feeling of excitement she gave.

NORMANDIE
C^{ie} G^{le} TRANSATLANTIQUE
French Line
LE HAVRE — SOUTHAMPTON — NEW-YORK

Ideologies in Conflict

Schiaparelli, for example, used Surrealist trimmings on her clothes, and even crowned one of her models with a hat in the shape of a shoe.

Not only were artists of all nationalities attracted to the Surrealist circle in Paris, but the movement now began to make a serious impact abroad. The most important of its foreign manifestations was the International Surrealist Exhibition held in London in 1936. This followed individual exhibitions by Max Ernst (1933) and Salvador Dali (1934). Dali celebrated the collective manifestation in true Surrealist fashion by donning a diving suit in which to deliver a totally (and deliberately) inaudible lecture.

Meanwhile, Surrealist groups were formed in countries as distant from one another as Chile and Czechoslovakia. This internationalism had one important consequence for the Surrealists. It tended to place the emphasis more and more on the visual arts, which were universal, rather than on the literary texts with which Surrealism had begun.

From the artistic point of view, the movement was developing in three ways. First, and this is an obvious point which is nevertheless often missed, the art works were becoming more substantial, and in that sense more 'serious'. Surrealist painters were able to produce these deeper works thanks to the more generous patronage which had now become available to them from collectors like the Englishman Edward James. At the same time, some of the artists connected with the movement began to cast about for ways of preserving Surrealist freedom of association while still making a public point. Picasso's *Guernica*, a cry of rage at the destruction of the town by bombing during the Spanish Civil War, had a prominent place in the Spanish Pavilion at the International Exhibition of 1937. As a political painting on a heroic scale it makes an interesting contrast with the work which the leading Mexican muralists, Rivera, Siqueiros and Orozco, were producing at the same time on the other side of the Atlantic.

Guernica was, however, an atypical work, a response to an exceptional situation and an exceptional opportunity. More significant in general were the paintings produced by Salvador Dali, the most talked of Surrealist of the thirties, and the most successful with the fashionable world. In technique his highly polished paintings reverted to the tradition of the virtuoso Salon artists of the nineteenth century. Their mysterious distortions and strange collocations of objects might be the product of Surrealist free association, but the process of association was kept strictly private, and the spectator was confronted only with the result.

Another important development in Surrealist art was the cult of the object. An exhibition of Surrealist

1936

General Events

Germany occupied the demilitarized Rhineland zone.
The Olympic Games were held in Germany.
George V died and was succeeded by Edward VIII.
Roosevelt was reelected President of the United States.
Metaxas became dictator of Greece.
The U.S. Farm Relief Act was passed.
Farouk became King of Egypt.
The Irish Republican Army was outlawed.
A.J. Ayer published *Language, Truth and Logic*.
The franc was twice devalued.
Chiang-kai-shek entered Canton.
Edward VIII abdicated in order to marry Mrs Simpson, and was succeeded by his brother George VI.
Trotsky left Russia and settled in Mexico.
Italy proclaimed the annexation of Abyssinia.
General Francisco Franco rebelled against the Spanish Republican government. The Spanish Civil War began.
The British ended their occupation of Egypt except for the Canal zone.
China declared war on Japan.

The Arts

Literature
Montherlant – *Les Jeunes Filles*
W.H. Auden – *Look, Stranger!*
Margaret Mitchell – *Gone with the Wind*
Aldous Huxley – *Eyeless in Gaza*
Georges Bernanos – *The Diary of a Country Priest*
Robert Frost – *A Further Range*

Drama
Rattigan – *French without Tears*
Robert Sherwood – *Idiot's Delight*
Kaufman and Hart – *You Can't Take it With You*

Music
Britten – *Our Hunting Fathers*
Lambert – *Summer's Last Will and Testament*
Schoenberg – Violin Concerto, Op. 36
Prokofiev – *Peter and the Wolf*

Art
Mondrian – *Composition in Red and Blue*
Arshile Gorky – *Image in Xhorkom*
Dali – *White Calm*
Meret Oppenheim – *Object (Déjeuner en fourrure)*
The International Surrealist Exhibition was held in London.

Architecture
Frank Lloyd Wright – 'Falling Water' (house), Bear Run, Pennsylvania
Albert Speer – Congress Hall, Nuremberg (1936–9)
The Tecton Group – Highpoint I, London

Cinema
Jean Renoir – *Une Partie de Campagne* (not released until 1946)
Fritz Lang – *Fury*
Chaplin – *Modern Times*

Above: Mussolini addressing the crowd from the Palazzo Venezia in Rome.

Below: Photography in the thirties was being used as a fine art form, as in this picture taken by Edward Weston of the California desert.

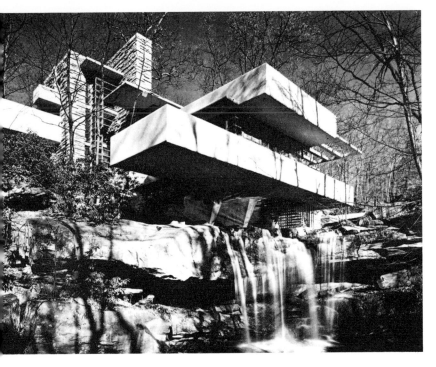

Above: Frank Lloyd Wright's most famous piece of domestic architecture — 'Falling Water', Bear Run, Pennsylvania.

Right: Sport in the thirties. A competitor in a women's motor race in France.

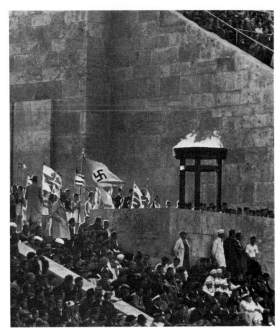

Above: Olympic Games, Berlin. Crowds watch the Olympic fire at the Marathon gate.

Above: The Duke and Duchess of Windsor after the storm of the abdication. A wedding photograph by Cecil Beaton.

Ideologies in Conflict

objects was held at the Charles Ratton Gallery in Paris in 1936. These objects were, essentially, derivations from the readymades of Marcel Duchamp – strange and incongruous assemblages of found material. One part of their significance was that they were three-dimensional without being sculptural. It is, for instance, impossible to apply the word 'sculpture' to Meret Oppenheim's celebrated fur-teacup. The Surrealist object worked, not through form, but through the associations it aroused. Materials were used like the images in a poetic text.

One important sculptor did, for a time, belong to the Surrealist group, though he was later to be expelled from it when his sculptural preoccupations got in the way of his fidelity to Surrealist doctrine. This was Alberto Giacometti, and the work he produced at this period shows him being drawn in three different directions – towards Surrealist free association (the works were created in his head, and given substance only when fully imagined), towards ancient and primitive art (for example, Cycladic sculpture), and towards the traditional role of the sculptor as an inventor of new forms and formal relationships.

If it was European Surrealism which took the limelight, very important things were being prepared in America. In large part, this was due to government intervention. In 1933, in order to help artists who had been hard hit by the depression, the Public Works of Art Project was set up. A year later, it was replaced by the Federal Art Project, within the framework of the Works Progress Administration. Through the Federal Art Project, hundreds of artists found employment, being paid a monthly stipend for their work. By 1943, when it came to an end, 16,000 works of art had been created by a total of 3,000 artists. The important thing about the F.A.P. so far as the future of American painting was concerned, was that it made no distinction between what was abstract and what was figurative. Artists were given enough money to paint full time, and were endowed with an *esprit de corps* which was something entirely novel in the history of American art.

American painting in the thirties followed at least three different directions. There was a reaction against what seemed the excesses of the *avant-garde* and a desire to return to American roots. Particularly insistent on such a return were the Regionalists, among them Thomas Hart Benton (with whom Pollock was to study) and Grant Wood. There were also painters who concentrated, like their predecessors before the First World War, on the American urban scene. Though both they and the Regionalists might look reactionary, there

General Events

Frank Whittle made the first jet engine.
Guernica was destroyed by bombing.
The Spanish government moved to Barcelona.
Baldwin retired as British Prime Minister, and was succeeded by Neville Chamberlain.
The German airship *Hindenburg* was destroyed at Lakehurst, New Jersey, after a transatlantic crossing.
The railways were nationalized in Mexico.
Martin Buber published *I and Thou*.
King George VI was crowned.
Egypt joined the League of Nations.
Japanese planes sank the American gunboat *Panay* in Chinese waters.
The Arab High Committee in Palestine was declared illegal.
A trade-pact was signed between the United States and the Soviet Union.
The Japanese took Nanking. The Chinese government made its capital at Chungking.
Francoist forces took Gijon, completing the conquest of north-western Spain.

The Arts

Literature
Hemingway – *To Have and Have Not*
Malraux – *L'Espoir*
John Steinbeck – *Of Mice and Men*
George Orwell – *The Road to Wigan Pier*
John Dos Passos – *U.S.A.*
Virginia Woolf – *The Years*
Christopher Isherwood – *Sally Bowles*
W.H. Auden – *Sham*

Drama
Auden and Isherwood – *The Ascent of F.6*
Giraudoux – *Électre*
J.B. Priestley – *Time and the Conways*
Brecht – *A Penny for the Poor*

Music
Stravinsky – *Jeu de Cartes*
Shostakovich – Symphony No. 5
Poulenc – Mass in G
Hindemith – *Nobilissima Visione*
Berg – *Lulu*
Carl Orff – *Carmina Burana*

Art
Delvaux – *The Call of the Night*
Picasso – *Guernica*
Braque – *Woman with a Mandolin*
Miró – *Nature morte avec chaussure*
Nazi Exhibition of 'Degenerate Art', Munich

Architecture
Auguste Perret – Musée des Travaux Publics, Paris

Cinema
Jean Renoir – *La Grande Illusion*
Marcel Carné – *Drôle de Drame*
Julien Duvivier – *Le Carnet de Bal*

Above: The Hindenburg disaster; the world's largest airship goes up in flames at Lakehurst, New Jersey.

Above: Jessica Tandy and Laurence Olivier in *Henry V* at the Old Vic, London.

Right: Surrealist eroticism. Detail from *The Call of the Night*, by Paul Delvaux.

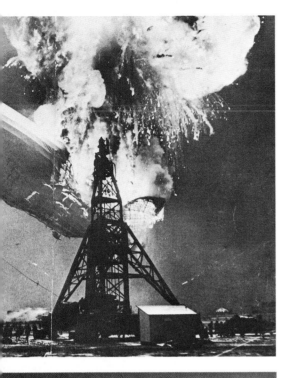

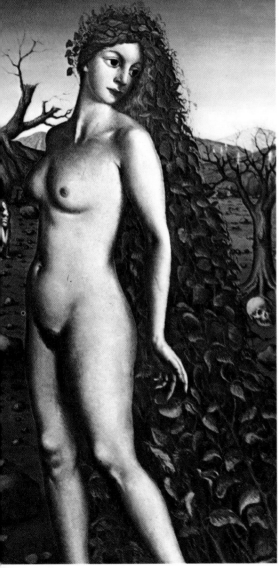

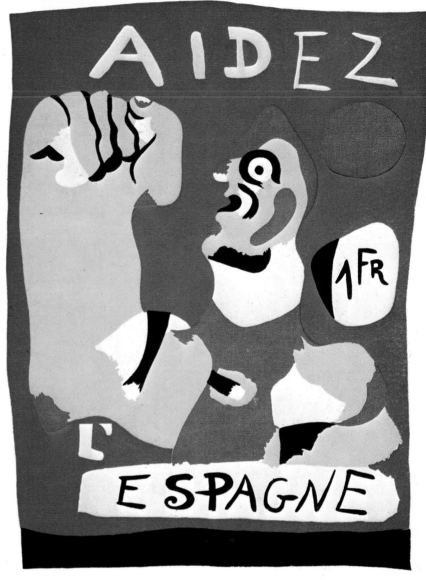

Above: Poster designed by Joan Miró in support of the Spanish Republican government.

Below: Laurel and Hardy in *Way Out West*.

1938

was something very important about their work, a keen consciousness of American identity. It had already appeared in American literature, and was now also starting to show itself in American music – for example in Gershwin's *Porgy and Bess*, and Aaron Copland's ballet *Billy the Kid*.

Painting of the American urban scene shaded into the fully developed social realism of painters like Ben Shahn and William Gropper, who saw art chiefly as a way of conveying a social message. Their efforts were influenced by knowledge of what was going on in Mexico, and indeed by actual experience of Mexican muralism, as Rivera was now receiving important American commissions.

Finally, there was an important minority of abstract artists who by 1936 (the year of the 'Cubism and Abstract Art' exhibition at the Museum of Modern Art in New York) had banded themselves together as a group. The American Abstract Artists, as they called themselves, had a tendency to recapitulate whatever had taken place previously in Europe. Some knew European abstraction through direct contact with it, others got their knowledge chiefly from exhibitions and illustrations in books and magazines. What mattered was not their imitativeness, but their faith that the road they were following was the right one. This faith was strengthened by a trickle of newcomers from Europe such as the French Purist Jean Hélion, or Josef Albers, once a member of the staff of the Bauhaus, who took over the art department of Black Mountain College in South Carolina in 1933. Another immigrant, Hans Hofmann, opened an art school on New York's Eighth Street in 1934.

Between them Hofmann and Albers provided American abstract painting with a new aesthetic, a place to stand. Jackson Pollock, who had settled more or less permanently in New York in 1935, after a period out west, found a place on the books of the F.A.P. in 1938. He was already painting pictures which gave glimpses of his mature style. More developed still was the art of the Armenian immigrant Arshile Gorky, previously an obsessive imitator of approved European styles. A new era in American art was about to begin.

But another highly significant development was also taking place in America, with the gradual evolution of a genuine popular culture based on music. Gershwin's opera *Porgy and Bess* (1935) was built on the foundations laid by *Rhapsody in Blue*, and reconciled the operatic tradition with show music. Duke Ellington, also busy trying to reconcile popular and art music, began another process. With the coming of swing, jazz, once the voice of an alienated minority, became the voice of industrial society taken as a whole.

General Events

J. Ladisla and George Biro invented the ballpoint pen.
The Labour Standards Act was passed in the United States, to regulate minimum wages and maximum hours and to prohibit child labour.
Franco's forces entered Catalonia.
Trial of Bukharin and other 'Old Bolsheviks' in the Soviet Union.
Austria was declared part of the German *Reich* after a German invasion.
Chamberlain met Hitler at Berchtesgaden.
Nazi movements were suppressed in Chile and Brazil.
German troops occupied the Sudeten territory in Czechoslovakia.
Libya was declared part of Italy.
There was anti-Jewish legislation in Italy.
The Czechs terminated their pact with Russia.
Anthony Eden resigned as British Foreign Secretary, and was succeeded by Lord Halifax.
Germany mobilized.

The Arts

Literature
Sartre – *La Nausée*
Cyril Connolly – *Enemies of Promise*
Graham Greene – *Brighton Rock*
Joyce Cary – *Castle Corner*
Samuel Beckett – *Murphy*
Daphne Du Maurier – *Rebecca*
Robinson Jeffers – *Selected Poetry*
Evelyn Waugh – *Scoop*

Drama
Thornton Wilder – *Our Town*
Jean Cocteau – *Les Parents Terribles*
Jean Anouilh – *La Sauvage*
Brecht – *The Private Life of the Master Race*

Music
Honegger – *Jeanne d'Arc au Bûcher*
Bartok – *Violin Concerto*
Strauss – *Daphne*
Copland – *Billy the Kid*

Art
Picasso – *Woman in an Armchair*
Henry Moore – *Reclining Figure*

Architecture
Frank Lloyd Wright – Taliesin West, Phoenix, Arizona
Nervi – Aeroplane hangar, Orvieto
Oud – Shell Building, The Hague
The Tecton Group – Finsbury Health Centre, London

Cinema
Eisenstein – *Alexander Nevsky*
Hitchcock – *The Lady Vanishes*
Leni Riefenstahl – *Olympische Spiele 1936*

Above: Fashionable life in Paris; *Sunday at the Clay Pigeon Shoot*, by A.E. Marty.

Above: *Still Hope.* Chamberlain caricatured at the time of the Munich agreement.

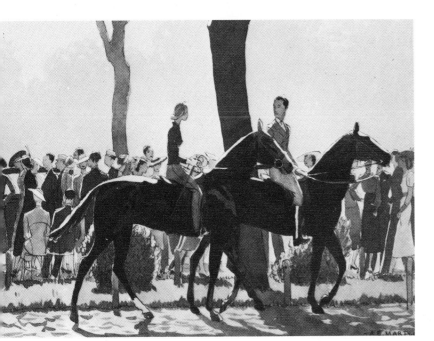

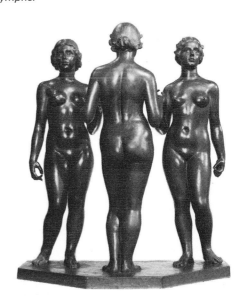

Right: *Five Years of Hitler's Regime*. A Communist-organized protest exhibition in Paris mocked the Nazis. Meanwhile their expansionism was becoming ever more evident with the *Anschluss*, the take-over of Austria. Hitler and other Nazi bosses (below) could now strut and posture in Vienna.

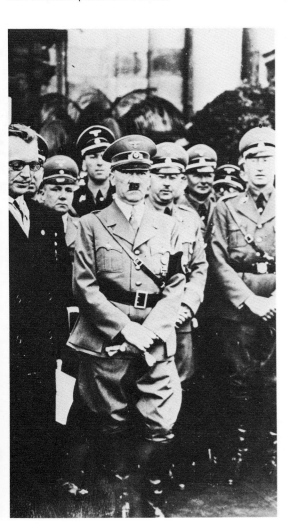

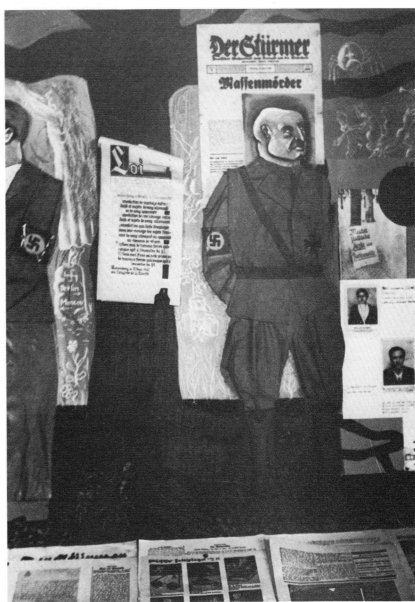

Henry Moore's shelter drawings, of which this is one,
show Londoners sheltering in the London
Underground during the Blitz. They are among the
most moving artistic images produced during World
War II.

The End of the Beginning
1939 – 1945

The Second World War had even more destructive effects on the arts than the First. Thirty-five million died in warfare, and a further ten million in Nazi concentration camps. The world's stock of creative vitality was therefore necessarily sapped. Yet not all the consequences of the disaster were negative: the visual arts, for example, suffered a decisive transformation, and were at the same time given completely new opportunities. New York, which had hitherto existed somewhat on the periphery of new developments in art, became a creative centre which rivalled the Paris of the pre-1914 period in its commitment to innovation. What happened there during the war was to set the tone for the whole of the post-war epoch.

Abstract Expressionism, the new American art-style of the 1940s, had its roots in Surrealism. Indeed, where Surrealist painting was concerned, it had some claims to be *plus royaliste que le roi*. Surrealist theory had always placed great emphasis upon pure automatism, activity from which the conscious mind was entirely excluded. 'Surrealism,' read the First Surrealist Manifesto of 1924, 'rests on the belief in the higher reality of certain neglected forms of association, in the omnipotence of dream, in the disinterested play of thought. It tends to destroy the other psychic mechanisms and act as substitute for them in the solution of life's principal problems.'

The so-called 'veristic' Surrealism of Dali and Tanguy had always met with a certain amount of opposition from André Masson, who believed that the act of painting should be as spontaneous as the act of automatic writing. This point of view had found a new recruit in the person of the young Chilean artist Roberto Matta. Matta joined the Surrealist Movement in 1939, after having studied architecture in Le Corbusier's Paris office. He began to paint in 1938, and moved to New York in the autumn of 1939.

He was soon to be followed by almost the whole of the official Surrealist Movement, headed by Breton himself. In 1942 the American heiress Peggy Guggenheim, who was at that time married to the painter Max Ernst, opened a New York gallery called 'Art of this Century'. This was to provide a focus for the activities of the exiled European Surrealists, and it was also to provide opportunities for most of the new generation of American artists.

The most important link between the European Surrealists in exile and contemporary American artists was the work of the Armenian-born painter Arshile Gorky. Gorky had come to America when he was sixteen, and most of his experience was therefore American. As an artist, he was a slow developer. His work of the late twenties and of the thirties was a recapitulation of various recognized European styles. With the war he became bolder, influenced particularly by Matta, with whom he had now become friendly. He took 'biomorphic' Surrealism – a style in which the forms are not representational, but nevertheless bear a tantalizing resemblance to real and often sexually suggestive objects – and made it more fluid and calligraphic, achieving a deliquescent look which was something entirely new. By 1944 he had met the exiled Breton, who immediately recognized his originality and talent, and his liberation as an artist was complete.

Also working in New York during the early forties was Jackson Pollock. Pollock had worked for the Federal Art Project since 1938, and in 1940 he exhibited for the first time in New York; among the other artists included in the exhibition were Lee Krasner, later to be Pollock's wife, and another soon-to-be famous Abstract Expressionist, Willem de Kooning. A number of French artists also

The End of the Beginning

1939

participated. In 1943, Pollock was given his first one-man show at Peggy Guggenheim's 'Art of this Century' Gallery, and this marked the beginning of his dazzling public career. Even at this point his work was recognized, by perceptive critics such as Clement Greenberg, as something uniquely American in its wildness, its freedom, and still more so in its use of the metaphor that art had a frontier which must always be pushed back, as the pioneers had pushed back the frontier in the American West.

Abstract Expressionism, even in this early phase, represented a rebellion against the social consciousness of the previous decade. It seemed as if American painters, cut off by the war from Europe, felt free to explore their own subjectivity, and at the same time to assert a typically American individualism.

In Europe, working under far more difficult conditions, artists reacted to events in a different way. English artists, for example, became conscious of their position as citizens of a beleaguered country, rather than of their separate status as artists. English modernists, still a small and isolated band in 1939, began to emerge, thanks in part to a renewal of the war-artists scheme which had been used during the First World War. Henry Moore, unable to sculpt because of wartime conditions, made a series of drawings of Londoners sheltering from the Blitz, and these display a humanism and a compassion which makes them seem almost timeless. Later, when sculpture was again possible, he went on to create *The Northampton Madonna*, an attempt to make an image which would remain true to his own sculptural principles while fitting a traditional Christian scheme.

Throughout the first forty years of the century, it was the continent, and particularly Paris, which had given British artists a lead. Abruptly isolated from these sources of information and inspiration, they began a search for roots at home. This, combined with the high emotions generated by the war, led to a revival of romanticism, whose influence was felt, not merely in painting and sculpture, but in all the arts. In painting one can see it particularly clearly in John Piper's architectural studies or in Sutherland's landscapes and his powerful *Crucifixion* (also for Northampton), as well as in the work of more 'literary' artists such as John Minton. Francis Bacon, an important talent emerging at the very end of the war, took things a step further in his breakthrough work *Three Studies for the Base of a Crucifixion* (1944). This has an apocalyptic fervour suited to the terror of the times in which it was created.

'Apocalypse' was in any case a fashionable word in the England of the time. One thing that gave it

General Events

Hahn and Strassmann discovered nuclear fission.
Paul Müller invented DDT.
Pan-American Airways started regular commercial flights between the United States and Europe.
Italy invaded Albania.
The Spanish Republican government collapsed.
German troops entered Czechoslovakia.
John Dewey published *Culture and Freedom*.
Hitler and Mussolini signed a ten-year 'Pact of Steel'.
The United States denounced the 1911 trade pact with Japan.
Germany invaded Poland (1 September).
Britain and France declared war on Germany (3 September).
Russia invaded Finland.
A British expeditionary force of 158,000 men was sent to France.
The Battle of the River Plate (13 December), was followed by the scuttling of the *Graf Spee*.

The Arts

Literature
Christopher Isherwood – *Goodbye to Berlin*
Thomas Mann – *Lotte in Weimar*
John Steinbeck – *The Grapes of Wrath*
James Joyce – *Finnegan's Wake*
Richard Llewellyn – *How Green was my Valley*
Louis MacNeice – *Autumn Journal*

Drama
T.S. Eliot – *The Family Reunion*
Kaufman and Hart – *The Man Who Came to Dinner*

Music
William Walton – Violin Concerto
Carl Orff – *Der Mond*
Webern – Cantata No. 1, Opus 29
Schoenberg – *Kol Nidre*, Opus 39
Britten – *Les Illuminations*

Art
Joan Miró – *Seated Woman II*
Ben Shahn – *Handball*
Baumeister – *Eidos V*
Kandinsky – *Ambiguity*
Picasso – *Fishing at Night off Antibes*

Architecture
Richard Neutra – Berger House, Hollywood
Frank Lloyd Wright – Rosenbaum House, Florence, Alabama

Cinema
Jean Renoir – *La Règle du jeu*
Marcel Carné – *Le Jour se lève*
Victor Fleming – *Gone with the Wind*
John Ford – *Stagecoach*

Above: The end of the Spanish Civil War. Republican refugees arriving in France from Barcelona.

Above: Self-portrait drawing by Matisse.

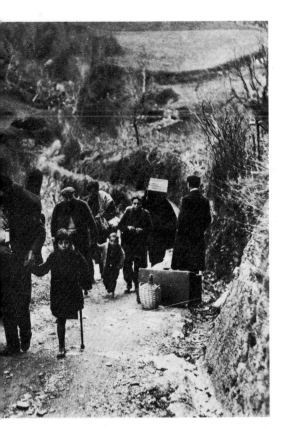

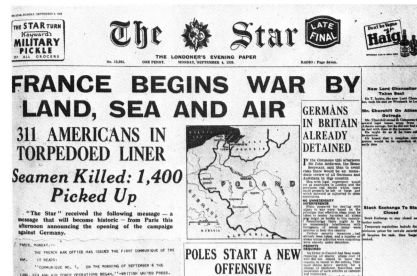

The reality and the fantasy: an English newspaper announces the outbreak of war (above), while a French propaganda poster tries to keep up morale (right).

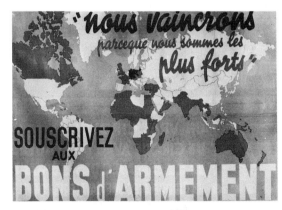

Above: Painted and carved relief by Ben Nicholson.

Right: One of the most popular films of all time: Clark Gable and Vivien Leigh in *Gone with the Wind*.

The End of the Beginning

1940

currency was the existence of a group of poets, followers of Dylan Thomas and the English Surrealist David Gascoyne, who called themselves the New Apocalypse. On the whole, their work has not stood the test of time. The best poetry directly describing the war was probably that connected with the campaign in the western desert, and in particular that written by Keith Douglas, who was killed in France shortly after the Normandy landings. But the most substantial poetic monument of the period is undoubtedly T.S. Eliot's group of meditative longer pieces, *Four Quartets*, and this can be called 'war poetry' only in the most tenuous sense.

The new romanticism manifested itself in the theatre, with Ronald Duncan's now very dated *This Way to the Tomb* (1945), ancestor of a whole series of poetic dramas in the immediate post-war period; and in the novel – perhaps more unexpectedly – with Evelyn Waugh's luscious *Brideshead Revisited* (also 1945), a book very unlike anything he had written previously. Its plangent nostalgia for a partly imaginary aristocratic past makes a strange contrast with George Orwell's harsh little anti-communist fable, *Animal Farm*, published in the same year.

One sees in the English culture of the war years both an attempt to preserve the heritage of the 'classical modernist' past, typified by Cyril Connolly's influential literary review *Horizon*, and signs pointing towards a very different kind of future. One of the most significant of these signs was C.E.M.A., the Council for Entertainment, Music and the Arts, an organization which at last gave *avant-garde* activity some kind of official status. Its founder was Lord Keynes, the Bloomsbury mandarin and economist, and it was eventually to develop into the Arts Council of Great Britain.

In France, and more particularly in Paris, the pulse of innovation slowed. A gap began to open between the masters of the first generation of modernists and their followers. It was made more conspicuous by the fact that Nazi disapproval of modern art forced the major artists into isolation, even though the majority were not actually persecuted.

The most important cultural group in Paris was the one which gathered around the philosopher, playwright and novelist Jean-Paul Sartre, and his close friend and associate Simone de Beauvoir. On a basis already provided by Karl Jaspers, Sartre was busy evolving Existentialism, a quasi-nihilist view of human existence and its purposes which soon, paradoxically, began to exercise a wide popular appeal among the young. Existentialism became a cult among the youth of the newly liberated Paris,

General Events

Finland surrendered to Russia.
Germany invaded Norway and Denmark.
Churchill replaced Chamberlain as British Prime Minister.
Germany invaded Holland, Belgium and Luxembourg.
340,000 British troops were evacuated from Dunkirk (29 May–3 June).
Italy declared war on Britain and France.
German troops entered Paris (14 June).
Pétain became head of the French government.
The British bombarded the French fleet at Oran.
The Battle of Britain took place (August).
The London Blitz began.
The British Eighth Army under Wavell began an offensive in North Africa.
Trotsky was assassinated in Mexico.
Roosevelt was reelected President of the United States, for a third term.
A.J. Ayer published *The Foundations of Empirical Knowledge*.
C.G. Jung published *The Interpretation of Personality*.
The Lascaux Caves were discovered.

The Arts

Literature
Graham Greene – *The Power and the Glory*
Arthur Koestler – *Darkness at Noon*
W.H. Auden – *Another Time*
Dylan Thomas – *Portrait of the Artist as a Young Dog*
Hemingway – *For Whom the Bell Tolls*

Drama
Eugene O'Neill – *Long Day's Journey into Night* (produced 1956)
Brecht – *Puntila* (first produced 1948)

Music
Stravinsky – Symphony in C
Schoenberg – *Variations on a Recitative for Organ*, Opus 40
Webern – *Variations for Orchestra*, Opus 40

Art
Morris Graves – *Blind Bird*
Stuart Davis – *Report from Rockfort*
Beckmann – *Circus Caravan*
Max Ernst – *Europe after the Rain* (1940–42)

Architecture
Frank Lloyd Wright – Southern College, Lakeland, Florida

Cinema
John Ford – *The Grapes of Wrath*
William Wyler – *The Westerner*
Disney – *Fantasia*
Chaplin – *The Great Dictator* (his first talkie)
Hitchcock – *Rebecca* (his first Hollywood movie)

Above: *Europe after the Rain* (1940–42). Max Ernst's prophetic vision of a ravaged continent.

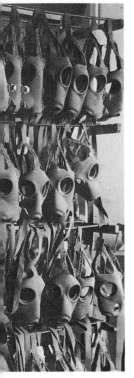

Left: Jack Benny — a favourite radio star in an age of radio, and in a country as yet unaffected by war.

Left: Ready for a horror that never came. Gas masks in Britain.

Below: Ready for a horror that did. Rescue-squad worker in the Blitz.

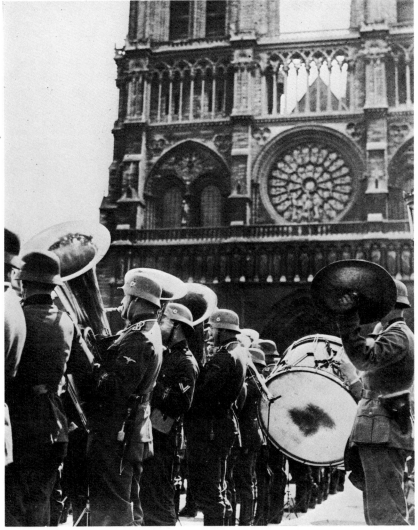

Above: The fall of Paris. German soldiers in front of Notre-Dame.

1941

and imparted a new tone to nightclubs and cabarets, in addition to inspiring impassioned discussions among students in rebellion against the compromised and compromising world of their parents.

Sartre, and another leading existentialist writer, Albert Camus, both tried their hands at the stage. Sartre's *Huis Clos* (1944) was a direct reaction to the corruption and claustrophobia of the war years. His *Les Mouches* (1942), in which flies become furies, follows a venerable tradition of the French drama by putting contemporary dilemmas into classical dress, and is based on the legend of Orestes. A contemporary playwright was also attracted to Greek myth: Jean Anouilh. In *Antigone* (1944), a subject which had been treated by Cocteau nearly two decades earlier, Anouilh found an oblique way of talking about the experience of living under the Occupation.

The artist who comes closest to Existentialism in his personal attitudes is the sculptor Giacometti, who had been expelled from the Surrealist movement because of his growing obsession with external reality. Giacometti, who was a Swiss national, spent the period 1940–45 in Geneva, and it was during this time of exile from Paris that he evolved the essentials of his post-war, non-Surrealist style. The characteristic extreme attenuation of form is already visible in the *Woman with Chariot* of 1942–3, in which the figure is placed on a wheeled base so that it can be moved and seen from various distances, and in the tiny figures on large pedestals many of which were made in 1944. These seem to express the same painful doubt about the stability of appearances found in existentialist writings.

During the war years, Paris also saw the emergence of a new style of painting related in many respects to the Abstract Expressionism evolving at the same time in the United States. It was an art which relied on an extremely free and rich use of materials, and its practitioners, though 'new' to the critics, were not usually very young men. One of the most typical practitioners of the style was Jean Fautrier, born in 1898, who had his first post-war show at the Galerie Drouin in 1945. It consisted of a series of pictures called *Hostages*, based on memories of men the artist had seen being led out to be shot by the Gestapo, or being taken away as deportees. The real subject of Fautrier's canvases, however, was paint itself – the creamy, luxurious quality of the materials was at odds with the subject matter, and the dissonance said something about the waning vitality of the *École de Paris*.

A more important artist who held his first one-man show in 1945, immediately in the wake of the Liberation, was Jean Dubuffet. What was significant about Dubuffet was his hostility to the

General Events

The Lend Lease Bill was signed in the United States.
Prince Paul, pro-Nazi Regent of Yugoslavia, was deposed.
The British invaded Abyssinia.
Rommel attacked Tobruk.
Rudolf Hess landed in Scotland.
The *Hood* and the *Bismarck* were sunk.
The Germans invaded Russia.
The Japanese bombed Pearl Harbour (7 December).
The United States and Britain declared war on Japan (8 December).
The Japanese sank the *Prince of Wales* and the *Repulse* by bombing.
The Japanese invaded the Philippines.
Germany and Italy declared war on the United States.
Hong Kong surrendered to the Japanese.
The Manhattan Project (atomic research) began.
Niebuhr began *The Nature and Destiny of Man* (1941–43).

The Arts

Literature
F. Scott Fitzgerald – *The Last Tycoon*
Louis Aragon – *Le Crève-Coeur*
Franz Werfel – *The Song of Bernadette*
Ilya Ehrenburg – *The Fall of Paris*
Virginia Woolf – *Between the Acts*
John P. Marquand – *H.M. Pulham Esquire*
A.J. Cronin – *The Keys of the Kingdom*
Joyce Cary – *Herself Surprised*

Drama
Noël Coward – *Blithe Spirit*
Brecht – *Mother Courage and Her Children* (first performed 1949)
Brecht – *The Resistible Rise of Arturo Ui* (written)

Music
Britten – Violin Concerto
Britten – *Sinfonia da Requiem*
Tippett – *A Child of Our Time* (first performed 1944)
Shostakovich – Symphony No. 7 (*Leningrad*)
Walton – *Scapino Overture* (first performed 1942)

Art
Arshile Gorky – *Garden in Sochi*
Paul Nash – *Bombers over Berlin*
Stuart Davis – *New York under Gaslight*
Stanley Spencer – *Shipbuilding in the Clyde* (–47)
Henry Moore – *Shelter drawings*
Jackson Pollock – *Magic Mirror*

Cinema
Orson Welles – *Citizen Kane*
William Wyler – *The Little Foxes*
H.C. Potter – *Hellzapoppin*

Below: The brilliant young Orson Welles in his greatest film, *Citizen Kane.*

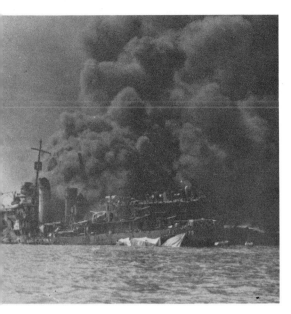

Left: Burning American ships at Pearl Harbour, after the Japanese surprise attack. What appeared a master stroke, however, had simply served to awaken a 'sleeping giant'; by bringing the United States into the war the Axis Powers had sealed their fate.

Below: The Germans in Russia. A still from a Nazi propaganda film.

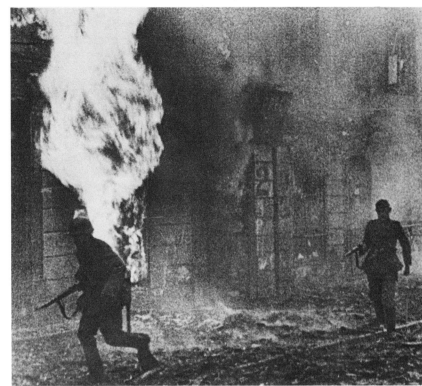

Left: A British ration-book; a symbol of wartime for many in Britain that was not to disappear until the fifties.

Below: Balthus — *The Living Room* (1941–3). A good example of the artist's very personal eroticism.

The End of the Beginning

French tradition of *belle peinture*, his insistence on achieving his results by the most awkward route. He is heavily permeated by the idea of the 'absurd' which is also to be found in Sartre.

The French film industry suffered heavily from wartime restrictions – not merely those imposed upon it by the censorship, but those which were the result of wartime shortages. It nevertheless continued to produce good work, though largely in a pre-war tradition. Film-makers, for many reasons, were forced to abandon contemporary subject-matter and to return to the remote and artificial. A typical example is Marcel Carné's *Les Visiteurs du Soir*. It makes a striking contrast with the way in which the Italian cinema was developing at the same period, a development heralded as early as 1942 by Luchino Visconti's *Ossessione*. *Ossessione* pointed the way to the neo-realistic style which Roberto Rossellini was to perfect in *Roma, Città Aperta* (1945), and this in turn was the beginning of a technical revolution in the cinema, where studio locations were abandoned for 'real' settings, and where amateur players often began to challenge the professional actor.

The Occupation found the French intellectual community heavily divided against itself. Leading writers by no means presented a united front of resistance to the enemy. Among the more prominent collaborators were Charles Maurras, who was imprisoned after the war, and Robert Brasillach, who was shot in 1945. Both men had been associated with the pre-war *Action Française*. Another typical figure from the war years was the scapegrace Maurice Sachs, who, after a period of collaboration with the Gestapo, died in 1944, as a deportee in Hamburg. Most of his books (*Le Sabbat* is best known) were published posthumously.

The arts were not completely suppressed in Germany. The *avant-garde* painters who had not joined the emigration sometimes continued painting in secret, creating works which they were unable to exhibit. A case in point was Emil Nolde. Nolde would perhaps have collaborated willingly with the Nazi regime, but he was declared a decadent artist, and no less than 1,052 of his works were confiscated from German museums. Living in retirement, he created a long series of watercolours and drawings which he entitled 'Pictures I did not paint'. But he dared to show them only to a few of his most trusted friends.

The Austrian twelve-tone composer Anton Webern also had a moment of enthusiasm for the Nazi regime, but he too found himself banned. He continued to compose and the last three works he completed were written between 1939 and 1941. Characteristically brief, they consist of two

1942

General Events

The Allies agreed not to make separate peace-treaties.
The Japanese invaded Burma and the Dutch East Indies.
The Japanese captured Singapore.
The British raided St Nazaire.
Bataan was taken by the Japanese.
U.S. naval forces defeated the Japanese in the Battle of the Coral Sea and at Midway.
Heydrich was assassinated in Czechoslovakia and Lidice destroyed in retaliation.
Rommel took Tobruk.
In Russia, the Germans reached Stalingrad.
400,000 American troops landed in North Africa.
The French fleet was scuttled in Toulon.
Lend Lease was extended to the Soviet Union.
Oxfam was founded.
Magnetic tape was invented.
The Americans developed ENIAC, the first electronic computer.

The Arts

Literature
T.S. Eliot – *Little Gidding*
Albert Camus – *L'Étranger*
John Steinbeck – *The Moon is Down*
Juan Luis Borges – *Ficciones*
Stephen Spender – *Ruins and Visions*
Evelyn Waugh – *Put Out More Flags*

Drama
Thornton Wilder – *The Skin of Our Teeth*
Terence Rattigan – *Flare Path*
Jean-Paul Sartre – *Les Mouches*
Sean O'Casey – *Red Roses for Me*

Music
Richard Strauss – *Capriccio*
Copland – *Rodeo*
Prokofiev – *War and Peace* (first complete performance 1955)
Copland – *A Lincoln Portrait*
Roy Harris – Fifth Symphony
Khachaturian – *Gayane*
Messiaen – *Quatuor pour la fin du temps*

Art
Edward Hopper – *Nighthawks* (1941–2)
Mondrian – *Broadway Boogie-Woogie* (1942–3)
John Piper – *Windsor Castle*
Braque – *Still life with black fishes*

Architecture
Oscar Niemeyer – Casino, Pampulha, Belo Horizonte, Brazil
Richard Neutra – Nesbitt House, West Los Angeles

Cinema
Luchino Visconti – *Ossessione*
Orson Welles – *The Magnificent Ambersons*
Marcel Carné – *Les Visiteurs du soir*
John Huston – *The Maltese Falcon*

Above: De Gaulle as leader of the Free French. Churchill commented: 'The Cross of Lorraine is the heaviest cross I have to bear.'

Above: Matta — *The Hanged Man.* A European Surrealist, working in America, prefigures Abstract Expressionism.

Below: *This is Nazi Brutality.* Ben Shahn uses imagery related to Heartfield's collages to attack the same target.

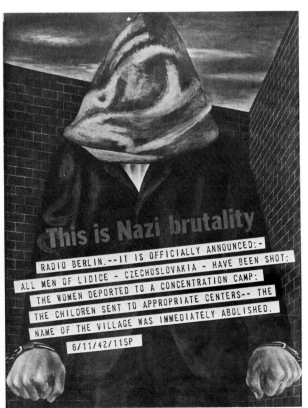

Above: Edward Hopper. *Nighthawks* (1941–2). A masterpiece of the American Realism which Abstract Expressionism would soon displace.

Above: John Piper. *Somerset Place, Bath*; an example of British wartime romanticism.

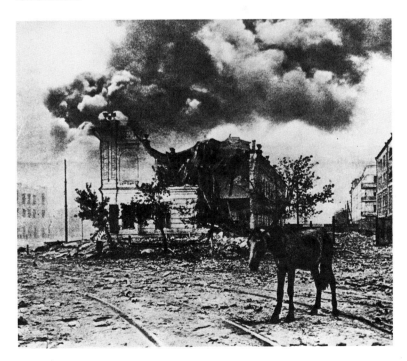

Above: Wartime reality. Stalingrad in flames, during the course of the battle that finally reversed German fortunes.

1943

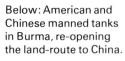

cantatas and a set of variations for orchestra. Webern's fate was tragic. In September 1945, when the war was already over, he was shot by a trigger-happy American sentry, a member of the occupying forces in Salzburg.

One composer who, though German, was able to continue his public career was the veteran Richard Strauss. Strauss's relationship with National Socialism was always somewhat ambiguous. He was courted by the Nazis because of his vast reputation, and sometimes seemed to respond to these overtures. Yet his opera *Die Schweigsame Frau* (1935) was withdrawn after the *Anschluss* because the librettist, Stefan Zweig, was Jewish; and the opera *Friedenstag* (*Day of Peace*) was banned after the outbreak of war. Strauss's two last operas belong to the war years. They are *Die Liebe der Danae*, composed in 1940, and the mellow conversation-piece *Capriccio*, written in 1941 and presented in Munich in 1942. This tranquil debate about the relative merits of poetry and music makes an extraordinary contrast with the political circumstances of its time though it is now generally recognized as one of Strauss's finest compositions.

In Russia, the war produced a reaction of patriotic fervour which tended to bring about a reconciliation between the regime and its artists. Shostakovich's *Leningrad Symphony*, his seventh, was directly inspired by the fervour with which the composer's native city resisted the Germans. It brought his popularity to a high point not only in Russia but also in America, where Toscanini conducted it in 1942. Prokofiev attempted the almost impossible task of turning Tolstoy's *War and Peace* into an opera. The finest scenes in this rather episodic work are those which centre on the personality of the heroic Russian commander, Marshal Kutusov. Eisenstein made what is, next to *Battleship Potemkin*, his best-known film, the first part of *Ivan the Terrible* (1944). This magnificent recreation of sixteenth-century Russia conveys both the splendour and the terror of the Russian destiny.

The war did not bring relief to all creative Russians, however. Marina Tsvetayeva, perhaps the most gifted poet of the Russian emigration, returned to her native country just before the war, but found life there so harsh that she finally hanged herself in despair in 1941.

During World War II, there was a new, and very important, environment which fostered artistic creativity, though in a rather strange way. This was California. Here, the creative impulse manifested itself in at least four different ways. One was in the long-established movie industry. In 1939, Hollywood produced the romantic blockbuster of all time, *Gone with the Wind*, with Vivien Leigh and

General Events

The Japanese were driven from Guadalcanal.
The British Eighth Army reached Tripoli.
General Paulus surrendered at Stalingrad.
Eisenhower took command in North Africa.
The American and British armies linked up in North Africa.
The German army surrendered in Tunisia.
American forces landed in New Guinea.
The Allies landed in Sicily.
Mussolini fell from power and was replaced by Marshal Badoglio.
The Allies landed in Italy.
The Italian Government surrendered unconditionally.
Italy declared war on Germany.
The aqualung was invented.
The worker-priest movement was founded in France.
There was a coal-miners' strike in the United States.
Jean-Paul Sartre published *L'Être et le néant*.

The Arts

Literature
Upton Sinclair – *Dragon's Teeth*
Robert Frost – *A Witness Tree*
James Thurber – *Men, Women and Dogs*
Henry Green – *Caught*
T.S. Eliot – *Four Quartets*
Graham Greene – *The Ministry of Fear*
Mary McCarthy – *The Company She Keeps*

Drama
James Bridie – *Mr Bolfry*
Brecht – *The Life of Galileo* (performed 1947)
Brecht – *The Good Woman of Setzuan* (written)

Music
Webern – Cantata for solo voice, chorus and orchestra, Op. 31
Milhaud – *Bolívar* (first performed 1950)
Lennox Berkeley – *Divertimento* in B-flat

Art
Henry Moore – *The Northampton Madonna*
Jackson Pollock – *Pasiphae*

Architecture
Oscar Niemeyer – Church of S. Francisco, Pampulha, Brazil

Cinema
Clouzot – *Le Corbeau*
Humphrey Jennings – *Fires Were Started*
William A. Wellman – *The Ox-Bow Incident*
Michael Curtiz – *Casablanca*

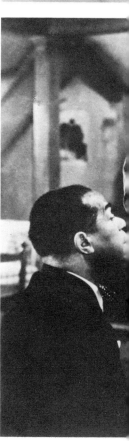

Right: Oscar Niemeyer — Church of S. Francisco, Pampulha, Brazil. Modern architecture enters a baroque phase.

Right: The Russians had not completely lost the ability to design effective propaganda posters that they had shown in the early years of the revolution.

Below: Humphrey Bogart and Ingrid Bergman in the classic, *Casablanca*.

Below: Barbara Hepworth — *Oval Sculpture*.

The End of the Beginning

1944

Clark Gable. This film had a twofold success. It was enormously popular in America at the time of its release, but did not reach much of Europe until after the war. It was then instrumental in once again establishing the American product with audiences which had for some years been starved of it. In 1941 it was the turn of something very different, Orson Welles's controversial (it was taken as an attack on the newspaper tycoon William Randolph Hearst) *Citizen Kane*. For many people this remains the most brilliant of all American movies, and an object lesson in the symbolic use of film images. Welles, an erratic *enfant terrible*, was never again to be given such artistic freedom, and was, unfortunately, never again to use his undoubted gifts in such an effective and concentrated way. His next film, *The Magnificent Ambersons*, was badly mauled by the studio bosses in the cutting room.

California was also one of the few places where architecture continued to flourish, chiefly in the form of the supremely elegant private houses then being built by Richard Neutra. Neutra, born in Vienna and at one time a pupil of Mendelsohn, had arrived in Los Angeles as early as 1925. His early reputation as an architect was founded on his experiments with off-site prefabrication. The shortages of traditional building materials, a consequence of the war, led him to experiment in a different way, with locally available building materials. His Nesbitt House of 1942, in West Los Angeles, used redwood board and batten and common brick and glass, all in themselves relatively traditional. But Neutra combined them so as to give a sense of 'throughness' and transparency which was ideally suited to the climate and informal lifestyle of the area.

Neutra's only rival as an innovative architect during the early forties was the Brazilian Oscar Niemeyer, then at the beginning of what was to be an exceptionally successful architectural career. Niemeyer was influenced by Le Corbusier, who came to Brazil in 1936 to advise on a new building for the Ministry of Education. Niemeyer was one of a group of architects who worked on this structure, which was not completed until 1943. Meanwhile he had set up his own private practice, and had begun to build on his own account. An important commission was a group of buildings, mostly recreational, at Pampulha, then a newly developed suburb of the city of Belo Horizonte. They included a casino, a yacht-club and a church. Most of these buildings were not defined by their function in any strict sense, and Niemeyer had to find a way of making the international modern idiom viable for tasks which cut right across its established preoccupations. He succeeded triumphantly, and pointed the

General Events

Monte Cassino was attacked by the American Fifth Army.
There were allied landings at Anzio.
American troops took the Solomon and Marshall Islands.
Allied forces entered Rome.
The D-Day landings took place in Normandy (6 June).
The first V-1 dropped on London.
Hitler narrowly escaped assassination.
The Warsaw Rising took place.
American forces captured Guam.
De Gaulle entered Paris (25 August).
Brussels was liberated.
The first V-2 dropped on London.
British airborne troops landed unsuccessfully near Arnhem.
American troops landed in the Philippines.
The Russians occupied Hungary; Horthy was deposed.
The Americans inflicted heavy losses on the Japanese at the Battle of Leyte Gulf.
Roosevelt was elected for a fourth term.
Vietnam declared independence under Ho Chi Minh.
The kidney-machine was invented.
C.G. Jung published *Psychology and Religion*.
Lewis Mumford published *The Condition of Man*.

The Arts

Literature
L.P. Hartley – *Eustace and Hilda* (3 vols. 1944–7)
Joyce Cary – *The Horse's Mouth*
Samuel Beckett – *Watt*
William Sansom – *Fireman Flower*
Saul Bellow – *Dangling Man*
Somerset Maugham – *The Razor's Edge*

Drama
Sartre – *Huis Clos*
Anouilh – *Antigone*
Tennessee Williams – *The Glass Menagerie*

Music
Prokofiev – *Cinderella*
Messiaen – *Vingt Regards sur l'Enfant Jesus*
Schoenberg – *Ode to Napoleon* (first performed 1945)
Poulenc – *Les Mamelles de Tirésias* (first performed 1947)
Hindemith – *The Four Temperaments*
Copland – *Appalachian Spring* (1943–4)

Art
Sutherland – *Christ on the Cross*
Picasso – *The Tomato Plant*
Matisse – *The White Dress*
Rouault – *Homo Homini Lupus*
Bacon – *Three Studies for the Base of a Crucifixion*

Cinema
Eisenstein – *Ivan the Terrible*, Part I
Capra – *Arsenic and Old Lace*

Above: The D-Day landings — the Allies take the battle to Europe in the largest invasion of all time.

Above: Private worlds in wartime. *Nude with Cupids* by primitive artist Morris Hirshfield.

Right: Churchill and De Gaulle in newly liberated Paris. It later became apparent that De Gaulle was building resentments under the superficial amity.

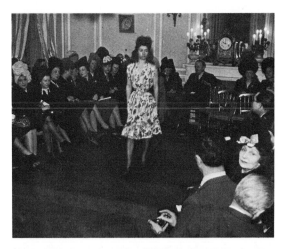

Right: The resilience of fashion — a show at Jacques Fath in Paris.

Below: Jackson Pollock — *Don Quixote*. Abstract Expressionism in development.

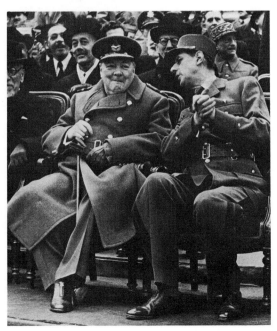

Above: The French resistance in Britanny helping American troops in their advance.

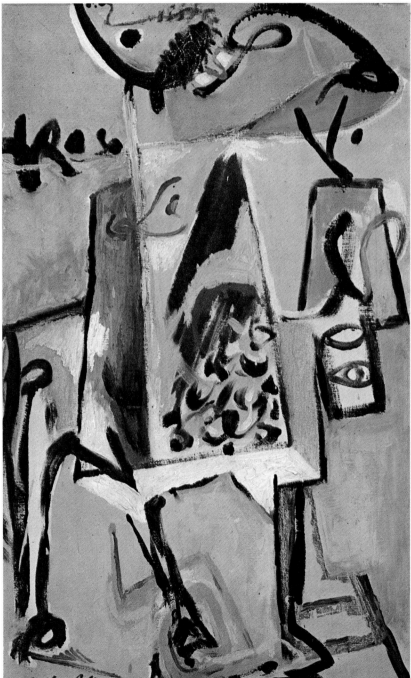

way to much of the glittering 'prestige' architecture of the fifties.

Because of its climate and its remoteness from the European war, California had also attracted a number of very distinguished European refugees. These included the composers Stravinsky and Schoenberg, then the heads of opposing schools of musical thought. The rivals had remarkably little effect on the musical life of the region, though Schoenberg joined the faculty of the University of Southern California, and taught there until his retirement in 1945 at the age of seventy. The only changes to affect his established twelve-tone idiom took place when he allowed his compositions to become somewhat more accessible, with a return of tonal implications, as in the Piano Concerto of 1942, and the *Ode to Napoleon* (a setting of a text by Byron) of 1944. Stravinsky and Schoenberg met only once during their shared Californian years, very briefly at the funeral of a mutual friend, and the Russian was not yet ready to interest himself in Schoenberg's dodecaphonic techniques. He continued to compose in neo-classical style.

Another refugee in California during the war years was Bertolt Brecht, and he, too, remained in comparative isolation, though he did have some contacts with members of the film community, such as the actor Charles Laughton. Despite the lack of opportunity to see his work performed, the early forties were Brecht's most fecund period as a playwright, and the time when he did his most important work. Some of this work was done in Denmark and Finland, some later, when he had removed himself from Europe altogether for reasons of personal security. The great epic plays and the best knock-about political comedies all date from 1940–45. They include *Puntila* (1940); *The Resistible Rise of Arturo Ui* and *Mother Courage* (both 1941); *The Life of Galileo* and *The Good Woman of Setzuan* (1943). Only one of these was given a performance in America while Brecht was still resident: *The Life of Galileo* in 1947. The renewal of his European success, on a much larger scale than he had ever enjoyed previously, had to await the East Berlin production of *Mother Courage* in 1949. Brecht's ideas about epic and didactic theatre, and his theory of the 'alienation effect' then began to revolutionize theatrical practice throughout the world.

It is curious to reflect that these supremely anti-romantic plays were written at the same time as Coward's comedy *Blithe Spirit* (1941), and are indeed somewhat earlier than *This Way to the Tomb*, *The Glass Menagerie*, and *La Folle de Chaillot*. Brecht's works now seem to belong to a different, and much later, theatrical generation.

General Events

The Russians took Warsaw and Cracow.
Stalin, Roosevelt and Churchill conferred at Yalta.
American troops entered Manila.
Budapest fell to the Russians.
British troops crossed the Rhine.
Okinawa was captured.
Roosevelt died and was succeeded by Harry S. Truman.
The Russians reached Berlin.
The United Nations charter was signed in San Francisco.
The Allies crossed the Elbe.
Mussolini was killed by Italian partisans.
Hitler committed suicide (30 April).
Berlin surrendered to the Russians (2 May).
Germany capitulated (7 May).
The war ended in Europe (8 May).
A British general election brought the Labour Party to power. Attlee became Prime Minister.
Atomic bombs were dropped on Hiroshima (6 August) and Nagasaki (9 August).
Japan surrendered.
De Gaulle was elected leader of a French provisional government.
Vitamin A was synthesized.
Karl Popper published *The Open Society and its Enemies*.

The Arts

Literature
George Orwell – *Animal Farm*
Evelyn Waugh – *Brideshead Revisited*
John Betjeman – *New Bats in Old Belfries*
Carlo Levi – *Christ Stopped at Eboli*
Nancy Mitford – *The Pursuit of Love*
Hermann Hesse – *Das Glasperlenspiel*

Drama
Ronald Duncan – *This Way to the Tomb*
Giraudoux – *La Folle de Chaillot*
Camus – *Caligula*

Music
Britten – *Peter Grimes*
Stravinsky – *Symphony in Three Movements*
Shostakovich – 9th Symphony
Strauss – *Metamorphosen*
Frank Martin – *Petite Symphonie Concertante*

Art
Henry Moore – *Family Group*
Yves Tanguy – *The Rapidity of Sleep*
Roberto Matta – *Being With* (1945–46)
Jean Fautrier – *Hostage*

Cinema
Marcel Carné – *Les Enfants du Paradis*
Rossellini – *Roma, Città Aperta*
David Lean – *Brief Encounter*
Bresson – *Les Dames du Bois de Boulogne*

Above: The uneasy allies — Churchill, Truman and Stalin at Potsdam. Their discussions influenced the fate of millions throughout the world.

Right and below: The atomic bomb explodes at Nagasaki — and what it left at Hiroshima. The world had entered the nuclear age.

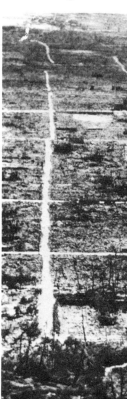

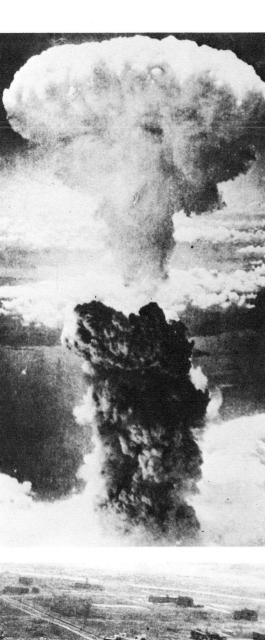

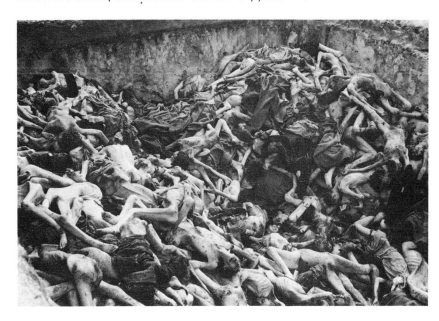

Below: An official photograph of the victims of Belsen. Such images were to remain in the European consciousness for many years.

Below: Art asserts human value. Henry Moore's *Family Group.*

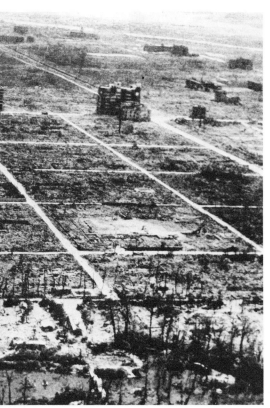

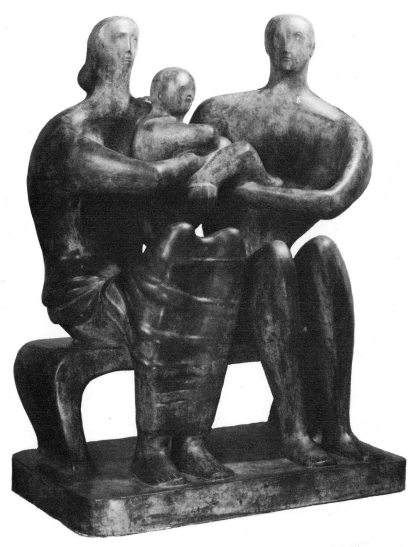

Below: Mark Rothko's *No. 8* (1952) shows a mystic
calm in an anxious epoch.

The Age of Anxiety
1946 – 1960

The Second World War, by once again shaking Western society to its roots, prepared the way for a broader and less self-conscious acceptance of the modernist ideal. Educated people, at least, began to be persuaded that they were living in a new era, and that this ought to have a culture to match.

At the same time, however, modernism found itself put on trial. Up to 1939, it had been able to present itself as something which was always contemporary and immediate. Now it came to be seen in a more sober light, as one style among many. The writers, musicians and artists of the post-war years had a formidable tradition against which to measure themselves. The modern arts, having to some degree come to terms with society, would now have to come to terms with themselves. They were threatened, on the one hand, by an increasing tendency towards academicism, and on the other by the danger of being chained to the treadmill of a 'perpetual revolution', which would become increasingly meaningless.

Different forms of expression were affected in different ways. The theatre, being at once one of the most popular and one of the most volatile of the arts, tended to reflect the mood of the moment especially accurately. The years immediately following the war were inevitably years of austerity in Europe. They were also years in which sensitive minds everywhere were trying to come to terms with a new terror – the threat of a nuclear holocaust. Meanwhile the rigid division of the world into Communist and anti-Communist spheres of influence produced a corresponding pressure for social and political conformity most dramatically exemplified by the rise of McCarthyism in America.

One reaction took the form of a retreat into extravagant theatricality, found in the plays of Christopher Fry in England, those of Tennessee Williams in America, and those of Jean Anouilh in France. In *La répétition* (1950), one of Anouilh's characters tries to give this a philosophical justification: 'Naturalness and truth in the theatre, my dear, are the most unnatural thing in the world. Don't think it suffices to find the precise tone of real life. . . Life is very pretty, but it has no form. The object of art is precisely to give it one, and through all possible artifices to create something that is truer than truth.'

Each of the dramatists I have just mentioned interpreted this formula in terms of his own native theatrical tradition. Anouilh opted for a kind of revival of the *Commedia dell'arte* in which stock characters – gorgon mothers, elderly generals, soiled waifs, idealistic young men – sustained their fixed roles through one plot after another. Anouilh produced eight full-length plays between 1946 and 1953. Fry adopted an almost parallel strategy. His personages are lay figures, clothed in extravagant poetic verbiage.

Tennessee Williams had more theatrical guts. His play *A Streetcar Named Desire* (1947) is related to the 'southern' tradition of American literature, and certainly owes something to Faulkner. In another, less flattering sense it is the work of a cut-price Strindberg. The real horrors of a play like *The Ghost Sonata* are falsified, and put at the service of a highly coloured but totally commercial theatricalism.

Bleaker and more sober dramatists were simultaneously trying to create a theatre of ideas, but their efforts were rather stiff-jointed. T. S. Eliot achieved an unexpected popular success as a playwright, especially with his first post-war play, *The Cocktail Party* (1949). In this and two subsequent plays – *The Confidential Clerk* (1953) and *The Elder Statesman* (1958) – Eliot employed a

The Age of Anxiety

mythological apparatus married to a desiccated variety of the drawing-room comedy. In addition one finds, as in some of Oscar Wilde's plays, a further element of melodrama. Interesting things are often being said, but they are got up in a guise which seems designed to distract us from the seriousness of the author's argument.

More openly serious were Arthur Miller in the United States and Jean-Paul Sartre in France. Miller stands in direct line of descent from Ibsen, whom he uses more honestly than Williams does Strindberg. Plays like *All My Sons* (1947) and *Death of a Salesman* (1949) were a critique of American values delivered from inside America, just at the moment when the United States arrived at the pinnacle of power.

Sartre, in *Morts sans sépulture* (1946), used the violent events of the Occupation just as Miller used philistine America for *Death of a Salesman*, to explore pressing issues posed by the contemporary world. But neither here, nor in *Les Mains Sales* (1948), a politico-detective drama about an assassination, does Sartre show much interest in the theatre as a form capable of development or extension. This, indeed, is what is disconcerting about his plays — their formal deadness, as opposed to the liveliness of the ideas for which they are a vehicle.

The 'problem play' did, however, take on new life in the hands of a group of young English dramatists in the late fifties. The turning-point was John Osborne's *Look Back in Anger* (1956), herald of the so-called 'Angry Generation'. The central figure, Jimmy Porter, spat out in his long tirades many of the things which the post-war young longed to say to their elders. Osborne's merits as a playwright lie in emotional energy, not in any great originality of approach. *Look Back in Anger* is a naturalistic play, and not even a very well-constructed one. *The Entertainer* (1957) relies heavily on the music-hall techniques suggested by its subject-matter, and clearly owes something to the influence of Brecht, whose productions of his own plays for the Berliner Ensemble were now at last making their impact.

Arnold Wesker's trilogy, *Chicken Soup with Barley* (1958), *Roots* (1959) and *I'm Talking about Jerusalem* (1960), was another ambitious attempt to bring the naturalistic drama up-to-date. More interesting is a play by John Arden, *Serjeant Musgrave's Dance* (1959), which is a piece of 'epic theatre' very much in Brecht's manner. Fair-minded to a fault, it tends to leave an audience admiring but unengaged, something which could never be said about either Wesker or Osborne.

The plays of Osborne and Wesker had fewer consequences for the future of live theatre than they did for that of television drama. The play which

General Events

A truce was declared in the Chinese Civil War.
The U.S. Supreme Court ruled that the segregation of Negroes on interstate buses was unconstitutional.
Italy gave the vote to women.
Xerography was invented.
De Gaulle resigned as French Premier and was succeeded by Georges Bidault.
Juan Peron was elected president of Argentina.
Churchill coined the phrase 'Iron Curtain' in a speech at Fulton, Missouri.
Britain and France evacuated subjects from the Lebanon.
The Nuremberg trials took place.
The first meeting of the U.N. General Assembly took place.
President Truman created the Atomic Energy Commission.

The Arts

Literature
Dylan Thomas – *Deaths and Entrances*
André Gide – *Journal 1939–42*
Robert Penn Warren – *All the King's Men*
Simone de Beauvoir – *Tous les hommes sont mortels*
William Carlos Williams – *Paterson 1–4 (1946–51)*
Kazantzakis – *The Life and Manners of Alexander Zorbàs*
Robert Lowell – *Lord Weary's Castle*

Drama
Eugene O'Neill – *The Iceman Cometh*
Jean-Paul Sartre – *Morts sans sépulture*
Jean Cocteau – *L'Aigle à deux têtes*

Music
Britten – *The Rape of Lucretia*
Menotti – *The Medium*

Art
Graham Sutherland – *Thorn Head*
Picasso – *Sea Urchins*
Léger – *Composition with Branch*
Mark Rothko – *Prehistoric Memories*
Adolph Gottlieb – *Voyager's Return*

Architecture
Neutra – Kaufman Desert House, Palm Springs (–1947)
Powell and Moya – Churchill Gardens Development, Pimlico, London (1946–55)

Cinema
De Sica – *Sciuscia (Shoeshine)*
Rossellini – *Païsa*
Jean Cocteau – *La Belle et la Bête*
William Wyler – *The Best Years of Our Lives*

Below: The first post-war Volkswagens in commercial production on show at the Paris Motor Show. Few realized how crucial these sturdy machines were to be in the German recovery.

Below: Robert Colquhoun — *Fortune Teller*. English art still struggling to come to terms with France.

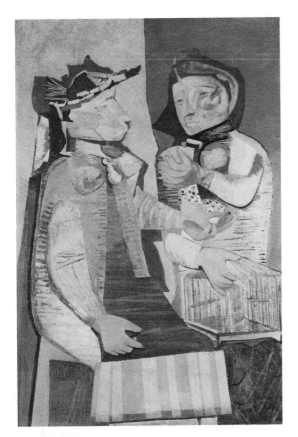

Above: A magnificent new synagogue (built 1946–52) in Cleveland, Ohio, by refugee architect Erich Mendelsohn.

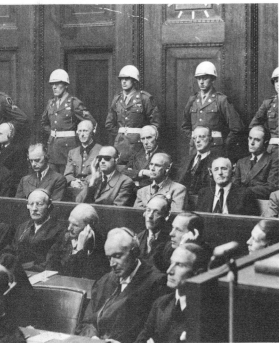

Above: Nazi defendants and American guards at the war crimes trials in Nuremberg.

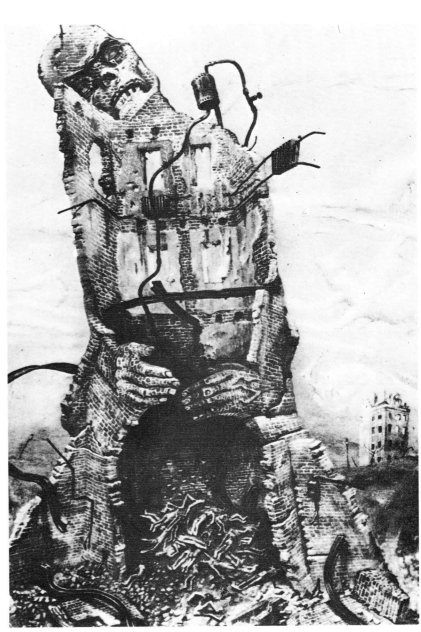

Right: B.W. Linke — *Execution in the ghetto*. A Polish painter remembers recent horrors.

The Age of Anxiety

reflected the problems of contemporary life in a direct and naturalistic way more and more tended to find its way on to the small screen, rather than being presented in the theatre itself. On stage, actors and dramatists alike found themselves freed from the demands of absolute naturalism, in much the same way that the invention of photography had freed the painter from the obligation of recording exactly what he saw. Television had another effect too. It immensely increased dramatic output by its insatiable demand for scripts. A novice dramatist might find himself with an audience of several million.

It was television, with its inherent bias towards naturalism, which ensured that the theatre itself would develop in a different and more abstract way. By the end of the fifties, an immense variety of theatrical conventions had become acceptable. In 1958, for example, all of the following plays were first presented on the London stage – *The Elder Statesman* (T. S. Eliot), *The Birthday Party* (Harold Pinter), *Chicken Soup with Barley* (Arnold Wesker), and *The Hostage* (Brendan Behan).

Much earlier, however, an entirely new kind of drama had appeared in France. Its three chief exponents were Jean Genet, Eugene Ionesco and Samuel Beckett. The first to be performed was Genet, with *Les Bonnes* (1947). The story is that of two murderous maids, who fail to kill their mistress but achieve catharsis when one poisons the other in the ritual they have rehearsed so often. Genet does not so much argue as demonstrate. He is already through with naturalism; the theatre must be pared back, reduced to its essence.

Ionesco's *The Bald Prima Donna* (1948) is an even fiercer gesture of rebellion against established theatrical norms. Ionesco is concerned with the idea of man's isolation, and with the awareness of death, represented in schematic terms. He is also very much interested in the life of language, independent of plot or action. *The Bald Prima Donna* originated in the *clichés* of a French/English phrase-book. The play is a symphony of platitudes leading to silence.

Language operates in somewhat the same way in the most important play of the fifties, Samuel Beckett's *Waiting for Godot*. This was written in 1948–9, published in 1952, and finally produced in 1953. It has no plot, no structure of events. Two tramps, or clowns, Vladimir and Estragon, conduct an interminable duologue while waiting for someone who never comes. Their exchanges are, however, interrupted by the appearance of bullying Pozzo and his slave Lucky. By talking, the characters put up a desperate, unavailing defence against silence and timelessness.

Beckett is a disturbing writer, and one of the most disturbing things about him is his apparent assump-

1947

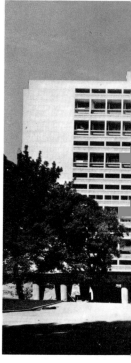

General Events

The British coal industry was nationalized.
U.S. Secretary of State General George Marshall called for a European Recovery Programme (the Marshall Plan).
Rationing was abolished in the U.S.S.R.
The U.N. announced a plan for the partition of Palestine.
Burma became an independent republic.
India was declared independent and was partitioned into India and Pakistan.
The Cominform (Communist Information Bureau) was established at a meeting in Warsaw.
The Benelux customs union came into being.
King Michael of Rumania abdicated.
The Taft-Hartley Act restricting the rights of unions was passed by the U.S. Congress over President Truman's veto.
The first supersonic flight took place.
Karl Jaspers published *The Question of Guilt*.

The Arts

Literature
Albert Camus – *La Peste*
Thomas Mann – *Doktor Faustus*
Malcolm Lowry – *Under the Volcano*

Drama
J.B. Priestley – *The Linden Tree*
Tennessee Williams – *A Streetcar Named Desire*
Jean Genet – *Les Bonnes*
Arthur Miller – *All My Sons*

Music
Menotti – *The Telephone*
Gottfried von Einem – *Dantons Tod*
Britten – *Albert Herring*
Schoenberg – *A Survivor from Warsaw*

Art
Arshile Gorky – *Agony*
Willem de Kooning – *Pink Angels*
Henry Moore – *Three Standing Figures*
Giacometti – *Man Pointing*

Architecture
Affonso Eduardo Reidy – Pedregulho Housing Development, Rio de Janeiro (1947–55)
Le Corbusier – *Unité d'habitation*, Marseilles (1947–52)

Cinema
Carol Reed – *Odd Man Out*
King Vidor – *Duel in the Sun*
Chaplin – *Monsieur Verdoux*
Clouzot – *Quai des Orfèvres*

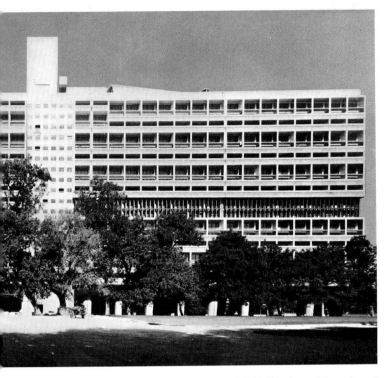

Left: Le Corbusier's *Unité d'habitation*, Marseilles (1947–52). Social engineering for a 'brave new world'.

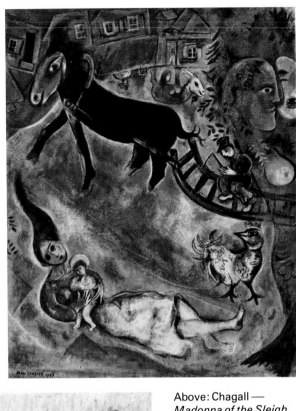

Left: Two aspects of post-war fashion — English Utility dress (above), and the New Look by Dior (below).

Below: Arshile Gorky — *The Limit.* The new American art forcing the pace.

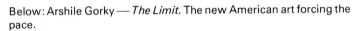

Above: Chagall — *Madonna of the Sleigh.*

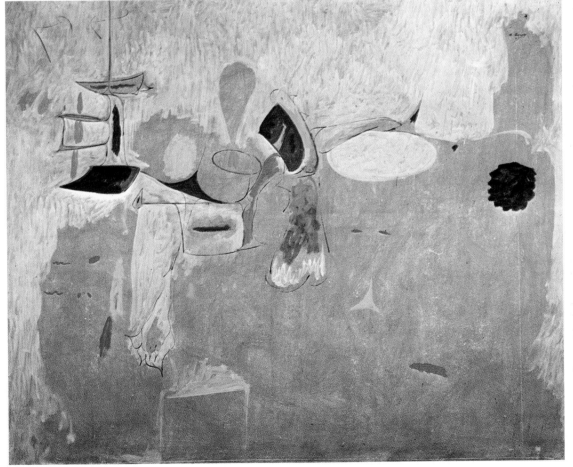

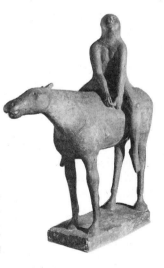

Above: Marino Marini — *Horseman.* Inspired by peasants whom Marini had seen watching aeroplanes in wartime.

The Age of Anxiety

tion that some irretrievable catastrophe has already happened. *Endgame* (1957), for example, seems to be based on the assumption that the world has already come to an end, and that what we see on stage are survivors, inhabiting their private hells. Beckett's idea of hell is far more pitiless than the one Sartre put forward in *Huis Clos* (1943).

If the leadership of the drama remained in France, it was the United States which became the centre of innovation for the visual arts. The America which Arthur Miller had criticized so sharply was, in fact, very suitable ground for the growth of a style of painting which laid no stress on one man's responsibility to another, and none on the society that surrounded him. Abstract Expressionism flourished in the soil already fertilized by the Surrealist immigration during the war. The stress was on truth to one's own psyche, and on innovation without reference to anything which had happened previously. Jacques Barzun went so far as to characterize Abstract Expressionism as an 'abolitionist' style, meaning by this that the painters connected with it wanted to do away altogether with the art of the past.

If we look for a father-figure of the New York school of painting during the early post-war years, it would be neither Arshile Gorky nor Jackson Pollock, but the veteran Hans Hofmann, who exercised great influence both as painter and teacher. Hofmann's career typified many of the qualities that went to make up the rich American amalgam. He had lived in Paris from 1904 to 1914, and had been in contact with Matisse, Picasso, Braque and Gris. It was Matisse's work that he particularly admired, and it is this which can be thought of as underlying the more decorative and expansive side of Abstract Expressionist painting.

The 'organizer' of the Abstract Expressionist movement, again insofar as it had one, was another painter, Robert Motherwell. Like so many others of his generation, Motherwell began his career under the influence of the Surrealists, and in particular under that of Matta, with whom he made a trip to Mexico. As the movement got under way, the range of Motherwell's activities continued to increase. He was co-editor of the influential but short-lived magazine *Possibilities* in 1947–8, and in 1948 founded an art-school with three other important painters: William Baziotes, Barnett Newman and Mark Rothko.

The European view of Abstract Expressionism has always been that it was a kind of 'instantaneous' art, dashing and gestural in the manner of Pollock. Motherwell's work to some extent disproves this, and Mark Rothko's is utterly opposed to such a formulation.

General Events

Gandhi was assassinated.
The Communist Party took power in Czechoslovakia.
The Marshall Plan passed the U.S. Congress, which voted $17 billion in aid for Europe.
The Jewish state of Israel came into existence.
The Berlin Blockade began (lifted September 1949).
Belgium gave the vote to women.
The long-playing record was invented.
Transistors were invented.
Queen Wilhelmina of the Netherlands abdicated and was succeeded by her daughter Juliana.
Truman was elected president of the United States.
The World Council of Churches was instituted.
Count Folke Bernadotte, U.N. mediator in Palestine, was assassinated by Jewish terrorists.
T.S. Eliot published *Notes Towards the Definition of Culture.*
Malraux published *Psychologie de l'Art.*

The Arts

Literature
Ezra Pound – *Pisan Cantos*
Graham Greene – *The Heart of the Matter*
F.R. Leavis – *The Great Tradition*
Norman Mailer – *The Naked and the Dead*
Evelyn Waugh – *The Loved One*
W.H. Auden – *The Age of Anxiety*
Kazantzakis – *Christ Recrucified*

Drama
Tennessee Williams – *Summer and Smoke*
Terence Rattigan – *The Browning Version*
Jean-Paul Sartre – *Les Mains Sales*
Christopher Fry – *The Lady's Not for Burning*

Music
Vaughan Williams – Sixth Symphony
Richard Strauss – *Four Last Songs*
Olivier Messiaen – *Turangalîla Symphony*

Art
Andrew Wyeth – *Christina's World*
Léger – *Homage to David*
David Bomberg – *Monastery of Ay Chrisostomos, Cyprus*
Jackson Pollock – *Composition No. 1*

Architecture
Pier Luigi Nervi – Exhibition Hall, Turin (1948–9)

Cinema
De Sica – *Bicycle Thieves*
Huston – *Treasure of Sierra Madre*
Olivier – *Hamlet*
Visconti – *La Terra Trema*

Below: Two attitudes to movie-making. Bogart and Bacall star in *Key Largo.* De Sica's *Bicycle Thieves* (bottom) relies on absolute realism.

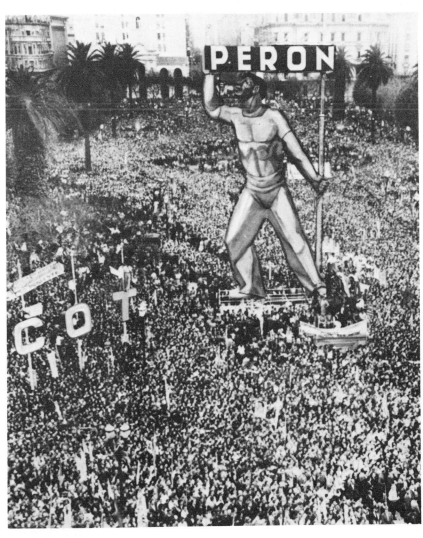

Above: Exuberance in concrete. Pier Luigi Nervi's Exhibition Hall, Turin (1948–9).

Below: American Realism survived the advent of Abstract Expressionism. Andrew Wyeth's *Christina's World*.

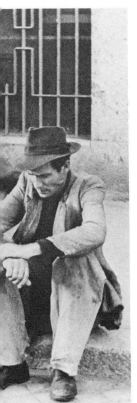

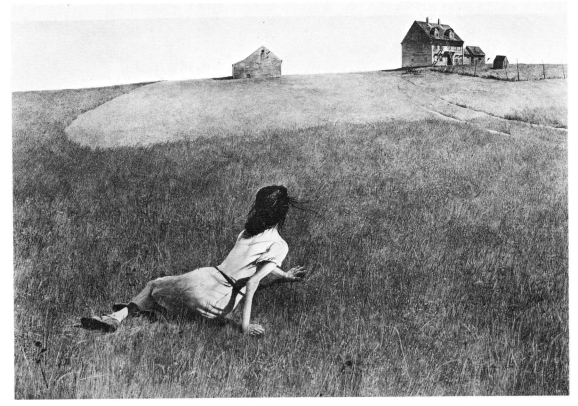

The Age of Anxiety

1949

Rothko began as an Expressionist; he too felt the influence of Matta and Masson, and followed the standard pattern by having an exhibition at the Art of this Century Gallery in 1948. Gradually his work grew simpler, and by 1950 he had reached the point where the figurative element had been discarded. A few rectangles of colour were placed on a coloured ground. Their edges were not defined, and their position in space was therefore ambiguous. They floated towards the spectator, or away, in the shallow space Pollock also used, with a kind of rhythmic pulsation. At their best, Rothko's paintings have the hieratic splendour of Russian icons, and the mysterious simplicity of Malevich's Suprematist compositions. It is an art, not of action, but of contemplation.

By the fifties, new tendencies were becoming apparent in American art — the radical simplification, discarding painterliness, of Barnett Newman and Ad Reinhardt; and the neo-Dada of Jasper Johns and Robert Rauschenberg. Johns, in particular, was making experiments with banal images — the American flag, numbers printed in series — which were to have a great influence upon the development of American Pop Art.

In Europe, and particularly in France, abstract painters were already exploring a direction akin to that taken by the Abstract Expressionists in New York before the news of American experiments crossed the Atlantic. Georges Mathieu, for example, had started painting in a freely calligraphic way as early as 1937. Europeans first became aware of what was happening in America when Peggy Guggenheim's collection, which contained many Abstract Expressionist paintings, made a tour of European cities in 1948; Mathieu himself then became chief propagandist for the new style.

On the whole, the European exponents of free abstraction — or *'art informel'* as it came to be called — make a poor showing when they are compared to their American counterparts. What they did was too sweet, too luscious, too compromised. One painter who seems to have realized the defects of the tradition in which he was working was the Franco-Russian, Nicolas de Stael, who eventually abandoned abstraction in favour of extremely simplified figuration, where the forms at first sight look like abstract marks.

Whatever one sees as the influence of Abstract Expressionism, free abstraction was not the only option for European artists. Some countries developed distinct national styles of their own. One such was Austria, where a small group of so-called 'Vienna Surrealists', among them Erich Brauer, borrowed from pre-war Surrealism, from Symbolists such as Klimt, and from late medieval imagery.

General Events

Chiang-kai-shek resigned as President of China and retired to Formosa; the Communist People's Republic was proclaimed under Mao-tse-tung.
The North Atlantic Treaty was signed in Washington.
Eire became a republic.
Israel was admitted to the U.N.
The U.S. withdrew from South Korea.
Apartheid was officially established in South Africa.
The Council of Europe was established.
The German Federal Republic and the German Democratic Republic were founded.
Holland gave sovereignty to Indonesia, and France gave sovereignty to Vietnam.
Cortisone was discovered.
The first Russian atomic bomb tests took place.
Yugoslavia joined the U.N., despite Russian opposition.

The Arts

Literature
Simone de Beauvoir — *The Second Sex*
Orwell — *Nineteen Eighty-Four*
Nancy Mitford — *Love in a Cold Climate*
Angus Wilson — *The Wrong Set*
Joyce Cary — *A Fearful Joy*
Edith Sitwell — *The Canticle of the Rose*

Drama
T.S. Eliot — *The Cocktail Party*
Arthur Miller — *Death of a Salesman*

Music
Britten — *Let's Make an Opera*
Carl Orff — *Antigone*
Hindemith — Concerto for Flute, Oboe, Clarinet, Bassoon and Orchestra

Art
Graham Sutherland — *Portrait of Somerset Maugham*
Victor Pasmore — *Spiral Motives*
Robert Motherwell — *At Five in the Afternoon*

Architecture
Mies van der Rohe — Apartments, 845–60, Lakeshore Drive, Chicago (1949–51)
Philip Johnson — Glass house, New Canaan, Conn.
Frank Lloyd Wright — Laboratory Tower for S.C. Johnson & Son, Racine, Wisconsin

Cinema
Carol Reed — *The Third Man*
John Ford — *She Wore a Yellow Ribbon*
Gene Kelly and Stanley Donen — *On the Town*
Jacques Tati — *Jour de Fête*

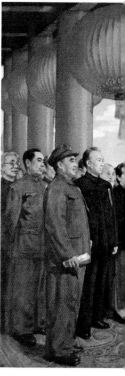

Above: War's aftermath. Orson Welles in the shady world of *The Third Man.*

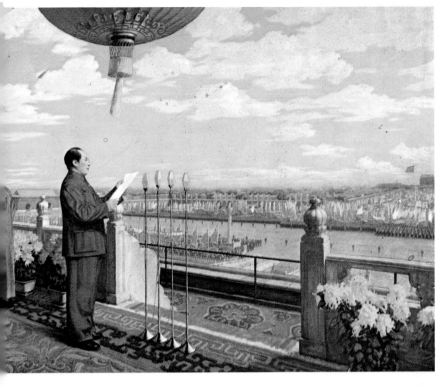

Above: Mao-tse-tung announces the birth of the People's Republic of China; the great importance of this event in establishing Chinese self-confidence after a century of humiliation and turmoil quickly became apparent.

Below: Helene Weigel as Mother Courage and Angelika Hurwicz as Katrin in the first production of Brecht's play.

Above: A new extravagance in fashion reflected growing European confidence. A design by Jacques Fath.

The Age of Anxiety

The short-lived Cobra Group of 1948–50 was multi-national, but stood for a reversion to Nordic Expressionism. The artists concerned came from Denmark, Belgium and Holland, and the name Cobra itself is taken from the initial letters of *Co*penhagen, *Br*ussels and *A*msterdam. Among the members were the Dane, Asger Jorn; the Dutchman, Karel Appel; and the Belgians, Corneille and Alechinsky.

In Italy, post-war art developed in two completely contrary directions. One was figurative, and embraced everything from the Social Realism of Renato Guttuso to the classicist humanism of a group of Italian sculptors which included Manzù, Marini and Emilio Greco. The other was the extreme abstraction best typified by the slashed monochrome canvases of Lucio Fontana. The situation in Italy showed the multiplicity of choices now open to the modern artist, and the way in which the once-unified modernist tradition had split up into numerous branches.

In Britain, there was also a movement towards Social Realism, with the emergence of the so-called 'Kitchen Sink' school at the Young Contemporaries Exhibition of 1952. Their arrival was enthusiastically welcomed by the leading English art critic of the time, John Berger. 'Their way of looking,' he wrote, 'implies a fresh intention; an intention to discover and express the reality, the sharper meaning, given to such apparently unremarkable subjects by the lives and habits of the people they concern.'

The Kitchen Sink artists (they included Jack Smith, John Bratby and Edward Middleditch) marked a first step towards Pop Art.

Intellectual obsession with mass-culture manifested itself earlier in Britain than in America, perhaps because a great many of its most typical manifestations, being American, seemed interesting and exotic to the austerity-ridden British. The first recognizably Pop Art object seems to have been the small collage *What is it makes today's homes so different, so appealing?* created by Richard Hamilton for an exhibition called *This Is Tomorrow* held at the Whitechapel Art Gallery in London. The year was 1956, that of Osborne's *Look Back in Anger*, which has an equally revealing though more scornful obsession with similar subject-matter.

Hamilton's collage represents an important shift in attitudes – it marks the moment when high culture began to step down off its pedestal. Many of the most important cultural developments of the sixties were to follow almost automatically.

The division between America and the rest of the world which so clearly existed in painting and sculpture repeated itself, though in subtler form, in

1950

General Events

Senator Joseph McCarthy denounced the American State Department as being full of Communists.
Alger Hiss, a former State Department official, was sentenced for perjury.
Klaus Fuchs was found guilty of betraying British atomic secrets to the Russians.
The Chinese invaded Tibet.
North Korea invaded South Korea and captured Seoul.
U.N. forces under MacArthur recaptured Seoul.
South Korean forces crossed the 38th parallel; U.N. and South Korean forces were compelled to withdraw; Chinese troops crossed the 38th parallel.
The U.S. recognized Vietnam and sent a military mission.
Baudouin became Regent of Belgium in place of his father, Leopold III.
In Britain the Labour Party won a general election.
Gilbert Ryle published *The Concept of Mind*.
The anti-Communist McCarran Act was passed in the U.S. over a presidential veto.

The Arts

Literature
Hemingway – *Across the River and into the Trees*
Pound – *Seventy Cantos*
Pablo Neruda – *Canto General*
Tennessee Williams – *The Roman Spring of Mrs Stone*

Drama
Christopher Fry – *Venus Observed*
Marcel Aymé – *Clérambard*

Music
Copland – Quartet for Piano and Strings
Harry Partch – *Cloud Chamber Music*

Art
Franz Kline – *Chief*
Barnett Newman – *Tundra*
Léger – *The Constructors*
Matisse – *Zulma*
Dubuffet – *Corps de Dame*

Architecture
Le Corbusier – Notre-Dame du Haut, Ronchamp (1950–55)
Le Corbusier – Supreme Court, Chandigarh, India (1950–56)
Eero Saarinen – Technical Center of General Motors, Warren, Michigan (1950–55)

Cinema
Cocteau – *Orphée*
Buñuel – *Los Olvidados*
Wilder – *Sunset Boulevard*
Antonioni – *Cronaca di un amore*
Max Ophuls – *La Ronde*
Kurosawa – *Rashomon*

Right: Le Corbusier — Chapel of Notre-Dame-du-Haut, Ronchamp (1950–55). Architecture used once again as a medium for personal statements.

Below: Giacometti group — *La forêt*; Existential sculpture.

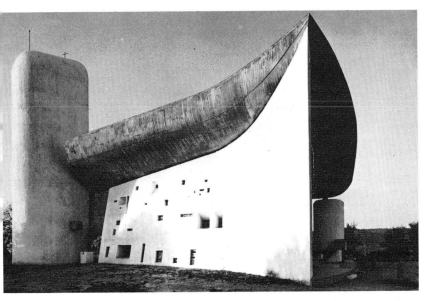

Below: British designs for European Recovery Programme posters.

Right: Jackson Pollock — *Lavender Mist.* Subjectivity on a monumental scale.

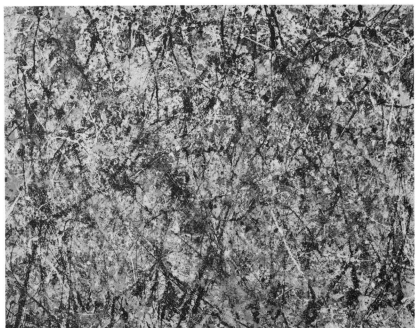

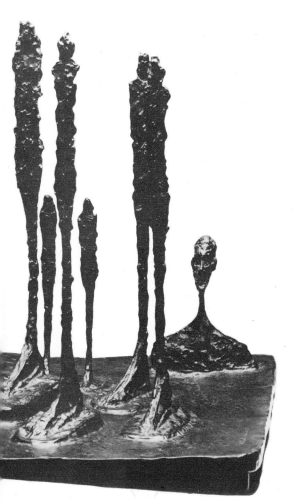

Right: Senator McCarthy's Investigation Committee (McCarthy is on the left). The anti-Communist hysteria was to leave its mark on American culture and politics for many years to come.

The Age of Anxiety

architecture. The United States had been protected from the worst consequences of the war, and had at the same time received a great influx of leading European architects, who found that it was the only place where they could hope to practise their profession. There was therefore no break with what the International Modern Movement had achieved in the twenties and thirties. Mies van der Rohe had already evolved the site-plan for one of his most important post-war projects, the Illinois Institute of Technology, in 1939–40; and some of the buildings were erected as early as 1946.

The Illinois Institute of Technology was typical of one aspect of modern architecture in America during the fifteen years that followed the war. There was an enormous number of prestige buildings for leading American universities, which had then entered a period of rapid expansion, partly thanks to the increase in numbers of students brought by the GI Bill of Rights. The Korean war ensured that the flow continued long after 1946.

Among the notable buildings put up for university clients were Louis Kahn's Medical Research Building for the University of Pennsylvania (1958), and Paul Rudolph's Art and Architecture Building for Yale (1959). The idea behind such buildings seems to have been that in themselves they should make a contribution to the institution as a work of art, as well as serving some useful function.

Even more eager to commission prestige projects of this type were certain commercial clients. It was the second great era of the skyscraper in New York. Two of the best-known are Lever House, by Gordon Bunshaft of Skidmore, Owings and Merrill (1952); and Mies van der Rohe's Seagram Building (1958). The latter has long been regarded as the ultimate refinement of the International Modern style. The monolithic, bronzed-glass structure soars from a plaza which leaves plenty of room for the spectator to admire not only the perfection of the detailing, but the extravagance of using so little of the site.

The Seagram Building is eloquent about something else as well. It leaves us in no doubt that a very high degree of technology was needed in order to construct it.

Considerations of prestige also affected the form of a number of important buildings constructed outside America. Some, such as José Luis Sert's American Embassy building in Baghdad (1955–63), were actually built for U.S. Government purposes. More often, however, they were visible expressions of a new sense of nationhood, like Niemeyer's splendid Presidential Palace in Brasilia (1958), or the beautiful but controversial Sydney Opera House (1956–68) by Jorn Utzon.

1951

General Events

Seoul was taken by North Korean forces and again retaken.
There was a purge of the Czechoslovak Communist Party.
Mossadeq became Prime Minister of Iran.
Burgess and Maclean, British diplomats who had spied for the Russians, fled to the U.S.S.R.
King Abdullah of Jordan was assassinated.
The Conservative Party won a British general election; Churchill again became Prime Minister.
Peron was re-elected President of Argentina.
American presidents were limited to two terms by the 22nd Amendment.
Julius and Ethel Rosenberg were sentenced to death for espionage against the U.S.
Electric power was produced from atomic energy.
The Festival of Britain took place in London.
Ortega y Gasset published *Man as Utopist Creature*.
The U.S.S.R. exploded an atomic bomb.

The Arts

Literature
J.D. Salinger – *The Catcher in the Rye*
C.P. Snow – *The Masters*
William Faulkner – *Requiem for a Nun*
Graham Greene – *The End of the Affair*
Herman Wouk – *The Caine Mutiny*
Anthony Powell – *A Question of Upbringing*
Heinrich Böll – *Wo Warst du, Adam*

Drama
Sartre – *Le Diable et le Bon Dieu*
Christopher Fry – *A Sleep of Prisoners*
Anouilh – *Colombe*
Ionesco – *The Chairs*

Music
Britten – *Billy Budd*
Menotti – *Amahl and the Night Visitors*
Hindemith – *Die Harmonie der Welt* (Symphony)
Stockhausen – *Kreuzspiel*
Stravinsky – *The Rake's Progress* (libretto by W.H. Auden and Chester Kallman)
Cage – *Imaginary Landscape No. 4*

Art
David Smith – *Hudson River Landscape*
Dali – *Crucifixion*
Kenneth Armitage – *People in a Wind*
Emilio Greco – *Seated Figure*
Picasso – *Massacre in Korea*

Architecture
Robert H. Matthew and J.L. Martin – Festival Hall, London
Aalto – Town Hall, Saynatsalo, Finland

Cinema
Alf Sjöberg – *Miss Julie*
Bresson – *Journal d'un curé de campagne*
Hitchcock – *Strangers on a Train*
Jacques Becker – *Edouard et Caroline*

Above: The Festival of Britain tried to proclaim Britain's recovery.

Above: Scene from Menotti's *The Consul*. The newspapers called it a 'lounge-suit opera'.

Right: William Roberts' poster for London Transport in Festival year entitled *London's Fairs*.

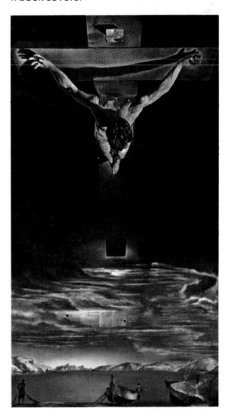

Below: Salvador Dali — *Crucifixion.*
This work was later to inspire many sci-fi book covers.

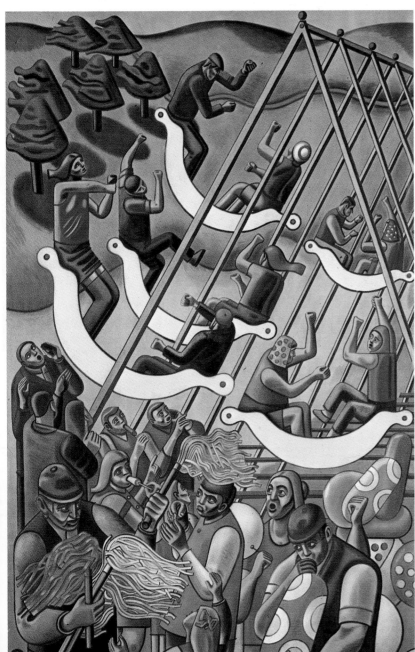

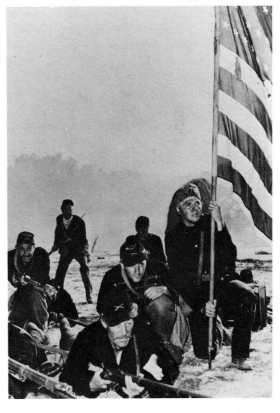

Above: John Huston's impeccable Civil War movie,
The Red Badge of Courage.

The Age of Anxiety

European requirements were on the whole very different. What was most needed was housing, and architects found themselves plunged into a new type of social engineering. An important example was set by Le Corbusier's *Unité d'habitation*, Marseilles (1947–52), the realization of a dream long cherished by the architect. Since the early twenties he had been interested in the idea of the super sky-scraper set in parkland as a way of improving the circulation of population and at the same time reducing the metropolis to human dimensions. The *Unité* at Marseilles, followed by similar buildings at Nantes-Rezé (1952–7), in Berlin (1957) and at Briey-la-forêt (1960), gave practical expression to Le Corbusier's ideas – they were meant to be vertical garden-cities, giving each family a maximum of privacy and independence in a minimum of space. No less than 350 families were contained within the eight double-storeys of a single vast construction.

These *Unités*, in turn, were the progenitors of the often taller though less bulky tower-blocks which played so prominent a role in post-war public housing, and which have since earned themselves an infamous reputation. Yet not all post-war housing was constructed according to Le Corbusier's pre-scriptions. In Britain, local authorities tried everything from cosy, cottagey terraces to 'mixed' developments combining low maisonettes and towers. The latter is well-exemplified by the large development designed by the firm of Powell and Moya at Churchill Gardens, Pimlico, London (1946–55).

The *Unité d'habitation* represented a new technological development as well as new ideas in planning. Working at Marseilles in relatively difficult post-war conditions, Le Corbusier could not hope to equal the refinement of finish which had characterized his pre-war work, and which was still to be found in what architects like Mies van der Rohe were doing in America. He made a virtue of necessity, building in concrete, and leaving the marks of the rough board shuttering still visible in the finished work. Later, working at Chandigarh in India with yet more limited technical resources, he carried this method still further, substituting rough strength for sophistication.

Le Corbusier's treatment of concrete, or *béton brut*, was to be one of the chief sources of inspira-tion for the style which came to be called the New Brutalism. The new movement was headed by the British architects Peter and Alison Smithson. The school they designed for Hunstanton, Norfolk (1954), shows a direct, no-nonsense use of the most common modern building materials, producing Miesian strictness without Miesian luxury. The

1952

General Events

Neguib seized power in Egypt; Farouk was dethroned.
King George VI died and was succeeded by Elizabeth II.
The U.S. exploded the first hydrogen bomb.
Eisenhower was elected President of the U.S.
Chinese Premier Chou-en-lai visited Moscow.
A State of Emergency was proclaimed in Kenya following Mau Mau attacks.
Slanksy was accused of high treason in Czechoslovakia and executed.
Israel and Germany agreed on compensation for Nazi persecution of the Jews.
Jericho was excavated by Kathleen Kenyon.
Archaeological finds could now be dated by the radio-carbon technique.
Isotopes came into general use in medicine and industry.

The Arts

Literature
Hemingway – *The Old Man and the Sea*
Ray Bradbury – *The Illustrated Man*
Doris Lessing – *Martha Quest*
Angus Wilson – *Hemlock and After*
Evelyn Waugh – *Men at Arms*
Truman Capote – *The Grass Harp*
John Steinbeck – *East of Eden*

Drama
Beckett – *Waiting for Godot* (published; *première* in 1953)
Agatha Christie – *The Mousetrap*
Rattigan – *The Deep Blue Sea*
Marcel Aymé – *La Tête des autres*

Music
Prokofiev – Seventh Symphony
John Cage – *Williams Mix*
Pierre Boulez – *Structures* (for two pianos)
Hans Werner Henze – *Boulevard Solitude*

Art
Jack Levine – *Gangster Funeral* (1952–3)
Jackson Pollock – *Convergence*
Helen Frankenthaler – *Mountains and Sea*
Willem de Kooning – *Woman and Bicycle* (1952–3)

Architecture
Oud – Biomarine Children's Sanatorium, near Arnhem (1952–6)
Mies van der Rohe – Crown Hall, Illinois Institute of Technology (1952–6)
Gordon Bunshaft (Skidmore, Owings and Merrill) – Lever House, New York

Cinema
De Sica – *Umberto D.*
Becker – *Casque d'or*
Elia Kazan – *Viva Zapata!* (with Brando)
René Clément – *Jeux Interdits*
John Huston – *The African Queen*

Right: Gordon Bunshaft's Lever House, New York. Prestige corporation architecture such as this seems centuries apart from the interior of a 'People's House' at Market Bosworth, England (below), which reflects the worst aspects of austerity-ridden British planning.

Below: Perhaps the greatest Hollywood western — *High Noon*, directed by Fred Zinneman.

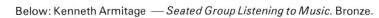
Below: Kenneth Armitage — *Seated Group Listening to Music.* Bronze.

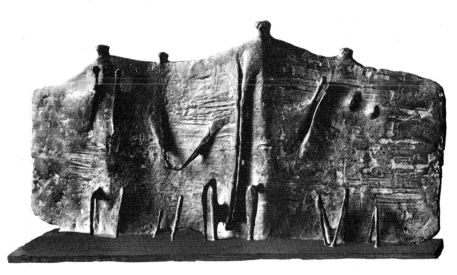

Below: Matisse — *Seated Blue Nude III.* Papier découpé.

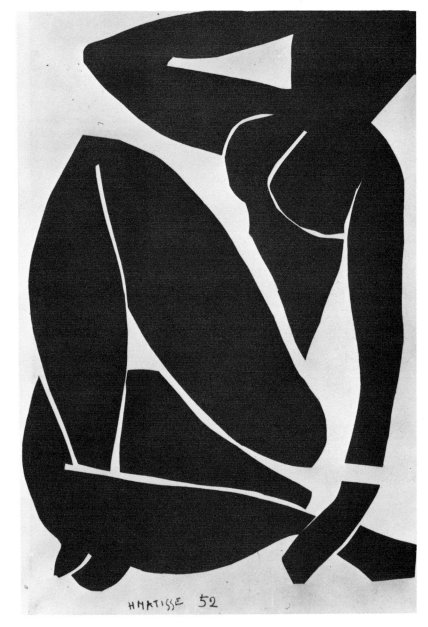

127

The Age of Anxiety

attitude expressed at Hunstanton was to be taken still further by another architect associated with the New Brutalism – James Stirling. In a low-cost housing scheme at Ham Common (Stirling and Gowan, 1956) Stirling demonstrated how the new ready-made building-systems, such as CLASP, could be recycled and used *ad hoc* to produce an individual yet economical result. The confidence of work such as Stirling's in public housing makes a strange contrast with the eclectic timidity of one of the few important 'prestige' buildings erected in Britain during the same period: Sir Basil Spence's Coventry Cathedral (1954–62).

In a strange way, the two greatest extremes in the architecture of the forties and fifties can be brought together, and turn out to be expressing much the same thing. One extreme is represented by a small group of symbolic, very personal buildings in which the idea of practical use plays little part. The best known are Le Corbusier's chapel of Notre-Dame du Haut at Ronchamp, Vosges (1950–4); and Frank Lloyd Wright's Guggenheim Museum in New York (1956–9). The other extreme consists of a kind of architecture which is now beginning to be called 'post-modern'. It embraces both the hotels being built by Morris Lapidus in Miami in the mid-fifties, and the amazing street-scape of giant advertising signs being created in Las Vegas during the same period. In both categories one sees a rebellion against the utilitarian ideal and a return to symbolic architecture.

While the architects can be said to have been supplying a blue-print, albeit one that was constantly altered, for post-war society, by contrast, a vocal critique of it was being supplied by the writers.

Poetry was extraordinarily various. In England, the high-pitched romanticism of Dylan Thomas's *Deaths and Entrances* (1946) was succeeded by the anti-romantic dryness of the Movement poets, among them Philip Larkin, Donald Davie, Kingsley Amis and John Wain. The change in direction was marked by the publication of Philip Larkin's second book of poems, *The Less Deceived*, in 1955. Wry and withdrawn, prone to see the absurdity of any situation, Larkin summed up the attitudes of a whole generation of English intellectuals – the boys who had come from the red-brick schools and red-brick suburbs of the north of England, and who had made it into the two great universities. These intellectuals were radical in their social attitudes, but often conservative in cultural stance. They were conscious of their membership of a very important club, to which they had been admitted only by their own efforts.

In America, the situation was different. Poets had long been affiliated to universities, and academic

General Events

Russia temporarily severed diplomatic relations with Israel.
Stalin died and was succeeded by Malenkov.
Tito visited London.
Dag Hammarskjöld was elected Secretary-General of the U.N.
Jomo Kenyatta was tried and convicted of managing Mau Mau.
Vietnamese rebels attacked Laos.
Queen Elizabeth II was crowned.
A Korean armistice was signed at Panmunjon on July 27.
After a royal *coup d'état* in Iran, Premier Mossadeq was arrested and imprisoned.
Mount Everest was climbed for the first time.
Russia exploded a hydrogen bomb.
'Piltdown Man' was proved to be a hoax.
Martin Heidegger published *Introduction to Metaphysics.*

The Arts

Literature
Ian Fleming – *Casino Royale*
Charles Olson – *The Maximus Poems, 1–10*
Saul Bellow – *The Adventures of Augie March*
James Baldwin – *Go Tell It on the Mountain*
Alain Robbe-Grillet – *Les Gommes*

Drama
T.S. Eliot – *The Confidential Clerk*
Arthur Miller – *The Crucible*
Graham Greene – *The Living Room*
Tennessee Williams – *Camino Real* (final version)

Music
Britten – *Gloriana*
Britten – *Spring Symphony*
Shostakovich – Tenth Symphony
Stockhausen – *Electronic Study I*
Earle Browne – *Twenty-five Pages*

Art
Matisse – *L'Escargot*
Reg Butler – *The Unknown Political Prisoner*
Henry Moore – *King and Queen*
Mark Tobey – *Edge of August*
Max Ernst – *Cry of the Seagull*

Architecture
Max Bill – Hochschule für Gestaltung, Ulm (1953–5)
Nervi – UNESCO Conference Hall, Paris (1953–7)

Cinema
Tati – *Mr Hulot's Holiday*
Clouzot – *Le Salaire de la Peur*
Fritz Lang – *The Big Heat*
Teinsuke Kinosuga – *Gate of Hell*
Fellini – *I Vitelloni*
Mizoguchi – *Ugetsu Monogatori*

Below: Germaine Richier —*Ant.* Bronze and wire.

Above: Hans Hartung. Engraving. An example of European free-form abstraction.

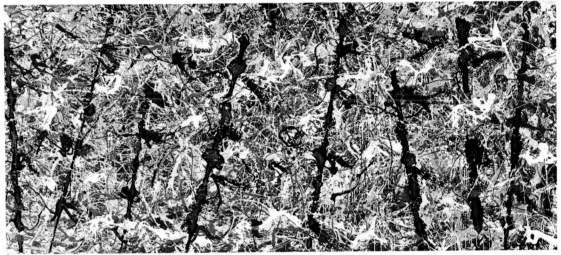

Above: Jackson Pollock — *Blue Poles.* One of the major masterpieces of Abstract Expressionism.

Below: The coronation of H.M. Queen Elizabeth II. An official photograph by Cecil Beaton.

Below: Francis Bacon — *Study after Velazquez.* A version of the portrait of Pope Innocent X.

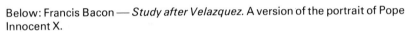

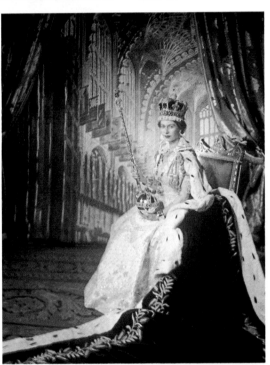

Above: Stalin's funeral, an event that began a gradual process of change in the Soviet Union, but no great cultural liberalization.

The Age of Anxiety

poetry had begun to develop various groups and sub-groups. There were dandified conservatives, such as Richard Wilbur. There were followers of Pound, chief among them Charles Olson, whose theory of the 'unit of breath', expressed in his essay *Projective Verse*, was to have great influence on the development of American poetry.

The most celebrated practitioners of poetry in the America of the fifties were, however, the Beats, and chief among these was Allen Ginsberg. Ginsberg's long poem *Howl*, published by the City Lights Bookshop in San Francisco in 1956, caused a sensation amongst the restless young. *Howl* is a heady mixture of New York Jewish radicalism and backwoods American non-conformity. It is equally in debt to the Bible and to Whitman, and its chanting rhythms are given their special flavour by a mixture of the high style and the low – the speech of the intellectual and the coarse demotic of the factory floor – spiced with zany humour. The improvisatory element in beat poetry also owed a great deal to the long-established tradition of improvisation in jazz. Its note of protest was new in post-war literature, and so was the open rejection of everything Americans thought they had achieved. Thousands of Americans, adrift in a materialist and complacent society that seemed to have little that was satisfactory to offer them, turned *Howl* into a sacred text. An ill-advised and unsuccessful police prosecution gave the final touch to its celebrity.

In 1959, yet another note was introduced into the wide gamut of American poetry, with the publication of Robert Lowell's *Life Studies*, herald of what was later to be called 'confessional verse'.

As one might expect, both the war and the immediate consequences of the peace supplied material for a great many of the novels which appeared immediately post-war. Of all the war-novels, the most successful, and also the most notorious, was Norman Mailer's *The Naked and the Dead* (1948). Mailer takes up the theme of comradeship which had already been developed by Hemingway – the book is about a small group of American soldiers who are members of a reconnaissance patrol sent out before a proposed attack on a Japanese-held island in the Pacific. Mailer later failed to fulfil his promise as a major novelist, chiefly because of a developing self-consciousness, an unwillingness to see that the fictional world has its own rules, which have nothing to do with autobiography.

The more traditional novel did, however, stage a post-war comeback, chiefly in the hands of fairly senior writers, those with the ability to create a whole world, peopled with characters. They are, however, an extremely mixed bag. Among them we

1954

General Events

Nasser seized power in Egypt.
Malenkov became Premier of the U.S.S.R.
The Vietnamese Communists took Dien Bien Phu from the French; they also occupied Hanoi.
The U.S. Supreme Court ruled that segregation in public schools was a violation of the Constitution.
The South East Asia Treaty Organization was established.
Senator Joseph R. McCarthy continued his anti-Communist witch-hunt, but was finally censured by a Senate resolution.
There was widespread public concern about the disposal of radio-active waste.
The connection between smoking and lung-cancer was seriously suggested for the first time.
The first vertical take-off aircraft flew.
Roger Bannister ran a mile in 3 mins., 59.4 secs.
American troops were first sent to Vietnam.
Gilbert Ryle published *Dilemmas*.

The Arts

Literature
Kingsley Amis – *Lucky Jim*
John Betjeman – *A Few Late Chrysanthemums*
William Golding – *Lord of the Flies*
Françoise Sagan – *Bonjour Tristesse*
Tolkien – *The Lord of the Rings* (parts 1 and 2)
Nicanor Parra – *Poemas y Antipoemas*

Drama
Christopher Fry – *The Dark is Light Enough*
Rattigan – *Separate Tables*
John van Druten – *I am a Camera* (based on Isherwood)
Brendan Behan – *The Quare Fellow*

Music
Britten – *The Turn of the Screw*
Copland – *The Tender Land*
Walton – *Troilus and Cressida*
Pierre Boulez – *Le Marteau sans Maître* (1953–4)

Art
John Bratby – *Dustbins*
Graham Sutherland – *Portrait of Churchill* (destroyed)
Dubuffet – *Les Vagabonds*

Architecture
Basil Spence – Coventry Cathedral (1954–62)
Felix Candela – Church of the Virgin Milagrosa, Mexico City (1954–5)
Peter and Alison Smithson – Secondary School, Hunstanton, Norfolk

Cinema
Visconti – *Senso*
Kurosawa – *The Seven Samurai*
Fellini – *La Strada*
Elia Kazan – *On the Waterfront*

Left: Marlon Brando in *On the Waterfront* directed by Elia Kazan, whose films expressed a slightly suspect but culturally influential anger.

Below: A casualty at the battle of Dien Bien Phu.

Left: Reg Butler — *Girl*. Bronze.

Above: Colonel Nasser greets his people; he was one of the first signs of true independence in the Third World.

Left: *Seven Samurai*, one of the first Japanese films to make an impact in the West.

131

The Age of Anxiety

find Thomas Mann, with *Doktor Faustus* (1947); Boris Pasternak, with *Dr Zhivago* (1958); Giuseppe di Lampedusa, with *The Leopard* (1958); and Evelyn Waugh with a trilogy of novels about the war, seen from a point of view very different from the one expressed by Mailer: *Men at Arms* (1952), *Officers and Gentlemen* (1955) and *Unconditional Surrender* (1961). If these very different books and authors have any one thing in common it is a nostalgia for an irrecoverable past.

In Britain, the rapid changes taking place in society found expression in the work of a number of novelists whom critics associated with the 'Angry Generation' in the theatre. There was a spate of novels about working-class life. Among the most notable were Alan Sillitoe's *Saturday Night and Sunday Morning* (1958), and David Storey's *This Sporting Life* (1960). There were also comic novels about life in the provinces, which dealt at a slightly higher social level. Kingsley Amis's hugely successful *Lucky Jim* (1954) was largely responsible for the creation of a new type, the middle-class anti-hero with a hatred of cultural snobbery and all forms of intellectual pretentiousness.

Social rebellion in America expressed itself in a different and more subjective form, first with J. D. Salinger's *The Catcher in the Rye* (1951) with its enormously appealing picture of helpless adolescent rebelliousness, and then in the 'beat' novels of Jack Kerouac, among them *On the Road* (1957), *The Dharma Bums* (1958) and *The Subterraneans* (1958). Kerouac recounts the incidents of his own life in very thinly fictionalized form. For instance, the hero of *The Dharma Bums*, who appears in the book under the sobriquet 'Japhy Ryder', is fairly obviously the poet Gary Snyder. Kerouac belongs to the American tradition of autobiographical frankness, telling all, whose most distinguished exponents are probably Henry Miller and Edward Dahlberg.

The symbolic novel, however, flourished during the period just as much as the novel of reportage, and sometimes appeared in somewhat unexpected guises. Graham Greene used contemporary political events as a framework in both *The Quiet American* (1955), set in a Vietnam the Americans were just beginning to penetrate; and in *Our Man in Havana* (1958), set in Batista's Cuba. In these books he used political corruption and moral squalor as the framework for a debate about good and evil, but in such a way as to leave us always uncertain as to which would triumph.

Greene's allegories are more subtle than Orwell's, but *Nineteen Eighty-Four* (1949), a vision which shows a hapless hero in the grip of tyranny and 'doublethink', is undoubtedly a powerful political

1955

General Events

Malenkov resigned and was succeeded by Bulganin.
Italy, West Germany and France established the European Union.
Churchill resigned as British Prime Minister, and was succeeded by Anthony Eden.
West Germany became a member of NATO.
Peron resigned the presidency of Argentina.
Gaitskell succeeded Attlee as leader of the British Labour Party.
There was a bus-boycott in Montgomery, Alabama, organized by blacks protesting against segregation.
The International Copyright Convention came into force.
A practical vaccine for poliomyelitis was discovered.
South Vietnam was proclaimed a republic.

The Arts

Literature
John O'Hara – *Ten North Frederick*
Joyce Cary – *Not Honour More*
Graham Greene – *The Quiet American*
Nabokov – *Lolita*
Herman Wouk – *Marjorie Morningstar*
Iris Murdoch – *The Flight from the Enchanter*
Philip Larkin – *The Less Deceived*
Evelyn Waugh – *Officers and Gentlemen*

Drama
Sartre – *Nekrassov*
Ugo Betti – *The Queen and the Rebels* (posthumous)
Arthur Miller – *A View from the Bridge*
Tennessee Williams – *Cat on a Hot Tin Roof*

Music
Walter Piston – Sixth Symphony
Stockhausen – *Gesang der Jünglinge*
Tippett – *The Midsummer Marriage*

Art
Annigoni – *Portrait of Queen Elizabeth II*
John Bratby – *Still Life with Chip Fryer*
Larry Rivers – *Double Portrait of Birdie*
Robert Rauschenberg – *Bed*

Architecture
Frank Lloyd Wright – Price Tower, Bartlesville, Oklahoma
Viljo Revell – Kueneule Textile Works, Hanko, Finland
José Luis Sert – U.S. Embassy, Baghdad (1955–63)

Cinema
Max Ophuls – *Lola Montès*
Antonioni – *Le Amiche*
Ingmar Bergman – *Smiles of a Summer Night*
Alain Resnais – *Nuit et Brouillard*
Elia Kazan – *East of Eden* (with James Dean)
Nicholas Ray – *Rebel without a Cause* (with James Dean)
Satyajit Ray – *Pather Panchali*
René Clair – *Les Grands Manoeuvres*

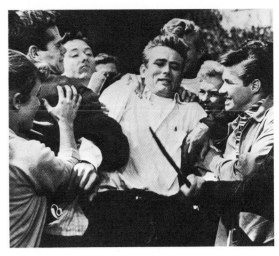

Above: Teen hero, on his way to becoming a cult figure. James Dean in *Rebel without a Cause*.

Above: Kurosawa (in hat) directs *I Live in Fear*.

Left: Robert Motherwell — *I Love You Ila*.

133

The Age of Anxiety

tract. William Golding's first book, *Lord of the Flies* (1954), is another forcefully gloomy political and moral allegory, a chilling elaboration of the doctrine of original sin.

Women writers were also attracted to the symbolic novel. Muriel Spark, a Catholic like Waugh and Greene, began a long series of novels with transcendental overtones with *The Comforters* (1957). In Iris Murdoch's early books, as in Muriel Spark's, events often move outside the ordinary or naturalistic frame of reference, and the development of events is wilfully distorted for the sake of keeping to some predetermined symbolic pattern.

One further allegorical work deserves a mention – J. R. Tolkien's extraordinary three-volume prose-epic, *The Lord of the Rings*. At one level this is superior fantasy of the kind also popular with the readers of science-fiction, a genre which was making rapid progress, though little noticed by critics, throughout the fifties. *Lord of the Rings* has elements of the fairy-story, of Nordic sagas and of *Alice in Wonderland*. Its success showed how far the rebellion against naturalism could be taken, and it played a substantial part in creating a new ethos for the sixties.

Very different from Tolkien, but 'outsiders' in much the same sense, are the Argentinian Juan Luis Borges and the Russo-American Vladimir Nabokov. In the fifties Borges published a series of books containing short-stories, parables and essays – they include *Ficciones* (1956), *El Aleph* (1957) and *Otras Inquisiciones* (1960). Nabokov's most popular book was the scandalous *Lolita* (1955), responsible for introducing the word 'nymphet' to the language, but his best was probably *Pnin* (1957). Like that of Borges, his work shows a concern with the nature of fiction itself.

In their self-consciousness and their dandified precision these otherwise very different writers can be compared to the French 'new novelists' who emerged at this time. These – they included Nathalie Sarraute, Alain Robbe-Grillet, Michel Butor and Marguerite Duras – mistrusted the traditional structure of the novel, avoided the pathetic fallacy and refused to commit themselves to the creation of character. This severity did not, however, preclude a liking for puzzles (a point in common with Borges). In Robbe-Grillet's *Les Gommes* (1953), for example, one finds a detective story without a solution which also seems to be based in some measure, like Eliot's *The Waste Land*, on the cards of the Tarot.

The rejection of conventional fictional strategies in the work of the new novelists was eventually to have a powerful and lasting impact on the cinema, a medium in which many of them also worked.

1956

General Events

Sudan became an independent republic.
Khrushchev denounced Stalin at the 20th Soviet Communist Party Conference.
Nasser was elected President of Egypt.
Nasser seized the Suez Canal.
The Israelis invaded Sinai.
French and British forces occupied the Canal Zone but were forced to withdraw.
Soviet troops invaded Hungary to put down the uprising.
Eisenhower was re-elected President of the U.S.
Martin Luther King emerged as the leader of the de-segregation campaign in America.
Castro landed in Cuba with a small armed force in an attempt to overthrow Batista.
The transatlantic telephone service was inaugurated.
Japan was admitted to the U.N.
A.J. Ayer published *The Revolution in Philosophy*.

Below: Eduardo Paolozzi — *Jason*. Bronze.

The Arts

Literature
Colin Wilson – *The Outsider*
Angus Wilson – *Anglo-Saxon Attitudes*
Borges – *Ficciones*
Allen Ginsberg – *Howl*

Drama
John Osborne – *Look Back in Anger*
Anouilh – *Pauvre Bitos*

Music
Stravinsky – *Canticum Sacrum Sancti Marci nominis*
Frank Martin – *The Tempest*
Luciano Berio – *Mutazioni*
Stockhausen – *Piano Piece XI*
Messiaen – *Catalogue d'oiseaux* (1956–8)

Art
Philip Guston – *The Clock* (1956–7)
Braque – *Studio IX* (1952–6)
Alan Davie – *The Martyrdom of St Catherine*
Richard Hamilton – *Just what is it makes today's homes so different, so appealing?*

Architecture
Buckminster Fuller – Auditorium, Honolulu
Nervi and Annibale Vitelozzi – Palazzo dello Sport, Rome (1956–7)
Stirling and Gowan – Housing, Ham Common, London
Utzon – Sydney Opera House (1956–68)
Frank Lloyd Wright – Guggenheim Museum, New York (1956–9)

Cinema
Elia Kazan – *Baby Doll*
Bresson – *Un condamné à mort s'est échappé*
Clouzot – *Le Mystère Picasso*
Bergman – *The Seventh Seal*

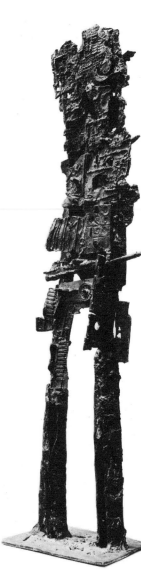

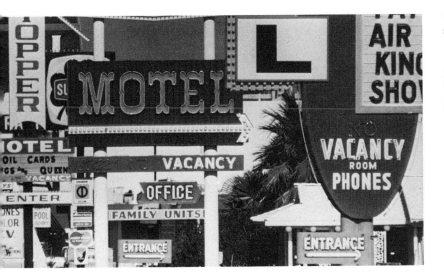

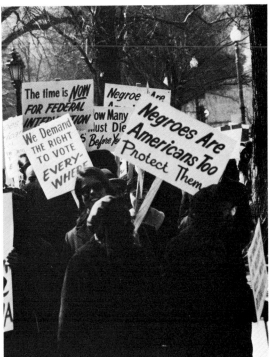

Left: Las Vegas landscape. Pop Art before it became self-conscious.

Above: Civil rights demonstrators protest outside the White House.

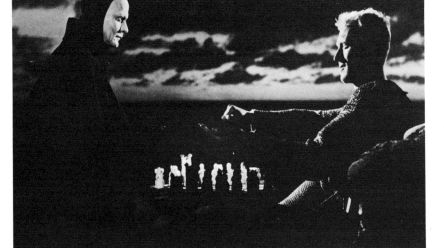

Left: Ingmar Bergman's apocalyptic myth — *The Seventh Seal.*

Below: Another kind of legend. Marilyn Monroe in Joshua Logan's *Bus Stop.* This, too, is Pop Art in the making.

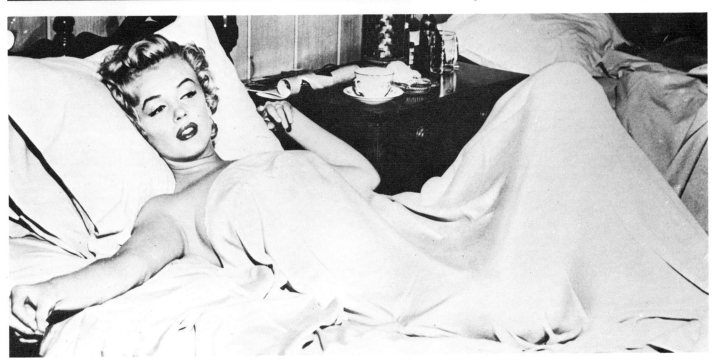

The Age of Anxiety

In the forties and fifties film was, in any case, perhaps the freest and richest of the means of creative expression. One of the most striking things about it was its growing internationalization. These were the years, for example, in which both the Swedish and the Japanese cinema came to the fore. Films like Akira Kurosawa's *Rashomon* (1950) and Ingmar Bergman's *The Seventh Seal* (1956) moved audiences everywhere as self-sufficient works of art. So did the Bengali-language Indian films of Satyajit Ray: the three works that make up his Apu trilogy – *Pather Panchali, Aparajito* and *Apur Sansar* – were made in 1955, 1957 and 1959 respectively. Another distinguished recruit to the international scene was the Polish director Andrzej Wadja, with *Kanal* (1957) and *Ashes and Diamonds* (1958).

But Japanese, Swedish, Indian and Polish movies were only the brilliant sidelines of the development of film. The continuity lay elsewhere – in Italy, France and, of course, the United States. The Italian cinema continued on the basis of the neo-realist style already established by Visconti and Rossellini. De Sica's *Bicycle Thieves* (1948) and *Umberto D.* (1952); Visconti's *La Terra Trema* (1948), Fellini's *I Vitelloni* (1953): all of these were works which valued man even at his most worthless, and which allowed the protagonists to show the audience whatever qualities they possessed without trickery or forcing.

Gradually, however, a new tone began to creep into Italian film-making. With Fellini, for example, the realism of *I Vitelloni* became the sentimental *commedia dell'arte* of *La Strada* (1954), and finally a resonant, self-indulgent exploration of decadence in *La Dolce Vita* (1959), a film which announced that Italian society had taken on an entirely new tone, and that, chameleon-like, the director had changed to suit it.

Michelangelo Antonioni, whose breakthrough film with the international public was *L'Avventura* (1960), is at first sight Fellini's opposite, but the two are closely allied in subjectivity of attitude. The novelist Alberto Moravia, writing about Antonioni in 1961, noted that among his qualities were 'the complete elimination of everything that produces movement, incident, conflict, progression or agitation, such as psychology, plot development, characters and ideas'. It was not intended as a hostile assessment. Moravia understood that, in the person of Antonioni, the Italian cinema had produced an equivalent for the 'new novelists' in France.

The French cinema proceeded in much the same direction though from a different starting point. After the war, the industry seemed to pick up the threads with surprising smoothness. René Clair

General Events

Eden resigned as Prime Minister of Britain and was succeeded by Harold Macmillan.
Israel withdrew from Sinai, and handed over the Gaza strip to the U.N.
The 'Six' signed the Treaty of Rome, marking the beginning of the European Common Market.
Archbishop Makarios was released from detention.
Russia launched the unmanned spacecraft Sputnik I.
Tunisia was proclaimed a republic.
Ghana attained independence.
Attempts to make artificial rain in New South Wales increased rainfall by 25 per cent.
A.J. Ayer published *The Problem of Knowledge*.

The Arts

Literature
L.P. Hartley – *The Hireling*
Patrick White – *Voss*
William Faulkner – *The Town*
Iris Murdoch – *The Sandcastle*
Muriel Spark – *The Comforters*
Jack Kerouac – *On the Road*
Nabokov – *Pnin*
Borges – *El Aleph*

Drama
Beckett – *Endgame*
Osborne – *The Entertainer*
Robert Bolt – *Flowering Cherry*

Music
Walton – Cello Concerto
Stockhausen – *Gruppen* (1955–7)
Pierre Boulez – *Improvisations*
Schoenberg – *Moses and Aaron* (*première*; begun in 1930)
Luigi Nono – Music for violin solo, strings and woodwinds
Stravinsky – *Agon*
Poulenc – *Dialogues des Carmélites*

Art
Bacon – *Screaming Nurse*
Victor Vasarély – *Cassiopée*
Graham Sutherland – *Princess Gourielli*

Architecture
Le Corbusier – Benedictine Monastery of Ste. Marie de la Tourette, Éveux-sur-Ardèche (1957–60)

Cinema
David Lean – *The Bridge on the River Kwai*
Satyajit Ray – *Aparajito*
Andrzej Wadja – *Kanal*

Right: Mathias Goeritz — Square of the Five Towers; this is the entrance to the Satellite City, Mexico City (1957–8).

Below: Scene from the *première* of Hindemith's *Harmonie der Welt*, based on the life of the astronomer Johannes Kepler.

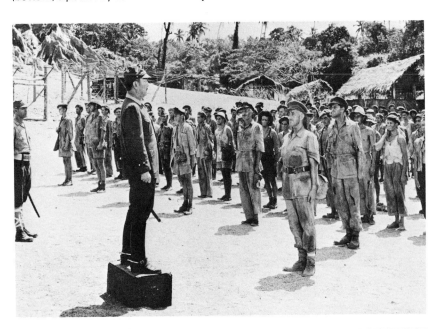

Below: Fashions in sentimentality. Still from *Bridge on the River Kwai* and (bottom) a poster by Saul Bass for *Bonjour Tristesse*.

BONJOUR TRISTESSE

Above: Rock 'n' roll played by Bill Haley. Haley was not only one of the creators of the sound, he has displayed staying power in a world of ephemera.

The Age of Anxiety

1958

returned from Hollywood and started to make films again; Jean Renoir and Marcel Carné also continued to film. Looking back, the French cinema of this immediately post-war period was essentially one that favoured skilful craftsmen. One recalls with most pleasure impeccably prepared, but rather unspontaneous works, such as Clair's elegant *Les Grands Manoeuvres* (1955).

Some outsiders were able to make a mark in this rather closed situation. One was Cocteau, whose *Orphée* (1950) was a sumptuous late bloom of the surrealist movement. Another was Jacques Tati, with a series of anarchically individual comedies starting with *Jour de Fête* (1949). A third was the classically austere Robert Bresson.

By the mid-fifties, a revolt was being prepared by a group of intellectuals centred round the periodical *Les Cahiers du Cinéma*. The first breakthrough was made by Alain Resnais with a documentary on the concentration camps, *Nuit et Brouillard* (1955). The first feature film of the 'nouvelle vague', as it came to be called, was Claude Chabrol's *Le Beau Serge* (1958); and this was followed by François Truffaut's *Les Quatre Cent Coups* (1959) and *Tirez sur le pianiste* (1960), by Jean-Luc Godard's *A Bout de Souffle* (1960), and by Resnais' own feature *Hiroshima Mon Amour* (1959). The procedures of the 'nouvelle vague' cinema had much to do with the 'new novel'. It was Marguerite Duras, for instance, who wrote the script for *Hiroshima Mon Amour*. It was a script which proposed a very different kind of narrative syntax from anything which had hitherto been seen in the movies, and its impact was correspondingly profound.

Other 'nouvelle vague' films were less serious in tone; they borrowed much from the American cinema and everything about them was light, flexible and informal. In one way they were self-consciously cinematic; and in another they assumed that film was a language which could be understood by the whole of a new post-war generation, without the need for further tutoring.

The development of American films was rather different. American directors retained their expertise in areas where Europeans had scarcely ever been able to rival them. They continued, for example, to make wonderful musical films like *On the Town* (1949). They also went on making excellent westerns. The industry was, however, deeply shaken by the activities of Senator Joseph McCarthy's Un-American Activities Committee, which led to the blacklisting of many talented people, and much mutual recrimination.

One of those who decided to co-operate, rather than ruin their careers, was the most-discussed Hollywood director of the time – Elia Kazan, who

General Events

The West Indies Federation came into being.
Egypt and Sudan linked up to form the United Arab Republic.
Vice-President Richard M. Nixon made a 'goodwill' tour of South America, and was received with hostility.
De Gaulle was elected President of France.
Alaska became the 49th State of the Union.
Russia made Egypt a loan to build the Aswan Dam.
Ayub Khan became Prime Minister of Pakistan.
Governor Orval Faubus of Arkansas closed public schools in Little Rock in an attempt to avoid desegregation, reopening them as private schools.
John XXIII was elected Pope.
There were race-riots in Notting Hill, London.
J.K. Galbraith published *The Affluent Society*.
Stereophonic gramophone records became generally available in the U.S.

The Arts

Literature
Iris Murdoch – *The Bell*
J.G. Cozzens – *By Love Possessed*
Angus Wilson – *The Middle Age of Mrs Eliot*
Alan Sillitoe – *Saturday Night and Sunday Morning*
Giuseppe di Lampedusa – *The Leopard*
Boris Pasternak – *Dr Zhivago*
Graham Greene – *Our Man in Havana*

Drama
Brendan Behan – *The Hostage*
Harold Pinter – *The Birthday Party*
T.S. Eliot – *The Elder Statesman*
Peter Shaffer – *Five Finger Exercise*
Arnold Wesker – *Chicken Soup with Barley*

Music
Varèse – *Poème électronique*
Britten – *Noye's Fludde*
Stravinsky – *Threni*

Art
Max Ernst – *Après moi le sommeil*
Alexander Calder – *The Dog* (stabile)
Henry Moore – Reclining figure for UNESCO Building, Paris
Karel Appel – *Women and Birds*

Architecture
Oscar Niemeyer – Presidential Palace, Brasilia
Mies van der Rohe – Seagram Building, New York
Louis Kahn – Alfred Newton Richards Medical Research Building, University of Pennsylvania, Philadelphia (1958–60)
Gio Ponti and Nervi – Pirelli Tower, Milan

Cinema
Andrzej Wadja – *Ashes and Diamonds*
Satyajit Ray – *The World of Apu*
Hitchcock – *Vertigo*
Buñuel – *Nazarin*
Claude Chabrol – *Le Beau Serge*

Above: The high tide of prestige architecture. Mies van der Rohe's Seagram Building.

Right: The Atomium, symbol of the Brussels International Exhibition. The atomic age expressed, rather naively, in architecture.

Below: Louis Kahn — Alfred Newton Richards Medical Research Building, University of Pennsylvania, Philadelphia (1958–60).

Above: New Polish cinema. Zbigniew Cybulski in Andrzej Wadja's *Ashes and Diamonds*.

Left: Jasper Johns — *Flag*. A herald of Pop Art.

The Age of Anxiety

1959

denounced several former Group Theatre associates as Communists. This somewhat ig-nominious episode points to the flaw in most of Kazan's films, which is his desire to have his cake and eat it – to be thoroughly commercial and yet at the same time to denounce social injustice. Kazan's resemblance to Italian neo-realists like Rossellini is superficial, but he can undoubtedly be a marvellous director of actors. He succeeded especially well with the young Marlon Brando and with James Dean.

Dean, whose reputation reached its peak in 1955 with Kazan's *East of Eden* and Nicholas Ray's *Rebel without a Cause*, was one of a pair of potent new American stars. The other was Marilyn Monroe. Apart from their appeal to the public, they had two other things in common: vulnerability and self-destructiveness. Monroe offered sex shorn of its threatening quality but not of a sense of humour; Dean acted out the fantasy of the shy, troubled adolescent.

If popular and intellectual elements found some meeting place in the cinema, they certainly found none in the field of 'serious' music. In fact, this was the area of creative activity in which the gap between so called 'high' and popular culture – so typical of this period – was most evident.

The rise of the long-playing gramophone record, which made the masterpieces of classical music freely available in every home, was an example of the means by which technology was altering the way that information about the arts was transmitted. But in this case it tended to concentrate attention on the achievements of the past, as opposed to what was taking place in the present. Lovers of music turned away from what was being done by contemporary composers in order to explore the immense heritage which had suddenly been made available to them on disc.

'Serious' musical activity during this period could essentially be divided into three categories. First, there were composers pursuing traditionally established paths, though sometimes with experimental overtones. The most senior and respected was Stravinsky, whose long-established neo-classicism reached a climax with the opera *The Rake's Progress* (1951). He then began to take possession of a manner he had once totally rejected – the dodecaphonic style of Schoenberg. The ballet *Agon*, parts of which date from 1953, shows the beginning of this process, and the wonderful *Threni* (1958) is the first piece which Stravinsky composed throughout in twelve-tone technique.

Shostakovich and Prokofiev, obedient to the established Soviet aesthetic, continued to compose in a traditional manner; and in England Britten showed that the opera, by its nature one of the most

General Events

The Batista regime collapsed in Cuba; Castro came to power.
De Gaulle became President of the Fifth Republic.
Archbishop Makarios returned to Cyprus, which became a republic.
Hawaii became the 50th State of the Union.
Lunik III, a Russian satellite, photographed the back of the moon.
A British hovercraft crossed the Channel in two hours.
The St. Lawrence Seaway was opened.
Singapore became self-governing.
Teilhard de Chardin published *The Phenomenon of Man*.

The Arts

Literature
William Burroughs – *The Naked Lunch*
Muriel Spark – *Memento Mori*
Günter Grass – *The Tin Drum*
Saul Bellow – *Henderson the Rain King*
Colin MacInnes – *Absolute Beginners*
Charles Olson – *Projective Verse*
Robert Lowell – *Life Studies*

Drama
Ionesco – *Rhinocéros*
Arnold Wesker – *Roots*
John Arden – *Serjeant Musgrave's Dance*

Music
Henze – *Der Prinz von Homburg*
Pierre Boulez – *Livre du Quatuor*
Peter Maxwell Davies – *St. Michael Sonata*
Stockhausen – *Kontakte* (1959–60)

Art
Stuart Davis – *The Paris Bit*
Morris Louis – *Saraband*
Jasper Johns – *Numbers in Colour*

Architecture
Paul Rudolph – Art and Architecture Building, Yale University (1959–63)
Oscar Niemeyer – The Square of the Three Powers, Brasilia
Arne Jacobsen – Royal Hotel, Copenhagen

Cinema
Alain Resnais – *Hiroshima Mon Amour*
Wilder – *Some Like It Hot* (with Marilyn Monroe)
François Truffaut – *Les Quatre Cent Coups*
Satyajit Ray – *Apur Sansar*
Fellini – *La dolce vita*

Above: Jerry Lee Lewis was one of a number of rock stars whose music was being pumped out on the new '45s' through juke boxes and radios all over the world.

Below: Karel Appel — *Big Animal Devours Little Animal.*

Right: Oscar Niemeyer — The Square of the Three Powers, Brasilia.

Below: Alberto Burri — *Ferro*. Relief made of soldered and painted metal.

Above: Still from Fellini's *La dolce vita* — a gleeful exposure of fashionable decadence.

Below: Georges Mathieu — *Painting*. Mathieu was one of the chief European propagandists for Abstract Expressionism.

The Age of Anxiety

conservative of musical forms, was still capable of developments. Starting with *Boulevard Solitude* (1952), Hans-Werner Henze also renewed the exploration of operatic possibilities.

The next group of composers were the dedicated experimentalists, and essentially their explorations now led them in two different directions. One was towards the aleatory – music into which there enters the element of chance. Composers associated with this tendency included John Cage, a veteran of the *avant-garde* in America, his compatriot Earle Browne, and a pupil of Messiaen, Pierre Boulez. As a European, Boulez took a more disciplined view of what was meant by 'chance' than his fellow musicians across the Atlantic. In *Imaginary Landscape No. 4* (1954), Cage had proposed a 'music' for a number of randomly tuned radio-receivers. Boulez, in some of his works a strict serialist, said: 'Chance plays the part of a railway point which clicks at the last moment. This idea is not a product of pure chance, but of non-determined choice.'

The other direction led to electronic music. Here the chief experimentalists were Karl-Heinz Stockhausen and the veteran Edgar Varèse. It was Varèse who, with his *Poème électronique* (1958), produced the first music written directly on tape.

These musical experiments found only a restricted public. What, on the other hand, showed immense capacity for growth, was the popular music industry. This expansion, which took place from the mid-fifties onwards, was largely due to the rise of rock 'n' roll. Rock 'n' roll had its origins in the American South. It combined Negro music – jazz and blues – with poor-white Country and Western. This interbreeding produced a driving, rhythmic sound with universal appeal, particularly to the young. Many of the early rock 'n' roll stars were black, among them Chuck Berry and Little Richard, and it was Berry, in particular, who crystallized an anti-romantic, anti-puritan, openly hedonistic attitude that attracted teenagers all over the world.

But the undisputed 'King of Rock', was the white singer, Elvis Presley. Presley's first single, *That's All Right Mama*, was recorded in 1954. By 1956 he was a colossal star, at number one in the American hit parade every week without interruption between August and December. What he came to symbolize was a new culture, in opposition to what was officially approved. It developed its own clothes, language and life-style. The one thing it did not attract, at least until the conclusion of the decade, was intellectual analysis or comment. The last five years of the fifties were the Age of Innocence for rock 'n' roll. It was the cessation of that innocence which in large part created the cultural atmosphere of the sixties.

1960

General Events

Brezhnev became President of the U.S.S.R.
The U-2 incident occurred. An American spy-plane was shot down over Russia and the pilot, Gary Powers, was captured after bailing out.
Khrushchev, Eisenhower, De Gaulle and Macmillan met in Paris for abortive summit talks.
Cyprus became independent as a republic under Makarios.
The Belgian Congo was granted full independence and the U.N. was forced to intervene in the ensuing political disturbance.
The Nixon-Kennedy debates took place on television in the course of the U.S. election campaign.
A heart pacemaker was developed in Birmingham by a group of British surgeons.
There was a Negro sit-in campaign at lunch-counters in America.
The U.S. Senate passed the Civil Rights Bill safeguarding Negro voting rights.
Sartre published *Critique de la raison dialectique*.
A.J. Ayer published *Logical Positivism*.

The Arts

Literature
Lawrence Durrell – *Clea* (final novel in the Alexandria Quartet)
Ted Hughes – *The Hawk in the Rain*
Abram Tertz – *The Trial Begins*
Michel Butor – *Degrees*
David Storey – *This Sporting Life*
Borges – *Otras Inquisiciones*

Drama
Robert Bolt – *A Man for All Seasons*
Harold Pinter – *The Caretaker*
Arnold Wesker – *I'm Talking About Jerusalem*

Music
Britten – *A Midsummer Night's Dream*
Pierre Boulez – *Portrait of Mallarmé*

Art
Pierre Alechinsky – *The Green being Born*
Lucio Fontana – *Spatial Concept*
Takis – *Electro magnetic* (1960–67)
Giacomo Manzù – *Fruit and vegetables on a chair*

Architecture
Breuer – IBM Research Centre, La Gaude, near Nice (1960–62)
Paul Rudolph – Endo Laboratories, Long Island (1960–64)
Jean Tschumi – Nestlé Headquarters, Vevey, Switzerland

Cinema
Antonioni – *L'Avventura*
Hitchcock – *Psycho*
Visconti – *Rocco and his Brothers*
Truffaut – *Tirez sur le pianiste*
Jean-Luc Godard – *A Bout de Souffle*

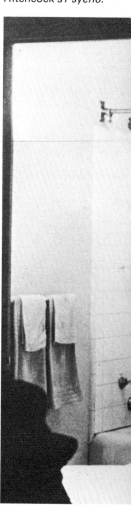

Above: Jean-Luc Godard. Jean Seberg and Jean-Paul Belmondo in *A Bout de Souffle*.

Below: The psychological thriller. A scene from Alfred Hitchcock's *Psycho*.

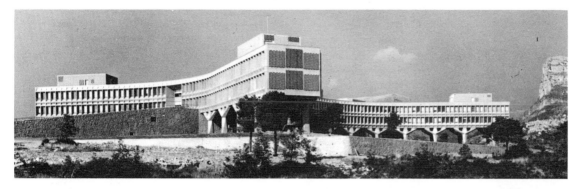

Left: Marcel Breuer. IBM Research Center, La Gaude, near Nice. Corporate prestige.

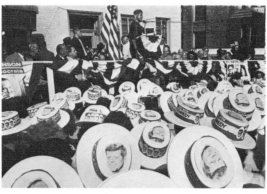
Left: John F. Kennedy campaigning for the Presidency.

Below: *Moon and Half-Dome* by Ansel Adams. Photography could be specific yet romantic in this period, while painting could not.

Above: By this time the television image had become almost universal. Here a family gather to watch on a remote Sardinian farm.

The Modernist Dilemma

1961 – 1975

It has already become customary to speak of the sixties as a decade with a powerful and distinctive flavour of its own, and to say that in this respect, as in their essential hedonism, they resemble the twenties. They are usually discussed chiefly in terms of the rise and decline of Pop Art and the parallel rise and decline of Rock Music.

In fact, it makes better sense to look for a political and social span, rather than a merely cultural one. Looked at on these terms, one needs to think, not of a period between 1961 and 1970, but of one between 1962 and 1975: 1962 was the year in which an American military council was first established in Vietnam, and 1975 saw the final American withdrawal, with the last personnel being airlifted by helicopter off the roof of the Saigon embassy, and the fall of South Vietnam to the Communists.

The Vietnam war had a polarizing effect, not merely on the young people of America who were likely to be affected by the draft, but on intellectuals everywhere. Like the Spanish Civil War, it produced a sense of alienation which divided many of the intellectual and creative leaders of the American and Western European community from their own governments and the society that surrounded them.

The building of the Berlin Wall in 1961 marked the end of one phase of the conflict between Communist and Capitalist societies. Ideology acknowledged itself no match for the attractions of material prosperity. The year of the Berlin Wall was also the year of the Bay of Pigs fiasco, when American-supported Cuban exiles made a clumsy and ill-planned attempt to overthrow the fledgling government of Fidel Castro. In 1962 came the trauma of the Cuban missile crisis, when John F. Kennedy, who had stumbled so badly over Cuba, faced down the Russian government.

The connected events of the Bay of Pigs and the missile crisis had an effect which was not wholly understood at the time. One event did not neatly balance the other. After Kennedy's success in standing up to the Russians, the atomic terror at last began to fade from people's minds – they had learned to live with it. What now took its place as a burning issue was colonialism: the relationship of prosperous and developed nations to others which they had long been accustomed to treat, either directly or indirectly, as tributary to themselves.

In the thinking of the 'New Left', colonialism did not affect Vietnam alone or Cuba alone. It was an issue which appeared wherever the basic situation existed. Even before 1961 it was important because of what was happening in Algeria and in the former Belgian Congo. It consistently affected attitudes towards Israel, since the displaced Arab Palestinians had begun to see themselves as some of its most unfortunate victims. Through its role in the Arab-Israeli conflict it impinged in turn upon the whole question of world energy supplies. This was gradually becoming acute, and was brought to a sudden head by the Yom Kippur War of 1973 and the Arab oil embargo which followed it. This embargo triggered off a world-wide economic recession which was as significant in its own way as the American defeat in Vietnam.

The image of colonialism, whether correctly formulated or not, also played a greater or lesser role in the internal politics of many of the developed western nations. In America, the struggle for racial equality continued throughout the sixties. sometimes exploding into communal violence. In Britain, as early as 1962, the immigration laws had to be changed to restrict the flow of immigrants from non-white Commonwealth countries. Even in West Germany, throughout the period the most

Left: An icon for the late sixties. *Screamin' J. Hawkins* by Karl Wirsum, 1968.

The Modernist Dilemma

1961

prosperous and most industrially successful European power, the problem of so-called 'guest-workers' from Turkey and other Eastern European countries made itself felt.

Colonialism, as well as being a fact, became for the young a metaphor with tremendous emotional resonance. The struggle for racial equality was paralleled by a more subtle, but no less lacerating and persistent struggle for equality between the sexes. Meanwhile disadvantaged groups of all kinds – disadvantaged by race, sexual preference, age or youth – began to see themselves in terms of the colonized struggling against the colonizers.

There were, however, things which seemed to go against the general trend I have outlined here. While scientific research brought many new benefits, especially in the fields of medicine and communications, the more powerful nations often seemed to indulge in it for its own sake, as a competitive assertion of technological might and superfluity of material resources. The United States and Russia competed to be the first to put a man on the moon and to bring him home safely, knowing that there was little to be gained from the enterprise except the satisfaction of doing it, and, what is more, of doing it first. The human courage required nevertheless moved the hearts of millions watching on television.

Yet part of the emotional dynamic of the period was a growing revulsion against technology and its consequences. No sooner had artists fallen in love with the phenomenon of mass-consumerism than they began to fall out of love with it again; and a large part of the educated public followed their example. Seeing the damage technology could do, and the wastage of natural beauty and natural resources it often brought in its train, people began to think in terms of conserving what existed, and of improving it piecemeal, rather than of opting for something new, untried and possibly destructive. There was another, more personal kind of reaction as well. Feeling the strains imposed by contemporary urban life, of which technology was an inseparable part, many of the younger generation retreated inwards, seeking the solace of hallucinogenic drugs and popular mysticisms.

Some of the tendencies against which people struggled had been set in motion by the Modern Movement itself. The Modern Movement in architecture, for example, had led to the large-scale creation of environments which now seemed terrifyingly harsh and mechanistic. Modernism thus became divided against itself. The long-cherished ideas and plans of some of its leading thinkers were at last coming to fruition; and as they did so they aroused the passionate opposition of those whom they were intended to benefit the most.

146

General Events

The United States broke off diplomatic relations with Cuba.
President Kennedy established the Peace Corps.
The Bay of Pigs invasion took place in Cuba; the United States acknowledged responsibility.
The United Nations condemned apartheid.
The Berlin Wall was built.
Dag Hammarskjöld, Secretary General of the United Nations, was killed in an air accident in Africa.
Britain began negotiations for entry into the Common Market.
In Jerusalem, Adolf Eichmann was found guilty of concentration camp atrocities.
Rafael Trujillo, dictator of the Dominican Republic, was assassinated.
Yuri Gagarin orbited the earth in a Russian satellite to become the first man in space.
In a British trial, Gordon Lonsdale, George Blake and the Krogers were convicted of spying.

The Arts

Literature
Graham Greene – *A Burnt Out Case*
Iris Murdoch – *A Severed Head*
Evelyn Waugh – *Unconditional Surrender*
Thom Gunn – *My Sad Captains*
Henri Michaux – *Connaissance par les Gouffres*

Drama
Carl Zuckmayer – *Die Uhr schlägt eins*
John Osborne – *Luther*
John Whiting – *The Devils*

Music
Stockhausen – *Zyklus*
Kodály – Symphony in C
Alexander Goehr – *Sutter's Gold*
Nono – *Intolleranza 60*
Henze – *Elegy for Young Lovers*

Art
Edward Keinholz – *Roxy's*
Yves Klein – *Feu F 43*
Peter Phillips – *For men only starring MM and BB*
Larry Rivers – *Parts of the Face*

Architecture
Louis I. Kahn – Residence Hall, Bryn Mawr College, Pennsylvania (1961–5)
Nervi – Palazzo del Lavoro, Turin
Sheffield City Corporation Architects Dept. – Park Hill Estate, Sheffield

Cinema
Alain Resnais – *Last Year in Marienbad*
Antonioni – *La Notte*
Buñuel – *Viridiana*
Huston – *The Misfits*
Pier Paolo Pasolini – *Accatone*

Above: A Czechoslovakian postage stamp celebrating man's first venture into space — a prestigious achievement for the Soviet Union.

Below: *West Side Story.* The American musical retains its vitality. Music, Leonard Bernstein. Director, Robert Wise.

Right: Pier Luigi Nervi. Palazzo del Lavoro, Turin.

Below: Concrete in another guise, as part of the Berlin Wall. One of several manifestations of Great Power confrontation in the early sixties.

Above: Peter Phillips. *For men only, starring MM and BB*. British Pop Art at its most exuberantly male chauvinist.

The Modernist Dilemma

1962

One feature of the art of the sixties was the multiplicity of choices it offered to the spectator. At a superficial glance it seemed that there was an endless succession of styles, each of which would suddenly appear, and devour whatever had preceded it, only to be devoured in its own turn by whatever followed. This impression was false, since no style was ever completely abolished – the limelight might swing away from it, but the artists who adhered to it usually persisted in their own development.

The most internationally successful of all these styles in the early sixties was Pop Art. It flourished especially vigorously in England and in the United States, but had different roots in each country.

In America its origins were to be found in the neo-Dada of Robert Rauschenberg and Jasper Johns. This soon became associated with what came to be known as 'The Art of Assemblage' – the title of an important exhibition put on at the Museum of Modern Art in New York in 1961. Assemblage was basically collage carried over into three dimensions, and it had strong associations with the 'objects' made by leading Surrealists in the thirties. Its importance to Pop Art was twofold – it sanctioned the random collocation of chance-found things and images, and it fostered the basic assumption that these would come from the detritus of the modern urban environment.

Among the leading American Pop artists, five in particular stand out. They are Jim Dine, Claes Oldenburg, James Rosenquist, Roy Lichtenstein and Andy Warhol. Dine and Oldenburg are the two who come closest to the neo-Dadaists Johns and Rauschenberg. Dine specializes in combining real objects and paint; Oldenburg makes objects which lie between the realms of sculpture and painting. Usually he transposes them in some way – the scale becomes very large (a hamburger the size of a sofa), or they become soft and squashy where we expect them to be hard and rigid (an egg-beater made of cloth and loosely stuffed with kapok). The essential thing, however, is that the subjects themselves are always banal.

The same is true of the other three artists I have mentioned. Rosenquist dismembers billboard imagery and puts it together again in different combinations; Lichtenstein based his earliest work on images taken from comic strips, and has continued to paint in a technique borrowed from the way these strips are printed; Warhol makes icons of roughly silk-screened photographic images, sometimes seen in isolation, sometimes endlessly repeated. These images have different connotations – sometimes glamorous, sometimes horrifying (Marilyn Monroe or the electric chair). Warhol treats them in such a

General Events

A U.S. military council was established in Vietnam.
Pompidou became Prime Minister of France.
The Cuban Missile Crisis led to a direct confrontation between the United States and the Soviet Union.
Ben Bella became Premier of Algeria.
Uganda and Tanganyika became independent.
U-2 pilot Gary Powers was traded by the Russians for Soviet spy Rudolf Abel.
The Commonwealth Immigrants Act was passed in Britain, restricting immigration from the West Indies and Pakistan.
The Telstar satellite was launched.
The Second Vatican Council opened.
U.S. astronauts Glenn, Carpenter and Schirra were put into orbit.
A number of children were born with malformations due to the use of thalidomide.

The Arts

Literature
Vladimir Nabokov – *Pale Fire*
Anthony Burgess – *A Clockwork Orange*
Katharine Anne Porter – *Ship of Fools*
Francis Ponge – *Le Grand Recueil*
Robert Pinget – *L'Inquisitoire*

Drama
Max Frisch – *Andorra*
Dürrenmatt – *The Physicists*
Wesker – *Chips with Everything*
David Rudkin – *Afore Night Come*
Anne Jellico – *The Knack*
Tennessee Williams – *The Night of the Iguana*

Music
Nono – *Sul Ponte di Hiroshima*
Boulez – *Pli selon Pli* (definitive version)
Maxwell Davies – *Sinfonia*
Stravinsky – *The Flood*
Britten – *A War Requiem*
Tippett – *King Priam*

Art
Robert Rauschenberg – *Barge*
James Rosenquist – *Silver Skies*
Andy Warhol – *Green Coca-Cola Bottles*

Architecture
Max Abramowitz – Philharmonic Hall, Lincoln Center, New York
Kenzo Tange – Golf clubhouse, Tatsuka, Japan
Eero Saarinen – TWA Terminal, Kennedy Airport (completed)

Cinema
Truffaut – *Jules et Jim*
Polanski – *Knife in the Water*
Francesco Rosi – *Salvatore Giuliano*
David Lean – *Lawrence of Arabia*
Antonioni – *L'Eclisse*

Right: Derek Boshier — *The Indenti-kit Man.*

Below: Hans Arp — *S'Élevant.* 'Classic' modernism carrying on into the sixties.

Right: Peter O'Toole in *Lawrence of Arabia.*

Above: The triumph of banality. Andy Warhol's *Green Coca-Cola Bottles.*

Below: The king of rock. Elvis Presley in *Girls, girls, girls.* A publicity shot posed in this way would have been considered a joke only a few years later.

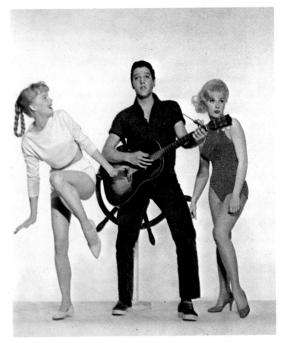

The Modernist Dilemma

1963

way as to ensure that all emotion is drained out of them. They become inert stereotypes.

The basic thing about American Pop Art was that it involved a kind of *trahison des clercs*. It took material that intellectuals had always condemned and exalted it as the only possible subject-matter for the contemporary artist.

British Pop was rather different. It celebrated popular images because the artists found them exotic; art was a blow struck against the grey, cramped post-war environment in which most of the artists had been brought up. Much of it was slightly nostalgic. It looked back affectionately at artefacts, characters and a whole environment which was already disappearing at the time when the works were made. This is true, for example, of the pictures of wrestlers by Peter Blake in the middle sixties.

Far more than its American equivalent, British Pop Art of the early and middle sixties was hedonistic. It revelled in a new sense of luxury, enjoyment and freedom, as Britain became more prosperous, and as social and moral constrictions began to loosen. Richard Smith made romantic near-abstracts based on packaging; Allen Jones began to ransack fetishistic girlie-magazines. David Hockney, with his hair dyed platinum blond, became the darling of the media, and used some of his quirkily drawn paintings as a vehicle for declaring his own homosexuality.

Later, some of these enthusiasms were to be condemned. Allen Jones, for example, found himself picketed by militant feminists, who disapproved of the sexism they discovered in his work.

Pop, even in the early sixties, was not the only style open to modern artists; another genre, which critics tried to make into a direct rival, was Op Art (a lumping together of art works which were either optical or kinetic). Unlike Pop, Op was chiefly a European tendency. It could trace its origins to the Russian Constructivists and to the Bauhaus, where tentative experiments had already been made.

Some artists – Victor Vasarély and Bridget Riley are the best known examples – made use of optical illusions of movement generated by means of hue and pattern employed abstractly. Others, such as the Venezuelan Jesus Rafael Soto, used actual superimpositions – metal plaques, for example, projecting slightly in front of a lined screen, which imparts an effect of vibration.

Others made three-dimensional pieces with real rather than apparent movement. The principle of the unpowered mobile had long been known and power had been used occasionally. Naum Gabo had produced a sculpture which consisted of a single vibrating rod powered by a small motor in the very early twenties. What was new about the pieces now

General Events

De Gaulle blocked British entry to the Common Market.

Hugh Gaitskell, leader of the British Labour Party, died and was succeeded by Harold Wilson.

There were civil rights demonstrations marked by violence in Birmingham, Alabama.

The United Arab Republic agreed to union with Syria and Iraq.

Philby, a Soviet double agent, disappeared from Beirut, and was granted asylum in Russia.

Adenauer was succeeded by Erhard as West German Chancellor.

The government of South Vietnam was overthrown by a Buddhist-led military coup.

Macmillan was succeeded as British Prime Minister by Sir Alec Douglas Home.

Kennedy was assassinated by Lee Harvey Oswald, who was subsequently shot dead by Jack Ruby while in police custody.

Kenya became independent.

A vaccine for measles was perfected.

Friction welding was invented.

Pope John XXIII died and was succeeded by Paul VI.

The Arts

Literature
Muriel Spark – *The Girls of Slender Means*
John Fowles – *The Collector*
J.D. Salinger – *Raise High the Roof-Beam Carpenters*
Thomas Pynchon – *V.*
Solzhenitsyn – *One Day in the Life of Ivan Denisovich*
Montherlant – *Le Chaos et la nuit*

Drama
Hochhuth – *The Deputy*
Ionesco – *Le Piéton de l'Air*
Kenneth Brown – *The Brig*
Joan Littlewood and others – *Oh! What a Lovely War!*

Music
Walton – Variations on a Theme by Hindemith
Tippett – Concerto for Orchestra
Barber – Piano Concerto No. 1

Art
David Hockney – *Picture emphasizing stillness* (1962–3)
Richard Smith – *Soft Pack*
Roy Lichtenstein – *Whaam!*

Architecture
Alison and Peter Smithson – The Economist Building, London
Le Corbusier – Carpenter Center for the Visual Arts, Cambridge, Massachusetts

Cinema
Losey – *The Servant*
Hitchcock – *The Birds*
Visconti – *The Leopard*
Bergman – *The Silence*
Fellini – *8½*

Below: Elizabeth Taylor as Cleopatra, Richard Burton as Antony, in the blockbuster film, *Antony and Cleopatra*.

Right: A scene from Fellini's very personal film-testament, *8½*.

Above: Roy Lichtenstein — *Whaam!* Pop Art at its most exuberant. The image is taken from a comic strip.

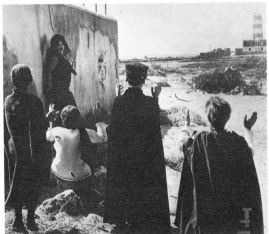

Above: Bridget Riley — *Fall.* Riley's Op Art derives ultimately from Seurat's Pointillism, and is full of references to nature.

Left: Mrs Jacqueline Kennedy, flanked by Senator Edward M. Kennedy (left) and Attorney General Robert F. Kennedy (right) at the funeral of her murdered husband. Kennedy's assassination was one of the first events in world history to be flashed into homes throughout the world by television. The world shared the experience and the shock.

The Modernist Dilemma

being made was their imaginative elaboration. Takis, for example, made sculptures in which the component parts were suspended in mid-air by means of electro-magnets; Nicholas Schoffer produced elaborate constructions which rotated and flashed with coloured lights. Exhibition organizers, alert to the mood of the public, were eager to assemble great collections of these machines and to make them the basis for elaborate exhibitions. A particularly grandiose kinetic show was put on at the Musée d'Art Moderne in Paris in the summer and autumn of 1967.

One disadvantage of kinetic art, as it turned out, was that it was largely 'exhibition art'. It set out to amuse and entertain the public with a display of technological marvels. Once these marvels were fully understood, they lost a great deal of their attraction.

Kinetic art, like Marinetti's Futurism before it, suffered from a naively romantic worship of the machine. Most of the technology employed by the artists was in fact very simple – their small electric motors, levers and chains of gears represented something which, at the very moment when they displayed it, was well on the way to being out-dated. When the tide turned, kinetic artists were the first to suffer, without ever having really penetrated the mysteries of technology.

A very different kind of abstract art was making more headway in America at this time. This was the Post Painterly Abstraction of artists like Kenneth Noland, Jules Olitski and Frank Stella. These three very different artists all have a connection with Abstract Expressionism, and especially with the variation of it practised by Barnett Newman, who as early as 1950 had developed a deliberately inert, simplified style – for example, a vast field of colour would be articulated by a single vertical stripe.

Post Painterly Abstraction is about three things: the way colour operates when it is allowed to act as a force in itself; the absolute unity of colour and ground; and the desire to make the painting a complete, coherent, non-referential object. Early monochrome paintings by Stella, painted circa 1961, consist of stripes the width of the stretcher which supports the canvas, and each divided from the other by a thin margin which is bare of paint.

Unlike optical art, Post Painterly Abstraction eschews the dynamic. Its only concession to movement is the frequent choice of compositional formats – Noland's regular horizontal stripes are a good example – which suggest the work is an excerpt from an endless continuum.

With its emphasis on the painting-as-object, Post Painterly Abstraction was obviously veering towards the idea of the completely independent

1964

General Events

Zanzibar was declared a republic and united with Tanganyika to form Tanzania.
Northern Rhodesia became the independent republic of Zambia.
A United Nations peace force took over in Cyprus.
Ian Smith became Premier of Southern Rhodesia.
Pandit Nehru died, and was succeeded by Lal Bahadur Shastri as Prime Minister of India.
Moise Tshombe became Premier of the Congo, and declared a People's Republic.
Malta and Malawi both became independent.
Harold Wilson became British Prime Minister.
Khrushchev fell from power, and was succeeded by Kosygin and Brezhnev.
King Saud of Saudi Arabia was deposed.
Lyndon B. Johnson was elected President of the United States.
China exploded an atomic bomb.
Ranger VII, launched from Cape Kennedy, took close-up photographs of the moon's surface.

The Arts

Literature
Angus Wilson – *Late Call*
William Trevor – *The Old Boys*
Philip Larkin – *The Whitsun Weddings*
Aragon – *Le Fou d'Elsa*
Michel Deguy – *Biefs*

Drama
Peter Weiss – *Marat/Sade*
John Osborne – *Inadmissible Evidence*
Joe Orton – *Entertaining Mr Sloane*
James Baldwin – *Blues for Mr Charlie*
LeRoi Jones – *The Toilet*

Music
Lutoslawksi – *Venetian Games*
Maxwell Davies – *Veni Sancte Spiritus*
Henze – *Ariosi*
Gerhard – *The Plague*
Bernstein – *Third Symphony*

Art
R.B. Kitaj – *The Ohio Gang*
Andy Warhol – *Orange Disaster*
Edward Keinholz – *State Hospital* (1964–6)

Architecture
Hans Scharoun – Philharmonic Concert Hall, West Berlin (1956–64)
Giovanni Michelucci – Church of S. Giovanni Battista, near Florence

Cinema
Antonioni – *The Red Desert*
Jacques Demy – *Les Parapluies de Cherbourg*
Kubrick – *Dr Strangelove*
Buñuel – *Diary of a Chambermaid*
Kozintsev – *Hamlet*
Hiroshi Teshigahara – *Woman in the Dunes*

Right: Frank Stella — *Ifafa II*. Stella's shaped monochromes were part of Post Painterly Abstraction.

Right: David Smith — *Cubi XVIII.* A new type of sculpture, assembled from industrial materials.

Below: The main indoor gymnasium, built for the Tokyo Olympics. It is a clear indication of the adventurous forms Japanese architects were introducing.

Above: David Hockney — *Cubist (American) Boy with Colourful Tree.* During this period Hockney was fascinated by conventions of representation.

Right: The Beatles had already reached the heights of popularity. Their music was heard everywhere, and their style was imitated by many other groups.

The Modernist Dilemma

1965

three-dimensional object — that is, towards some kind of sculpture. Sculpture had, in any case, undergone a radical transformation. In the hands of Anthony Caro in England and David Smith in the United States, it had abandoned both modelling and figuration, and had become instead an assemblage of 'found' metal parts. Caro, in particular, abolished the idea of the pedestal and greatly extended the principle that Tatlin had invented — that a sculpture was not necessarily a three-dimensional solid, but something which occupied space, and articulated it by means of related planes and the gaps and angles between them.

In the America of the mid-sixties three-dimensional work developed, in the hands of artists like Robert Morris and Donald Judd, into what was dubbed Minimal Art. A minimal piece might be a single, large-scale solid or a series of solids. In either case, the emphasis was on the unitary. The artist provided an image which not only occupied a given space, but which provided an image of possible order throughout all the space that could be imagined by the spectator.

Minimal Art was a solution to many of the most pressing problems of logic and coherence to face the twentieth-century visual artist, but it exacted a price for the security it offered. Art was now able to speak only about a single subject, which was art itself. Cézanne's formalism, his search for unity, had been carried to an unforeseen but logical conclusion.

Having arrived at this point of rest, the visual arts began to try to escape from the dilemma in which they had placed themselves. The first solution offered, which derived directly from Minimal Art itself, was what came to be called Earth Art. Minimal sculptures had always tended to be large. Now, under the influence of the new interest in ecology, and in the traces left by remote and primitive cultures, they moved out of doors, and became marks in the grass, immense trenches dug in the earth, huge mounds of earth and stones. For poetic as well as practical purposes it was often convenient to site them in remote places. The most familiar example, because it is so very photogenic, is the late Robert Smithson's *Spiral Jetty* (1970), a stone construction which juts out from the shores of the Great Salt Lake in Utah.

Much Earth Art, as well as being physically remote, was necessarily temporary. Photography therefore became essential as a way of making a record. From this point, it was easy to shift the emphasis to the photograph itself, and from that to putting the stress on the concept of the work, rather than its embodiment. Minimal Art thus led by easy stages to what came to be called Idea or Conceptual Art.

154

General Events

Sir Winston Churchill died.
Malcolm X, the Black Muslim leader, was assassinated.
There were Ku Klux Klan shootings in Selma, Alabama, following civil rights demonstrations.
Students demonstrated in Washington against the U.S. bombing of North Vietnam.
There was a revolution in Algeria; Ben Bella was deposed.
There were race riots in the Watts district of Los Angeles.
In Rhodesia, the Ian Smith government made a Unilateral Declaration of Independence.
De Gaulle won the election for the French presidency.
Herbert Marcuse published *Culture and Society*.
Both Soviet and American astronauts 'walked' in space.
There was war between India and Pakistan.

The Arts

Literature
Tom Wolfe — *The Kandy-Kolored Tangerine-Flake Streamline Baby*
Louis Zukofsky — *All: The Collected Shorter Poems 1923–58*
Muriel Spark — *The Mandelbaum Gate*
Violette Leduc — *La Bâtarde*
Alain Robbe-Grillet — *La Maison de Rendezvous*
Sylvia Plath — *Ariel* (posthumous)

Drama
Peter Weiss — *The Investigation*
Einar Kipphardt — *The Case of Robert T. Oppenheimer*
Slawomir Mrozek — *Tango*
Harold Pinter — *The Homecoming*
Vaclav Havel — *The Memorandum*

Music
Paul Dessau — *Requiem for Lumumba*
Stravinsky — *Variations and Introitus: T.S. Eliot in Memoriam*
Leonard Bernstein — *The Chichester Psalms*
Richard Rodney Bennett — *The Mines of Sulphur*

Art
Kenneth Noland — *Grave Light*
Sergio de Camargo — *Large Split White Relief no. 34/74*
Martial Raysse — *Tableau simple et douce*

Architecture
Kenzo Tange — Roman Catholic Cathedral, Tokyo
Casson, Conder and Partners — Elephant and Rhinoceros Pavilion, London Zoo

Cinema
Kon Ichikawa — *Tokyo Olympiad 1964*
Milos Forman — *Loves of a Blonde*
Godard — *Alphaville*
James Ivory — *Shakespeare Wallah*
Bondarchuk — *War and Peace*

Above: Bob Dylan, hero of the folk-music revival. His thought-provoking lyrics were an influential innovation in Pop music.

Right: Assassination of Black Muslim leader Malcolm X. The Black Muslims gave many American blacks a sense of identity, but the violent 'long hot summers' of the late sixties were in part the result.

Above: Viljo Revell — Town Hall, Toronto. Civic flamboyance expressing Canada's prosperity.

Above: Martial Raysse — *Made in Japan.* French Pop Art parodies Ingres' *Turkish Bath.*

Right: Omar Sharif and Julie Christie in David Lean's *Dr Zhivago.*

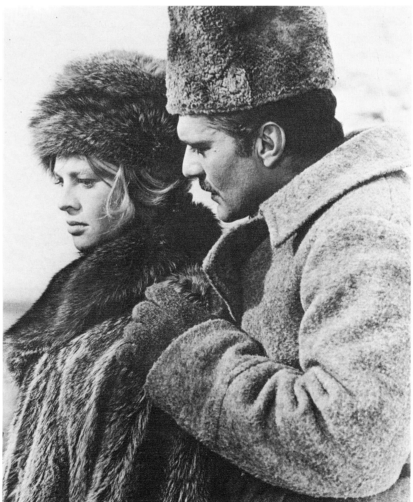

The Modernist Dilemma

Conceptual Art marked an important watershed in the development of the Modern Movement as a whole, since it made manifest something which had in fact been latent from the very beginning: the tendency to value the artist's intention more than his actual execution. It was important for another reason as well. Conceptual artists were not content with the narrow territory of aesthetic theory. They claimed the right to make statements about any subject that took their fancy, whether they were experts in it or not. Thus Conceptual Art soon ventured, often very amateurishly, into fields such as linguistic philosophy and sociology. Any lapses the artist might make in his handling of these subjects were excused on the grounds that he was attempting to handle them as art, and that the end result must be regarded as an art work, and not as philosophy or sociology *per se*.

Meanwhile, towards the end of the sixties, American Pop Art had generated two further developments: Body Art and Super Realism. Body Art developed out of the 'happening', which had formed an integral part of the rise of Pop in America, and had indeed been one of its most effective organs of publicity. Happenings were collages which used not merely objects in space, but human beings and the passage of time. Improvised absurdist charades, they owed a little to Beckett and Ionesco, and perhaps even more to reports and memories of cabaret turns put on by the Russian Futurists and Zurich Dadaists. The first wave of happenings did not last for long, and in the middle sixties it seemed as if this invention of the art world was to have its main impact on the experimental theatre. What happenings did leave behind them as a legacy for the seventies was the idea that the human body itself – bent, twisted, posed, put into all sorts of extraordinary situations – could itself be the stuff of which art was made. In 1972, for example, the English artist Stuart Brisley, acting in the name of art, immersed himself for days at a time in a bath in which there floated various items of raw offal. Perhaps significantly, a great deal of Body Art was extremely masochistic, and entailed a lot of discomfort for the performer.

Super Realist painting was art based on photography. Its subject-matter was deliberately banal, and a number of artists claimed that in any case the choice of subject had no real meaning. What mattered was the endeavour to copy a given image as precisely as possible. The English, but American-domiciled, Malcolm Morley would turn the snapshot or colour illustration he was copying upside down, and cover all but the small area with which he was concerned. The interest lay in seeing how closely, under these conditions, the copy could

General Events

Indira Gandhi became Prime Minister of India.
Madrid University students battled against the police in demonstrations against the Spanish government.
H. Kamuzu Banda became President of Malawi.
The Nkrumah government in Ghana was toppled by a military coup.
Kiesinger became West German Chancellor.
British Guiana became independent as Guyana.
The 'Cultural Revolution' began in China.
There were race riots in Chicago, Cleveland and Brooklyn.
The Tashkent Declaration officially ended the confrontation between India and Pakistan.
An American B-52 bomber carrying four unarmed hydrogen bombs crashed off the coast of Spain.
Both Russian and American spacecraft made soft landings on the moon.

The Arts

Literature
Truman Capote – *In Cold Blood*
Bernard Malamud – *The Fixer*
Isaac Bashevis Singer – *In My Father's Court*
Leonard Cohen – *Beautiful Losers*
John Fowles – *The Magus*
René Char – *Retour amont*
Italo Calvino – *Le cosmicomiche*

Drama
Grass – *The Plebeians rehearse the Uprising*
Dürrenmatt – *Der Meteor*
Osborne – *A Bond Honoured*
The Royal Shakespeare Company, London (produced by Peter Brook) – *US.*
Peter Handke – *Public Abuse*
Albee – *A Delicate Balance*

Music
Michael Tippett – *The Vision of St. Augustine*
Stravinsky – *Requiem Canticles*
Britten – *The Burning Fiery Furnace*
Henze – *The Bassarids*

Art
Patrick Caulfield – *Still life with red and white pot*
Roy Lichtenstein – *Yellow and Red brushstrokes*
Takis – *Signal*

Architecture
Louis I. Kahn – Laboratories at the Salk Institute, La Jolla, California
Gio Ponti – Secretariat Buildings, Islamabad, Pakistan

Cinema
Bergman – *Persona*
Resnais – *La Guerre est Finie*
Alexander Kluge – *Yesterday Girl*
Bresson – *Au Hazard Balthazar*

Left: Marchers in China's Cultural Revolution, an event instigated by Mao to ensure that the party bureaucracy did not become merely the seat of 'vested interests'. It had considerable impact on the new left in the West.

Below: Alfred Pellan — *Carnivores.* Canadian Surrealism.

AFTER 'THE MONARCH OF THE GLEN' BY SIR EDWIN LANDSEER. PETER BLAKE. 1966.

Above: Indian Prime Minister Indira Ghandi, standing next to a bust of the Mahatma, in Cairo to meet Nasser. As leader of the second most populous nation in the world, she promoted a recognition of women's abilities.

Left: Peter Blake — After *'The Monarch of the Glen'.* Fashionable neo-Victorianism.

157

The Modernist Dilemma

1967

be made to match the original. Chuck Close, copying snapshot portraits on a giant scale, deliberately reproduced all the aberrations which come from using a lens at wide aperture.

Though the artists themselves might discount subject-matter, the public did not. Super Realism met with an enthusiastic reception from private patrons and exhibition organizers, but not usually from critics. People saw in it a truthful reflection of the society they lived in, with power to speak about things, such as the world of super-highways and drive-in eating places, which had never before been the subject of art.

Super Realist sculpture was based not on photography, but on a process of direct casting from the human body. In different hands this could produce very different results. John de Andrea used it to make curiously bland nude facsimiles of American co-eds; Duane Hanson, by contrast, made sharply satirical portraits of American working-class and lower-middle-class stereotypes.

By the middle of the seventies two things were generally agreed – first that the Modern Movement itself seemed to be stumbling to a halt, and second that there had never been such a wide variety of styles available to the contemporary artist. Broadly speaking, these styles were the following – first the Minimal, Conceptual, Body Art and Super Realist styles, which have already been discussed. Second, a kind of modified realism, often with slightly metaphysical overtones, which was making headway in Europe. Thirdly, a revival of the politically oriented *Neue Sachlichkeit* which was taking place, particularly in West Germany. Fourth, various kinds of political art which aimed to break through modernist élitism while not necessarily going back to any kind of social realism. Fifth, art created in terms of fetishes and obsessions, making reference both to the new fashions for ethnology and ecology, and to a newly established permissiveness about previously tabu, especially sexual, subject-matter.

One consequence of the confusion that prevailed in the fine arts was a strong revival in the crafts, particularly in England, the United States, Holland and West Germany. In finely made craft-objects patrons found satisfactions that the fine artist often seemed intent on denying them – respect for workmanship, sensuous finish, permanence, and respect for the human scale.

As modernism began to flounder in the West, it made progress under Communism and in the Third World. It became, for example, a universal idiom in the countries of Latin America. Even Mexico largely abandoned the social realistic style of Rivera and the Mexican muralists, and turned towards abstraction. Much modern art was produced in India.

General Events

700,000 people marched down New York's Fifth Avenue in support of U.S. soldiers in Vietnam.
Hanoi was bombed by the Americans.
The Six-Day War between Israel and the Arab nations took place – the Israelis captured the old city of Jerusalem and took control of the Sinai Peninsula.
Che Guevara was killed in Bolivia.
50,000 people demonstrated against the Vietnam War in Washington.
A junta of Greek officers staged a successful coup and King Constantine was forced into exile.
There were race riots in Cleveland, Newark and Detroit.
The world's first heart-transplant was carried out in South Africa.
The Nigerian Civil War began.
China exploded its first hydrogen bomb.

The Arts

Literature
William Styron – *The Confessions of Nat Turner*
Isaac Bashevis Singer – *The Manor*
William Golding – *The Pyramid*
Isherwood – *A Meeting by the River*
Ted Hughes – *Wodwo*

Drama
Charles Wood – *Dingo*
Alan Ayckbourn – *Relatively Speaking*
Peter Nichols – *A Day in the Death of Joe Egg*
Arrabal – *The Architect and the Emperor of Assyria*
Hochhuth – *Soldaten*
Peter Weiss – *The Song of the Lusitanian Bogeyman*

Music
Frank Martin – Cello Concerto
Copland – *Inscape for orchestra*
Henze – Concerto for Double Bass and orchestra
Walton – *The Bear*
Alexander Goehr – *Arden Must Die*

Art
John McCracken – *The Absolutely Naked Fragrance*
Philip Pearlstein – *Two Naked Models in the Studio*

Architecture
I.M. Pei – National Center for Atmospheric Research, Boulder, Colorado
Sachio Otani – Conference Hall, Kyoto

Cinema
Antonioni – *Blow Up*
Arthur Penn – *Bonnie and Clyde*
Buñuel – *Belle de Jour*
Bo Widerberg – *Elvira Madigan*
Losey – *Accident*

Above: *The Forsyte Saga* — television recycles Galsworthy. This series was shown all over the world.

Right: Two faces of the war in Vietnam. U.S. Marines interrogate a prisoner. At home, a demonstrator supports the war.

Left: Israel was victorious in the Six Day War. Israeli troops with burnt-out Egyptian vehicles.

Right: Minimal Art. Robert Morris — *Untitled Felt Piece.*

Below: San Francisco hippies in Golden Gate Park. These were heady days for youth.

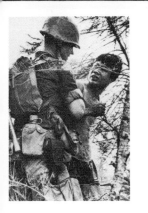

159

The Modernist Dilemma

1968

In Africa, a new generation of artists struggled to reconcile native tradition with new ideas and new formats, at the same time as they struggled to find a means of marketing what they produced. In almost all the European Communist countries except Russia, modernism made considerable progress. It was particularly marked in the more sophisticated nations of Eastern Europe: in Poland, Hungary and Czechoslovakia. In the Soviet Union itself attention was increasingly directed towards the work of so-called 'un-official' artists, excluded from the state system of patronage and working in various modernist or semi-modernist styles.

If a great deal of energy went into the visual arts during the sixties and seventies, often with confusing results, even more went into that of popular music. In addition to being the era of Pop Art, the sixties were also that of rock culture. Rock music dominated the sensibility of the whole decade and permeated almost every cultural endeavour.

It was the era of groups, not of solo singers, and these groups usually composed music as well as performing it. The most extraordinary and the most successful were the Beatles. The Beatles came from Liverpool, and served their musical apprenticeship in Hamburg. By 1961 they were well known and popular in Liverpool itself; by 1962 they had a hit record; by 1963 they were teen idols; but it was what then happened that made the Beatles special.

In February 1964 the group arrived in America, and completely transformed the pop music scene on the other side of the Atlantic. What was unique about them was the fact that their music refused to become stereotyped. It progressed inexorably. And the place where it progressed was not on stage, in live performance, but in the recording studio. The orchestrations became ever more elaborate, the harmonies more complicated; there was a multitude of new effects, ranging from Indian sitars to motor car horns – and of new technical tricks. Over the years, the Beatles themselves changed with their music: they grew their hair, admitted in public to smoking marijuana, preached a message of hope and mysticism, peace and love. By the end of the decade the public and private pressures had become too great, and they split up.

Their chief rivals were the Rolling Stones, who projected a very different image: hostile and anarchic, they voiced not the hopes of the young but their fears and frustrations. Immense open air concerts were typical of the progress of rock in the late sixties. It was the Rolling Stones who topped the bill at the Altamont Festival (1969), when a group of Hell's Angels, hired to act as bodyguards, stabbed a black youth to death in front of the stage as the group played.

General Events

The U.S. Navy intelligence ship *Pueblo* was captured by North Korea.
Dubček became First Secretary of the Czechoslovak Communist Party.
President Johnson announced that he would not seek another term.
Martin Luther King Jr. was assassinated.
There was student rioting in Paris.
Robert F. Kennedy was assassinated in Los Angeles while campaigning for the Democratic nomination for the presidency.
The Democratic Convention in Chicago was marked by riots and police brutality.
Czechoslovakia was invaded by Soviet and Warsaw-pact troops; Dubček was arrested.
Nixon was elected U.S. President.
South Africa was excluded from the Mexico City Olympics.

The Arts

Literature
John Updike – *Couples*
Gore Vidal – *Myra Breckenridge*
Ginsberg – *T.V. Baby Poems*
Mailer – *The Armies of the Night*
Montherlant – *La Rose de sable* (written in the thirties and withheld)
Horst Bienek – *Die Zelle*

Drama
Osborne – *Hotel in Amsterdam*
Edward Bond – *Narrow Road to the Deep North*
Marguerite Duras – *L'Amante Anglaise*
Max Frisch – *Biographie*
Rochelle Owens – *Futz!*
Michael McClure – *The Beard*

Music
Roger Sessions – Eighth Symphony
Harrison Birtwistle – *Nomos*
Berio – *Sinfonia*
Dallapiccola – *Odysseus*

Art
Robert Morris – Untitled (soft sculpture) 1967–8
César – *Compressions*

Architecture
Mies van der Rohe – National Gallery, Berlin
Leo de Syllas (Architects' Co-Partnership) – St Paul's Cathedral Choir School, London

Cinema
Polanski – *Rosemary's Baby*
Kubrick – *2001: A Space Odyssey*
Godard – *Weekend*
Collectively directed, ed. Chris Marker – *Loin du Vietnam*
Milos Forman – *The Fireman's Ball*
Franklin Schaffner – *The Planet of the Apes*

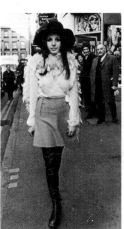

Above: See-through fashion in London's Carnaby Street.

Right: A poster inspired by the Paris 'events', and produced by students. These events were among the first public indications that the revolutionary role was passing from the hands of official European Communist parties.

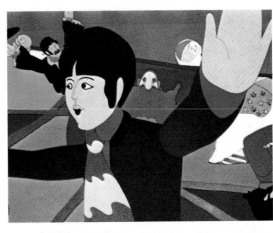

Right: Still from the Beatles cartoon film, *The Yellow Submarine*, which represented a fusion of much of the talent produced by sixties' Britain.

Below: Wolf Vostell — *Miss Amerika*. The main image is from a news film by Eddie Adams.

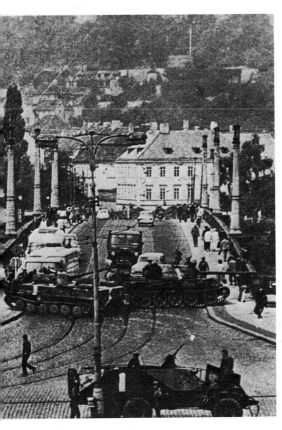

Above: Russian tanks at the River Moldau Bridge in Prague, after the Soviet invasion of Czechoslovakia to crush the experiment in Communism with a human face under Dubček.

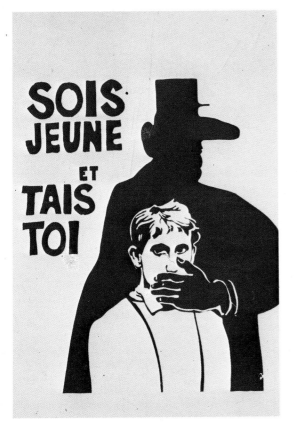

The Modernist Dilemma

Rock expanded so much that it had something to offer almost everyone – provided they were young. It could accommodate the easy-going hedonism of the Beach Boys, leaders of the Californian surfing cult; but also the political dirges and anthems in praise of soft drugs purveyed by such psychedelic groups as Country Joe and the Fish.

It was very much a music of paradoxes. It often preached rebellion – especially against the drug laws and the war in Vietnam, but also against all the constrictions of bourgeois society. It produced more than its fair share of *âmes maudites*, among them mesmeric performers like Jimi Hendrix and Janis Joplin, both of whom died as a result of drug overdoses. Yet it was, too, a multi-million dollar industry.

Bob Dylan, who had emerged from New York's Greenwich Village folk-scene in 1961, represented yet another aspect of the new music – the way in which, during the early sixties, it became a vehicle for radical political protest. Dylan, as he developed, also reflected rock music's increasing attraction towards the private, quasi-surrealist internal monologue. He became an important cult figure and model, not merely for his own audience but for other rock musicians such as the Beatles.

The development of rock in the sixties and seventies inevitably had an effect on the progress of 'serious' music. In some ways this effect was a damaging one, but in others it was beneficial. The tremendous amount of creative energy that went into rock, and rock music's increasing ability to encompass themes and musical subtleties which had previously seemed beyond the grasp of music addressed to any kind of mass market, made 'serious' music even more isolated than the *avant-garde* visual arts. In addition to this, a gap began to open between the surviving makers of the Modern Movement in music, and a new generation of experimentalists who were thinking in different ways.

Among the major composers Stravinsky, after the death of Schoenberg in 1951, remained upon a solitary pinnacle. Now using the twelve-tone method which Schoenberg had invented, he continued to produce new music. But this grew increasingly gnomic, and all his late compositions were very brief. The nationalists, Russian and English, continued to be productive. Shostakovich's 18th Symphony received its *première* in 1972. Benjamin Britten's *War Requiem* (1962) was an attempt at a statement about universal human issues, almost in Mahler's manner. His opera *Death in Venice* (1973), based on the novella by Thomas Mann, seemed to show that this supposedly defunct musical form still had some life left in it, as did operas by Britten's compatriot, Michael Tippett,

1969

General Events

Two U.S. astronauts were the first men to land on the moon.

Golda Meir became Prime Minister of Israel.

Ayub Khan resigned as President of Pakistan, and was succeeded by Agha Muhammad Yahya Khan.

De Gaulle resigned as President of France: Pompidou was elected to succeed him.

Prince Charles was invested at Caernarvon Castle as Prince of Wales.

The first American troops were withdrawn from Vietnam.

Ho Chi Minh died.

600 British troops were sent to Belfast to quell rioting.

There were massive anti-Vietnam demonstrations throughout America.

Lt. William Calley and Staff Sgt. David Mitchell were put on trial for a massacre of civilians at My Lai.

A human ovum was successfully fertilized in a test-tube.

The Arts

Literature
Philip Roth – *Portnoy's Complaint*
Lillian Hellman – *An Unfinished Woman*
Nabokov – *Ada*
Basil Bunting – *Collected Poems*
Jorge Semprun – *La Deuxième Mort de Ramon Mercader*
Christa Wolf – *Nachdenken über Christa T.*
Miguel Angel Asturias – *Maladrón*

Drama
Peter Nichols – *The National Health*
David Storey – *The Contractor*
Peter Barnes – *The Ruling Class*
Joe Orton – *What the Butler Saw*

Music
Nono – *Contrappunto Dialectico*
Cage – *Winter Music*
Britten – *The Children's Crusade*
Messiaen – *The Transfiguration*
Maxwell Davies – *Worldes Bliss*

Art
Larry Bell – *Untitled*
Larry Poons – *Green Droop*
Niki de Saint Phalle – *Black Nana* (1968–9)

Architecture
Frederick Gibberd – No. 1 Terminal, Heathrow Airport
Kallmann, McKinnell and Knowles – Boston City Hall
Skidmore, Owings and Merrill – Alcoa Building, San Francisco

Cinema
John Schlesinger – *Midnight Cowboy*
Dennis Hopper – *Easy Rider*
Sam Peckinpah – *The Wild Bunch*
Eric Rohmer – *Ma Nuit chez Maud*
Oshima – *Diary of a Shinjuku Thief*

Above: Large numbers of American blacks served in Vietnam.

Right: American astronaut Buzz Aldrin walked on the moon's surface. The landing was watched throughout the world.

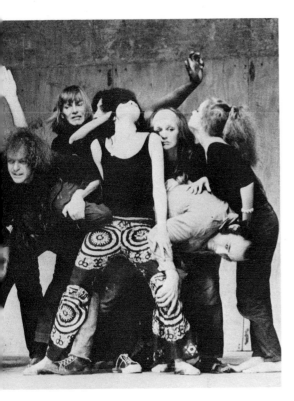

Right: Tim Scott — *Bird in Arras VI.* The new British sculpture.

Above: Members of the Living Theatre in *Antigone*.

Below: *Satyricon*. More decadence from Fellini.

The Modernist Dilemma

Below: TV as a teaching instrument. A scene from *Sesame Street*.

and by the German composer Hans Werner Henze.

Henze's development pursued an especially interesting course, ranging as it did from romantic stage works like *Elegy for Young Lovers* (1961) and *The Bassarids* (1966) – both with libretti by W. H. Auden and Chester Kallman, the latter being based on the *Bacchae* of Euripides – to semi-staged cantatas, often with a political message. Henze's political concerns were shared by a number of other composers working on both sides of the Iron Curtain. Notable works in this vein were written by Luigi Nono (whose *Intolleranza 60* was the subject of a neo-Fascist demonstration during its *première* at the Venice Festival of 1961), and by the veteran Marxist and Brecht collaborator Paul Dessau (*Requiem for Lumumba*, 1965).

The main development in *avant-garde* music was, however, that aleatory experiments began to gain the upper hand over strict serialism, and that there was a fresh current of influence both from John Cage and from Olivier Messiaen. Cage prompted not only a series of neo-Dadaist experiments, but an investigation of monotony. Steve Reich's *Drumming* (1972), with its deliberate lack of inflection, was indebted not only to Cage, but to certain aspects of rock.

In fact, there was, in the late sixties and early seventies, a covert and scarcely acknowledged interbreeding between 'serious' and popular forms, encouraged by the fact that both kinds of music used the same electronic means to achieve their chosen ends. The more sophisticated exponents of rock were as willing to borrow from the 'serious' *avant-garde* as they were to take ideas from such sources as Indian music.

The 'folk' element in rock may also have had something to do with a strong revival of interest in early church music, especially among younger English composers such as Peter Maxwell Davies, Harrison Birtwistle and John Tavener.

Poetry, especially the poetry produced by Ginsberg and the beats, also made a fruitful, if temporary alliance with rock music, and in the sixties attracted sufficient public interest to make it possible to stage massive public poetry readings, ambitious attempts to import the atmosphere of the rock concert into the staid world of literature.

Beat poetry, however, was by no means the only kind of verse to attract public attention. In the sixties the so-called confessional school won at least as much notice. The confessional poets were American – the whole movement can be said to have started with the publication of Robert Lowell's *Life Studies* in 1959. Other prominent writers working in the same vein included John Berryman, Sylvia Plath and Anne Sexton. The tendency

General Events

Biafra capitulated, and the Nigerian civil war ended.
The Conservatives won a British general election and Edward Heath became Prime Minister.
Arab guerillas hijacked three New York-bound jets, and blew them up in Jordan.
Four students were killed by the National Guard at an anti-Vietnam War protest at Kent State University, Ohio.
Nasser died and was succeeded by Sadat.
De Gaulle died.
Gomulka, Communist Party First Secretary in Poland, resigned.
Salvador Allende was elected President of Chile, heading a Marxist government.
There was a major British oil find in the North Sea.
A.J. Ayer published *Metaphysics and Common Sense*.
Theodore Roszak published *The Making of a Counter-Culture*.

The Arts

Literature
Hemingway – *Islands in the Stream* (posthumous)
Saul Bellow – *Mr Sammler's Planet*
James Dickey – *Deliverance*
Michel Tournier – *Le Roi des aulnes*
Heinrich Böll – *Aussatz*

Drama
Anthony Shaffer – *Sleuth*
Ionesco – *Jeux de Massacre*
David Hare – *Slag*
Peter Weiss – *Trotsky in Exile*

Music
Walton – Variations on an Impromptu of Benjamin Britten
Maxwell Davies – *Vesalii Icones*
Berio – *This Means That . . .*
Elliott Carter – Concerto for Orchestra
Tippett – *The Knot-Garden*

Art
Rosenquist – *Flamingo Capsule*
Duane Hanson – *Tourists*
Robert Smithson – *Spiral Jetty*

Architecture
Erickson and Massey – Canadian Pavilion, Expo, Osaka
Belluschi and Nervi – Roman Catholic Cathedral, San Francisco
Minoru Takeyama – Ichi-Ban-Kan Department Store, Tokyo

Cinema
Robert Altman – *M.A.S.H.*
Antonioni – *Zabriskie Point*
George Roy Hill – *Butch Cassidy and the Sundance Kid*
Costa-Gavras – *Z*
Visconti – *The Damned*

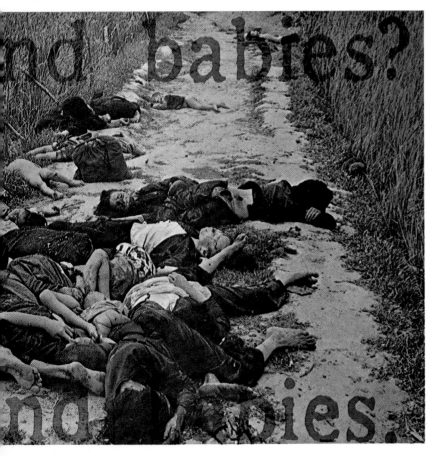

Below: Scene from a new Peking opera celebrating the Chinese revolution. During the Cultural Revolution such operas were one of the few permitted forms of 'entertainment'.

Above: David Hockney — *Mr and Mrs Ossie Clark and Percy* (1970–71). Seventies elegance.

Below: Poster from the Art Workers' Coalition, based on a photograph of the Song-My Massacre. Seventies brutality.

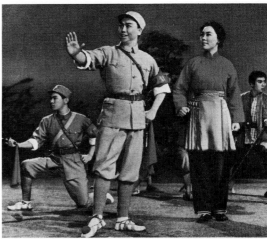

Above: Scene from Andy Warhol's film *Trash*.

165

The Modernist Dilemma

nevertheless received its critical *imprimatur* from the Englishman A. Alvarez, whose influential paperback anthology *The New Poetry* was published in 1962. In this, a mixed bag of English and American writers, he put quite special emphasis on the work of Lowell and Berryman.

Sylvia Plath was another writer who was to attract Alvarez's enthusiasm. An American living in England (she was married to the English poet Ted Hughes), Plath committed suicide in 1963. A posthumous collection, *Ariel*, containing poems written just before she died, became the basis for a considerable cult. What attracted readers to Plath's work was the implication that the poet was literally sacrificing herself for her art — poetry and self-destruction were inextricably intertwined:

> Dying
> Is an art, like everything else,
> I do it exceptionally well.
> I do it so it feels like hell.
> I do it so it feels real.
> I guess you could say I've a call.

The idea that the poet must necessarily validate his or her work in this way for a time became unhealthily prevalent; it also seems to have played a part in the suicide of Anne Sexton in 1974. Indeed, of the four writers I have named, Lowell, who spent long periods in mental institutions, was the only one who did not in the end destroy himself.

Another, healthier poetic tendency in the sixties was the expansion of horizons to include several literatures, not just one. In England and the United States, Russian poets such as Yevtushenko and Voznesensky made a considerable impact with their impassioned readings, and translations of their work were published in paperback. In English-speaking countries there was also a considerable revival of interest in German poetry, especially in the post-Brechtian and politically oriented poetry of the writers of the '*Gruppe 47*'. Interest in German and Russian verse was fed by two important anthologies, *Modern German Poetry 1910–1960*, edited and translated by Michael Hamburger and Christopher Middleton (1962); and *Modern Russian Poetry*, edited by Vladimir Markov and Merill Sparks. The latter was published in 1966. Only French poetry, preoccupied with language rather than emotion, remained isolated from any but a purely national audience.

Novels developed in three ways, each of which seemed to lead novel-writing in new directions. First, there was a confessional mode, which paralleled what was happening in poetry. Interestingly, such novels were often the work of poets. Sylvia Plath, with her pseudonymous *The Bell-Jar* (1963), an account of an adolescent nervous break-

1971

General Events

The fighting in Indochina spread to Laos and Cambodia.
Idi Amin seized power in Uganda.
Women were granted the right to vote in Switzerland.
The age for enfranchisement was reduced to 18 in the United States, by the 26th Amendment.
Britain introduced preventive detention and internment without trial in Northern Ireland.
Bangladesh seceded from Pakistan, and India went to war with Pakistan on the rebels' behalf.
Lin Piao, Mao-tse-tung's heir-apparent, died in an aircrash, apparently while fleeing after an attempted coup.
10,000 people were killed by a cyclone and tidal wave in Bengal.

The Arts

Literature
V.S. Naipaul — *In a Free State*
Christopher Isherwood — *Kathleen and Frank*
Graham Greene — *A Sort of Life*
W.H. Auden — *A Certain World*
Geoffrey Hill — *Mercian Hymns*

Drama
Osborne — *West of Suez*
Alan Bennett — *Getting On*
Fassbinder — *Freedom of Bremen*
Peter Weiss — *Hölderlin*

Music
Lutoslawski — Cello Concerto
Ligeti — *Lontano*
Lukas Foss — *Baroque Variations*
Harrison Birtwistle — *Meridian*
Menotti — *The Most Important Man*

Art
Claudio Bravo — *Le paquet bleu*
Oyvind Fahlstrom — *World Bank*
Gilbert & George — *8 Part Photo Piece*

Architecture
Nervi — Audience Hall, The Vatican
Noriaki Kurokawa — Capsule offices and apartments, Tokyo
Basil Spence — British Embassy, Rome

Cinema
Milos Forman — *Taking Off*
Kubrick — *A Clockwork Orange*
Bogdanovich — *The Last Picture Show*
Losey — *The Go-Between*
Schlesinger — *Sunday, Bloody Sunday*

Above: Franz Gertsch — *Medici*. This vast Super Realist work measures four by six metres.

Below: Malcolm McDowell in Kubrick's *A Clockwork Orange*, a violent and disturbing fantasy of the future based on the novel by Anthony Burgess.

Below: Charlotte Moorman performs on Nam June Paik's TV Cello.

Above: American peace poster symbolizing a nation divided.

The Modernist Dilemma

down, was a pioneer in this genre. The tendency reached a spectacular climax with Erica Jong's freewheeling best-seller *Fear of Flying* (1973). In this it was for all practical purposes impossible to separate the author from her narrator heroine, Isadora Wing. Another practitioner, a rather unlikely one, of what came to be called 'faction' was Truman Capote, whose massive documentary novel about a murder case, *In Cold Blood*, was published in 1966.

There was also a fashion, especially in America, for satirical fantasies. Among them were Joseph Heller's anti-war novel *Catch-22* (1961), and two outrageous sexual satires: Philip Roth's *Portnoy's Complaint* (1969) and Gore Vidal's *Myra Breckenridge* (1968).Connected with the development of satirical fantasy was the rise of science fiction. Formerly, even in the 1950s, when pulp science fiction (paperbacks and comic books) was already enormously popular, science fiction and science fantasy had been divided into two separate and distinctly unequal categories. On the one hand were books by such established writers as Wells, Huxley and Orwell, who did not devote themselves entirely to the genre, but used it occasionally as a vehicle for conveying their ideas. And on the other hand there were purely popular writers, on a level with those who wrote westerns and true romances.

In the sixties, established writers continued to make use of science fiction formats, just as before. A case in point was Anthony Burgess's savagely dystopian *A Clockwork Orange* (1962), later made into an equally dystopian film by Stanley Kubrick. But now, in addition, writers whose experience was chiefly in the popular field began to attract serious critical attention. Two cases in point are J. G. Ballard, whose wider reputation was probably founded by *The Crystal World* (1966), and the incredibly uneven but also incredibly prolific Michael Moorcock in his Jerry Cornelius novels (*The Final Programme*, 1969; *A Cure for Cancer*, 1971, and *The English Assassin*, 1972).

Science fiction also became a popular source of ideas for the moviemaker. Kubrick filmed *A Clockwork Orange*, and also made the spectacular *2001: A Space Odyssey* (1968). But he was only one of a number of leading directors who experimented with the genre. Godard did so with *Alphaville* (1965), and there were science fiction elements in Hitchcock's *The Birds* (1963), and in Antonioni's *Zabriskie Point* (1970).

The sixties and the first half of the seventies were in any case a liberating period for the art of the film. It was at last possible to see film-making as a completely separate creative genre, obedient to its own rules. The great directors – Antonioni, Buñuel,

1972

General Events

The United States ceded Okinawa to Japan.
Bangladesh, formerly East Pakistan, became a sovereign state.
The 'Watergate' affair began with the arrest of five men inside Democratic National Headquarters in Washington.
Richard M. Nixon was re-elected President of the United States.
Britain imposed direct rule on Northern Ireland.
Britain, Eire and Denmark agreed to become full members of the E.E.C.
Ceylon became a republic, and renamed itself Sri Lanka.
Eleven members of the Israeli team were killed by Arab terrorists at the Munich Olympics.
Gough Whitlam's Australian Labour Party ended 23 years of rule by the Liberal-Country Party.
10,000 people were killed in an earthquake at Managua, Nicaragua.
General Amin expelled 8,000 Asians with British passports from Uganda.

The Arts

Literature
Eudora Welty – *The Optimist's Daughter*
Philip Roth – *The Breast*
John Berryman – *Delusion etc.*
David Storey – *Pasmore*
Hans-Magnus Enzensberger – *Der Kurze Sommer der Anarchie*

Drama
Tom Stoppard – *Jumpers*
John Arden and Margaretta D'Arcy – *The Island of the Mighty*
Alan Ayckbourn – *Time and Time Again*
Tennessee Williams – *Small Craft Warnings*
Franz Xavier Kroetz – *Stallerhof*

Music
Steve Reich – *Drumming*
Shostakovich – Eighteenth Symphony
Tippett – Third Symphony
Berio – *Recital I (For Cathy)*
Elizabeth Lutyens – *Time Off? Not a Ghost of a Chance!*

Art
Nam June Paik – *Paik-Abe Video Synthesizer*
Panamarenko – *Airship, 'The Aeromodeller'*
Al Held – *North, North-East*

Architecture
Aalto – Finlandia Hall, Helsinki
Niemeyer – Headquarters for the French Communist Party, Paris

Cinema
Francis Ford Coppola – *The Godfather*
Ralph Bakshi – *Fritz the Cat*
Bill Douglas – *My Childhood*
Fassbinder – *The Bitter Tears of Petra von Kant*

Left: A scene from the popular musical film *Cabaret* based on Isherwood's stories.

Above: The Olympic village at Munich, remembered as the scene of an act of Palestinian terrorism.

Below: Piotr Kowalski — *Measures to be Taken*. Artwork at the Kassel Documenta.

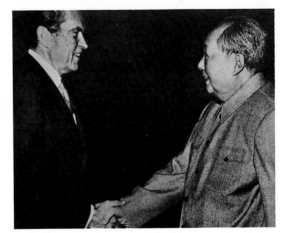

Above: Nixon meets Mao on his visit to China. The balance of world power was changing dramatically.

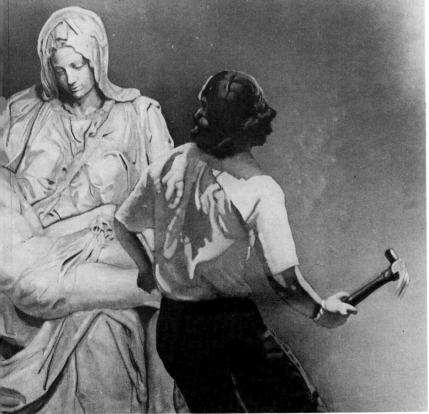

Left: A.B.N. Productions — *The Pietà Damaged*. A group of Dutch artists made instant art from news events.

The Modernist Dilemma

Visconti – gave a completely authoritative stamp to whatever they touched; and not far behind them came a new generation, which included men like Milos Forman, Bertolucci and Robert Altman. In the complex *Nashville* (1975), with its plethora of characters, Altman tried to give a portrait of contemporary America in terms of country and western music, and at the same time demonstrated how free and fluid the grammar of film-narrative now was.

From 1966 onwards (the date of Alexander Kluge's *Yesterday Girl*), West Germany began to develop a low budget minority cinema which was responsible for highly original films. The leading directors were the prolific and uneven Fassbinder and Werner Herzog, both of whom provided a more accessible version of Godard's radicalism.

Film-makers acquired, not only a new and more subtle language, but greater liberty to treat the subjects of their choice in their own way. There were occasional protests – about the violence in some of Sam Peckinpah's films for example; or about the sexual content of Bertolucci's *Last Tango in Paris* (1973), but on the whole the censors were everywhere fighting a rearguard action. It was this change in cultural climate which made possible the extraordinary late career of Luis Buñuel, from the uncompromising *Viridiana* (1961) onwards.

Film, however, suffered losses as well as making gains. What it chiefly lost was its position as the preeminent form of popular entertainment. That had now been taken over by television. It is true that films still fed television, since in many countries it is possible to see almost any movie on the small screen only a few years after its release, though often in a seriously mangled version. It was also true that the downturn in cinema-going, which caused serious anxiety to the film industry in the sixties, had begun to reverse itself by the mid-seventies. But films were now a minority art-form, however substantial.

It was therefore television, not film, which became, *par excellence*, the consensus medium, and took on the burden of reflecting the real standards of any community. It was television, too, that reached into every home, and provided the common stock of information. Yet its universality was of a peculiarly specialized kind. The Hollywood movies of the thirties and forties had been seen all over the world. The great stars were stars not merely in America, and in countries where the English language was spoken – they were stars everywhere. With very rare exceptions television personalities, whether they were actors or commentators, became stars only in their own countries or even regions. The charisma of a Johnny Carson, for example, was powerful in the United States, though in England this greatest of American television personalities

General Events

Britain, Eire and Denmark joined the Common Market.
Spiro T. Agnew, United States Vice-President, resigned, and pleaded *nolo contendere* to one count of income-tax evasion.
A Vietnam cease-fire agreement was signed in Paris.
All foreign-operated oil-firms were nationalized in Iran.
Fighting once again broke out between the Arabs and the Israelis (the 'Yom Kippur War').
The Arab oil-producing nations embargoed shipments to the U.S., Western Europe and Japan, thus producing an energy crisis.
Diplomatic relations were established between East and West Germany.
Salvador Allende, President of Chile, was overthrown by a military junta, and reportedly committed suicide.
Peron was re-elected President of Argentina, with his second wife Maria Estela Martinez as Vice-President.
The Spanish Premier, Luis Carrero Blanco, was assassinated.

The Arts

Literature
Thomas Pynchon – *Gravity's Rainbow*
Burroughs – *Exterminator!*
Erica Jong – *Fear of Flying*
Robert Lowell – *The Dolphin*
Patrick White – *The Eye of the Storm*

Drama
Athol Fugard – *Sizwe Banzi is Dead*
Brian Friel – *The Freedom of the City*
Copi – *The Four Twin Girls*
Ionesco – *Ce Formidable Bordel*

Music
Penderecki – First Symphony
Boulez – '... explosante/fixe ...'
Thea Musgrave – Viola Concerto
Britten – *Death in Venice*
Maderna – *Satyricon*

Art
Stephen Posen – *Occam's Razor*
Richard Estes – *Paris Street Scene*
John Davies – *Old Enemy* (1973–5)

Architecture
Patrick Hodgkinson – Brunswick Centre, London
John Portman and Associates – Hyatt-Regency Hotel, San Francisco

Cinema
Bogdanovich – *Paper Moon*
Lindsay Anderson – *O Lucky Man!*
Nicholas Roeg – *Don't Look Now*
Truffaut – *La Nuit Americaine*
Bertolucci – *Last Tango in Paris*
Herzog – *Aguirre, Wrath of God*

Above: The fall of Nixon — Senate Watergate hearings. America's political dramas became good television.

Above: The new popularity of modern dance. Maurice Béjart rehearses a new ballet.

Above: Minimal Art. Richard Serra — *Different and Different Again.*

Above: *Neue Neue Sachlichkeit.* Hermann Albert — *Homage to Otto.* (Otto Dix.)

Left: The male menopause. Brando in Bertolucci's *Last Tango in Paris.*

171

The Modernist Dilemma

remained virtually unknown. The exceptions were certain serials, often but not always derived from classic novels (*The Forsyte Saga* was one of the most successful), and ambitious cultural and scientific programmes like Lord Clark's lectures on *Civilization* and Professor Bronowski's *The Ascent of Man*. These cautiously aspiring 'prestige' efforts were untypical of the medium as a whole – of its vulgarity as the common denominator.

While in the cinema the director had tended to usurp the position once accorded to the star actor or actress, in the theatre it was the writer who was often forced to take a back seat. The writer's theatre retained its importance chiefly in England, where there was a wide range of interesting new plays, ranging from the social realism of Wesker to the spare ambiguities of Pinter: from the intellectual fireworks of Tom Stoppard to the perceptive boulevard comedies of Alan Ayckbourn.

The countries of the Soviet bloc also produced some interesting new playwrights, usually specialists in political allegory, notably Mrozek in Poland and Vaclav Havel in Czechoslovakia. And in Germany there was a powerful upsurge of documentary or would-be documentary drama, most of it the work of playwrights who had thoroughly absorbed the lessons of Brecht. Among the leading German playwrights of the period were Peter Weiss; Einar Kipphardt (whose *The Case of Robert T. Oppenheimer*, 1965, was perhaps the most 'authentic' effort of this particular school); and the controversial Hochhuth, who in *The Deputy* (1963) made serious accusations against Pope Pius XII for his supposed actions during the Second World War, and in *Soldaten* (1967) turned his attention to Sir Winston Churchill to highly controversial effect. These plays, however, did not stem a general tendency to create the text in the theatre itself, rather than in the privacy of the study.

Some of the most interesting theatrical experiments were those in which the text was brushed aside in favour of ritual or improvisation. Among theatre professionals, Grotowski's Polish Laboratory Theatre, founded in 1959, was particularly influential; but few people were able to experience Grotowski's work directly, even after 1970 when he and his company changed direction and started to look for ways of breaking down the conventional barriers between actor and audience.

More visible was the work of a number of American experimental companies. The La Mama Experimental Theater Club, founded in New York in 1961, was responsible for producing an enormous number of new plays, among them Rochelle Owens' deliberately outrageous *Futz!* (1968), where bestiality with pigs played a prominent part in the

General Events

There was world-wide inflation, accompanied by a financial recession.
Golda Meir was succeeded as Prime Minister of Israel by Yitzhak Rabin.
West German Chancellor Willy Brandt resigned after an aide was shown to be an East German spy.
A three-day working week was introduced in Britain because of a miners' strike.
Edward Heath called an election and was succeeded by Harold Wilson as British Prime Minister.
The Portuguese dictatorship fell in a bloodless coup.
Syria and Israel agreed to a cease-fire on the Golan Heights.
Peron died, and was succeeded by his wife.
Makarios was overthrown by Greek-Cypriot rebels; Turkish forces invaded the island and occupied much of it.
Nixon was forced into resignation by the consequences of Watergate; Gerald Ford succeeded him as President.
The Greek junta was forced out of office.
Solzhenitsyn was deported from the U.S.S.R.
Patricia Hearst was kidnapped.

The Arts

Literature
Philip Larkin – *High Windows*
Philip Roth – *My Life as a Man*
Richard Brautigan – *The Hawkline Monster*
Anne Sexton – *The Death Notebooks*

Drama
Sam Shepard – *Geography of a Horse Dreamer*
Tom Stoppard – *Travesties*
Edward Bond – *Bingo*
Alan Ayckbourn – *The Norman Conquests*

Music
Richard Rodney Bennett – Concerto for Orchestra
Harrison Birtwistle – *Imaginary Landscape*
Britten – Third Cello Suite
Stockhausen – *Herbstmusik*
John Tavener – *Ultimos Ritos*
Xenakis – *Cendris*

Art
Arakawa – *And/or in Profile*
Julio Le Parc – *Scheinkörper 12*
Dorothea Rockbourne – *Golden Section Painting: Parallelogram and Square Separated*

Architecture
Takamitsu Azuma – Nursery School, Osaka
Ahrends, Burton and Koralek – Public Library, Maidenhead, Berkshire, England

Cinema
Fassbinder – *Fear Eats the Soul*
Francis Ford Coppola – *The Conversation*
Polanski – *Chinatown*
Bresson – *Lancelot du Lac*
Fellini – *Amarcord*

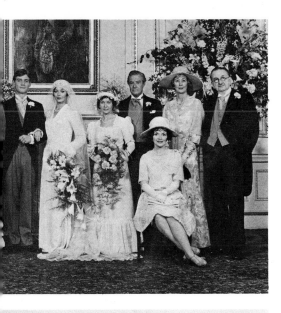

Left: Vicarious participation. The wedding that ended the TV series *Upstairs, Downstairs*, followed by millions worldwide. The early twentieth century had now become the setting for nostalgic soap opera.

Below: Philip Pearlstein — *Male and Female models on cast-iron bed.*

Above: Jeremy Mackay-Lewis — Credit Lyonnais building, London (1974–8). Post-modern architecture.

Below: A scene from *The Sting*, apotheosis of the buddy-movie. It also promoted popular interest in the long-neglected music of Scott Joplin.

Left: Claudio Bravo — *The Studio.* Compare this with Pearlstein's equally rigorous realism.

The Modernist Dilemma

1975

action. Many of the texts chosen for staging were extremely ramshackle, but La Mama stood for an outburst of theatrical energy which offered a real challenge to the conventional Broadway scene. Even less respectful of the idea of the text were the Bread and Puppet Theater, also founded in 1961, and the improvisatory Living Theater. The Living Theater lived and worked as a commune, and their most remarkable effort was *Paradise Now*, a show which tried to put into effect Antonin Artaud's ideas about a 'Theatre of Cruelty'. In 1968, the year of *Paradise Now*, the Living Theater began an influential European tour.

If the theatre and the cinema, in their different ways, responded sensitively to a rapidly changing cultural climate, architecture, the 'social art' *par excellence*, found it hard to make the needed adjustments, and attracted fiercer criticism than ever before. This criticism was of two kinds — stylistic and sociological. The pure, classic forms of International Modernism were too bland for an impatient new generation of architects, and by the mid-seventies it had become commonplace to speak of Post-Modern Architecture as a new category. The difficulty was to find a common stylistic denominator among the buildings which defied established modernist conventions.

At the same time, Le Corbusier's ideal of the *Unité d'habitation*, adapted for practical use in the tower blocks of numerous new housing projects, attracted even more opposition than it had in the sixties as the social strains these structures imposed were recognized. In St Louis, some blocks in a large housing scheme built as recently as 1952–55 were dynamited in 1972. They had become unfit for further use after being consistently vandalized.

There was a continuing reaction, not just against tower blocks and authoritarian planning of all kinds, but against over-elaborate technology. It was realized, for example, that the sealed glass-and-steel constructions so typical of the last phase of International Modernism were not only impossible to construct by the primitive building methods still in use in many parts of the world, but enormously wasteful of energy resources, since they were not only poorly insulated but needed to be both heated and cooled artificially.

The early seventies, in particular, were a time when a completely new range of architectural problems presented itself to both architects and clients, but with no obvious solutions in sight.

These problems were symptomatic of a profound social malaise, which was also beginning to affect all the arts. Artists were more and more returning to their pre-modernist role by producing direct reflections of their society and its development.

General Events

King Faisal of Saudi Arabia was assassinated.
Chiang-kai-shek died.
There was civil war in Angola between the rival independence movements MPLA and FNLA.
Cambodia fell to the Communists; the Khmers Rouges occupied Phnom Penh.
South Vietnam fell to the Communists.
Mozambique became independent.
There was civil war in Ethiopia between the central government and Eritrean separatists.
The Greek monarchy was rejected in a national referendum.
Ehrlichman, Haldeman and other Nixon advisers were convicted for their part in Watergate.
There was civil war in Lebanon, with fighting between Palestinian guerillas and Phalangists.
General Gowon was overthrown in Nigeria.
Indira Gandhi governed India under Emergency Powers.
President Mujibir Rahman was overthrown and killed in a military coup in Bangladesh.
Margaret Thatcher replaced Edward Heath as leader of the British Conservative Party.

The Arts

Literature
V.S. Naipaul – *Guerillas*
Anthony Powell – *Hearing Secret Harmonies* (the twelfth and final volume of 'A Dance to the Music of Time')
E.L. Doctorow – *Ragtime*
Saul Bellow – *Humboldt's Gift*
John Ashbery – *Self-Portrait in a Convex Mirror*
Max Frisch – *Montauk*
Gabriel Garcia Marquez – *Autumn of the Patriarch*
Régis Debray – *L'Indésirable*

Drama
Harold Pinter – *No Man's Land*
Robert Patrick – *Kennedy's Children*
Carl Zuckmayer – *The Rat-Catcher*
Edward Albee – *Seascape*

Music
Robin Orr – *Hermiston*
Aulis Sallinen – *The Horseman*

Art
John Salt – *Two-toned Trailer*
John de Andrea – *Woman in Bed* (1974–5)

Architecture
Louis I. Kahn – Kimbell Art Museum, Fort Worth, Texas
Foster Associates – Ipswich Centre (Willis, Faber and Dumas, Insurance Brokers), Ipswich, England

Cinema
Robert Altman – *Nashville*
Woody Allen – *Love and Death*
Francis Ford Coppola – *The Godfather II*
Claude Chabrol – *Une Partie de Plaisir*

Above: Signs of the times in Los Angeles.

Right: Robert Altman's film *Nashville* — a nation mirrored by the country-music industry.

Below: Stephen Spielberg's *Jaws* — film-chiller of the year.

Below: Ludmila Seefried-Matjekova — *Cry I.* Contemporary frustrations symbolized in sculpture.

Below: The Culture Machine. The Pompidou Centre in
Paris, designed by Piano and Rogers, opened in 1977.
A fine example of post-modernist architecture.

Epilogue

There are three ways of approaching the cultural events of the last years of the seventies, and of trying to form an opinion about the final quarter of the twentieth century as a whole. They are to look at political and economic tendencies, interpreting these in the broadest sense; to look at the sociology of culture, as this now seems to be developing; and to look at the fate of modernism itself. To present these topics in that order gives the advantage of a gradually narrowing focus.

The key factor, in economic and political terms, seems to be the question of the supply of energy and raw materials. Put simply, this means that either the pace of technological advance must be drastically slowed, or that new sources of energy must quickly be found, and established ones used more economically.

The energy crisis has arrived at an awkward time, since the democratic societies of the west have in any case created within themselves a pressure of expectation which cannot be satisfied under existing conditions. Governments must always promise more in terms of the standard of life than they can reasonably expect to deliver.

But the problem is not confined to the western democracies alone. It is even more visible and acute in many of the countries which go to make up what is now called the Third World. The people of these nations, many of which are very new, have been led both by their own leaders and by those who were formerly their masters to expect the almost immediate arrival of a millennium, which is, of course, unlikely ever to be reached. In national terms, it often seems that the have-nots can improve their position only at the expense of the haves.

This, then, is the shaky foundation upon which a culture of some kind must be built. Many hard-pressed governments have, to their credit, been willing to allocate part of their inadequate resources to the arts. State intervention in this field, already well-established in some countries (England and the Scandinavian democracies are good examples) during the fifties, has now become a commonplace.

But intervention of this type has had one unexpected consequence. It has tended to turn most branches of artistic expression into official art. The fact that this has not been commonly realized is due to a paradox. In the West, and even in a number of countries of the Soviet bloc such as Poland, officialdom has been willing to give a certain countenance to the *avant-garde*. This did not mean that the *avant-garde* claimed the lion's share of state patronage; everywhere that governmental support was offered, the bulk of it went to enterprises working within traditionally established rules – to national theatres and opera-houses, to state dance-companies and major museums. But it did mean that the *avant-garde* was brought within the boundaries of the official establishment, so that there even arose a bureaucratic formula for encouraging apparent rebellion.

There have also been other factors at work: *avant-garde* activities were usually in particular need of subsidy because they attracted so little patronage from individuals. Whereas, at the beginning of the century, it was the individual who backed his own judgement – the art dealers Kahnweiler and Ambroise Vollard are cases in point – and encouraged activities with which the state would have nothing to do, now it was the state which became almost the sole resource for the dedicated experimentalist. By the middle of the seventies it was possible to formulate a rule of thumb: the more conspicuously *avant-garde* the activity, the more dependent it was on official patronage of one kind or another.

Epilogue

The position of the experimental artist, writer or musician was made doubly awkward by the fact that the modernist tradition within which they worked had originated as an élitist revolt against the populism of nineteenth-century culture. Modernism was indeed the second stage of that revolt, the first having been symbolism. Where the symbolists were content to inhabit their own ivory towers, modernism was, from its beginning, aggressive. Many of the early modernists had had a good dose of Nietzsche. They believed in the superiority of the creative artist as a being who towered above the heads of the mass, and who by right of that superiority could make and act as he pleased, ignoring the desires or prejudices of others.

As I have tried to demonstrate in earlier sections of this book, the artist as superman was also, both in his own estimation and in that of an important part of his audience, the artist as revolutionary. But revolution is a deeply ambiguous concept. The Modern Movement did transform many things, the visual arts in particular. The error was to equate these changes with the revolutions that took place in politics – revolutions set in motion, not by any act in the artistic sphere, but mainly by the social and economic upheaval of the First World War.

In the mid-seventies there was a renewed impulse towards the democratization of the arts. It had roots in a number of different places, and took a number of guises. Those who guided state patronage felt, quite rightly, that since the arts were paid for by all, they must be made available to as many people as possible. Creative people, too, now wanted to communicate with a broader audience. In addition, they sometimes wished to express their own politically revolutionary principles, which does not amount to quite the same thing.

There was therefore an effort to proselytize a new audience, and to teach it what the arts had to offer. More than this, the enjoyment of the arts, and their availability, had gradually and almost insensibly come to be seen as a universal right, like the rights to food, clothing and shelter, even though that right was often not exercised.

There were, however, certain difficulties. The right to enjoy art became to some extent confused with a right to make it. Everyone must be allowed the right to exercise innate creativity. This idea, admirable in itself, often led to a drastic lowering of standards, as it was felt that fledgling efforts must not be subjected to too much adverse criticism. In extreme cases, there was a tendency to ask whether it was truly democratic to have fixed standards at all – that is, if they had not been already outmoded by the relentless dynamic of modernism.

Quite apart from this, the pressure of expectation already described had a curious side-effect. Despite all the efforts of the propagandists, an imbalance existed between the production and consumption of art. Far more people aspired to be full-time artists, musicians and writers than even the most developed economies could support.

Finally, there was a difficulty over artistic communication itself. It often seemed that the modern arts could not serve as a vehicle for specific ideas, especially political ideas, without devaluing themselves and losing their specifically modernist character. Political art seemed to have the choice of being either banal or unintelligible to the intended audience.

The art most concerned with the actual structure of society – contemporary architecture – continued

These three images from art in the late seventies show three of its preoccupations: with sociology, ecology and politics.
Below: Stephen Willats — *Concerning our Present Way of Living* (1979).
Below right: Arwed D. Gorella — *From a Drought Area* (1977).
Bottom right: John Dugger — *Victory is Certain* (1976). A banner commemorating the new People's Republic of Angola.

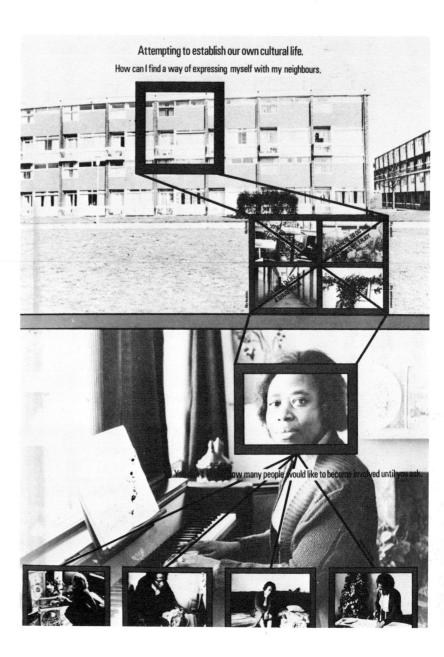

Attempting to establish our own cultural life.
How can I find a way of expressing myself with my neighbours.

to be weak just where it should have been strongest. New buildings might be spectacular technological achievements, but they were seldom successful as tools for creating new and better social relationships.

Yet, while commentators in the more developed western countries had already begun to say that the Modern Movement was losing its potency as a creative force, the myth of modernism continued to spread. Outside the Europe of its origins – in Japan, India, Latin America and Africa – some version of modernism tended to become the accepted norm of artistic activity, attempting to ally itself with whatever remained of indigenous culture.

The amalgam was often less than happy, and one of the most interesting questions of the mid-seventies concerned the way in which these hybrid cultures might develop.

The cultural chauvinism which had continued to exist even in the sixties, and which made it possible to discuss the arts almost entirely in terms of what was taking place in the United States and in western Europe, became less and less easy to sustain. In certain cases it broke down altogether. The architectural commentators of the seventies, for example, had already been forced to recognize the importance of contemporary Japanese architecture. Here vigorous economic growth had led to a great upsurge of building, much of it in new and experimental forms. In addition, acute problems of pollution and overcrowding had led to important advances in the theory and practice of urban planning.

The collapse of chauvinism was an excellent thing, but even more important was its corollary – the death of the idea that any one cultural centre was necessarily pre-eminent. Yet even this had one inevitable disadvantage. It became no longer possible to construct theoretical patterns about the way modern culture had developed or would develop. Towards the end of the nineteenth century scientists had begun to complain about the burden of knowledge. No one mind could any longer hope to master all the ramifications of a single subject or major area of research. Science did, however, have two advantages. Since the kind of knowledge it dealt in was objective, one discovery could be built on another while still allowing ignorance of work in other areas. And, where the mind itself faltered, tools such as the computer could eventually be brought to its aid.

In the modern arts, there is an assumption that all reactions are subjective and that all discoveries must be made afresh by every new generation. The problem of evaluating what is produced and creating some sort of intellectual pattern to make sense of it therefore becomes increasingly acute. The artist can no longer rely on the work of others in the way that the generation of Leonardo, for example, made use of earlier discoveries in perspective; artists must now always return to the beginning and create an entirely personal idiom.

In many parts of the world, the Modern Movement, despite its name, has become an old vessel into which new wine is being poured. What the result will be no-one is yet in a position to say, and perhaps no-one will ever be in a position to evaluate the consequences of these changes. The uncertainty in which we find ourselves is greatly increased by the uncertain future of technological society itself, to which the modern arts have become so intimately, and often so unhappily, linked.

Bibliography

Literature

CONNOLLY, Cyril *The Modern Movement* London, 1965 (brief accounts of 100 key books: English, French and American)

DONALD, Miles *The American Novel in the Twentieth Century* London and New York, 1978

FREEBORN, Richard (ed.) *Russian Literature: A History from Pushkin to Solzhenitzyn* London, 1976

GARLAND, Henry and Mary *The Oxford Companion to German Literature* Oxford, 1976

GILLIE, Christopher *Longman Companion to English Literature* revised edition, London, 1978

HART, James D. *The Oxford Companion to American Literature* 4th edition, New York, 1965

HARVEY, Sir Paul (ed.), revised EAGLE, Dorothy *The Oxford Companion to English Literature* revised edition, Oxford, 1973

HARVEY, Sir Paul and HESELTINE, J.P. (ed.) *The Oxford Companion to French Literature* Oxford, 1959

HAWKINS, William E. *Dictionary of Russian Literature* London, 1957

MARKOV, Vladimir *Russian Futurism: a history* London, 1969

MOORE, Harry T. and PERRY, Albert *Twentieth Century Russian Literature* London, 1976

POLLARD, Arthur (ed.) *Webster's New World Companion to English and American Literature* London and New York, 1973

ROBERTSON, J.G. and REICH, Dorothy *A History of German Literature* 6th edition, Edinburgh and London, 1970

SPILLER, THORP, JOHNSON, CANBY, LIDNEY and GIBSON *A Literary History of the United States* 4th edition, revised, New York, 1974

WARD, A.C. *Longman Companion to Twentieth Century Literature* London, 1970

WARD, Philip (ed.) *The Oxford Companion to Spanish Literature* Oxford, 1978

WILKINS, E.H. *History of Italian Literature* revised edition, Cambridge, Massachusetts, 1974

Drama

BRUSTEIN, Robert *The Theatre of Revolt* Boston, 1964; London, 1965

CLARK, Barrett H. and FREEDLEY, George (ed.) *History of Modern Drama* New York, 1947

ELLIS-FERMOR, Una *The Irish Dramatic Movement* 2nd edition, London, 1954

Enciclopedia dello spectacolo Rome, 1954–66

ESSLIN, Martin *The Theatre of the Absurd* New York, 1961; London, 1962

GASSNER, John and QUINN, Edward (ed.) *The Reader's Encyclopaedia of World Drama* London, 1970

GERTEN, H.F. *Modern German Drama* 2nd edition, London, 1962; New York, 1964

GORCHAKOV, Nikolai *The Theater in Soviet Russia* New York, 1957

GOTTFRIED, Martin *A Theatre Divided: the Post-war American Stage* Boston, 1969

GUICHARNAUD, Jacques *Modern French Theatre, from Giraudoux to Genet* New Haven, Connecticut, 1967

HARTNOLL, Phyllis (ed.) *The Concise Oxford Companion to the Theatre* London, 1972

MALTAU, Myron *Modern World Drama* London, 1972

MELCHINGER, Siegfried *Concise Encyclopaedia of Modern Drama* New York, 1966

ROOSE-EVANS, James *Experimental Theatre* new edition, London, 1973

TAYLOR, John Russell *The Penguin Dictionary of the Theatre* London and New York, 1967

TAYLOR, John Russell *Anger and After* 2nd edition, London, 1969 (published in New York, 1969, as *The Angry Theatre*)

WILLIAMS, Raymond *Drama from Ibsen to Brecht* London, 1968; New York, 1969

Music

A Guide to Popular Music London, 1960

BLOM, Eric (ed.) *Grove's Dictionary of Music and Musicians* 5th edition, London, 1954

COOPER, Martin (ed.) *The New Oxford History of Music*, Vol. X, 1890–1960 London, 1974

GRIFFITHS, Paul *A Concise History of Modern Music* London, 1978

HARDY, Phil and LAING, Dave (ed.) *The Encyclopaedia of Rock*, 3 vols. London, 1976

MELLERS, Wilfred *Music in a New Found Land* London, 1964 (contains a substantial section on the blues and jazz)

PANASSIÉ, Hugues and GAUTIER, Madeleine *Dictionary of Jazz* London, 1956

THOMPSON, Oscar (ed.) *The International Cyclopaedia of Music and Musicians* 10th edition, New York, 1975

Art

ASHTON, Dore *The Life and Times of the New York School* Bath, 1972

BARRETT, Cyril *Op Art* London, 1972

BATTCOCK, Gregory (ed.) *Minimal Art – A Critical Anthology* London, 1968

BRETT, Guy *Kinetic Art* London, 1968

DORVAL, Bernard *The School of Paris* London, 1962

DUBE, Wolf-Dieter *The Expressionists* London, 1972

FRY, Edward F. *Cubism* London, 1966

HAFTMANN, Werner *Painting in the Twentieth Century*, 2 vols. 2nd edition, London, 1965

HUYGHE, René (ed.) *Larousse Encyclopaedia of Modern Art* London, 1965

KULTERMANN, Udo *New Realism* London, 1972

LIPPARD, Lucy R. *Pop Art* London, New York, 1966

LUCIE-SMITH, Edward *Movements in Art since 1945* revised edition, London, 1975

LUCIE-SMITH, Edward *Art Today* London and New York, 1977

MARTIN, Marianne W. *Futurist Art and Theory* Oxford, 1968

MEYER, Ursula *Conceptual Art* New York, 1972

NADEAU, Maurice *The History of Surrealism* New York, 1965

OVERY, Paul *De Stijl* London, 1969

Phaidon Dictionary of Twentieth-Century Art London, 1973

RICHTER, Hans *Dada* London, 1965

ROH, Franz *German Art in the Twentieth Century* revised edition, London, 1968

ROSE, Barbara *American Art since 1900* London and New York, 1967

ROSENBLUM, Robert *Cubism and Twentieth Century Art* revised edition, New York, 1966

RUBIN, William S. *Dada and Surrealist Art* London, 1969

RUSSELL, John and GABLIK, Suzi *Pop Art Redefined* London, 1969

SANDLER, Irving *Abstract Expressionism: The Triumph of American Painting* London and New York, 1970

VERGO, Peter *Art in Vienna, 1898–1918* London, 1975

WALKER, John A. *Art since Pop* London, 1975

WILLETT, John *Expressionism* London, 1970 (covers all means of artistic expression)

WILLETT, John *The New Sobriety: Art and Politics in the Weimar Period* London, 1978 (covers all means of artistic expression)

Architecture

BANHAM, Reyner *The New Brutalism* London, 1966

BAYER, Herbert, GROPIUS, Isa and GROPIUS, Walter (ed.) *Bauhaus, 1919–1928* 3rd edition, New York, 1959 (covers all aspects of Bauhaus activity)

HITCHCOCK, Henry-Russell *Architecture: Nineteenth and Twentieth Centuries* 3rd edition, London, 1968

JENCKS, Charles *Modern Movements in Architecture* 2nd edition, London, 1977 (jargon-ridden but comprehensive)

JENCKS, Charles *The Language of Post-Modern Architecture* revised edition, London, 1978

KIDDER SMITH, G.E. *The New Architecture of Europe* London, 1961

McCALLUM, Ian *Architecture U.S.A.* London, 1959

PEHNT, Wolfgang (ed.) *Encyclopaedia of Modern Architecture* London, 1963

PEVSNER, Nikolaus *The Sources of Modern Architecture and Design* London, 1968

WHITTICK, Arnold *European Architecture in the Twentieth Century* Aylesbury, 1974 (covers topics usually omitted, such as fascist architecture in Germany and Italy)

Cinema

ANDERSON, Joseph L. and RICHIE, Donald *The Japanese Film* Rutland, Vermont and Tokyo, 1959

ARMES, Roy *French Cinema since 1946*, 2 vols. London and New Jersey, 1966

BAWDEN, Liz-Anne (ed.) *The Oxford Companion to Film* London, 1976

BLUM, Daniel and KOBAL, John *A Pictorial History of the Talkies* revised edition, London 1974

CAWKWELL, Tim and SMITH, John M. (ed.) *The World Encyclopaedia of Film* London, 1972

COWIE, Peter *Seventy Years of Cinema* South Brunswick and New York, 1969

GRAHAM, Peter *The New Wave* London, 1968

GRIERSON, John *Grierson on Documentary* London, 1966

RHODE, Eric *A History of the Cinema from its Origins to 1970* London, 1976 (currently the best narrative history of its subject)

ROTHA, Paul and GRIFFIN, Richard *The Film Till Now* 3rd edition, London, 1960

SADOUL, Georges *Dictionary of Films* Berkeley and Los Angeles, 1975

181

The publishers would like to acknowledge the help of the following sources in providing pictures for this book. Individual pictures are denoted by the pages on which they appear and a letter which gives the position on the page (by labelling clockwise, from the top left).

All Sports Photographic: pp. 174/175c. Annan: pp. 30/31d. Arts Council, London: pp. 158/159d, 178/179c. Baltimore Museum of Art: pp. 26/27c. Basel, Kunstsammlung: pp. 42/43c. Cecil Beaton (Victoria & Albert Museum): pp. 116/117e. Galerie Claude Bernard, Paris: pp. 172/173d. Galerie Beyeler, Basel: pp. 104/105a. Bonn, Städtische Kunstsammlungen: pp. 68/69a. Brussels, Royal Museum: pp. 30/31e. Bulloz, Paris: pp. 30/31a, 48/49h. Caisse Nationale des Monuments Historiques, Paris: pp. 20/21e. Camera Press, London: pp. 74/75d, 86/87d, 88/89b, 90/91e, 92/93c, 100/101e, 104/105f, 106/107a, 108/109a, d, 110/111a, 118/119a, 120/121d, 122/123d, 128/129c, 130/131c, 132/133b, 134/135a, b, 142/143f, 148/149d, 150/151a, 152/153c, 156/157a, 158/159f, 162/163a, 164/165b, c, e, 166/167c, e, 168/169b, d, 170/171a, e, 172/173a, 174/175a. Carnegie Institute: pp. 18/19a. Leo Castelli Gallery, New York: pp. 138/139e, 148/149b, 152/153a, 170/171b. Chevojon, Paris: pp. 22/23b. Chicago Art Institute: pp. 36/37a, 76/77b, 104/105b, 144/145. Marchioness of Cholmondley: pp. 26/27a. Connaissance des Arts, Paris: pp. 13/14b, 58/59c, 154/155a. Cooper-Bridgeman Library, London: pp. 10/11, 17/18a, d, 20/21d, 52/53, 92/93b. Copenhagen, Statens Museum for Kunst: pp. 22/23a. Courtauld Institute, London: pp. 48/49c. Dars Archives, London: pp. 13e, 18/19c, 28/29b, 58/59d, 70/71e, 78/79d, 106/107c, 132/133c. Edinburgh, Scottish National Gallery of Modern Art: pp. 148/149e. Collection van Abbemuseum, Eindhoven, the Netherlands: p. 2. Fischer Fine Art, London: pp. 62/63c, 82/83d. Fogg Art Museum: pp. 88/89e. Ghizzoni: pp. 38/39d. Gimpel & Fils, London: pp. 172/173e. Glasgow Art Gallery: pp. 124/125b. Solomon R. Guggenheim Museum, New York: pp. 28/29d, 30/31c, 38/39a, 108/109c. Halifax, Dalhousie University: pp. 156/157b. O.K. Harris Gallery, New York: pp. 6/7. Hartford, Wadsworth Atheneum: pp. 100/101a. Hedrick Blessing: pp. 30331b, 90/91b. Lucien Hervé, Paris: pp. 18/19b, 60/61c. Hirschhorn Museum, Smithsonian Institution: pp. 152/153e. Michael Holford, London: pp. 40/41, 56/57c, 146/147d. Imperial War Museum, London: pp. 44/45a, 50/51a, e, 54/55a. René Jacques, Paris: pp. 12/13c. Sidney Janis Gallery, New York: pp. 108/109e. 132/133d. the Jewish Museum, New York: pp. 160/161d. Annely Juda Gallery, London: pp. 54/55c. John Kobal Collection, London: pp. 78/79e, 136/137e, 138/139d, 140/141a, d, 148/149c, 166/167d. R. Lalance: pp. 12/13a. Lords Gallery, London: pp.

78/79a, 82/83b, 88/89c. Ludwig Sammlung, Cologne: pp. 160/161c, 166/167a. Mander & Mitchenson, London: pp. 64/65c. Mansell Collection, London: pp. 42/43e, 86/87a, 90/91c, 94/95e, 102/103a, b, 110/111c. Archivo Mas, Barcelona: pp. 32/33d, 74/75b. Metropolitan Museum, New York: pp. 68/69d. Minneapolis Institute of Art: pp. 102/103c. National Film Archive, London: pp. 102/103d, 106/107e, 118/119e, 120/121e, 130/131a, d, 136/137c, 142/143e, 154/155c, 160/161b, 162/163c, 168/169a, 170/171d, 172/173c, 174/175b, c. Oslo, National Gallery: pp. 14/15b. Paris, Musée des Arts Décoratifs: pp. 66/67c. Paris, Musée National d'Art Moderne: pp. 36/37b. Philadelphia, Museum of Art: pp. 22/23d, 24/25g, 36/37e, 50/51c, 98/99f. Mrs A.M. Phillips Collection, London: 116/117d. Popperfoto, London: pp. 46/47b, 62/63d, 66/67b, 76/77d, 84/85e, 86/87c, 88/89a, 90/91d, 92/93a, 94/95c, 98/99b, 100/101c, d, 102/103e, 110/111b, e, 114/115a, e, 116/117f, 118/119b, 122/123b, 124/125a, e, 126/127a, 130/131b, 136/137a, 138/139c, 142/143c, 146/147b, 150/151d, 152/153d, 154/155d, 156/157d, 158/159a, c, e, 160/161a, e, 162/163c. Press Association: pp. 44/45c. Ritz Hotel, London: pp. 24/25a. Royal Institute of British Architects, London: pp. 22/23c. Saint Dizier, Musée de l'Automobile Française: pp. 18/19d. Saint Louis Art Museum: pp. 28/29a. Galerie Schwab, Stuttgart: pp. 70/71b. Seeberger, Paris: pp. 108/109b, 120/121c. Miki Slingsby, London: pp. 42/43a, 94/95a. Snark International, Paris: pp. 4/5, 8, 12/13d, 14/15c, 16/17b, e, 24/25c, e, f, 28/29c, 32/33c, 34/35a, 36/37f, 38/39c, f, 42/43d, 44/45b, d, 46/47a, d, 48/49a, d, e, f, 50/51b, f, 54/55b, d, 56/57d, 58/59b, 60/61d, 62/63a, e, f, 64/65b, e, 66/67d, e, 68/69b, c, 70/71a, c, 72/73b, c, d, 74/75a, c, 76/77c, e, 82/83c, e, 84/85b, d, 86/87e, 88/89d, 90/91a, 94/95d, 98/99a, c, d, 100/101b, 104/105d, 108/109f, 114/115d, 120/121a, 124/125c, 126/127e, 128/129d, 134/135c, e, 142/143a, 146/147a, e, 150/151e. Stockholm, Moderna Museet: pp. 132/133a. Tate Gallery, London: pp. 22/23e, 24/25b, 38/39e, 46/47c, 62/63b, 66/67a, 74/75e, 80/81, 86/87b, 94/95b, 96/97, 104/105c, 106/107d, 110/111d, 114/115b, 116/117c, 130/131e, 148/149a, 150/151b, 162/163b, 164/165a. Agence Top, Paris: pp. 64/65b. USIS: pp. 126/127b, 132/133e. Victoria & Albert Museum, London: pp. 60/61a, 90/91f, 92/93e, 142/143d. Vienna, Albertina: pp. 38/39b. Vienna, Museum für angewandte Kunst: pp. 24/25d. Vienna, Österreichische Galerie: pp. 50/51d. Visual Arts Library, London: pp. 34/35c. Wallraf-Richartz Museum, Cologne: pp. 64/65a. Washington, Library of Congress: pp. 104/105e, 136/137d. Washington, National Gallery of Art: pp. 122/123c. Washington, Phillips Collection: pp. 60/61b. Whitechapel Gallery, London: pp. 178/179a. Whitney Museum, New York: pp. 14/15a, 70/71d. Zurci, Kunszgewerbemuseum: pp. 20/21b.

DATE DUE

GAYLORD		PRINTED IN U.S.A.